JOHNSTOWN
PENNSYLVANIA

JOHNSTOWN
PENNSYLVANIA

A HISTORY, PART TWO: 1937–1980

RANDY WHITTLE

Charleston London

History
PRESS

Published by The History Press
Charleston, SC 29403
www.historypress.net

Front page: The main Bethlehem gate at the Upper or Franklin Works was the location of several picket and worker confrontations during the Little Steel Strike. This photograph was taken by UPI on June 13, 1937. *Courtesy Johnstown Area Heritage Association.*

First published 2007

Manufactured in the United Kingdom

ISBN 978.1.59629.052.5

Library of Congress Cataloging-in-Publication Data

Whittle, Randy G.
 Johnstown, Pennsylvania: a history / Randy G. Whittle Jr.
 v. cm.
 Contents: Pt. 1. 1890-1936
 ISBN 978-1-59629-052-5 (alk. paper)
 1. Johnstown (Pa.)--History. I. Title.
 F159.J7W48 2005
 974.8'95--dc22

 2005023094

CONTENTS

Labor Relations during the Great Depression

I. The Johnstown Steel Strike of 1937

Organized Labor and the New Deal

Throughout the 1920s and early 1930s, the American labor movement waned. There were few backers in Congress, and the Harding, Coolidge and Hoover administrations were unfriendly. Membership in the American Federation of Labor (AFL) fell from 4.1 million in 1920 to 2.2 million by 1933.

Roosevelt's first term became one of bitter labor strife. Through Section 7A of the National Industrial Recovery Act, early New Deal legislation, the Roosevelt administration had supported a labor policy to be administered as part of its NRA industrial codes.[1] Workers would have "the right to organize and bargain collectively through representatives of their own choosing, and they shall be free from interference, restraint or coercion of employers in the designation of such representatives...or activities for the purpose of collective bargaining." This language plus the policies of those involved in the National Recovery Administration helped revitalize the labor movement. In May 1935, however, the U.S. Supreme Court declared the National Industrial Recovery Act unconstitutional. Several weeks later, President Roosevelt signed into law the National Labor Relations Act, a law sponsored by Senator Robert Wagner. Among other things, it had been drafted to clarify ambiguities that had surfaced with Section 7A. The Wagner Act took effect soon after the NIRA was nullified.

The new legislation also created the National Labor Relations Board, which was authorized to conduct hearings and order workplace elections. As had been true with the NIRA, the National Labor Relations Act was quickly challenged in court. In 1937 the Supreme Court upheld the law by a five to four majority.[2]

The CIO and Its Split with the AFL

Meanwhile, a major issue was debated within organized labor: whether to move away from a craft-guild basis of union organization toward a more comprehensive industry-wide approach. The development of modern industry—automobiles, steel, coal, textiles and the like—meant that labor's interests could hardly be protected or served through trade unions established along craft-skill and work-tool lines.

The AFL, led by William Green, had remained cemented to the older guild philosophy of the late Samuel Gompers. The newer approach was best described by its champion, John L. Lewis, president of the United Mine Workers (UMW): "The labor movement of this country cannot fulfill its mission unless the basic mechanized, mass production industries are organized upon an industrial basis. It is clear that the American Federation of Labor, so long as it permits craft unions to possess jurisdiction over skilled workers in these basic industries, cannot meet the proper requirements of an organized labor movement in America."[3]

At the annual convention of the AFL in October 1935, a bitter policy debate dominated the meeting. Lewis was seeking charters for several industrial unions. After their denial, Lewis lamented, "The AFL is standing still with its face toward the dead past." The next month the Committee for Industrial Organization (CIO) was formed. Its chairman was the foremost labor leader of the age, John L. Lewis.[4]

Steel Workers' Organizing Committee

Soon efforts would be getting underway to organize the automobile industry, rubber plants and other enterprises along industry-wide lines.

For many reasons—problems his UMW had been having with non-union captive mines controlled by steel companies, a desire to outdo William Green's occasional urgings about organizing the steel industry ("all words, no action") or other unknown reasons—John L. Lewis decided in late 1935 to embark upon a program to organize the American steel industry.

While speaking at a miners' rally at Greensburg, Pennsylvania, in April 1936, Lewis publicly advocated the creation of an industrial union for steelworkers. He revealed he had urged the AFL to spend $1.5 million for "industrial organization" in general but confided his proposal had been rejected. Lewis mentioned a forthcoming session of the Amalgamated Association of Iron, Steel, and Tin Workers. "I hope the leaders of the organization will see the writing on the wall and that it will take for its policy a movement for organization on a practical basis."[5]

By early June it was evident that Lewis had been making serious inroads with the Amalgamated Association of Iron, Steel, and Tin Workers about which union would affiliate with the CIO. Green began bemoaning a split in the labor movement and even appeared at an UMW meeting, urging the CIO to disband. Lewis stated there was no split in the labor movement. It was getting stronger. He did, however, resign as vice-president of the AFL and continued to express cutting remarks about its leadership.[6]

With the Amalgamated Association of Iron, Steel, and Tin Workers joined into his new crusade, Lewis announced the creation of the Steel Workers' Organizing Committee

(SWOC). From UMW funds and contributions made by other CIO affiliates, SWOC had a war chest of over $500,000. Lewis's close associate, Phillip Murray of the UMW, was named SWOC chairman. His headquarters were in Pittsburgh. Murray's team included the nation's best labor professionals and organizers. There was also a good publicity staff and competent legal talent.

While the campaign to organize the steel industry already had weeks of press coverage, it was formally announced on June 13, 1936. A few days later, fourteen labor organizers backed up by more than four hundred people began establishing themselves in steel communities throughout the Midwest and East.[7]

SWOC organizers pursued two separate but closely related objectives. They sought membership cards from steelworkers by the thousands. They also focused upon taking over company-controlled unions by discussions in clandestine meetings with their officers. In Johnstown this meant signing up the officers of the Employee Representation Plan, started by Midvale Steel in 1918.[8]

The Steel Industry Reaction

On June 28, 1936, the Iron and Steel Institute, whose outgoing chairman was Bethlehem's president, Eugene Grace, issued news releases and paid advertisements in the national media and steel city newspapers stating that the steel industry would hold steadfast to three principles:

> *It would oppose the "closed shop" requiring workers to join unions.*
> *It would resist any intimidation of workers who wanted to work by those supporting a strike.*
> *It would not bargain with outside parties.*[9]

The statement was viewed by the SWOC as a declaration of war.

On October 3, 1936, an advertisement appeared in Johnstown newspapers: "Johnstown's Industries Pay 30 percent Of Your Local Tax Bill, $761,227 to the City Treasury Alone." Also printed was "Prosperity Dwells Where Harmony Reigns." The ad was sponsored by the Citizens' Council of Greater Johnstown, an affiliate of the Johnstown Chamber of Commerce.

Lunch at the Mayflower

On January 9, 1937, John L. Lewis and Pennsylvania Senator Joseph Guffey were lunching at Washington's Mayflower Hotel when Myron Taylor, chairman of the U.S. Steel Corporation, and his wife entered. After being seated, Taylor went over to chat briefly with the senator and Lewis. Following lunch, Lewis visited the Taylor table and chatted for thirty minutes. The conversation underway, a watershed event, was watched with interest by many in the dining room.

The next day Lewis and Taylor met again in Taylor's hotel suite, the first of several private meetings. The two men resumed their secret negotiations at Taylor's New York City townhouse. By the end of February, an understanding had been reached.[10]

The agreement was refined and finalized in Pittsburgh on March 2, 1937, between SWOC representatives Lee Pressman, Sidney Hillman and Philip Murray and Benjamin Fairless, president of U.S. Steel. There was a wage increase, an eight-hour day, a five-day workweek and

time and a half for overtime. Grievance procedures and seniority provisions were included. The "open shop," however, remained.[11]

Insofar as Johnstown was concerned, the agreement applied to the Lorain Steel Company at Moxham, a unit of the Carnegie-Illinois Steel Corporation of U.S. Steel. Being unionized, this part of the Johnstown workforce would escape the forthcoming steel strike.

The Lewis-Taylor accord is attributed to Myron Taylor's awareness that the times had changed. He was seeking to avoid a protracted and costly dispute he doubted his corporation could win in the New Deal epoch. A frequent visitor to Europe, Taylor sensed the coming of war. Being in the good graces of organized labor would be an advantage in military contracting.

The Independents: Little Steel

The agreement between SWOC and the U.S. Steel Corporation had the effect of banding together the independent steel companies—Bethlehem, Youngstown Sheet and Tube, Inland, Republic, Sharon, Crucible and Jones and Laughlin. All decided unilaterally to meet the wage, workday and workweek items agreed to between SWOC and Benjamin Fairless. The spokesman for the group was Tom Girdler, the recently named chairman of the American Iron and Steel Institute. Girdler was fiercely anti-union.

By March 8, SWOC organizers were insisting upon a signed agreement with the Bethlehem Steel Company. On March 20 a meeting lasting about forty-five minutes occurred between a team of SWOC representatives and Bethlehem senior staff. Two days later the Bethlehem Steel Company issued a public statement that, among other things, stated, "The management at any of our plants will meet at mutually convenient times with any people claiming directly or through any organization to be representative of any of our employees and we will consider with them any matters…which they may present to us."

At this same time the results of elections of the Bethlehem Employee Representation Plan were announced—fifty-five people had been elected from the Cambria Steel operations and eight were elected from the Conemaugh and Blacklick Railroad to represent their units in bargaining with the Bethlehem management.

The announcement was worded in the jargon of progressive democracy. A SWOC statement, however, voiced objections: "Phillip Murray, chairman of SWOC, informed a mass meeting… that CIO's objective…will be recognition of John L. Lewis' committee as the exclusive bargaining agency in all its plants."[12]

In May SWOC reached an agreement with Jones and Laughlin for a union-recognition election. Soon afterward its workforce voted 17,000 to 7,200 to affiliate exclusively with SWOC.[13] On May 24, Crucible Steel also reached an agreement with SWOC. The other independent companies refused to sign.

Tom Girdler next made a public statement: "I won't have a contract, verbal or written, with an irresponsible, racketeering, violent Communist body like the CIO."[14]

In dealing with strikes at Massillon and Canton, Ohio, Girdler laid off vast numbers of Republic employees. On May 30, when workers and their families sought to establish a picket line at Chicago, police fired on them, killing ten persons and injuring about one hundred others, a tragedy known as the Memorial Day Massacre.

Bethlehem Steel

SWOC did not call a strike at any Bethlehem facility, including Johnstown. Why Bethlehem alone among the independents escaped is not known. Two students of the 1937 Little Steel Strike wrote that SWOC's sign up campaigns directed at various Bethlehem operations had not gone as well as they had at the other independent companies.[15]

The Strike at Johnstown

The steel strike against Bethlehem at Johnstown started with the Brotherhood of Locomotive Firemen and Enginemen and the Brotherhood of Railroad Trainmen against the Conemaugh and Blacklick Railroad (CBL), a Bethlehem Steel subsidiary. The CBL moved materials between the various plants and some captive mines. It also served to connect them with the PRR and the B&O. Had the CBL been brought to a complete standstill in 1937, Cambria's Johnstown operations would have halted.

H.M. Vansant, vice-president of the Brotherhood of Locomotive Firemen, stated, "We are calling this strike because the company has refused to sign a contract. The walkout will affect 346 employees. David Watkins (SWOC) has promised to cooperate with us and not oppose our strike. We expect to have all members of these two unions out on strike."[16]

The June 10 walkout by the brotherhoods caught SWOC leaders by surprise. When reporters asked Clint Golden what action SWOC would take, he refused comment but arranged a meeting with the SWOC leadership.

SWOC had no choice but to urge its Johnstown recruits to strike. Not doing so would have been seen as a lack of union solidarity. The railroad strike, if successful, would have shut down Cambria Steel anyhow.

The strike against the Bethlehem Steel Corporation in Johnstown began just after midnight on June 12. Pickets began forming around all seven gates. An eleventh-hour conference between union and company officials accomplished nothing. As he emerged from the meeting, David Watkins, the sub-regional director for SWOC, announced, "The company again refused to sign a contract." Ralph Hough, assistant to the general manager of Bethlehem's Johnstown steel operations, stated, "All I can say about the strike is the mill will continue to run."[17]

A Tense Calm

"Our strike tonight is more than a sympathy strike," Watkins stated. "We have specific demands of our own to make. We want signed contracts with Bethlehem covering wages, hours, recognition, and working conditions. Ten thousand men will go out." Watkins added that there were between 2,200 and 2,500 miners working in captive mines at Rosedale, Franklin and Heilwood. "The United Mine Workers have not signed a contract with Bethlehem's captive mines. I don't think anybody can keep these miners working when there is a strike in the steel mills."

A carnival atmosphere was said to have prevailed at first. "We are not having any trouble and we're not looking for any," someone stated.[18]

Inasmuch as the Johnstown economy was tightly interwoven with Bethlehem's Cambria operations, the strike naturally concerned local businessmen. Circumstances were unfolding so that of Bethlehem's twenty-eight operations, only Johnstown was experiencing a strike. The anomaly not only harmed the local economy, but it also raised a fear that work normally done at Johnstown might be shifted elsewhere, perhaps permanently.[19]

Whether Watkins was speaking with information from SWOC headquarters or was voicing personal hopes, he also made pronouncements on June 12 that the strike would soon spread to the remaining twenty-seven Bethlehem Steel plants. He knew that if Johnstown alone were struck, his own members soon would feel they were doing the "heavy lifting" for the entire Bethlehem workforce whose members would benefit from the Johnstown strikers' trials and deprivations.

The basic attitude of Johnstown community leaders was that if workers wanted to strike, they should be free to strike. If they wanted to work, they should be free to work. Pickets could persuade, heckle and jeer. There could be no violence, intimidation or physical restraint of workers entering or leaving the mills and no violence or threats to their homes, property or families.

Mayor Daniel Shields announced the posture of the city government: "I do not intend to assign special deputies to Bethlehem. In fact, I have none. I intend to be fair in this matter. I have no tear gas bombs, and I don't want any. I have the assurance of both sides there will be no imported pickets or workers and that the strike will be conducted within the law. Pickets can use persuasion but there must be no intimidation or coercion."[20]

Indications are that both the Conemaugh and Blacklick Railroad and the Cambria Steel facilities continued operating. Each side made statements exaggerating its success. Workers who passed through the gates were jeered and booed in the beginning, but they entered and left without physical restraint.[21]

Trouble at the Franklin Gate

Pennsylvania's Governor George Earle had flown to Johnstown from Philadelphia around noon on Sunday, June 13, to meet downtown with the mayor; Sheriff Michael Boyle; C.R. Ellicott, general manager of the Cambria Works; and C.W. Jones and H.M. Vansant, vice-presidents of their respective railway brotherhoods. During the meeting a disturbance broke out at the Franklin Gate as workers from the 7:00 a.m. to 3:00 p.m. shift were leaving.

There had been about seven hundred pickets, the most at any Cambria entrance gate during the strike. Pickets yelled, "Scab!" and other epithets at exiting workers. One was a black man, Taylor King. King pulled out a revolver but was immediately disarmed by the police before firing a shot. In the charged atmosphere, a riot had broken out. Fifteen persons were injured.

On hearing this Governor Earle ordered Lynn Adams, superintendent of the state police, to send seventy-five officers to Johnstown to be of service to Mayor Shields if he needed them. Earle then asked C.R. Ellicott to convey his views to Charles Schwab and Eugene Grace: "I have been a business man myself. I know the great advantage of a 'written contract'…This is a clear-cut issue. The unions simply want contracts and I feel they are entitled to them…The attitude of the company is unreasonable in not giving contracts to its men."[22] Through these

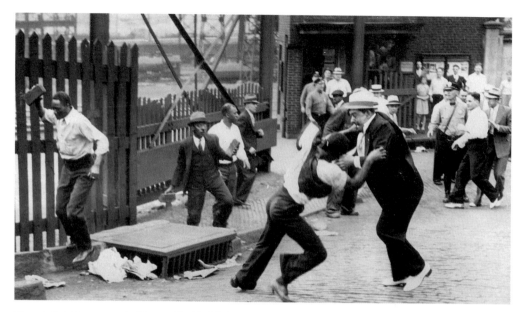

The main Bethlehem gate at the Upper or Franklin Works was the location of several picket and worker confrontations during the Little Steel Strike. This photograph was taken by UPI on June 13, 1937. *Courtesy Johnstown Area Heritage Association.*

remarks, reported in the *New York Times*, the governor had betrayed his own leaning—to support the strikers. Pennsylvania governors in past strikes had almost always sided with management. Earle was different.

The Citizens' Committee

On Monday evening, June 14, about sixty business and professional leaders of Johnstown—the citizens' committee—met at the Elks Home downtown. While convened and staffed by the chamber of commerce, the citizens' committee was kept separate, a fiction to avoid appearances of Bethlehem's influence since the corporation was heavily involved in the Johnstown chamber. An organizational meeting called by Reverend John Stanton, pastor of the Westmont Presbyterian Church, had been held the day before at the Fort Stanwix. Many Bethlehem officials were parishioners of Stanton's church.

The logician guiding the Monday evening meeting was Hiram Andrews, then a former Democratic assemblyman and the current editor of the *Johnstown Democrat*. Andrews reasoned that Bethlehem erred in not signing agreements with the two brotherhoods. Had this been done, SWOC would probably not have called a strike against Cambria Steel alone. He next focused on the irony of SWOC's striking Bethlehem's Johnstown mills while ignoring Sparrows Point, Lackawanna, Bethlehem City and other company plants. "To close Johnstown in order that other Bethlehem centers may have more work is nothing more or less than a ruthless betrayal of Johnstown workmen—union and non-union alike. Johnstown should not be sacrificed." Andrews concluded, "The CIO…has a right to fight Bethlehem through organization, but it does not have a right … to fight Johnstown by resorting to violence…In view of all the circumstances, law

13

enforcement authorities and the people of this city should take whatever steps may be necessary to guarantee to every Johnstown workman unimpaired egress and ingress to and from Johnstown's mills. And the labor leadership should be so notified that such is Johnstown's intention."[23]

More Troubles

Confrontations around the entrance gates became more unruly on Tuesday, June 15, and Wednesday the sixteenth. A riot near downtown resulted in the arrest of Murphy Kush, a known Communist. There were also many injuries. Johnstown policemen used tear gas to scatter a group of strikers, one of whom was shot. A non-striking worker suffered a fractured skull.

On hearing these reports, Earle instructed Major Lynn Adams to call in more reinforcements and to take over completely from the Johnstown Police Department all public safety responsibilities at the Bethlehem entrance gates. Union leaders were said to have been pleased with Earle's directive. The total state police presence was quickly doubled from one hundred up to two hundred men, including twenty mounted horsemen.

Shields telephoned the governor that he was glad there would be more state troopers but wanted to see them take more responsibility for law and order instead of "standing around with their arms folded."[24]

By early Wednesday, Shields had sworn in more than 350 special deputies. (The number was said to have reached 500 later.) Each was to be paid $125 per month and received a badge, stick and helmet. With state troopers policing the gates, the mayor directed city police and his sworn deputies (called "vigilantes") to patrol the streets and to protect workers' homes, their automobiles and the trolleys carrying non-striking workers to and from the mill gates. Statements were occasionally made that the deputies bullied strikers and pickets. If so, no charges were ever filed or credible media accounts reported.

In response to a request made to SWOC leaders by Governor Earle, David Watkins held a rally on June 15 and urged strikers not to throw "stones, bricks, and other missiles." There were a number of instances of automobiles overturned, trolleys showered with rocks that broke their windows and workers beaten. There were also charges of non-union workers' homes being damaged with rocks. Watkins insisted these actions were the work of hoodlums not affiliated with SWOC.

Early on the morning of Tuesday, June 15, James Hess, a twenty-five-year-old CBL employee, claimed he had been walking to work when a carload of strikers seized and undressed him, releasing him naked downtown. He quickly entered a building and was given clothes. Shields offered a reward of $5,000 for information leading to the perpetrators' capture and conviction and also sent telegrams both to the governor and to President Roosevelt. To Roosevelt, he stated, "I earnestly appeal to John L. Lewis through you as our president to withdraw the murderous element that now infects our city. The situation has grown so bad that strikers have resorted to…kidnapping."[25]

By Thursday, June 17, state troopers had taken charge of the gate areas to such a degree that pickets' physical efforts to impede workers entering and leaving the mills had become ineffective. Feeling safe not only at and near the entrances but also in their homes, autos and trolleys, workers began returning to work in droves. Major Lynn Adams stated, "No serious trouble has occurred on the picket lines." Workers inside the plants had stopped throwing nuts and bolts at pickets outside after state troopers started entering the plants to make arrests.[26]

Too Much of a Good Thing

Strikers reported to the governor about the tough enforcement measures effectuated by the state police.[27] Earle next sent a six-member investigation panel—a "commission"—to report back as to the appropriateness of the state police procedures. Earle's panel included Ralph Bashore, Pennsylvania secretary of labor; C.J. Boser, Pennsylvania's most senior labor mediator; and E.W. Prendergast, a personal secretary and aide. After a hasty visit to Johnstown, they reported to the governor. Major Lynn Adams had been instructed to use his own judgment in the beginning, but there were now new orders issued by the governor: State troopers were to remain within "observing distance" of the gates and be ready to move in quickly if there was violence.

Mayor Daniel Shields objected to the new order. He sent a telegram to the governor: "Your order to state police tonight will have a demoralizing effect and civil war is all we can expect. Ninety per cent of our people are opposed to the CIO...Mr. Governor, please untie the hands of our state police."

Secretary of Labor Ralph Bashore defended the new restrictions and stated he personally had seen between two and three thousand workers leaving the Franklin Mill Gate at the 3:00 p.m. shift changeover. The six pickets the state police allowed at the gate were said to have been unable to do any "missionary work."[28] Shields's vigilantes were reported intimidating strikers.[29]

Shields also sent a second telegram to President Roosevelt claiming inside information about plans to dynamite facilities and telling of threats to his family.

The Miners' March on Johnstown

At the same time that the governor had issued new instructions about state troopers' procedures and practices, word was received that the UMW was planning a "march on Johnstown." The report was based upon an announcement by P.T. Fagan, president of UMW District Two, stating that forty thousand miners was a "conservative estimate" of the numbers that would be going to Johnstown. Phillip Murray, also vice-president of the UMW as well as SWOC chairman, was scheduled to speak. Rumors began to circulate that the miners were planning demonstrations in support of strikers. While officials seemed to be taking the possibility of a miners' "march on Johnstown" seriously, in retrospect there are good reasons to believe the whole thing was a contrived bluff.[30]

When Sheriff Michael Boyle heard of the UMW march, he wired Governor Earle asking him to declare martial law and send troops to govern and police Johnstown.

Earle, however, first tried a different strategy. He sent a telegram to Eugene Grace asking him voluntarily to close the Cambria Steel mills. Grace refused and wired back, "For us to close the plant would involve the admission that the forces of law...are powerless to protect our men."[31]

"Modified" Martial Law

At 2:00 a.m. on Sunday, June 20, Colonel A.S. Janeway, a National Guard officer and Governor Earle's newly designated military commander in the strike area, announced that the governor had ordered all Bethlehem Steel facilities in and near Johnstown closed except for continuing plant maintenance since Bethlehem's management had refused to comply with the governor's

earlier request to close and evacuate the mills by 12:30 a.m. These actions, he said, were based upon the governor's declaration of "modified martial law." Janeway's "troops" were 525 state policemen and highway patrolmen assigned by Governor Earle.

Pickets were immediately withdrawn from all gates on the orders of David Watkins. Workers inside the plants were instructed to leave. All railroad traffic into the Cambria mills was halted. John L. Lewis immediately cancelled the miners' "march on Johnstown." Colonel Janeway also ordered the mayor to disband his civilian police. Johnstown city police were to cease all strike-related duties.

Reaction in Johnstown

Mayor Daniel Shields told reporters that the CIO was responsible for a "reign of terror." By closing the plant, Earle would be establishing "Communism and anarchy."[32] Shields also stated, "He [the governor] is playing politics with human lives."[33]

Eugene Grace wired Shields, "I wish to assure you and your city council we will not voluntarily close the Cambria Plant and have today advised Governor Earle that if the plant is closed, it will be on his orders and his responsibility.

"We cannot believe that the police power of this commonwealth will be used by its governor to prevent our employees in Johnstown from exercising their legal right to work."[34]

Perhaps the most trenchant and analytical reaction to the martial law declaration was in Hiram Andrews's June 20 column "Let's Talk Things Over." The Andrews piece starts with a constitutional law discussion: Martial law could be declared only if there were an imminent threat of invasion or insurrection. Earle's justification had been an announcement that forty thousand miners might come to Johnstown and possibly create a situation the civil authorities could not handle. Once the martial law declaration was in place, the miners' "march on Johnstown" was cancelled. With this threat of "insurrection" gone, the justification for martial law had also vanished.

Johnstown lawyers were quick to point out that there was no such thing as "modified martial law" and urged acquiring an injunction to stop the governor's action.[35]

The Citizens' Committee and Others in Action

With the governor's "modified martial law" firmly in effect and the mills completely idle, the citizens' committee and Larry Campbell, its aggressive secretary, went to work. Community leaders were guided by two beliefs: Earle's closing the mills was illegal, and the governor's action was rooted in his own political ambition. There seemed to be little in the way of broad support for the steel strike and even less for the martial law shutdown.

Francis Martin, citizens' committee chairman, and Larry Campbell wired Senator Styles Bridges, a New Hampshire Republican, requesting an invitation for them to appear before the Senate Post Office Committee which had been making inquiries into the steel strike. While some hope was extended that a Johnstown delegation might be heard, the request was probably scuttled by New Deal Democrats. The Johnstown group, however, had generated a wave of nationwide publicity.[36]

Civic leaders led by the *Tribune*'s publisher, Walter Krebs, and Hiram Andrews began urging the governor and other state officials that a three-way referendum be held:

1. Community wide—a strike or no-strike referendum open to a vote by all citizens.
2. A strike or no-strike referendum open only to Cambria mill workers.
3. A referendum open only to Cambria mill workers as to their union preference.[37]

"Staff [state employees] participation in such a proposed referendum is essential in order that the administration may have no doubt about the integrity of the balloting. Cost of the proposed referendum to be borne by citizens of community."

James Mark, a UMW officer who had recently replaced David Watkins as the SWOC leader in Johnstown, quickly refused. "We do not approve of the citizens of Johnstown participating in any election that would determine or attempt to determine whether the employees of the Bethlehem Steel Company should strike or not," he added.[38]

The citizens' committee broadened its membership base to include non-striking steelworkers. It also undertook a nationwide publicity campaign. Plans were quickly developed to place large advertisements in about forty major newspapers nationwide. These first appeared on June 24. Each ad opened with a huge "WE PROTEST." The item included, "If this can happen in Johnstown, it can happen in your community." A request for fund donations to help Johnstown pay for its crusade was included. Pennsylvanians were also urged to write their objections to Governor Earle.[39]

The citizens' committee also launched a campaign for workers to sign "back-to-work" petitions. As of June 24, supporters claimed to have acquired 6,000 unduplicated steelworker signatures seeking Cambria mills's reopening. By Saturday, June 26, the number was reported to have reached 9,300, more than half the total workforce.[40] There was something of a petition battle underway. Steelworkers were also signing petitions urging the governor to keep martial law in effect.

As an instrument to persuade Earle to give up "modified martial law," the citizens' committee petition became irrelevant. On Thursday, June 24, the governor announced that his declaration would be terminated at 7:00 a.m. on Saturday, June 26. State troopers would continue to police the entrance gates.

The Gates Reopen

James Mark had to reestablish his pickets and maintain an impression of solid worker support for the strike when his cause seemed to be collapsing. Normally a UMW officer, he called on coal miners to make a solid show of support for their steelworker colleagues. Throughout Friday, June 25, and early the twenty-sixth, miners from nearby counties flocked into Johnstown, honking car horns and driving about aimlessly in a hastily arranged demonstration. Their numbers could not be quantified. In addition to being seen and heard, they attended joint steelworker and miner meetings at the Moose Lodge. The meetings were not open to reporters. Mark kept making public statements like, "Steel must be organized to protect coal. Every year the captive mines are adding more tonnage, taking away work from commercial

companies." Lectures on interindustrial themes had little appeal to coal miners who had come to town to do picket duty.

Some miners stayed around and showed up at the 7:00 a.m. Saturday gate openings. While there were steelworker and coal miner pickets, the impression everyone received was that only maintenance personnel were entering the mills. Everything was quiet. No incidents were reported.

Later that Saturday at the 3:00 p.m. shift changeover, about two thousand steelworkers were seen leaving the Franklin Mill Gate and there were almost no pickets on duty anywhere. Workers were peacefully entering the Cambria mills in large numbers. A Bethlehem Steel spokesman stated that twelve of twenty-one open hearths would be operating by Saturday night. Typically sixteen were used. Larry Campbell stated to a reporter, "This thing is over if the visitors stay out of town."[41]

Renewed Determination

With more open hearths fired up, other parts of the Cambria mills operating and workers returning in increasing numbers, James Mark and his union loyalists became determined to fight harder.

A rally was held at Faith's Grove on Sunday, June 27. While bad weather was forecast, attendance was disappointing to SWOC leaders. Sheriff Michael Boyle, generally seen as pro-labor, estimated the crowd at 2,500—even less than the 3,000 "joint-independent estimate" printed in the *New York Times*. Rally leaders, however, were saying the crowd was in the 5,000 to 10,000 range.

Murphy Kush, a self-avowed Communist, presided. He made disparaging remarks about "Bethlehem stool-pigeons." Mark urged the women to get after their husbands to stay on strike and do picket duty, claiming a renewed effort would win the strike.[42]

Monday, June 28, was seen as a turning point in the strike. The test was how many workers would return to work as against the numbers that would be manning the picket lines. Early that morning, Captain William Clark, officer in charge of the state police on duty, toured the mill gates and reported a total of 2,500 to 3,000 steelworkers and sympathizers doing picket duty. This included an unknown number of miners and their family members.

Sidney Evans, a Bethlehem spokesman, stated, "The plant is now on a normal operating basis. Production is going forward as actively as before the strike was called. We have an adequate force of men in every department. We are running fifteen open-hearth furnaces today." At the same time there was said to be a widespread belief among Johnstown steelworkers that the National Labor Relations Board (NLRB) would be ordering an election and that a majority of the Cambria workforce would support SWOC. The vote being inevitable, there was no reason to strike.

While both sides were posturing, the leading news sources reported the pickets were dwindling. A *Tribune* reporter quoted a city police source, saying 8,325 workers had entered the plant on June 28.[43]

Those remaining on picket duty became even more militant. Incidents seemed to occur at the Franklin Gate, the location most watched by journalists. Windows of workers' cars were smashed. At 7:00 a.m. Monday, when five black men were leaving work, three were attacked by a mob. State troopers rescued them.

Boom!

At about 10:00 p.m. Monday, June 28, a large dynamite explosion blasted an opening in the sixty-six-inch line that brought industrial water from the Quemahoning Reservoir. The detonation occurred at the northern end of the Yoder Falls tunnel near Carpenter Park. While Bethlehem officials were busily trying to manage the shrinking water resources and adjust plant operations, a second explosion occurred at 3:00 a.m. June 29, a blast rupturing a thirty-six-inch main below the Border Dam.

There was a new crisis. Bethlehem officials had reported 90 percent of its workforce had returned to work. The explosions meant six thousand men had to be laid off until repairs could be made. A $10,000 reward was offered by the company for information convicting the perpetrators. No one was ever apprehended.

Reaction in the City

Mayor Daniel Shields called an emergency meeting of the city council for 9:00 p.m. Tuesday evening. Shields dispatched police officers to fetch James Mark and C.W. Jones and bring them to the session. The two men later claimed their forced appearance was "kidnapping."

Shields began by stating that it was his duty to maintain "law and order." He announced to Jones and Mark that as mayor he could no longer be responsible for their safety and suggested they should "peaceably withdraw." Shields continued, "It is my purpose to serve public notice that those who remain here shall do so at their own risk and there shall pass to the city no responsibility."

Samuel DiFrancesco, the attorney representing the two men, stood and tried to speak. Shields ordered him to sit down. When DiFrancesco continued, Shields twice ordered, "Remove the man." As he was evicted by policemen, the attorney shouted, "Do you call this the American way?"

Mark and Jones denied any knowledge or role in the dynamiting. Mark stated he was as anxious as anyone to arrest those responsible.[44] Shields was severely criticized, even by his supporters, for saying he would not protect the two strike leaders. Hiram Andrews, who had little use for Shields anyway, blasted him for ignoring the very "law and order" he espoused.

The Miners Return

James Mark seemingly had fewer options. There was no support anywhere for someone's dynamiting the water lines. Shields's constant talk about a possibility that someone might dynamite the Quemahoning Dam generated anxiety in the city that another Johnstown flood could happen. Men increasingly were returning to work, and the public in Johnstown and nationwide had become sick of various strikes underway.

Mark seemed obsessed with one idea—yet another forty-thousand-miner "march on Johnstown." On June 30, plans were made for a massive Fourth of July miners' and steelworkers' rally to take place at Faith's Grove near Morrellville. Phillip Murray, the SWOC chairman, would speak and hopefully would reenergize the strike.

Neither Captain Clark nor Sheriff Boyle wanted another martial law declaration—possibly the thing Mark most wanted. Both men simply stated their officers could handle any emergency if "something did happen on July 4."[45]

Meanwhile the numbers of pickets continued to dwindle. On Thursday, July 1, James Mark withdrew them altogether at least until after Sunday. He was predicting that after the rally there would be more and better picketing than ever.[46]

The Faith's Grove event took place without incident. Attendance figures as usual depended on whose counts were used. Mark's figure was 30,000. A "poll of independent counts"—newspaper reporters cooperating with each other—estimated there were 10,000 to 15,000. The *New York Times* reported 12,000. Steelworkers had come from as far away as Sparrows Point outside Baltimore. There were miners from West Virginia.

A surprise speaker showed up at the rain-soaked rally—Governor George Earle, already eyeing the U.S. Senate. Encouraged by people shouting, "Earle for president in 1940!" the governor talked openly about his "Little New Deal" in Pennsylvania and its "Little Wagner Act," which had outlawed company unions, prohibited unfair labor practices and provided for company-wide labor elections. "You don't need violence when you have a man like Franklin D. Roosevelt in Washington, a liberal Congress, and a governor like me in Pennsylvania who respect the workers' rights!" the governor shouted.

Earle promised to send Attorney General Charles Margiotti to Washington to "force them under the big Wagner Act or the state's little Wagner Act, to hold an election." Earle denounced violence, Communism and labor sometimes not living up to its own part of a contract. He denounced the dynamiting, saying it was the work of a "crazy man" and had done the strikers more harm than good.

Murray also spoke, but he had been outshone by Earle. Although the work stoppage was said to be underway, picketing was not scheduled to resume. In terms of a conventional strike, this one was over.[47]

More Hardball

Bitterness continued to smolder, especially as the strike was collapsing. After being caught, Ernest Layton, a twenty-one-year-old pump runner for Bethlehem, admitted to having lit three sticks of dynamite and throwing them under a train entering the wire mill. The sticks failed to explode. Layton's story was that he had tried the blasting to get good work assignments.

Things also got personal with Mayor Daniel Shields. On July 2, federal agents filed tax liens totaling $76,040 against the mayor and thirteen other people, stemming from the old 1924–25 Prohibition-era Emmerling Brewery case.[48] The tax lien had been legally complicated due to Herbert Hoover's having pardoned Shields in 1930. Resurfacing six years after the presidential pardon, the action was probably a personal vendetta. Eddie McCloskey (who despised Shields) had a brother, Hugh, working for the IRS. Hugh McCloskey denied involvement, a statement confirmed by his supervisor. Shields labeled the IRS action "spleen" generated by his opponents in the steel strike.[49]

Margiotti's Mission to Washington

On Governor Earle's instruction, Pennsylvania's Attorney General Charles Margiotti met on July 8 with Homer Cummings, the U.S. attorney general. Earle was seeking a government-mandated

union recognition election. As it turned out, the CIO had ideas different from those of Governor Earle. Before any such election, it first wanted an NLRB investigation into three matters:

> 1. *Whether there was a company union at Johnstown.*
> 2. *Allegations of discrimination and coercion in Johnstown involving over 300 cases.*
> 3. *Whether there was a relationship between Mayor Daniel Shields, the group of "vigilantes" appointed and deputized by him, and the Bethlehem Steel Corporation.*

Later that afternoon, Margiotti met with staff members of the NLRB, a meeting that led to a formal SWOC-CIO complaint charging Bethlehem with violating the National Labor Relations Act.[50] Extensive hearings were underway on September 8, 1937. They were held by the NLRB through a hearing examiner, Frank Bloom.

The NLRB (Bloom) Hearings

There were some preliminary skirmishes over the site where the extensive evidentiary hearings would take place. The Franklin Borough High School auditorium was chosen by the hearing examiner, putting the hearings in the heart of a community supportive of the strike.

The hearings delved exhaustively into the history and nature of the Bethlehem Employee Representation Plan; the role Daniel Shields allegedly played in personally scattering pickets and encouraging men to enter the mill areas; the entire story of Bethlehem Steel Corporation's using Pinkerton detectives to do surveillance on its workers and report their union activities; the background and facts about Sheriff Boyle's urging the governor to declare martial law; the citizens' committee origins, scope, funding sources and activities; Shields's deputizing of citizens as civilian-police; and payments both to and by the mayor for tear gas, police equipment and similar items.

When the Bethlehem Steel Corporation insisted on questioning witnesses about violence against workers continuing to work and strikers' vandalism to trolleys, workers' homes and automobiles and the like, Frank Bloom allowed limited testimony but put in the record a general stipulation that violence and property damage occurred.

The NLRB hearings began on September 8, 1937, and continued until April 22, 1938. On July 15, 1938, Bloom also accepted a statement of 142 stipulations of fact agreed upon by all parties. The hearings generated 21,717 typewritten pages or 11,072 pages when printed. Frank Bloom was instructed by the NLRB itself to produce a summary report with a recommended order. Bloom's report, dated November 9, 1938, was about fifty typewritten pages.[51]

The NLRB Decision and Its Appeal

The Bethlehem-SWOC case was argued before the National Labor Relations Board on March 29, 1939. On August 14, 1939, the NLRB ruled:

> 1. *The Bethlehem Steel Corporation maintained and controlled a company union. The Employee Representation Plan had to be discontinued.*

2. Bethlehem violated the interference clause (Section 8-1) of the NLRA by contributing to a citizens' committee whose purpose was to vilify the union and to break the strike, and also by having retained the Pinkerton Detective Agency to do surveillance of its workers.

Other charges were not substantiated.[52]

The Bethlehem Steel Corporation appealed the NLRB decision into the federal court system. The case was argued before the United States Court of Appeals for the District of Columbia on February 17, 1941. Judge Henry Edgerton was responsible for the eighty-seven-page opinion, dated May 12, 1941. It upheld the NLRB ruling by a two to one margin.[53]

The La Follette Committee

U.S. Senate Resolution 266, approved on June 6, 1936, had authorized the Committee on Education and Labor to establish a subcommittee "to make an investigation of violations of the rights of free speech and assembly and undue interference with the right of labor to organize and bargain collectively." The resolution created the Senate Civil Liberties Committee (often called the La Follette Committee). Staffed with bright and enthusiastic professionals, the committee's work was just getting underway at the same time as the SWOC organization drives. The La Follette Committee focused on industries using detective-style surveillance of their workers, weapons and tear gas, citizens' committees and other anti-union practices in general.

Committee hearings about the strike in Johnstown took place during the NLRB hearings. Most revelations about Johnstown unearthed by the La Follette Committee had also turned up during the more lengthy NLRB sessions, although there were slight differences in such things as the exact amount of cash contributions to the mayor for his "law and order" activities. The La Follette Committee exposed transgressions to the national media. It also had a potential to affect future legislation and to aid or harm political careers. On the other hand, the work of the NLRB involved litigation subject to the delays of higher judicial review.

The key inquiries of the La Follette Committee insofar as Johnstown was concerned had to do with the citizens' committee, the civilian police, the flow of money and armaments from Bethlehem Steel through the committee to Daniel Shields and the uses the mayor had made of the money. What was revealed was that Daniel Shields had received several payments in cash from Bethlehem Steel channeled through the citizens' committee and its treasurer, City Councilman Fulton Connor. Shields ostensibly used the money to pay for a small arsenal of weapons—tear gas, grenades, guns, projectiles, helmets, police sticks and the payment of civilian deputies. The inventory of weapons was shocking in itself, and there was a dispute over whether the Bethlehem Steel Corporation or Shields himself had paid for them using company-given money.

Having established that Shields had received $36,450 in five separate payments, the committee attempted to determine how the money had been spent. Shields testified he had purposely destroyed all financial records. He was forced into a difficult dilemma of revealing how many civilian deputies or vigilantes he had hired. The larger the number, the more money

to pay their salaries could be claimed. On the other hand, the more civilians he had hired, the more villainous he appeared to civil libertarians.

In the end Shields came up with some seemingly exaggerated numbers, all estimates derived from memory, to justify having expended $36,966—even more than the full amount given him by Bethlehem. Committee staff workers, meanwhile, had discovered that Shields had recently reduced some creditor claims and liens filed against him by $23,485. The mayor's explanation was that this had happened thanks to his wife's money.[54]

The revelations of the La Follette Committee and the NLRB hearings caused District Attorney Stephens Mayer to bring Daniel Shields and Fulton Connor up before the grand jury. Neither man was indicted.[55]

Denouement

The strike in Johnstown faded away after mid-July 1937—a Pyrrhic victory of sorts for Bethlehem Steel. The SWOC program became one of applying, testing and establishing the Wagner Act (NLRA) while vilifying the little steel corporations for harsh practices. The principal focus was on Tom Girdler and his Republic Steel Company but it had included the Bethlehem Steel Corporation's Cambria Works in and around Johnstown. What had gone on with Johnstown through the NLRB and the Senate Civil Liberties Committee was part of a bigger strategy that ultimately worked.

From late 1937 until the autumn of 1939, U.S. business conditions in general, including the steel industry, had declined. The SWOC effort was delayed until the economy improved. Meanwhile the NLRB actions resolved and were sustained in court.

After the Court of Appeals had upheld the NLRB ruling, a union-recognition election was held at Johnstown on June 25, 1941. SWOC was recognized as the exclusive bargaining agent by an 8,940 to 2,108 vote. Afterward jubilant steelworkers paraded through Johnstown and symbolically sank a container marked "Employee Representation Plan" in the Conemaugh River.[56]

The 1937 Steel Strike in Johnstown was a landmark event in Johnstown history. It marked the end of corporate paternalism and anti-union policy. Union success in Johnstown's two steel corporations would bolster organization drives in other industries and businesses. The small Communist group, which might have had some cause to come alive if the Johnstown labor movement were dealt a crippling blow, disappeared. Johnstown was a "union town."

II. OTHER SIGNIFICANT JOHNSTOWN LABOR MATTERS

The Teamsters: Local 110

In 1932 two local truck drivers, Henry Dwight Lehman and Charles Kocher, set about to unionize a number of drivers and chauffeurs in and near Johnstown. The next year their group of about twenty-five members was chartered as Local 110 of the International Brotherhood of Teamsters, Chauffeurs, Warehousemen, and Helpers of America, an affiliate of the AFL. Its first collective bargaining agreement was signed with the Alwine Dairy Company. Local 110 grew rapidly and by 1936 had a membership of one thousand.[57]

Within the AFL craft and tools tradition, Local 110 concentrated its organization efforts only on truck drivers and chauffeurs, inevitably creating jurisdictional problems with other unions in the same company and surfacing the problems separating craft and industrial unions.

Teamsters demonstrated great prowess and leveraging power at the vitals of certain businesses. In early 1938, the AFL had organized most bakeries and meatpackers at Johnstown through the Bakery and Culinary International 158. Janitors and certain other workers were members of Bartenders Local Number 581, and company truck drivers were in Teamsters 110. This admixture of unions in a generally declining economic situation brought forth an effort by management to scale back teamsters' wages, which they felt were disproportionately high in contrast with other locals. Local 110 struck at Johnstown meatpacking plants and bakeries by refusing to deliver flour and unprocessed meats or to move bakery products and processed meats to retail outlets. After the major food producers had been shut down for about one week, bread and packaged meats became scarce. Local 110 made special delivery arrangements to hospitals and similar institutions. Finally on May 9, thanks to state mediators, the strike and lockout were ended. Teamsters retained their 1937 wage scales.[58]

Teamster picketing sometimes sought to halt non-union truckers on public highways to coerce them to join their union. This brought in the state police to keep the highways open.[59]

International Ladies' Garment Workers' Union (ILGWU)

In late September 1936, a Philadelphia producer of women's dresses, Goldstein and Levin, opened a plant in downtown Johnstown. From a pool of over 2,000 applicants, some 250 workers were chosen and given apprenticeship training. By Thanksgiving rumors were circulating that a Communist agitator was attempting to organize the new female workforce.

Mayor Daniel Shields appeared before an assembly of these workers and assured them of "police protection," a pledge that triggered thundering applause and loud cheers.

Ostensibly to enroll the workers before "Communists" could do so, representatives of the International Ladies' Garment Workers' Union (ILGWU) began to organize the new workforce. Goldstein and Levin spokespeople announced the company had no objections to the union. Its Philadelphia operations were unionized through the ILGWU, an affiliate of the CIO. The company's posture was that it did not want its workers unionized until they were productive employees, meaning they were no longer apprentices.

The ILGWU effort in 1936 to enroll Goldstein and Levin workers, new to the workplace, failed. After a brief wartime strike in early 1945, ILGWU Local 424 was chartered.[60]

Other Union Activities

Most other union organization drives prior to the Second World War were comparatively uneventful. A local chapter of the Pennsylvania Telephone Union was founded in 1935 to represent telephone operators and clerks. In July 1941, employees of the Johnstown Traction Company were embroiled in organization drives led by two rival unions—the AFL and the CIO. The Amalgamated Association of Electric Railway and Motor Coach Employees (AFL) prevailed in a union-recognition election.[61]

LEISURE

I. THEATER AND ENTERTAINMENT

The Cambria Theater

The October 1903 fire that destroyed the Johnstown Opera House left the Cambria as the only true theater in the city. Owner I.C. Mishler of Altoona and Trenton, New Jersey, sold the Cambria in April 1904 to his resident manager, Harry Scherer, and a bar owner and manager of the newly formed Johnstown Bill Posting Company, Joseph Kelly. The deal included a membership in the Mishler Circuit, an arrangement assuring the top bookings on tour. Mishler was among the best go-between brokers in the entertainment business outside New York City.[62]

Under the Scherer-Kelly management, the Cambria Theater on Main Street downtown became one of the more interesting single-theater showplaces anywhere outside major cities. Its success came from many factors: Johnstown's growth and prosperity; being on the PRR between Pittsburgh and Philadelphia, two destination cities for touring-theatrical personalities and productions; Mishler's productive enterprise; and excellent newspaper coverage.

For many years, the Cambria would host the leading actors, productions, musical artists and dancers from anywhere—James O'Neill (Eugene O'Neill's father) and his troupe appeared in Hall Caine's *The Manxman*. Lionel Barrymore, who was to perform at the Cambria often, appeared in *The Other Girl* in January 1905. A young Cecil B. De Mille starred in *Lord Chumley*. Nan Patterson, a sensation for her three murder trials, was an unusual attraction in June 1905.

In March 1908, Leslie Carter was featured in David Belasco's *DuBarry*. *Ben Hur* had a three-day run at the Cambria in May 1908, featuring eight horses and a cast of three hundred. In January 1909, Louis Mann starred in *The Man Who Stood Still* and Alla Nazimova, the international legend, appeared in Ibsen's *A Doll's House*.

On February 8, 1911, Ferruccio Busoni, once described by Arthur Rubenstein as the greatest pianist of his own lifetime, performed at the Cambria Theater. Two days later David Belasco,

the famous theatrical innovator—actor, director, producer, playwright and collaborator with Giacomo Puccini on *Madama Butterfly* and *The Girl of the Golden West*—spent time in Johnstown personally making last-minute adjustments to his new play, *The Easiest Way*, then doing a trial run at the Cambria before its Broadway opening.[63]

Lillian Russell brought her troupe to Johnstown more than once. In an October 1913 interview shortly before Billy Sunday's revival crusade, she had praised the WCTU, saying that alcohol was "death to the mind, body, and soul." When in Johnstown, she stayed on her private railway coach.[64]

The Cambria Theater's artistic alumni also included Harry Lauder (before his knighthood), Ethel and Lionel Barrymore (several occasions each), Guy Bates, Blanche Ring, Edna Wallace Hopper, Anna Pavlova, Tyrone Power (father of the film star), Wilton Lackaye, Maud Adams, Helen Grayce, Charles Coeburn, Margaret Anglin, Marie Dressler, Edith Thayer, May Irwin, Eva Tanguay, David Warfield, Eddie Foy and the Foy family, Grace George, William Morris, Margaret Illington, Ruth St. Denis, George Primrose, Lew Dockstader, Polaire, Gertrude Hoffmann, Lady Constance Stewart Richardson, Helen Hayes, Percival Knight, Isabel Randolph, George Arliss and many more Broadway personalities and future film stars.

The great musical personalities appearing in Johnstown included Ignace Jan Paderewski (two occasions), Joseph Hofmann, Fritz Kreisler, John McCormack, Ernestine Schumann-Heink, Mischa Elman, Alma Gluck, Geraldine Farrar, Amelita Galli-Curci, Johnstown's Dan Jones (pianist), Luisa Tetrazzini, John Philip Sousa (several times) and Johann Gadski. Ernest Bloch, the noted Swiss composer, conducted a forty-piece orchestra for the dancer Maud Allen and her troupe. There were many others.

Other Theaters

Another theater, the Majestic, had a grand opening in mid-October 1907. The Majestic first concentrated on vaudeville, with two performances almost every day. By November 1910, however, its two daily shows were resulting in so many empty seats, the theater had to limit itself to a single daily performance, which caused endless booking problems. M.J. Boyle, the manager, announced the Majestic would concentrate largely on films,[65] but the Majestic continued to present anything that seemed marketable, including vaudeville.

In 1907 Scherer and Kelly developed a more modest theater in a building that had once been a small church—the Park Theater on Main Street adjacent to Nathan's Department Store. The Park featured continuous vaudeville, using obscure itinerant performers, but in time it became almost entirely a motion picture theater. Another movie house, the Garden Theater, got started across the street in the Pythian Temple Building, but the venture apparently failed. Kelly and Scherer acquired the theater in 1919 and reopened it as the "New Park" in what they were calling the Garden Theater Building.

Starting a new movie house in the silent film era was easy. Aside from a license, one only needed a room with a number of seats together with a screen, projector and a piano with a versatile pianist.

From 1910 to 1915, a number of motion picture houses opened. They included the Nemo in 1913, which found a new use for the former First Presbyterian Church after the

new edifice at Lincoln and Walnut Streets was finished. (The Nemo would later become the Embassy Theater.)

In 1912 an enterprising Greek immigrant, George Panagotacas, and his family opened the Grand Theater in a building complex that contained two other businesses he owned: an amusement parlor and the Keystone Candy Shop. The Panagotacas's concerns were all on Main Street between a corner drugstore and the Miller's Clothing Store. For a time a Greek proprietor from Altoona operated the Palace, a small theater adjacent the Grand. The Palace would later become the Ritz and the Grand eventually became the Strand. Panagotacas also opened the Park View Theater, previously the Park, after he acquired it in 1919. The theater closed in late April 1925, following a Johnstown showing of *The Birth of a Nation*.

In April 1913, the Newman Hardware Store Building on Central Avenue in Moxham was converted into a neighborhood movie house, the Theatorium, an impossible name later changed to the Ideal.[66] Other motion picture theaters during World War I included the Liberty on Bedford Street near the Swank Hardware Building, the Victoria on Broad Street in Cambria City and the Lyric (later Rialto) on Fairfield Avenue in Morrellville.

In the early 1920s, there were about one dozen motion picture theaters in Johnstown. Usually there were six including the Cambria downtown, two in Moxham and another two in Cambria City. Dale, East Conemaugh and Morrellville usually had a single movie house but at times there might be two.

The Movie Revolution

The second decade of the twentieth century was a time of film industry development affecting all forms of theater. The public's flocking to the several new picture houses in Johnstown took its toll on vaudeville, burlesque, the circus and live theater.

The Cambria Theater continued to balance excellence with economic survival. In 1912 it developed a stock theater of its own using a number of temporary actors, mostly from New York.[67]

The Cambria Theater also offered motion pictures, usually the big feature films like *The Coming of Columbus* in May 1912 and *The Birth of a Nation*, first shown in November 1915, breaking all attendance records for any theater-centered entertainment in Johnstown.[68]

Scherer and Kelly entered into a contract with the Triangle Film Corporation, which distributed the films of the three leading film directors of the period just before the United States's entry into the Great War—D.W. Griffith, Thomas H. Ince and Mack Sennett. The contract required the Cambria to have high standards of theater equipment and building comfort. While it cost the owners $50,000 over two years, Cambria had the first-showing rights to the leading popular films of the age.[69]

Morality Enforcement

Reverend Billy Sunday had made it clear in Johnstown, as he had done everywhere he staged his revivals, that the theater and motion pictures were a source of sin and were to be avoided altogether.

Mayor Cauffiel, who often assumed he had a celestial commission to enforce divine precepts, issued a public statement in April 1914 that he would censor all performances in Johnstown.

The new council in the commission form of local government had just enacted a revised licensing ordinance with conventional language about taxes on all kinds of operas, shows and performances. There was also some wording about restraining indecent and immoral exhibitions. The mayor had authority under the ordinance to ban and impose fines for any theatrical or film vulgarity. Cauffiel announced he would suppress the "widespread use of suggestive, coarse, and vulgar songs."[70]

In January 1915, Cauffiel declared that the license recently issued to the Cambria Theater was not valid because he, as mayor, had not signed it. He also added he would not sign the license without a written pledge that there would be no burlesque or vulgarity. Tom Nokes, then press representative for the Cambria Theater, countered that the theater would continue to operate. The matter seemingly went away.

Motion Picture Developments in the 1920s: Vitaphone

In 1927 Kelly and Scherer both attended the vitaphone premier showing of *Don Juan* at the Warner Theater in New York City. On that trip, they signed an agreement for vitaphone equipment to be installed in the Cambria Theater.[71] They also made arrangements for *Don Juan* to be presented to showcase the new equipment.

On April 25, 1927, vitaphone came to the Cambria Theater. *Don Juan* was shown, as were operatic arias sung by Giovanni Martinelli, Beniamino Gigli, Giuseppe de Luca and Anna Case. The New York Philharmonic was also both seen and heard in this local technology debut. Vitaphone would soon be replaced by a more versatile sound and film technology. Scherer and Kelly, however, had given Johnstown another first.[72]

Amusements: Postwar Theater and Motion Pictures

The once-thriving theatrical productions of the pre–World War I era were declining in the twenties and had become very infrequent during the Great Depression, a consequence of both film industry success and the soft economy. After World War II, movies remained the dominant ongoing Johnstown entertainment.

There were fourteen motion picture theaters in and near Johnstown at the end of the war. Six were downtown. A few had limited or sporadic schedules. The Hollywood in Cambria City, showing mostly foreign films, often was not open.

Most new film productions were shown by the Cambria, Embassy and the State—all downtown. The neighborhood theaters presented films several weeks after the premier showings. All the theaters featured reruns from time to time. The Majestic on Main Street near Lee Hospital often included vaudeville acts together with a film presentation.

In late August 1948, the Family Drive-In Theater opened near Mundy's Corner. The facility featured a gigantic aluminum screen and accommodated over five hundred vehicles.

In December 1951, the Park Theater Building at Main Street and Park Place was sold for conversion into retail space with offices above, the first of many theater closings to happen in the wake of television success. By 1954 the theater count was down to eleven. By 1957 there were eight.[73]

II. RADIO

On Thursday, January 26, 1922, Victor Raab and his wife listened at home to a concert given by Fritz Kreisler from Carnegie Hall in Pittsburgh. The performance had been broadcast by KDKA, Westinghouse's pioneering radio station. Raab had assembled the "wireless cabinet" they were using.[74] By May there were so many aerials in Johnstown that Fire Chief Harry Schultz began issuing instructions for grounding aerials and turning off idle radios to reduce lightning hazards.

Johnstown's first radio station, WTAC, owned and operated by the Penn Traffic Company, began broadcasting very early in 1923.[75] The station was more of an advertising gimmick than an ongoing commercial activity. Its equipment was on public display in the store itself. WTAC had planned to be "on the air" Monday through Saturday from 7:00 to 8:30 p.m., but its broadcasting was more sporadic. The station presented special programs, usually music performed by church choirs or singing clubs. In time there would be election returns, sporting event results and similar matters. The public usually learned about forthcoming programs from short newspaper articles that preceded the broadcasts.

On February 18, 1924, Mayor Louis Franke delivered an address about Lincoln and Washington aimed at Westmont's high school pupils. The students were assembled around a radio loaned by the Penn Traffic Company.[76]

Sales of radio equipment in the 1920s were brisk. Penn Traffic, the Johnstown Automobile Company, and specialty shops sold receivers, aerials, earphones and cabinets.

In 1924 local newspapers began publishing a daily radio schedule that listed program names, station call letters, broadcast times and the city of origin.

After about two years, WTAC ceased to exist and WHBP, a new station licensed in January 1925, began in Johnstown. WHBP was owned and managed by the Johnstown Automobile Company situated at Main and Johns Streets near the Point. The call letters stood for the names of company officers.[77] The firm not only held the Cadillac dealership but had also been selling Crosley and Atwater-Kent radios.

The first WHBP broadcast occurred Saturday, May 9, 1925. The Johnstown Automobile Company soon began getting "applause cards" and letters from scattered places east of the Mississippi River, including one from Bangor, Maine.[78]

In February 1929, WHBP was allowed a major increase in power by the newly created Federal Radio Commission—five hundred watts at night and one thousand watts during daytime—an upgrade that was part of a major transformation. The station also began affiliating with the Columbia Broadcasting System in early March 1929. On June 14, 1929, WHBP was renamed WJAC, call letters for the business that owned it: Johnstown Automobile Company.[79]

III. THE SUMMER PICNICS

During the 1920s large, well-planned summer picnics continued to be a feature of Johnstown's pastime activities. The bigger they were, the better. The picnics were sponsored by churches, lodges, the Ku Klux Klan, civic groups such as the chamber of commerce and business concerns for their employees.[80] There were also family reunions.

One of the largest was the Penn Traffic picnic usually held each August at Idlewild near Ligonier. The picnic was not only for store employees and their families but also for the general public as a customer relations outreach. On August 18, 1925, three special trains hauled 1,600 Johnstowners directly to the picnic site. Many other people and families went by automobile. First aid tents manned with physicians and nurses were set up for anyone in need. There were games, athletic contests and politicking. Each year's event sought to be bigger and better than earlier ones.[81]

The more popular picnic sites in and near Johnstown included Faith's Grove in Lower Yoder Township near Morrellville; Ideal Park just off the Somerset Pike, south of the city; and Crystal Beach near Bens Creek. Earlier there had been Island Park (Valley Park) just across the river from Crystal Beach. There was also Roxbury Park.

IV. JOHNSTOWN'S CLASSICAL MUSIC MAKING

The Orchestras

From the earliest times, Johnstown's theaters maintained small orchestras to perform in connection with their stage and silent film presentations. Some of the member musicians were moonlighting for extra income. The Cambria Theater Orchestra was often engaged for dances and background music at banquets and other events. The Nemo and the Majestic Theaters also maintained orchestras prior to the Great Depression.[82]

As early as 1910, there were discussions about establishing a symphony orchestra in Johnstown. When a Pittsburgh Chamber of Commerce delegation visited in late May 1910, the group was entertained by the "recently formed Johnstown Symphony Orchestra directed by Fred Patten."[83] Presumably this orchestra folded as there was no further news about it.

In 1914 Joseph Love, a Johnstown business leader, founded the Love Symphony Orchestra. Its thirty-five instrumentalists were led by Robert Findley, a violinist. The Love Symphony Orchestra gave at least two benefit performances for Memorial Hospital. One at the Majestic Theater had an audience of about one thousand.[84] After a brief splash, the Love Orchestra vanished.

During World War I, a Cambria Symphony Orchestra came into being largely through John Ogden, Cambria Steel's general superintendent. A lover of classical music, Ogden recruited versatile musicians into the Cambria Steel workforce, played a cello in its string section and was known to have purchased orchestral scores, possibly using company funds.[85] The orchestra's director and conductor was Charles Martin, a Johnstown musical personality who led choral groups, taught piano and gave recitals. Despite the orchestra name, it was not part of the corporation itself. The Cambria Symphony Orchestra was discontinued with the arrival of Bethlehem Steel and John Ogden's retirement.[86]

In early 1922, B.E. Meyer founded another symphony orchestra in Johnstown. Meyer was a violin instructor affiliated with the Johnstown College of Music, a nonaccredited grouping of quality teachers who had banded together around 1915 cooperatively to teach a range of musical instruments. The orchestra was intended to give Johnstown's many music students experience at ensemble playing.[87]

In 1928 several prominent local musicians founded the Johnstown Symphony Society Orchestra with a governing board headed by Dr. Kurt Lamprecht, a chiropractor and head of

a silver mining company. B.E. Meyer, the violinist, was vice-president and concertmaster. The conductor was Hans Roemer, who had directed the prestigious Schiller Chorus in Stuttgart, Germany, before coming to the United States. Judging from a group photograph taken in 1930, the Johnstown Symphony Society Orchestra had about forty-five members.[88]

In the late 1920s, Johnstown High School had its own symphony orchestra led by Ralph Wright, the supervisor of musical instruction for Johnstown schools. In May 1931, Wright and his 116 student musicians won the Class A championship in a statewide competition. The ensemble featured every conventional musical instrument of a modern symphony orchestra except the celesta, xylophone and harp. Twenty-one of its student members became instrumentalists in the first Johnstown Municipal Symphony Orchestra and a few developed professional careers with major orchestras and military bands.[89]

Silvio Landino

Around 1917 an Italian-born musician, Silvio Landino, was a member of a financially troubled touring opera company. While performing in Greensburg, Landino came to Johnstown seeking to be director of the Nemo Theater orchestra. After being chosen, he was also able to work for the Cambria Steel Company. Landino was a baritone, a violinist, a pianist and a versatile musician.

In 1922 Landino founded the Johnstown Opera Company, a group of local singers and musicians that put on an opera almost every spring throughout the 1920s, beginning with Cavalleria Rusticana in May 1922. In 1923 his group performed Gounod's *Faust*, starring Grace Sefton Mayer. In other years the Johnstown Opera Company performed *Il Trovatore* and *Aida* by Verdi, and *Shawnewis* by Charles Wakefield Cadman, a nationally well-known composer born in Johnstown.[90]

The People's Symphony (Community) Orchestra

In February 1932, Landino conducted the first performance of a reconstituted orchestra, the People's Symphony, which was also called the Community Symphony Orchestra. There were just over forty musicians and all indications are that the Community Symphony Orchestra had many of the same members as the earlier Johnstown Symphony Society Orchestra but with a new ensemble name and Landino instead of Hans Roemer as conductor. The Community Symphony Orchestra gave its farewell performance before Thanksgiving in 1932.

The Municipal Symphony Orchestra[91]

In the early 1930s, several prominent Johnstown business and professional leaders began taking an unusual interest in developing a community symphony orchestra. Many had sons and daughters who were talented and accomplished musicians, most of whom had performed in the state championship Johnstown High School Orchestra. The civic leaders included Tom Nokes, Harry Koontz, Harry Hosmer, Dan Schnabel and Francis Dunn, a Johnstown attorney. Dunn served as chairman of a new symphony steering committee made up of these plus several other community leaders.[92]

A strategy evolved. The forty or more performers of what had been the Community Symphony Orchestra would be doubled in size with the rich musical talent that seemed to abound in and around Johnstown, including students still in area high schools and many members from the 1931 championship orchestra. Landino would be the conductor. The Johnstown Municipal Recreation Commission and the Johnstown School Board agreed to sponsor the orchestra jointly. Concerts would be free and the instrumentalists would perform without pay initially. The new group would be named the Johnstown Symphony Orchestra.

The first concert of the reconstituted but much larger ensemble was given on Thursday, January 5, 1933, at Garfield Junior High School in Morrellville. By the season's end there had been five performances, each at a high school in a different section of the Johnstown area. With attendance averaging about 1,500, the orchestra's first season was a success.[93]

One of the major problems facing any fledgling orchestra is obtaining the many musical scores needed for a large group to perform a diverse repertoire. The absence of a rich musical library had probably contributed to the demise of the several earlier orchestras after each had given only a few concerts.

Silvio Landino had amassed a personal library of musical scores, which he had been making available to the Municipal Symphony Orchestra. There are some indications he had acquired the old Cambria Symphony Orchestra's library. In late 1937, he sold his collection of 108 classical works to the recreation commission for use by the orchestra, perhaps enabling the orchestra to continue.[94]

Landino continued to lead the Municipal Symphony Orchestra, a part-time position, until December 1935. His leaving was a bitter one. (Landino afterward sought in vain to establish another ensemble, the Johnstown Symphony Orchestra.)[95] The new conductor to assume the baton was Theodore Koerner, a German mechanic and tester who, like Landino, had been employed by the Cambria Steel Corporation. Under his direction the orchestra seemingly did more Beethoven, Wagner and other German works.

In its early years, the orchestra usually started in November and performed about once a month until its season ended in May. In the beginning, the concerts were free with occasional benefit performances to raise money for orchestral expenses. Between 1933 and 1935, the orchestra received two grants totaling $4,107 from the Civil Works Administration.

Although there had been a benefit concert given one month after the tragedy, the Saint Patrick's Day Flood set the orchestra back for a short while by reducing its ranks to only fifty-two members. In time, however, its numerical strength was restored. By the 1938–39 season, the programs were occasionally featuring guest appearances. In the 1939–40 season, the orchestra was soliciting two thousand patron members and had started an "out-of-town" advisory board to increase attendance and memberships. In the 1940–41 season there were only four concerts.

During the Second World War there were as many as twenty of the usual orchestra members on active duty in the armed services. With the overall population moving around, often from city to city, orchestra personnel were also changing, but performances continued.

While addressing a severe fiscal problem in 1961, a special committee chaired by Ted Focke recommended that the orchestra seek a top-quality, full-time conductor. In 1961 it hired a young, trained conductor, Phillip Spurgeon. Spurgeon brought discipline and fine musicianship to Johnstown. The orchestra has retained permanent, quality conductors ever since. Unlike its many

predecessors, the Johnstown Municipal Symphony Orchestra has survived and continues to be a significant cultural institution in the Johnstown community.[96]

V. GENE KELLY SCHOOL OF THE DANCE

In 1930 Harriet Kelly in partnership with another Pittsburgher, Lou Bolton, opened a small dancing school in the American Legion Hall on Main Street. Mrs. Kelly had been attracted to Johnstown by her brother, Gus, a resident. Her five children had all studied at Bolton's dance school in Pittsburgh, where she was the bookkeeper.

The Kellys were all talented, but one of them, Eugene Curran Kelly, was an exceptionally gifted dancer and general entertainer. He had a knack for learning and developing dance routines and worked tirelessly and enthusiastically to perfect them. After entering Penn State College in the autumn of 1929, Gene Kelly quickly became a star campus entertainer.

Once the Johnstown dance studio opened, Kelly was often called upon to give instruction. Lou Bolton soon grew weary of driving between Pittsburgh and Johnstown and Gene Kelly increasingly was asked to come in from college and substitute for him. Kelly quickly became very popular and well known in Johnstown. Inspired by his teaching magic and general pursuit of excellence, children and other pupils began working assiduously to learn and perfect their dance routines. Some of his pupils became professional dancers.

Soon the Kellys bought out Lou Bolton's interest in the school. It was becoming such a success that the family opened a companion studio in their native Pittsburgh, but the one in Johnstown was larger and earned more money.

In June 1932, Gene Kelly and his school presented *Johnstown on Parade* at the Nemo, a revue in twelve scenes. There were 150 local performers, including Kelly himself. *Johnstown on Parade* was such a success that Kelly put on another variety show five months later in close cooperation with radio station WJAC. In addition to promoting the Kelly school, its purpose was to showcase people often heard over WJAC. There would be at least one Gene Kelly review every year.

By 1932, the studio had become known as the Gene Kelly School of the Dance and was moved from the American Legion Hall into a two-story building on Vine Street. By 1935, Kelly's revues were cosponsored by charitable groups such as the Lee Homeopathic Hospital Junior Auxiliary and the Johnstown Catholic High School.

As time went on Kelly's career began to take off. The Gene Kelly School of the Dance continued to feature him, but his trips to Johnstown were becoming infrequent. By 1938, he was on Broadway, having been chosen for a small part in Cole Porter's *Leave It To Me*. In 1939 he played a larger role in *The Time of Your Life* by William Saroyan.[97]

Managed by Harriet Kelly, the Gene Kelly School of the Dance continued for more than twenty years after its namesake had become a star. Later Louise Kelly, a sister, headed the school, which was then called the Kelly Dance Studio. The Kellys became inactive with the school after 1953, and it closed in 1963.

AN ANTIQUE DRUM: JOHNSTOWN DURING WORLD WAR II

At 10:00 a.m. on New Year's Day, 1940, John Conway, his wife and three children arrived in a packed city council chamber. There were no speeches or customary festivities. Conway's oath was administered by the city clerk. Johnstown's twelfth mayor was a Democrat, a novice to city government, an ex-prizefighter, a boxing promoter and an embalmer who worked both at his brother's funeral parlor and as a deputy county coroner. Two new councilmen, Clyde Snook and Fred Brosius, were also sworn. A council meeting followed. By 10:32, the whole thing was over.[98]

The Phony War

By early 1940, the conflict in Europe had entered its Phony War phase. Poland had been devoured. The German General Staff was rehearsing blitzkrieg plans to be unleashed against France. In control of coastal China, the Japanese were coveting the oil and rubber resources of Southeast Asia while seeking commitments for U.S. iron and steel resources in the future. Despite a lull in heavy fighting, the dark clouds of war were gathering.

The Community Agenda

Johnstown's communal agenda remained unchanged. Channel works construction was committed and well underway. The civic concern was that somehow because of conflicting priorities in arming the nation, the project might get halted. Local Congressman Harve Tibbott and high-level Corps of Engineers officials assured everyone the Johnstown flood works would be completed, war or no war.

The long-standing program of installing sanitary sewers throughout the city continued. Construction was underway with as many WPA workers as could be retained given the ever-improving economy.

Sewer placement faced a competing civic project—a modern airport on a new site in the East Hills area. While Dan Shields had steered the community toward the new location, Conway would claim its accomplishment as his own. Justification was easily rationalized by balancing

Johnstown's civic interests with a national defense purpose. Local and federal advocates said the airfield was useful militarily. In peacetime, it would serve the community.

John Conway also discovered the city had been incurring annual general fund deficits. The fiscal year 1939 had ended with an operating loss of over $50,000. By the end of 1940, the cumulative shortfall had reached $110,000. A one-mill tax hike would have solved the deficit but no increase was imposed.

Throughout the Great Depression the city had been accruing a backlog of uncollected taxes, which had grown to $856,000 by 1940. WPA workers had documented who owed how much. As long as recouping earlier taxes was possible, the solons would not increase taxes.

Conway, a nice guy rarely willing to rock the boat, reviewed the 1940 budget for items to delete. He made a significant discovery. Questioning a need for the municipal court interpreter, the part-time position was eliminated. More significantly, the passing of the court interpreter signified that Johnstown's ethnic community was sufficiently proficient in English that someone to translate during court sessions was no longer needed.[99]

Conway and his council took action to address the staggering housing shortages that had plagued Johnstown for decades. In late January, the Johnstown Housing Authority was created and on March 5, 1940, the city council adopted a "declaration-of-need resolution," a programmatic requirement.[100]

Gambling Suppression

Police raids were conducted and fines were regularly imposed against a flourishing gambling trade. The same people were repeatedly arrested, tried and fined. Jail sentences were rare and there were no efforts to seek injunctions or judicial padlocking.

The raids doubtless had a political motive of appealing to reformers still smarting from the demise of Prohibition. Gambling proprietors were treated the same as Johnstown motion picture theater operators who were fined periodically for Sunday showings. Theater operators willingly paid court-imposed fines, a practice that went on until the ban against Sunday movies was voted out in the November 1940 election.[101]

Economic Recovery

Meanwhile, the hardened ice of the Depression was melting. Bethlehem's payrolls were averaging nearly $2 million per month throughout 1940, and 1941 was trending even better. By late 1940, Cambria Steel's coke and steel furnace units were operating at 10 percent above rated capacity, and U.S. Steel's Lorain Division was running at full capacity.[102] In October 1939, Bethlehem's Johnstown workforce was exceeding 12,000, a big improvement over earlier years. By midsummer of 1941, there were 15,500 employees and 85 percent of its production was defense related. There was also an order for 2,800 railcars.

Penn State College periodically issued and updated a sub-state business econometric report based on simple tabulations of bank debits, factory payrolls and independent store sales separately for each major city in the state. This composite gave a comparison of economic trends over many periods. Throughout 1939, the index for Johnstown had risen over 19 percent—the

largest gain among all Pennsylvania cities. In 1940 it rose another 24 percent, another statewide record. The Johnstown gain for 1941 was an additional 25 percent.[103]

The improving economy was taking workers off the WPA rolls. By midsummer 1941, the sanitary sewer program, supposedly 95 percent completed, had almost no workers. Three weeks after Pearl Harbor, sewer construction was terminated, and 280 workers were transferred to the airport project. Eighteen months earlier, nearly 1,000 WPA men had been installing sewers.[104]

The happier times spilled over into the civic arena. In 1940 the Greater Johnstown Community Chest, chaired by Wilson Slick, exceeded its goal by raising more than $125,000. The next year another record was reached. Headed by an up-and-coming community leader, Howard Picking Jr., the drive generated $135,000, the largest amount pledged up to that time.[105]

There were a few ominous indicators, however. Johnstown City's population had peaked at 67,327 in 1920. By 1930 it had eased to 66,993. The 1940 census revealed 66,668, another drop. Areas outside the city were growing, attracting affluent leadership elements moving from downtown Johnstown, Kernville and Moxham.

Bugle in the Valley

The Selective Service Act was signed by the president in September 1940. Peacetime quotas were restricted by law: No more than 900,000 men (twenty-one to thirty-five years old) could be drafted nationwide in any year.

There were eight draft boards in Cambria County and three in Johnstown City. Every board had three members appointed by the president. Each board prepared and kept current a roster of the eligible men within its area classified by fitness, certain skills and other categories. A call lottery administered in Washington provided the sequence in which eligible names on each board's roster would be called. As men were needed, quotas were assigned proportionately, at first to the states and then down to the local boards.

Most draftees entered the army. From Johnstown they went by special train to Altoona for more rigorous exams. Once judged fit, army draftees were usually sent from Altoona to Fort Meade, Maryland. The first Johnstown-area conscripts were ordered to report on November 27, 1940. Similar calls would continue until after the war.[106]

The U.S. Office of Production Management (OPM), an arm of the War Production Board, was charged nationally with causing industrial and resource firms to supply armaments and other military needs as well as to deliver domestic essentials. It also had enormous power to install new or otherwise to expand existing defense plants.

In mid-May 1941, the OPM created a regional advisory board representing nine counties in western central Pennsylvania, including Cambria and Blair. This board was intended to interface with national OPM officials about its areawide industrial resource needs. The chairman was Robert Waters, president of the National Radiator Corporation. Other Johnstown members were Bethlehem's general superintendent, Ralph Hough; Carroll Burton, vice-president in charge of the U.S. Steel plant; H.V. Brown, president of the Brown-Fayro Company; and James Warren, Penelec's industrial development engineer.[107]

In July 1941, following President Franklin Roosevelt's declaration on May 27 that a national emergency existed, Mayor John Conway appointed a Johnstown Council of Defense. The

twenty-five-member group consisted of veterans' organization leaders, police chiefs, draft board members, a labor leader, a hospital administrator, public officials and others. Conway announced the group's mission was "to protect the people, their homes, work, and morals." The immediacy of an emergency not felt, Conway's council did nothing until after the Pearl Harbor attack.

A Time of Shortages and Uncertainties

By July 1941, the national economy was experiencing a shortage of aluminum needed for military aircraft. Boy Scouts, Girl Scouts and volunteer firemen began house-to-house collection in and around Johnstown. The scrap was shipped from points throughout Somerset and Cambria Counties to a site on Railroad Street. By early August, some 4,750 pounds of aluminum had been collected.[108] This peacetime effort established a framework for more extensive and varied scrap-type drives conducted during the war.

Although the economy was improving, the likelihood of war created sustained uncertainties. Faced with the draft, young people had difficulty deciding whether to go to college, pursue a career, marry or join the military. Entrepreneurs found it difficult to judge what sorts of enterprises might succeed, considering manpower and materials shortages and uncertain markets.

December 7, 1941

News of the attack on Pearl Harbor reached Johnstown just after 2:30 in the afternoon. Almost everyone gathered around a radio to listen to the steady news updates from WJAC and the NBC Network. The station continued until after midnight. There were no big crowd gatherings. People went to church services. The *Johnstown Democrat* put out an extra. Shouting newsboys sold 25,000 copies before the Monday edition went to press.

Steelworkers were seen riding to their 11:00 p.m. shift changeovers reading the special news edition. They appeared quiet and determined. Each knew the work he would be doing had a new meaning, part of a war against a hated enemy.[109]

The Pearl Harbor attack prompted a new unity and community-wide resolve. The draft had been in effect for about one year, but there was a big rush to the military recruitment offices. In the first week, almost one thousand sought to enlist in Johnstown alone including a seventy-seven-year-old man who said he wanted to peel potatoes, wash dishes or do anything to serve.[110] Another elderly man seeking to enlist said, "I want a chance at Hitler."

Sales of war bonds and defense savings stamps soared. In the ten days following Pearl Harbor, more were sold than during the entire month of November. Bonds were often contest prizes and were sold through payroll withholding.[111]

Fortress Johnstown

Mayor Conway's defense council finally met. "We're going to put Johnstown defenses in order immediately to protect our people," he announced. "The mills are our first task. If anything happens there that doesn't look right, we're prepared to move at once."

Conway next began searching for any Japanese people who might be in Johnstown. He found one, George Nozaki, a fifty-seven-year-old downtown resident and chef at Johnstown's Bachelor's Club.[112] Neither Germans nor Italians were affected by the Pearl Harbor strike. Hitler's and Mussolini's simultaneous declarations of war against the United States happened on Thursday, December 11.

Presiding over his court on that December 11, Judge John McCann of Ebensburg made an impromptu speech to a packed gathering attending court. Having witnessed eighty-seven young recruits depart for the military and probably having just heard of the precipitous Rome and Berlin war declarations, McCann paused from the normal courtroom routine and announced, "There is no place for anyone…not loyal to the government." McCann said he expected air raid attacks before long.[113]

As the real war progressed, confused and basically uninformed officials sought to project an air of confidence and enlightened judgment that they had taken every needed precaution. Conway relayed Governor Arthur James's warning and instructions to the leaders of all Johnstown industries believed to be potential airraid or sabotage targets. The following were ordered to be guarded: Bethlehem Steel, the Lorain Division of U.S. Steel, the Johnstown Water Company, Pennsylvania Electric Company, the National Radiator Corporation, Johnstown Traction Company, radio station WJAC, the DeFrehn Chair Company, the Western Union Telegraph Company and the post office.

Conway issued a new order, seemingly a product of his awakened defense council: In the event of an attack or other disaster, the mayor had placed the city's emergency forces—fire, police, rescue, air raid squads and similar units—under Louis Sheehan, the popular and manifestly patriotic district commander of the American Legion. Sheehan, a World War I veteran, had apparently been doing Conway's civil defense thinking.

Conway also named Wilson Slick, the community chest president, to serve as coordinator of private agency, civil defense services. Conway also established a committee to promote war bond and defense savings stamp sales.

Johnstown's strategic importance, with its industries, mines and railroad junctions, was cited in connection with air raid preparations and a need for attack warning and all clear sirens. When Fiorello La Guardia passed through Johnstown by train in March 1942, ex-Mayor Daniel Shields, who knew La Guardia personally, learned of his trip and asked him to make a brief statement. La Guardia had just resigned from being U.S. civil defense director. When asked by a reporter whether Johnstown was a likely target, La Guardia answered, "One must never underestimate… his enemy. The Germans are pretty aware of Johnstown and its steel mills. It would probably be one of the central targets in an attack."[114]

On December 23, the city council introduced an ordinance that spelled out what everyone must do in air raid situations. It also provided for citywide blackouts in the event of nighttime emergencies.

By mid-March 1942, there were still no discrete air raid sirens in Johnstown. Arrangements had been made to use a collection of company whistles coupled with fire trucks driving about sounding alarms. After a preliminary siren audibility test was conducted on March 15, air raid wardens reported that in most of the Johnstown area, no one could hear whistles at all. Residents of East Conemaugh and Franklin were more fortunate. Pennsylvania Railroad whistles were audible.[115]

Five and a half months following the Pearl Harbor attack, the city finally received forty air raid sirens, but they could not be installed until electrical relays, slow in arriving, were on hand.[116]

Conway's shifting organizational changes became the subject of constant criticism. Many people were concerned that if a real emergency occurred, the civil defense plans would fail. There seemed to be groups and people with overlapping and confusing authority. There was some friction between county and city agencies. Air raid drills were rarely successful. Lights continued shining during blackouts.[117]

In November 1942, the chamber of commerce advocated a council of defense agencies, an idea that received strong editorial support.[118] The similar grouping already in existence was apparently considered ineffective.

Losses and Heroes

Johnstowners waited anxiously for dreaded telegrams and the casualty lists that were released and later publicized. Dan Shields and his family were relieved to learn that their son, Andrew, stationed at Wheeler Field near Pearl Harbor, had come through December 7 safely.[119] Another private, Roy Brewer from Daisytown, had been wounded near Pearl Harbor. The first reported fatality of an area serviceman was Harvey McClung, a young naval ensign from New Florence.[120]

"Buzz" Wagner

At the time of the Pearl Harbor frustration, with everyone eager to strike back, news came through that one of Johnstown's own, Boyd "Buzz" Wagner, a twenty-five-year-old first lieutenant stationed in the Philippines, had shot down two Japanese aircraft in a dogfight and then had strafed planes on the ground leaving five burning. A few days later, he arguably became America's first World War II ace by achieving five total kills in air-to-air combat. His parents were living in the Eighth Ward. Wagner added to the totals, and the news articles describing his victories were reported in Johnstown's newspapers later in 1942.

In late December a rumor reached Johnstown that Warner Brothers was planning a movie about "Buzz" Wagner to be titled *Pittsburgh Pilot*. The Johnstown Chamber of Commerce sent a telegram suggesting a title change to reflect Wagner's hometown and asking for the premier opening to be in Johnstown. Wagner had spent one year in Pittsburgh attending the university following his two years at the University of Pittsburgh at (UPJ) Johnstown. He had graduated from Nanty Glo High School before his family moved to Johnstown. However, the title did not need to be changed as the film was never made.[121]

Enemy Aliens

In both the prewar and wartime years, Johnstown remained a community of foreigners, including many who had not become naturalized citizens. Italian men up to the age of thirty-nine had been warned that a visit back to Italy would result in their conscription into one of the Italian armed forces. Although the local Fascisti chapter had folded in 1929, Johnstown's Italians were said to have been enthusiastic supporters of Mussolini's 1935 Ethiopian campaign. While the statements

of Consul Angelo Iannelli might have been exaggerated, he had reported a strong interest among local Italian men in joining Mussolini's army in the mid-1930s.[122]

The German community of Johnstown apparently had no significant ties to the German-American Bund, a Nazi front organization well rooted in some Pennsylvania cities.[123] Speakers occasionally visited churches and German societies giving addresses denouncing the Versailles Treaty and voicing arguments that Germany had not been responsible for the Great War.[124]

Johnstown had a strong chapter of the German and Austrian War Veterans' Association. Thanks to Harry Adler, a U.S. World War veteran and member of the American Legion, the former enemies openly marched in Armistice Day parades with American veterans.

In September 1936, the local German-Austrian chapter hosted its national convention in Johnstown. About 150 members from twenty U.S. cities attended. While the group passed an anti–League of Nations resolution, statements were made, including, "We now stand for America—that country of our adoption and choice." Ninety percent of the members had become U.S. citizens, and there were no reports of pro-Nazi rhetoric.[125] Members of the local chapter sensed some effort to plant Nazi sympathies into the group, which remained solidly anti-Nazi.

Prior to Pearl Harbor, a delegation from the German Embassy in Washington attempted to present a medal to Herbert Pfuhl, a first lieutenant in the German army during the war. Seeking to become a U.S. citizen, Pfuhl refused the medal.[126]

Any pro-Nazi sentiments within the Balkan regions from which many local families had originated were not shared in Johnstown. All indications were that Johnstown's Eastern Europeans were decidedly anti-Fascist throughout the 1930s and strongly favored the Allies during the war.

In 1940 the Alien Registration Act became law. All non-citizens of any nationality were required to be registered. The adults also had to answer some forty-five questions and every non-citizen was fingerprinted.[127]

Once the United States was at war, federal regulations involving Axis Aliens went into effect. All such people had to turn in their firearms, cameras and shortwave radios by 11:00 p.m. on January 5, 1942. Travel restrictions were also imposed upon them. By the end of February, Axis Aliens were furnished with identification certificates, which they were required to carry. As of the early morning, February 28, 564 certificates had been issued at the Johnstown post office alone.[128]

There are some indications that life may have been unpleasant for Germans living in and near Johnstown during the war, but their lot was not as strained as during the 1917–18 conflict. The Old Heidelberg Club, operated by the German and Austrian Veterans Association, was renamed The Pinehurst after war was declared. The Germania Club, a singing group, had announced a name change during the First World War but never followed through with it. Richard Speicher, president in 1941, acknowledged that the question of a new name had been discussed but he stated, "The club has been called the Germania Quartet Club for sixty years and that is still the name of the organization."[129]

In June 1942, eight saboteurs with money and explosives, all of whom previously lived in the United States, were landed in Florida and on Long Island from German submarines. They were carefully followed and eventually caught by U.S. law enforcement officers. J. Edgar Hoover's investigation concluded that one of the team's targets was the Horseshoe Curve on the

PRR mainline. There were also indications that local sympathizers were expected to assist the sabotage. Approximately 250 suspects were arrested in Altoona alone. The Horseshoe Curve and the Gallitzin Tunnel were given protective surveillance. If there were any Johnstowners accused of involvement, they were not identified.[130] In mid-September, four Johnstown aliens were taken into custody along with eight other persons from Revloc near Ebensburg. Dynamite, photos of Nazi leaders, a shortwave radio and code devices were reported to have been seized, but no names were released.[131]

Rationing

Even before December 7, there were spot shortages caused by the wars in Europe and Asia. In August 1941, gasoline became comparatively scarce, mostly along the eastern seaboard. Secretary of the Interior Harold Ickes, as defense oil coordinator, issued a ban on selling gasoline between 7:00 p.m. and 7:00 a.m. until the crisis passed.[132]

By the end of 1941, the Japanese had cut off about 90 percent of the peacetime U.S. rubber supply. The need for rubber caused by the military buildup squeezed domestic usage. Tires became scarce. Eight rationing boards were set up in Cambria County, including three in Johnstown City. These boards decided who got the precious few tires and tubes available for distribution. Speed limit restrictions of thirty-five miles per hour were instituted for conserving both tires and petroleum.[133]

The staff administrator for Cambria County was Wilbur Wright, a veteran of the First World War. In January 1943, the rationing director position was abolished due to reorganization, but Wright became the local OPA price control administrator with similar duties.[134]

The general goals governing the more extensive rationing to follow were to reduce the demand for goods, meet wartime needs, give the highest priority to the war effort and hold prices down.

By early June 1942, a system of gasoline rationing was implemented. Automobile and truck owners had to purchase annual stickers—typically "A," "B" or "C"—depending on their fuel needs and priorities. Gasoline could not be sold to anyone whose car had no sticker. People also had to obtain gasoline rationing books with varying numbers of gas purchase coupons allotted, based on the sticker category and other factors.

By early 1943, there were bans against pleasure driving. Sometimes the enforcement was harsh. Owners of cars parked at a racetrack, for example, might get cited and fined because of a presumption of "pleasure driving." In time policing the ban became so unworkable, enforcement was stopped and an honor system took effect.[135]

In late May 1943, wartime supply conditions resulted in an extreme gasoline shortage at Johnstown. The rationing boards cut normal allocations to "B" and "C" sticker holders and even caused the Johnstown Traction Company temporarily to make do with 10 percent less fuel, followed later by a second 10 percent reduction. The extreme shortage lasted two months.[136]

Rationing was soon imposed to limit consumption of sugar, canned goods, meats and alcoholic spirits. Some items were further regulated by a complicated point system. As certain commodities became scarcer, progressively more points had to be used up to acquire them. Since each person was allotted an equal number of points per period, the system provided another restraint on demand for items that had become scarce.[137]

Making Do with Scarcity

New automobiles and trucks could not be purchased. Almost all new home, road and major project construction was deferred "for the duration," a phrase meaning until after the war. Building materials had been diverted to war production, and there was little manpower and construction machinery for "nonessentials."

Shortages in gasoline, tires and tubes, cars and other items boosted trolley and bus ridership. Revenues and profits for the Johnstown Traction Company went up and the hard-pressed company actually paid dividends.[138] The Cambria County Fair was suspended for the duration. Although aggressively promoted, carpooling was not successful around Johnstown.

Countless people began growing "victory gardens"—a replay of the "war gardens" from twenty-five years earlier. Garden produce was a bonus, extra food above anything allowed under rationing.[139]

Scrap Collection

The aluminum collection drives conducted before Pearl Harbor marked the beginning of ongoing scrap collection throughout the war in response to the urgings of the War Production Board. Such collections were for iron and steel scrap, waste aluminum and discarded rubber items.

The first national goal was to raise over 17 million tons of iron and steel scrap in 1942. B.F. Faunce, secretary of the Brown-Fayro Company, was named chairman. After urging industries, commercial firms and householders to turn in scrap, Faunce organized teams of volunteers with equipment to make the collections. In the first nine months of 1942, over 12,300 tons of scrap metal had been collected throughout Cambria County alone. Everything from old bedsprings to worn-out machinery was gathered. Householders typically flattened their cans and saved them for periodic pick up. Even metallic foil from cigarette and chewing gum wrappers was saved. On a single day, February 19, 1943, almost 15 tons of tin cans were picked up in Johnstown.[140]

Price regulations coupled with significant changes in the normal recovery and distribution channels for scrap metal squeezed the profits of local salvage dealers during this period, but they managed to survive.[141]

Japanese silk stockings were favored women's apparel. The best substitute was nylon, then a new synthetic. Among the unusual items urged for salvage was hosiery made from either material. Clothing stores collected discarded silk and nylon stockings and other apparel for recycling into bags for explosive powders.[142]

Johnstown Business and Industry during the War

In early March 1941, Eugene Grace, president of the Bethlehem Steel Corporation, issued a statement to all employees: "Each of the 140,000 persons in the employ of Bethlehem…can make a contribution to the defense cause. Each can do his part in a great moment in the nation's history."

Grace's letter told of huge company investments for war production. By March 1941, Bethlehem's order backlog for defense-related products was 50 percent greater than the total value of the nation's ship and munitions production during the First World War. Bethlehem's production capacity had grown four times since 1918.[143]

Johnstown's 15,500 Bethlehem employees accounted for more than 11 percent of the corporation's workforce. Throughout the war, its Johnstown plants produced flywheels and brake drums for tanks, diesel engine heads, turbine rotors for ships, torpedo air-flask heads, breech blocks for artillery guns, artillery shell-cap forgings, breech-ring forgings for .37-millimeter guns, guide fins for bombs, tank tread and connector forgings and .57-millimeter anti-tank shell forgings.

The Bethlehem Shipbuilding Corporation turned out more than one thousand new vessels from 1941 until the end of the war, the largest single corporate producer in the United States. The Johnstown Works made about half the steel plate and much of the subassemblies for these ships. Since about 70 percent of the unloaded weight of oceangoing vessels is accounted for in the plates, the Johnstown contribution to the war effort in ships alone was staggering. In addition, most of Bethlehem's giant shipyard cranes were produced at Johnstown.[144]

In July 1944, the U.S. Army Ordnance Department decided to build a munitions factory on Bethlehem-owned property below Coopersdale. The plant was to cost $4 million including machinery and was expected to employ up to fifteen hundred workers. Ninety German war prisoners were used in the construction. It would forge eight-inch howitzer shells for shipment to a finishing plant near Philadelphia. The shell plant was owned by the government but operated by Bethlehem Steel. It began producing shell forgings in mid-February 1945.[145]

Bethlehem's Johnstown workers set at least two speed records for relining blast furnaces. In October 1942, Bethlehem's Number Seven was relined to boost capacity. Some 860 men working three daily shifts accomplished the job in twenty-one days, a feat hailed nationwide. Once again in January 1943, Number Eight at Franklin was relined in twenty-one days, making this a photo finish tie with Number Seven. In August 1943, Number Six was relined in eighteen days, yet another record. These accomplishments boosted the capacities of the blast furnaces and were considered patriotic.[146]

Throughout the war, the Lorain Division of U.S. Steel continued manufacturing specialty rail and switching tracks and related equipment needed on military bases and in coal mines, shipyards and defense plants. Later in the war, the Moxham plant turned out some parts for U.S. naval ships and made structural components used in testing the atomic bomb.[147]

The National Radiator Corporation produced specialty aviation parts, disposable wing-mounted fuel tanks, subassemblies and radiator heating units for B-29 bombers and parts for P-47 fighters and C-47 cargo planes. In March 1942, General Henry "Hap" Arnold sent a telegram to Robert Waters, the company's president, telling how bombers built with National Radiator parts had performed well during a successful mission in Libya. National Radiator engineers designed and the company produced manifold valves used in Liberty and Victory ships, tank landing craft and destroyer escorts. Its new powdered metals unit produced ingredients for radio and radar equipment, tanks and other vehicles.[148]

In 1944 the Sylvania Corporation opened a small plant at Adams and Main Streets in a building acquired by the Industrial Development Commission of the chamber of commerce. The plant produced proximity fuse components for anti-aircraft shells and similar explosives. Employment peaked at eight hundred.[149]

In 1942 the Albright Equipment Company of Pittsburgh opened a small plant in Ferndale to manufacture aviation engine valves.[150] Goldstein and Levin produced military nurse uniforms.

Because of the rubber shortage, synthetic rubber plants were built in several United States locations. The Griffith-Custer Steel Company in Woodvale successfully produced and installed the structural steel components needed to support the boilers (made by the National Radiator Corporation) used in these plants.[151]

Wartime Johnstown was a busy place. Labor was scarce. People were constantly moving in and out. Railroad traffic in coal, ores, freight and passengers was intensely heavy. Johnstown's contribution in World War II was beyond calculation.

Workforce and Labor Issues during the War

By 1940 the Johnstown employment scene was shifting from unemployment to labor scarcity, a transformation brought on by men and women entering the services and a soaring need for workers to make more of anything the community could produce. In early 1942, President Roosevelt named the National War Labor Board (NWLB) with employer, labor and general public representation. It was empowered to settle strikes affecting enterprises judged important to the war effort. Ostensibly the NWLB was to involve itself in disputes after collective bargaining and mediation had failed.

In January 1942, the Congress had also enacted the Price Control Act, which sought to hold down prices and rents and to restrict wage advances "except in unusual circumstances."[152]

Prices were rising, wages tended to be frozen and there were wartime mechanisms to force quick settlements of most strikes and prevent them from becoming prolonged and costly. The changeover from a depression to a wartime boom era was also taking place about the time of the NLRB ruling about Bethlehem's Johnstown machinations during the 1937 Steel Strike and that ruling's sustainment in the courts. There had also been other successful union drives by Teamsters Local 110 and others. Taken together, an explosive situation in Johnstown's labor relations had evolved during the war years.

In April 1942, a potentially serious strike at Bethlehem Steel over wages and the long-standing union insistence that there be a written collective bargaining agreement was resolved through the quick work of federal mediators. A parallel issue at the coke plant was also solved after workers agreed to abide by a forthcoming decision of the NWLB. The issues were all resolved in July 1942, and the first ever collective bargaining contract between the Bethlehem Steel Corporation and the CIO's United Steelworkers was signed on August 17, 1942. The agreement was based upon the Little Steel Formula.[153]

On April 1, 1943, the two-year collective bargaining agreement between the United Mine Workers and most coal operators expired. The miners themselves were seeking a two-dollar-per-day wage increase. The UMW agreed unilaterally to work for one additional month to allow time either for a contract to be negotiated or a new NWLB settlement order. This action by the UMW leadership was controversial within the union itself. In late April, wildcat strikes broke out, including several near Johnstown. The UMW neither called the strikes nor did John L. Lewis try to halt them at first.

By May 1, almost all mines were closed, affecting about 55,000 miners in UMW District II, which included Cambria, Somerset and Indiana Counties. District II typically produced about 200,000 tons of coal per day. War Production Board experts were predicting that within two

weeks every steel mill in the United States would be shut down if the coal strike continued. Faced with this information, President Roosevelt ordered the mines taken over and operated by the government. Strikes against the government were illegal.

In general Lewis supported the president and urged miners to return to work. Some obeyed while others remained on strike. There were strong differences between Lewis and his district leaders.[154] In mid-June, the NWLB denied a wage increase to the miners and refused to act on a proposal made by Lewis and the UMW that miners' hourly wages cover from when they entered until they exited a mine, the portal-to-portal concept. There were also suggestions for longer workweeks, an idea some miners rejected. By July the walkout was over, but from mid-June until October there were sporadic coalfield work stoppages around Johnstown.

In November, a contract was signed between the UMW and the U.S. government, an agreement reached after another strike had idled many mines, including those around Johnstown. This settlement ended the 1943 coal strikes, but there would be sporadic work stoppages throughout the war.[155]

Also in April 1943, the Johnstown Traction Company experienced a brief strike brought on by complicated issues and grievances awaiting the action of a seemingly dilatory arbitration panel. The strike was called on April 24. Many people were unable to drive due to rationing and neither trolleys nor buses were rolling. After eighteen hours, the strikers were persuaded to end the walkout in a flurry of negotiations involving Mayor Conway, federal mediators and others, all of whom promised to expedite arbitration panel action.

The panel met and recommended to the NWLB a new wage level of eighty cents an hour for most trolley operators. The NWLB, however, granted a scale of only seventy-two cents, triggering a strike lasting three additional days. Workers were finally persuaded to resume work when the NWLB regional panel agreed to reconsider the issue and an acceptable pay level was reached.[156]

By 1944, most of the recreation, street and general public works employees of the Johnstown city government had signed union cards with Local No. 325 of the State, County and Municipal Workers of America, a CIO affiliate. Exempt from the Wagner Act, the city government was required neither to recognize nor to bargain with the union. Mayor Arthur Schwing (mayor since early January) and two other members of the council (Fred Brosius and Clyde Snook) refused to bargain. On August 21, 1944, a strike was called effectively halting all refuse collection in Johnstown and Southmont Borough. Eighty city workers were affected. Nearly three weeks later, the strike was still ongoing.

Garbage was accumulating during a polio epidemic while the strike continued. The city decided to hire Fred Robel, a private contractor, to haul away the refuse piles. As the men and equipment began removing the stacks of smelly garbage, angry pickets confronted them and Robel gave up.

Finally the mayor proposed a plan to increase the men's wages by ten cents per hour effective with the 1945 budget. The offer was accepted and city workers began cleaning up. Although not a collective bargaining agreement, the accord marked a big change in city labor relations.[157]

Johnstown experienced other labor issues of varying seriousness. Some were caused by opposition to NWLB rulings, while others were intended to expedite the board's action.

Victory Bond Sales

Throughout the war, the sale of defense stamps and "victory" or war bonds was ongoing—one way the general public could fight. Much attention was focused on the eight "war loan" campaigns. Each was a promotion with bond-sale goals allocated over businesses and other organizations. Each also had a chairperson with support subcommittees. During the first seven drives, newspapers displayed graphs showing progress.

The first seven defense bond campaigns were successful. The eighth and final campaign was underway when Japan was surrendering. Its goal was not met because the war was over.

The "Buzz" Wagner Tragedy and Johnstown Heroes

After an appendectomy in August 1942, "Buzz" Wagner, the youngest lieutenant colonel in the Army Air Corps and a recipient of the Distinguished Flying Cross and Purple Heart, was ordered back to the United States to advise aeronautical engineers about fighter aircraft requirements. On October 19, he managed a brief, very public homecoming and returned a few days later for a longer family visit.

On November 29, Wagner took off from Eglin Field, Florida, for a night flight to Maxwell Field, Alabama. His airplane disappeared. A lengthy search was instigated, and on January 6, Wagner's remains were found in the plane's wreckage far outside his flight plan.

Johnstown was shocked and saddened. Wagner's body was flown to Johnstown for a full military funeral, a day of mourning and burial at Grandview Cemetery.[158]

Another important area hero was Marine Sergeant Michael Strank, a Croatian American from Franklin Borough, one of the six marines photographed in the historic flag raising over Mount Suribachi on Iwo Jima. Strank, only twenty-four years old, was killed March 1, 1945.[159]

Johnstown service men and women were awarded numerous medals and citations for heroism and exceptional acts during World War II. There were two Medal of Honor recipients: Lieutenant John H. Tominac from Franklin Borough and Lieutenant Edward Silk from Johnstown.[160]

Social Unrest

Throughout the war, families were divided. Husbands, brothers and young women were away on active duty. Wives and homemakers found it patriotic and financially rewarding to work in defense plants or at other jobs. The Glenn L. Martin Company, a Baltimore airplane manufacturer, actively recruited Johnstown women.

At the very time social norms were changing and family members were uprooted, there was increased social regimentation caused by the war itself—the military draft; complicated systems of rationing food and other essentials; the imposition of regulations that lowered highway speeds and forbade any kind of pleasure driving; and "brownouts" that prohibited electric signs, brightly lit store windows and billboard lighting.

There was a lot for people to rebel against. Juvenile crimes were up. On June 10, 1943, Louis Samuel, a West End grocer, reported his automobile seats had been slashed, the first incident in a wave of similar destruction. By the next January, some 45 automobiles had been vandalized in

the city alone. A few arrests followed, but the senseless epidemic continued. On November 10, 15 cars were hit in Westmont. By the middle of 1944, the borough had experienced 37 slashings. After lapses of a week to ten days, the cuttings would resume. The arrest of John Leckey, a fireman dismissed by Westmont Borough, seemed to have solved the problem. He was indicted, but a key witness moved away and Leckey's trial never took place. As of September 1944, 133 automobile slashings had occurred throughout the Johnstown area. The craze then suddenly ceased.[161]

A more positive form of rebellion took place after the Johnstown School Board hastily and somewhat quietly selected a George Kavel from Cornell University as its new head football coach. Kavel's appointment was considered by some to be a slap in the face to Clark Shaffer, a popular and reputedly competent coach at Cochran Junior High School.

On March 23, 1943, about 1,100 high school pupils led by Teddy Metzger, a future political leader, boycotted classes for most of the day, forcing the school board to reconsider what was seen as a hasty, unwise decision. Shaffer, somewhat embarrassed by the walkout, was named to the position.[162]

For Those in Peril

From 1941 until early 1946 the talk of the town was about the comings and goings of armed forces personnel. Whole newspaper pages were dedicated to coverage of individuals on active duty. Parents and relatives all dreaded receiving the telegrams that might tell of the death, wounding, missing in action or prisoner of war status of loved ones.

There are no reliable statistics as to the numbers of Johnstowners who served in the armed services during the Second World War. A very crude estimate is 7,500 from the city itself and another 4,500 from the suburban areas outside. Cambria County, including all of Greater Johnstown, contributed approximately 23,400 service personnel.

Death statistics are more reliable. In June 1946, the U.S. Army listed 698 men and women from Cambria County who had been killed in battle or had died on active duty in the war. The bronze plaques in the lobby of the Cambria County War Memorial Arena list the names of 858 active duty men and women who were killed or had otherwise died during World War II.[163]

From Drums to Bells

There was a subdued celebration on Tuesday, May 8, following President Truman's 9:00 a.m. announcement that Germany had surrendered. Although V-E Day (Victory in Europe) was intended to be a constrained nonevent, whistles were sounded and church bells rang forth. City hall and some businesses closed, but the steel mills and all defense production continued as if nothing had happened. Many school pupils and their teachers were able to listen by radio to the president's announcement and the commentary that followed. They were then dismissed for the rest of the day.[164]

As of V-E Day, fierce fighting was still raging on Okinawa and in the Philippines. The Japanese mainland was bombed daily. On August 7, Hiroshima was destroyed and the world changed.

On Monday, August 13, a preliminary announcement unveiled a forthcoming surrender declaration and a premature celebration began. At 7:00 p.m. on Tuesday, August 14, 1945,

Main and Franklin Streets on the evening of V-J Day, August 14, 1945. World War II had just ended. *Courtesy Johnstown Area Heritage Association.*

President Truman announced the Japanese surrender. Johnstown immediately exploded with jubilation. Downtown hosted crowds, traffic jams, confetti, horns, bells and well-behaved merrymaking. There was no property damage. The victory bell in Westmont sounded. Churches became packed with grateful worshippers attending impromptu services. The news that gasoline rationing had ended was irrelevant. Filling stations were closed.[165]

A WEAK PIPING TIME OF PEACE: POSTWAR JOHNSTOWN

I. JUBILATION, JOLTS AND JOBS

The horns and bells of victory segued into work whistles. World War II faded into memory as Johnstown pursued the challenges and comforts of peace.

Johnstown was a bustling place. Trolleys and buses brought throngs of people downtown everyday. Lists of veterans released from duty appeared in almost every newspaper. Veterans were welcomed heroes. Civic groups led by the Jaycees and the chamber of commerce set up a Veterans Service Center to advise ex-servicemen about their benefits. The Central Labor Council opened a similar office. The busiest of these places, however, was the Veterans' Administration Office in the post office building.

One returning veteran observed that throughout Johnstown there was an enthusiastic spirit of getting on with things. People were focused and motivated. Veterans were eager to pursue their careers, educations and business goals. Those who had worked in the mills before military service were rehired. The same was true of the other major employers. There was zeal to regain lost time, a peacetime continuation of wartime dispatch.[166]

While never formally stated, the underlying civic goal was to maintain wartime prosperity during the happy days of peace. An underlying fear was that the gloom of the Depression might return.

Business and community leaders had no baselines to compare markets or any sort of economic trends. Everything was different from either prewar or wartime conditions. No one could equate an unknown job supply with an equally indeterminate workforce.

People were moving into and away from Johnstown. Servicemen and women had seen other places that appealed to them. Wartime marriages, while uprooting natives, brought in new residents. The educational opportunities afforded by the GI Bill impacted the timeworn practice of quitting school "to work in the mill." Many Johnstowners who ordinarily would not attend colleges or trade schools were enrolling in them.

A Few Aftershocks

Victory brought simultaneous jolts: The Sylvania plant at Main and Adams Streets was closed on August 14, minutes after Japan surrendered. Its two shifts combined had employed 850 workers, mostly women. Two days later, the army cancelled several Goldstein and Levin contracts for nurse uniforms. Meyer Goldstein immediately went to New York to assess peacetime apparel markets. After returning, he announced there would be no layoffs. Some two to three hundred employees would be hired instead. On August 20, the shell plant at Tanneryville was closed.[167]

The Sweet without the Bitter

In 1942 many large American corporations had jointly established the Committee on Economic Development (CED), an organization to plan for the postwar economy. Through Bethlehem and U.S. Steel memberships, there was a Cambria County component to the national report.

The Cambria CED report was upbeat. Iron and steel production was expected to stabilize about 37 percent above 1939 levels. Similar gains were predicted for other features of the county's economy—coal, lumber, refractory ceramics, bricks and transportation equipment. No significant soft spots were indicated. Johnstown's economy was expected to roar.

Local production facilities had little need to retool. Johnstown's ore, scrap, coal and coke supplies were already on hand and replacement streams were flowing.[168]

A Rash of Strikes

The first postwar crisis in Johnstown was a steel strike. Unlike the 1919 and 1937 strikes, the January 1946 stoppage was an industry-wide matter and involved the same wage issue everywhere in the nation. Locally it affected Bethlehem, U.S. Steel, the National Radiator Corporation and several unionized fabricators. The strike idled over fifteen thousand steelworkers and about twelve hundred miners at Johnstown. A brief walkout on January 12 became a prelude to the strike proper, which began on January 21, lasted twenty-seven days and ended when everyone agreed to a government proposal for an 18½-cent hourly raise.[169]

The steel fabricators in Johnstown feared that the wage hikes plus the rising cost of nonfabricated steel meant higher costs for them. Since their product prices were still regulated by the Office of Price Administration (OPA) and fearing a cost squeeze might ruin them, local fabricators refused to ratify the agreement. Prompted by OPA assurances that price hikes for their products would be approved, the fabricator wage settlement was reached in late March.[170]

The nation's coal industry underwent a strike that began on April 1 and continued until May 29. Mines were again seized by the U.S. government, and federal officials negotiated a daily wage increase of $1.35 per miner with the UMW. More important, the concept of a royalty, a nickel on every ton of union coal for the UMW Welfare and Retirement Fund, was established.

With the mines no longer under government seizure, John L. Lewis began reasoning that no legal contract was in place and new negotiations were needed with coal operators. This led to a second nationwide coal strike in 1946. Although it was well known that the miners were opposed

to the second strike, they obeyed Lewis. The stoppage began on November 20 and continued for seventeen more days. Coal stockpiles were so low from the first strike, Johnstown steel mills had to close again. Davis Brake Beam downsized its sixty-member workforce to twelve. Serious cutbacks were implemented at both refractory plants.[171]

Bethlehem Steel Corporation's Postwar Plans

In 1941 Bethlehem had formally changed the name of its Cambria Steel subsidiary to "the Johnstown Works of the Bethlehem Steel Corporation." In December 1945, Eugene Grace, company president since 1913 and sixty-nine years old, resigned the presidency but continued as board chairman. His replacement by Arthur Homer brought no corporate redirection. Grace's philosophy—build, expand and modernize—remained in effect.[172]

Bethlehem had been planning an ambitious postwar modernization. When Arthur Homer and his five top aides visited Johnstown for an April 1946 inspection, its officials were assessing capital project placement in the corporate scheme of things.

About two weeks later, the corporation announced a major capital program to cost $134 million. The Johnstown Works would eventually receive over $8 million in improvements to include new electric generation and gas cleaning equipment. Improvements to the wheel plant would cost $4 million.[173]

Ralph Hough

From some points of view one might label the wartime and postwar period in Johnstown as "The Days of Ralph Hough," reflecting the ever-present, crusty, crude, foul-mouthed general manager of Bethlehem's Johnstown Works from October 1939 until his retirement in early January 1952. Hough would show up in the mills often late at night or at times when least expected. Whenever anything seemed amiss, he blamed the supervisor and not the workingmen, who generally liked him.

An often-told story was that Hough once complained of some windows being dirty at the Gautier Works. After being assured they would be cleaned, he left. When he saw them later, they still seemed dirty. Hough took a tool, smashed them and announced, "They'll be clean now."

Employment

While wartime conditions had caused a tight labor situation, the peacetime economy created confusing currents and crosscurrents in employment. Earlier trends furnished no basis for comparison because everything was different. Veterans were discharged in droves, while men were still enlisting and being drafted. Many had delayed retirement until after the war when their departures opened jobs for others. An inordinate number of people attending colleges or schools were not seeking work.

Almost half the estimated 43,000 servicemen from the four-county district around Johnstown had been discharged by late 1945. In January 1946, a peak number of veterans—2,903—applied for work at the local employment office. By November new applicants had dropped to 299.

This photograph, taken in late October 1942, shows Prospect Homes nearing completion. Johnstown had a severe housing shortage during World War II. These 111 housing units, plus another 100 units in Oakhurst, were completed, although most nondefense construction activity was halted until the end of the war. *Courtesy Johnstown Area Heritage Association.*

In April 1946, the highest monthly backlog of veterans seeking work, approximately 7,000, was noted. The figure was heightened by the late winter steel strike and the coal strike then underway. By November, the backlog had eased down to 4,081.[174]

II. HOUSING

Johnstown's decades-old housing problems had reached crisis proportions during the war. From 1942 through 1945, aside from public housing, only twenty-two new homes were constructed within the city proper, sixteen having been started before Pearl Harbor.

In the spring of 1945, having successfully attracted several new defense-related industries to the city, the chamber of commerce sought to find homes for their management personnel. Conspicuous advertisements seeking suitable housing were placed in local newspapers, but there were no responses. Vacancies did not exist. Families were still doubling up.[175]

Wartime rent control continued even beyond June 1947, when it was supposedly eased by the new U.S. Rent Control Act of 1947.

Rent control had been intended to prevent runaway inflation in housing during the war, but the program precipitated secondary ill effects. There were black market situations where renters would do countless favors and make side payments to keep their landlords happy. Appeals to the rent control hearing board were ongoing.

Material and labor shortages plus tight wartime rent control had led to little maintenance. Overcrowding and postponed upkeep contributed to housing stock deterioration. Even after

building materials and labor were available in the postwar years, controls on rent deterred investment in rental housing.[176]

Johnstown's public housing units, 111 in Prospect and another 100 in Oakhurst Homes, were intended for low-income families. Wartime regulations, however, had mandated unit availability for military needs—housing for war industry and service personnel families.

With the war over, W.H. Burkhard, the Johnstown Housing Authority executive director, was faced with a new mandate—housing eligible veterans. Since all units were occupied, obeying the directive would have meant evicting families when there was no other housing.

Meanwhile the housing authority had already submitted an application to the U.S. Public Housing Authority for $10.5 million to finance a program of 1,686 units. The request was rejected. The national public housing program was severely underfunded until 1949.

Veterans' Housing

All over the nation, returning veterans were experiencing housing shortages. Vacant homes and apartments were often unavailable. The Truman Administration experimented in 1946 with a Veterans' Emergency Housing Program. Its purpose was quickly to create 2.7 million dwellings for veterans and their families. In exchange for ground rent, local governments were to furnish and grade the sites and provide streets and sewer connections for factory-made units.

Even before the program was approved by Congress, Johnstown officials were informed that the city would be allotted 150 units, three-quarters of the 200 requested by the housing authority. Each unit had to be occupied within fifty days following the unassembled components' arrival.

Mayor Arthur Schwing and his council quickly put together a list of all the suitable properties either owned or readily obtainable by the city and immediately scheduled a tour to view them. The mayor and council were stuck to an issue they could neither politicize nor delay. A program failure or blunder would have been politically disasterous.[177]

Although the Johnstown Housing Authority was the lead agency, the city council remained active in the program that encountered difficulties and controversy. Rather than locate the very sites to be proposed, the council submitted for approval every conceivable place available, nine locations in all, hoping federal officials would reject several of them and simplify their decisions. The ploy failed. All nine locations were quickly approved, forcing the council to act.

By the end of 1946 the program was nearing completion. There were twelve homes placed in Coopersdale on Bressler Court near the river. Another forty-four were located at Berkeley Hills on city-owned property near the golf course. The largest site, ninety-three units, was in Walnut Grove at Emmerling Park and an adjacent Widmann tract, two sites that would later house the Solomon Homes Public Housing Project. A nightmare to administer locally and nationally, the program was discontinued in 1947.

Private Housing Initiatives

In March 1946, the Cambria County Board of Realtors undertook a survey to document statistically what everyone knew to be true—the unmistakable housing shortage. Of nine thousand

questionnaires distributed, about six thousand were filled in and returned. The survey was limited to the city. The survey revealed there were only twenty-six vacant rooms to rent. Owners of only twenty-one dwellings indicated a willingness to convert their homes into apartments. The survey also revealed that one family had moved into a chicken coop.[178]

The demand for housing coupled with general prosperity and a new Veterans' Administration mortgage program promoted private home construction.

Within the city itself, only 223 new residences had been built over the sixteen-year period that began with the Depression in 1930 and had ended in late December 1945. From 1946 through 1950, 269 new homes were built in the city alone, excluding the veterans' housing program.

In Westmont Borough, sixty permits for new dwellings were issued in 1946. In Geistown Borough, there were forty-one, and in Southmont there were another fourteen. Similar numbers of new buildings would be found in the other suburban municipalities, many of which had no building permit requirement.[179]

This pace of new home construction continued. In late 1953, the *Tribune-Democrat* undertook a survey: More than three thousand private dwellings had been built between 1948 and 1952. Westmont had averaged eighty-five per year; Johnstown City, fifty-five; Geistown, sixty; and Southmont had averaged forty. The newspaper also estimated that Upper Yoder and Lower Yoder Townships had each gained a total of four hundred new homes, about eighty per year. Richland and Stonycreek Townships were each averaging fifty-five.[180]

Land Subdivision

The pace of land subdivision also rekindled after the war. In December 1945, the Bethlehem Steel Company sold a 440-acre tract located in both Westmont and Lower Yoder Township to a trio of developers: Stephen Siciliano, proprietor of the Penn Real Estate Company; George Minno, secretary of the Cambria Building and Loan Association; and Ralph Willett, a contractor. The tract, west of the Sunnehanna Country Club, included the earlier Johnstown Municipal Airport. Except for being divided by Edwards Terrace Road (today's Goucher Street), the acreage was all in one piece. The developers planned homes for middle- to upper-income families and a small shopping center facing Goucher Street.[181]

III. PUBLIC AFFAIRS

Johnstown City Government

Mayor John Conway's term from early 1940 through 1943 had covered the military buildup period and about half of the war itself. Although personally popular, Conway had no background in local government. From the fading Depression into the war era, there was little he and his council could accomplish. Conway pushed the new airport in Richland Township and had a major role in launching public housing. In terms of a legacy there was little else. When his term ended, the city was carrying about $22,800 more in unpaid bills than cash.

In January 1943, the chamber of commerce had protested the city's recent 1½-mill tax increase. It also recommended a vigorous effort to collect delinquent taxes from prior years. The

council then ordered City Treasurer Arthur Schwing (a Republican) to institute a vigorous effort to collect unpaid taxes from the years 1936 through 1941.

Schwing refused. The council next instituted a successful mandamus action against him. The court order was worded to force the city treasurer to collect the back taxes. Schwing retained John Saylor, former city solicitor, to rescind the mandamus. The court, however, upheld it and Schwing had to institute collection.[182]

Schwing became something of an anti-establishment hero, protecting the downtrodden by refusing to press them for back taxes. He became a candidate for mayor, beat ex-Mayor Daniel Shields in the primary and even defeated Hiram Andrews, the Democratic candidate, in November of 1943.[183]

Old Mother Hubbard

After Schwing took the oath of office, he delivered a short speech describing Johnstown's finances:

> *Old Mother Hubbard went to the cupboard to fetch her poor doggie a bone.*
> *When she got there, the cupboard was bare, and then her poor doggie had none.*[184]

Arthur Schwing was quiet, unforceful, honest and deferentially polite. If Schwing had attended a public event, other attendees might later wonder if he had been there at all. Although his contemporaries had their faults, Schwing rarely had anything bad to say about anyone.

For various reasons the city's fiscal posture improved somewhat in 1944, a fortune traceable to the tax collection effort, general wartime affluence plus spending and wage restrictions. At the end of 1944, the city had its first net surplus in six years. After absorbing prior years' deficit accumulations, the Johnstown general fund carried about $52,000 more cash than unpaid bills into 1945.[185]

Except for completing the airport and the sudden and unanticipated veterans' housing program, nothing of consequence was accomplished during Arthur Schwing's term (1944–47). Like John Conway, he left no significant legacy.

An Ever So Slow Transformation: City Government Decline

During the general period encompassing the Depression, war and early postwar years, a gradual transformation was occurring in the Johnstown city government's basic approach to things. Like its languishing suburban neighbors, the city was becoming a caretaker, service provider municipality rather than a dynamic force for defining and addressing community needs and problems. Increasingly poor and less likely to choose dynamic leaders, the drift gravitated toward providing limited services and a general habit of avoiding major civic pursuits.

The 1917–18 comprehensive plan had bristled with key proposals and big thinking. Although some of the ideas were quixotic, the plan was visionary and some of it was implemented. Up through both of Louis Franke's two terms and even into Joe Cauffiel's final two years of scandal, city leaders were undertaking important ventures, including the Iron Street abandonment and the concomitant Hillside (Roosevelt) Boulevard project, Point Stadium, the Public Safety

Building, the acquisition of Roxbury Park, the airport program and so forth. The Johnstown School Board had built two major junior high schools and Central High School, and had launched school reform initiatives, including the start of what evolved into the University of Pittsburgh at Johnstown.

From the Depression onward things had become different in subtle ways. Johnstown's wealthy and more influential citizens had continued their migration into Southmont, Westmont, Upper Yoder Township and other suburban localities. On average, those left behind were less educated and not as affluent. They were not as concerned about the long-range development of the true sociological city as their predecessors had been a generation earlier. Their vision stopped at the city-limits lines.

Johnstown would clean and maintain the streets, furnish fire protection, police the city, pay the streetlighting bill, get rid of garbage and so forth. Addressing the overreaching community concerns had become the stuff of dreamers, editorial writers, visiting lecturers and greedy suburbanites with "hidden agendas."

In addition, since the focus of the city government was becoming more confined to routine services, less public money was available for capital projects. Like many other cities, Johnstown began looking to the state and federal government for capital financing.

The Channel Works Flood Control Project had been done by the U.S. Army Corps of Engineers and paid for almost entirely with federal money. The 1938–43 sanitary sewer installation work was undertaken largely by the WPA. The work to improve Stackhouse Park was accomplished by the CCC. The focus of the city government in capital project achievement was becoming one of getting other levels of government to pay for things previously financed and implemented by the municipal government. Barring outside money, major projects would rarely be done at all.

The total sewerage system project, for example, had been estimated to have been about 95 percent finished when halted during the war. Nothing in the way of significant sewer work, including the sewage treatment plant, continued until over a decade after the war. The city's posture had changed. Someone else had to foot the bill.

Public Governmental Authorities

Included in this general municipal disintegration in Johnstown was a movement toward public authorities. They are sub-units of a local government or two or more local governments. Authorities are established pursuant to state law. They must also heed any federal statutes and regulations applicable to whatever program the authority is administering. Each authority is governed by a board or commission with staggered terms. Once appointed, the authority often operates outside the control and management of the local government. Only rarely can a board member be fired. As time passes, their members and staff often associate with similar authorities throughout the state, lobby for added powers and evolve into independent fiefdoms controlled by business or political interests with their own agendas.

The Johnstown Housing Authority was established in 1940 to meet federal and state requirements necessary to undertake public housing. The Johnstown Redevelopment Authority was formed in July 1949 in keeping with another state law designed largely to allow Pennsylvania local governments to participate in the then-emerging urban renewal program. The Johnstown

City–Cambria County Airport Authority was created between March and June 1950 to broaden the support level of the airport so as not to be a burden on the city alone inasmuch as the airport served a much broader area than Johnstown City.[186]

In October 1950, the city established yet another authority, a five-member parking authority to acquire, build and manage parking facilities in downtown. Two of the original five members were residents of Westmont.[187]

The Johnstown Municipal Authority

The earliest of these still existing municipal authority laws was the Municipal Authorities Act (Act 191 of 1935), a broadly conceived statute designed to allow one or more municipalities to create and appoint authorities to undertake all sorts of projects and finance them with revenue bonds (bonds financed by fees and user charges, supposedly not taxes). Most important, a municipal authority had the power of eminent domain—condemnation of private property. In 1939 the law was amended through Act 85 to add the words "waterworks, water-supply works, and water-distribution systems" to the scope of eligible projects. When Act 85 of 1939 (the waterworks addendum) was enacted, Bethlehem Steel's lobbyist in Harrisburg was either "asleep" or had been otherwise unable to keep the bill from becoming law.

The creation of the Johnstown Municipal Authority offers a brief case history of the maneuvering that goes on, ostensibly in the cause of some public good, but actually in pursuit of mysterious agendas.

In October 1942, the *Johnstown Tribune* had begun to write once again about an old subject. The newspaper had learned that the Johnstown Water Company—a majority of its stock was owned or controlled by the Bethlehem Steel Company—was for sale. Who planted the news was not known. Quite suddenly, it was revealed that the city council had engaged two investment houses—Stifel, Nicholas and Company from Chicago and H.K. Hastings from Wheeling, West Virginia. The companies were talking bond issue for funding either purchase or condemnation of the water company.

A month later, Joseph Siciliano, a real estate broker and developer, resigned from the Johnstown Housing Authority he was chairing "because of the press of other business." A week later, Siciliano, a Democrat, was named by Mayor John Conway to the board of the municipal authority being formed. Siciliano also became its chairman.[188]

Given the developments in Johnstown in 1942 concerning the water company, corrective measures were fashioned. In early 1943, a bill was drafted and introduced mandating that whenever any utility subject to the regulatory cognizance of the Pennsylvania Public Utility Commission (PUC) was to be acquired by a municipal authority, approval of the PUC was first required. The bill became law in May 1943. Once again Bethlehem Steel controlled the situation, and the issue of Johnstown Water Company acquisition faded away for fifteen years.[189]

Carnival Atmosphere

The councils were typically split, and the independently elected officials sometimes became clown-like stock performers in a *commedia dell'arte*. The city's controller, Earl Mearkle, assumed

the role of the fighting watchdog. In late 1942, he got into a city hall fistfight with Councilman Vince Hartnett that led to Mearkle's conviction. On one occasion he argued with the council for one hour over a twenty-dollar expenditure. Mearkle often held up payrolls and once refused to certify the year-end financial statement. Council had to force its publication by court order. An obstructionist, Mearkle was repeatedly reelected.

Apart from seemingly comic acts in a public circus, the city was accomplishing little during the immediate postwar years, a potentially important period in its history.

Mayor W.E. "Ned" Rose

The 1947 election afforded Johnstown an opportunity to redeem itself with badly needed new leadership. Arthur Schwing did not seek reelection. Representative Walter E. "Ned" Rose Jr. decided to run as a Republican for mayor, a decision he had made while serving his fourth term in the Pennsylvania Legislature. Whatever the issues, Rose beat Eddie McCloskey by roughly 8,200 to 7,350. Dan Shields, a Republican running as a candidate for the Taxpayer's Party, finished third.

Rose was "old Johnstown." His grandfather, W.J. Rose, had founded a once prosperous construction and building supply firm. W. Horace Rose, the city's first mayor and a leading lawyer a generation earlier, was Ned Rose's great-uncle (W.J. Rose's brother). Ned Rose was also a first cousin once removed of Percy Allen Rose, Johnstown's leading lawyer between the wars. Rosedale Borough had been named for Ned Rose's great-grandfather who had settled there about one hundred years earlier. The Roses were as "old Johnstown" as the Swanks, the Lintons, the Suppeses, the Walters, the Haws or anyone else.

Ned Rose had a BS in commerce from the University of Pennsylvania's Wharton School and a degree from its law school, among the best schools of their kind in the nation. In 1938 at the age of twenty-six, he was elected to the Pennsylvania Legislature and was reelected in 1940, 1942 and again in 1946 after wartime service as a navy lieutenant.

Rose also possessed about as sharp a mind as anyone who had ever lived in Johnstown. He had scored so highly on an intelligence test administered by the navy, those responsible for the test took steps to verify there had been no cheating. In addition to his family pedigree, sharp mind, experience in Harrisburg and excellent education, Rose was personally charming and good-looking.

Unhappily, Rose had a serious problem—he was an alcoholic, a fact that was widely known. Rose's alcoholism was never discussed in the Johnstown newspapers, probably a reflection of Walter Krebs's policy to advocate for Johnstown, but it probably went further. There existed an undefined, never discussed aristocratic rank order in certain Johnstown circles. Here the Roses equaled or outranked the Krebs. For this reason perhaps, Ned Rose's drinking, widely bemoaned, never was mentioned by the fourth estate.

While in the legislature, Rose had twice introduced a bill to amend the Third Class City Code to allow optional "charters." Had it been enacted, citizen voters could authorize forms of government other than the then-mandatory, widely maligned Commission Plan of Municipal Government. Rose's bill, however, did not become law during his terms.[190]

The Financial Crisis and the Income Tax

As the 1947 calendar and fiscal year came to a close, city officials had been struggling to balance the 1948 budget. Whatever modest surpluses had formed in 1944 were gone by 1947.

Mayor-Elect Rose proposed a 1 percent income tax to be paid both by all city residents regardless of where they worked and by nonresidents who worked inside the city limits. The measure was enacted and took effect in March 1948.

While controversial, Rose openly advocated and defended the tax. He pointed out the need to pay off the city's debt, not add to it year by year. Many nonresidents who worked in the city were outraged, charging "taxation without representation." The only way to escape paying it to the city was for one's own borough or township to levy the same tax.

Defending the earned income tax as fair, just, legal and needed, Johnstown newspapers editorialized that suburban residents owed the city for municipal services they received and facilities they used.[191]

Ned Rose was affiliated with the Gleason faction of the Republican Party in Cambria County. During his first two terms as mayor, he also maintained a law office. Reelected in 1951 and 1955, Rose was mayor from early 1948 throughout all of 1959.

Mayor Rose spent most of his workday mornings at city hall. At noon he often withdrew to one of Johnstown's clubs where he ate lunch, socialized, drank and played pinochle throughout the afternoon. Johnstowners still recall his appearing on radio and television intoxicated. He nonetheless understood problems and proposed constructive workable solutions.

In 1960, Ned Rose secured a position as an attorney for the State Highway Department in Harrisburg. In early February 1969, a fire was started inside his Harrisburg apartment while he was presumably intoxicated. Rose was killed, ending a tragic but promising life.[192]

Postwar Public Education

The 1945–46 school year started with 9,300 pupils about three weeks after the war ended. The district began losing around 200 pupils per year until 1952–53 when the enrollment started rising by about 100 pupils per year, increases reflecting the baby boom birthrate spurt after the war.

The school plant, built to accommodate the enrollments of the late 1920s, required neither space additions nor new buildings. Many of the school facilities, however, were aging and becoming shabby.

Johnstown School District Enrollment[193]
1944–45 through 1953–54

Year	Total District without Kindergarten	Junior and Senior High School
1944–45	9,625	4,979
1945–46	9,313	4,517
1946–47	9,206	4,470
1947–48	9,054	4,227
1948–49	8,913	3,993

Year	Total District without Kindergarten	Junior and Senior High School
1949–50	8,892	4,015
1950–51	8,692	3,980
1951–52	8,229	3,640
1952–53	8,330	3,626
1953–54	8,426	3,643

Politics in School Affairs

In April 1946, the Johnstown City School Board named Dr. Roy Wiley as its new superintendent. Wiley was the first outsider since Dr. Samuel Slawson was chosen in 1922. Wiley was a true professional who fit the mold of those running the school board; the Republican Herbert Stockton, a no-nonsense, professional educator, was school board president. Other leaders were H.H. Darr and Emil Schwing. During some of the war, Herbert Stockton, a school board member without interruption since 1926 and an anti-Gleason Republican, chaired the Cambria County Republican Party.

In the 1947 era, when the Gleasons were regaining control of the Republican Party, several Gleason-faction Republicans were elected to the school board. Dr. Lynn Porch, the city physician, became the board president. Stockton, assigned to an unimportant committee, protested what was happening.[194]

Stockton soon began making charges that politics was infecting public education in Johnstown. The *Johnstown Tribune*, a virulently anti-Gleason newspaper, diligently reported the accusations. After serving for twenty-four years, Stockton was defeated in the 1949 Republican Primary, a victim of the Gleasons. The Republicans, however, lost in the November general election that followed, a defeat masterminded by John Torquato and his team of Democrats.

In early 1951, Dr. Roy Wiley encountered a movement by a school board majority to make a number of teacher assignments. In protest he submitted his resignation. Editorial support for Wiley reflected a grass-roots opposition to the developments. The school board backed down. Wiley remained but died in December 1953.[195]

The War Memorial Arena

The War Memorial of Greater Johnstown, Inc., established in March 1943 after a Lions Club meeting, was founded to provide a memorial for the servicemen and women from Johnstown then lost in the war. It began as a confederation of about sixty organizations. Hubert Horne, proprietor of an office supply firm, was the first president. After entering the navy, he was succeeded by Howard Stull, a well-known lawyer and ex-congressman. The beginning board had twenty-seven members.

Even before V-J Day, the organization had decided to bring forth a needed and functional facility rather than a monument with names and verses carved into it. The leading idea was a war memorial arena—a multipurpose sports and exhibition hall located downtown.[196]

By March 1946, the group had chosen a site at Union and Vine Streets. It included the Union Street School and about ten nearby houses. School board members were reportedly in favor

of the location and were said to have promised full cooperation. A Johnstown architect, H.M. Rogers, developed a drawing of the building estimated to cost $500,000.

War Memorial of Greater Johnstown, Inc., was renamed Cambria County War Memorial, Inc., expanding the area of focus and financial support. By August 1946, one year after the war, a fund drive to generate $750,000 was planned. The solicitation began officially in April 1947, but by late March the advanced gifts effort had already raised $281,200, thanks to Bethlehem Steel's $100,000 and Glosser Brothers's $30,000 gifts. The $750,000 target was increased to $1 million, a new goal that reflected both inflationary cost increases and confidence that the money would be obtained. By the end of the solicitation drive, pledges had totaled $754,000. Reaching the newer goal of $1 million was postponed for later.

By September 1948, the earlier zeal for a war memorial arena was waning. Of the $777,000 pledged, less than $600,000 had been collected. The organization had acquired several residential properties but encountered a major impediment when the Johnstown School Board insisted on receiving $75,000 for the Union Street School. There had been earlier hopes and promises the school would cost little to nothing. While antiquated, it still had two hundred pupils.

Faced with mounting real estate costs in a time of inflation, the property committee—Charles Kunkle Jr., Howard Picking Jr. and M.C. Williams—explored a major concept change, a new location. On November 23, 1948, they appeared before the city council seeking Union Park, a legacy from Joseph Johns's original village plan. Union Park contained several monuments and was said to have been used as a cemetery. It also housed the city's equipment garage, for which the war memorial group agreed to pay $50,000. The Union Park location would provide a bigger and better site and would avoid acquiring homes and a school building.[197]

Should the city give its approval, the change in park usage also required a favorable ruling by the Cambria County Court of Appeals. Mayor W.E. Rose and the council were supportive, and on February 11, 1949, the court approved the request. Any graves found would have to be "removed in a fitting manner and decently and reverently transferred at the city's expense."

Charles Kunkle Jr., chairman of the property committee, became president of the corporation. Having overcome the many site obstacles, the effort continued facing one difficulty after another. Costs were rising and some of the financial pledges were not paid.

The officers and board made a difficult decision—to go forward with construction although the funding was not entirely in hand. Funds would be sought through a second solicitation with a goal of $200,000. The remainder would be obtained by selling revenue bonds through a public authority.

A groundbreaking took place on October 31, 1949. The goal was to have the building finished and opened as part of the Johnstown Sesquicentennial Celebration planned for 1950. The Berkebile Construction Company was the lead contractor.

In February 1950, a second fund drive seeking to raise $200,000 was launched. The new goal proved very difficult to achieve but was helped by the city council's forgiving the $50,000 owed the city for its garage.

A final $700,000 had to be borrowed from investment bankers. The loan was supported by a feasibility study done by Ebasco Services, a New York consulting firm. Ebasco's analysis stated that the arena would gross $500,000 per year after five years in operation.

Although there were numerous small work items to be done, the opening event was a well-attended Ice Capades show held on October 16, 1950. The building was not turned over by the contractor until January 1951.

The early operation of the War Memorial Arena brought on a chain of recurring problems. The first manager, supposedly an experienced professional, was a disappointment. Lawsuits were threatened to collect about $100,000 in unpaid pledges. By May 31, 1951, the end of the arena's first fiscal year, $85,000 of the $988,000 in total pledges had not been received. There was also an operating loss of $1,000.

By May 31, 1952, at the end of the second fiscal year, the arena had a cumulative loss of $53,677. At the end of 1953, the arena had $39,000 in unpaid bills but only $2,000 in cash with no mention of debt service or depreciation. Creditors were patiently hoping to be paid. Routine costs had been higher than expected and big-time events such as admission fee basketball games had not materialized.[198]

Early Postwar Politics: John Torquato and the Gleasons

John Torquato was born in Windber in 1908, son of a highway contractor who was a Republican. A star high school athlete and a popular campus leader at St. Francis College, Torquato quickly gravitated to politics, which became a lifelong obsession. His cousin, George Arcurio Jr., observed, "All John ever thought about was politics. He lived politics all the time, every day." Charismatic, forceful and usually friendly, Torquato had become a Democratic precinct worker in Johnstown in 1928, before he was old enough to vote. In 1934, when only twenty-six, Governor George Earle named him secretary of the Pennsylvania Workers' Compensation Board.

After Arthur James, a Republican, became governor, Torquato went to work for State Treasurer Harold Wagner and later for Ramsey Black, both Democrats. In time Torquato was serving as assistant director of the Treasury Department's Bureau of Investigation. In June 1942, Torquato was chosen chairman of the Cambria County Democratic Party, a position he held for thirty-six years.

When Torquato assumed the chairmanship, registered Republicans outnumbered Democrats by a close margin—43,480 to 42,600. After his first two years as county chairman, Democrats exceeded Republicans 44,133 to 43,748. The gap in favor of the Democrats would grow wider. Innovative voter registration methods plus rigorous precinct organization were features of the Torquato technique.

Torquato maintained strict party discipline and organization. On election days, his workers knew what to do. Torquato, the boss, was not known for participatory democracy.

After two terms of two years each, Torquato was challenged head-on by State Senator John Haluska. While there were charges and counter charges, Torquato won the contest and remained county chairman.[199]

In the Truman-Dewey race in 1948, Truman carried Cambria County 41,533 to 27,725. Four years later when Eisenhower had won big in Pennsylvania over Adlai Stevenson (by 2,416,000 to 2,146,000), Stevenson had carried Cambria County by more than 10,000 votes, an anomaly best explained by Torquato's party organization.

Torquato's power had first begun to manifest itself in the 1947 county and city elections. The Democrats swept the county offices, and Walter Rose, the Republican mayor elected at that time, had a politically fragmented council with which to work.

Some political bosses immerse themselves in day-to-day government operations, knocking heads to get things done. From all indications John Torquato did not get involved in government management other than to arrange jobs for party loyalists or other people he sought to help. He might settle a dispute between two Democrats, but he avoided micromanaging public officials he had helped to elect.

John Torquato was nearly the same age as Andrew Gleason, Gus Gleason's oldest son. When Gus Gleason had died in 1940, the Republican Party became unglued. Various people had been assuming leadership positions in the party—Walter Suppes, J.J. Sheehan from Patton, Harry Engelhart from Ebensburg, Herbert Stockton and others. During the war both Andrew and Robert Gleason, Gus Gleason's two sons interested in politics, were away on military duty. It was also during this time that Torquato's aggressive voter registration efforts were producing numerical advantages of Democrats over Republicans.

By 1947, Andrew Gleason, an army veteran and Johnstown attorney, was asserting new GOP leadership. "There is no place for machine politics," he told the Dale-Oakland Young Republicans who were meeting in October jointly with the Women's Progressive Republican Council of Dale. The meeting was chaired by the president of the Dale-Oakland Young Republicans, Frank Pasquerilla, only twenty-one years old.[200]

Whatever the effort and degree of discipline, the Republicans lost big time in Cambria County in the 1947 general election. Democrats captured control of the county commission. Samuel Di Francesco, a Democrat, was elected district attorney. Democrats won most of the "row offices." The only Republican success was Ned Rose's election as Johnstown mayor.[201]

By the April primary in 1948, there was a major battle for control of the Republican County Committee (whose members are elected) and the party chairmanship (chosen by the committee), a battle between the Gleason and the anti-Gleason factions. J.J. Sheehan of Patton was a leader of the anti-Gleason group, while George Edkins Jr. of Johnstown was the Gleasons' man. On June 12, the Gleasons won decisively. Edkins was named county chairman.

The Gleasons were generally aligned with the more liberal factions in Pennsylvania Republican politics. There had been long-standing opposition in Johnstown to the Gleasons, generally from old Johnstown, more conservative circles that had included Stephens Mayer, Marlin Stephens, Walter Suppes and educational reformer Herbert Stockton. Walter Krebs, the *Tribune*'s publisher, repeatedly printed anti-Gleason rhetoric stating that Gleasonism was ruthless bossism.

One of the news items that appeared in connection with the 1948 intraparty fight was based on an interview with Gerald Sherry, a Republican committeeman from Carrolltown. He lamented, "Mr. Gleason [Andrew J.] threatened to ruin me in my business as a contractor. He first tried to persuade me…that I had picked the wrong candidate…He went so far as to say that he has the power to see that I wouldn't build anything anymore."

Andrew Gleason denied having used abusive, roughshod tactics. "The Republican Party around here has always been a 'we organization,'" he stated.[202]

In October 1949, William Burkhard, executive director of the Johnstown Public Housing Authority, died. Soon afterward George Edkins, the county GOP chairman, was named to replace him. Gleason-faction Republicans controlled the housing authority in Johnstown.

When Edkins resigned the county chairmanship to assume the authority position, Robert Gleason, an insurance broker and the party's vice-chairman, stepped up to the chairmanship.

In November 1948, John Torquato's disciplined precinct-by-precinct organization delivered another Democratic sweep. Not only had Truman beaten Dewey in Cambria County by a three to two margin; but a newcomer, Colonel Robert Coffey, a World War II veteran pilot and hero from Upper Yoder Township just outside Johnstown, defeated the incumbent congressman, Harve Tibbott, an Ebensburg Republican. Coffey's sixteen-thousand-vote lead in Cambria County had more than offset his poorer showing in Armstrong and Indiana Counties.

Coffey's victory was brief. After a few weeks in Congress, he was killed in an F-80 crash while on reserve training. There would be a special election in September to fill the vacancy.

A decision was made to nominate Colonel Coffey's mother to run for her late son's seat. John Saylor, a popular attorney and ex-city solicitor, became the Republican candidate and won the race by roughly 59,400 to 51,000. Mrs. Coffey, not a skillful campaigner, had carried Cambria County.[203]

Beginning in 1948 until 1960, the Democrats generally were dominant in the county government, and Republicans tended to rule in the city, a sweeping generalization with exceptions and factions. Workers typically were expected to fork over 2 percent of their wages to pay for party costs. Those who refused were not promoted, and if they made work performance mistakes, they risked dismissal.[204]

Torquato had a tight organization. Designated workers were responsible for making sure every Democrat voted. If a precinct did not deliver an estimated vote count for every issue or candidate, Torquato knew something was wrong and he fixed it. Every party position was filled. Nothing was left to chance.

The Gleasons did not have a detailed organization that was regimented and disciplined. Andrew Gleason, a behind-the-scenes boss, was not the official party chairman. The Gleasons had friends that were loyal. Family members had contacts with high Republican officials throughout Pennsylvania and in Washington. This became evident in March 1952, a few months before the Republican National Convention that chose the Eisenhower-Nixon ticket. Andrew Gleason was fêted at a dinner at Gallitzin. Senator James Duff led a huge delegation of bigwigs from Washington, Harrisburg and all parts of Pennsylvania. About two thousand people attended, including some prominent Democrats.[205]

John Torquato and Andrew Gleason were good friends. They knew one another during the early Depression when Torquato had been working with his family's road construction business and Gleason was working for the state highway department. In 1950 the Nehi Bottling Company in Lorain Borough was sold to several local residents. The company's new president was Andrew Gleason, and its vice-president was John Torquato.[206]

Postwar Highway Developments: "The Easy Grade Bottleneck"

In 1936 two county commissioners, John Thomas and Frank Hollern, began crusading for a new highway between the city and Westmont. The plan was to extend Grant Street past the Chapin Arch entrance to Grandview Cemetery, cut and fill in for a new roadway to pass near

the former Bethlehem Management Club and tie the new highway into the Mill Creek Road (Menoher Highway in 2006) below its intersection with Diamond Boulevard. By following a careful alignment, the new route would have a maximum grade of 5 percent. The proposed road was called "the Easy Grade"—a name of contrast considering other Westmont approaches from the city.[207]

There was support from the Pennsylvania Department of Highways and favorable reception by the U.S. Bureau of Public Roads. The route was added to the federal aid system in July 1939 as an extension of the Menoher Highway connecting Johnstown to Ligonier.

The major landowner was the Bethlehem Steel Corporation, which backed the project. The new road caused access problems for Grandview Cemetery, but its management cooperated by providing an entrance from Mill Creek Road.

Work began early in the spring of 1940. By June the project was plagued by landslides and massive stones rolling down into Barnett and Franklin Streets.[208]

As soon as the Easy Grade was opened to traffic in July 1941, a serious traffic jam developed at the intersection of Grant Street (modern Menoher Boulevard) and Haynes Street. The unforeseen bottleneck necessitated a major reworking of the traffic pattern including new connections with Haynes and Somerset Streets and with Mill Creek Road.

While postponed because of the war, it was generally understood that the "Grant Street" project would be the priority postwar highway improvement at Johnstown.

"Wild Bidding"

The first postwar road construction season, 1946, faced a serious problem all over—"wild bidding." At many bid openings there were no proposals at all and whenever bids were submitted, they typically exceeded engineering estimates by big margins. Wild bidding was reported to have been worse in Cambria County than anywhere in Pennsylvania.

The Grant Street (Menoher) extension into and beyond Haynes Street was advertised for bids several times in 1946, as was a badly needed Bridge Street-Central Avenue project in Moxham, but wild bidding caused there to be no major roadwork in and near Johnstown in 1946.[209]

By late July 1947, there were only two important projects underway—the extensive widening and general improvements to Solomon Run Road (the leading approach from most of Johnstown to the airport) and work extending and improving the alignments of Berkley Hills Road (modern Goucher Street) from Upper Ferndale to Westmont.

The high-priority Grant Street and Bridge Street–Central Avenue projects, having repeatedly been advertised for bids, finally got underway late in 1948 but were not completed until early 1949.[210]

The Windber Road: Route 56

In 1947 various groups began crusading for a more modern Windber Road (Route 56). The project was approved and construction began in 1950. Some of Bedford Street and Scalp Avenue were reconstructed, new sections with improved grades were installed and the "Geistown Cloverleaf" was built.[211]

Community Street and Highway Policy

Several years after the war, Johnstown leaders began to wake up to their needs for good roads. Newer industries were turning to trucking as an alternative to railroad dependency. The crusading advocacy of civic leaders from 1910 to 1929, having seemingly vanished during the Depression and war years, was slowly becoming rekindled.

There was no county or regional planning agency. The chamber of commerce's highway committee began assuming a civic advocacy role for Johnstown highways, an activity generally limited to business and professional people attending committee meetings, discussing highway proposals and formulating recommendations.[212]

IV. THE POSTWAR CHAMBER OF COMMERCE

The Chamber of Commerce and Its Fourteen Points

The first postwar annual dinner meeting of the Johnstown Chamber of Commerce was held on December 5, 1945. Roland Dunn, the executive secretary, reviewed the chamber's "Fourteen Point Plan of Progress," its goal-oriented work program.[213]

At the December 1946 meeting, a renewed emphasis was to be placed on "municipal consolidation," proposed as the key chamber initiative for 1947. Three months later, Roland Dunn spoke about consolidation at a meeting in Westmont attended by 192 people. Dunn gave a number of uncontested arguments for area-wide consolidation. A few people signed support petitions but the consolidation issue apparently faded away.[214]

The chamber of commerce advocated creating an airport authority and worked with Mayor Ned Rose to secure airline service in 1948.

The chamber's Industrial Development Commission had tagged a few notable successes during the war (Sylvania, Bestform, Albright Equipment Company). It had also assisted Cloyd Page in his 1948 start-up of a small mattress and box spring company following the closing of the Johnstown National Mattress Company that Page had managed for its Huntington, West Virginia, owners.

The National Radiator Humiliation

In early August of 1950, the chamber and its Industrial Development Commission lost a major battle over the relocation and modernization of a National Radiator Corporation sheet metal plant. Members of the Altoona Chamber of Commerce had learned that National was looking for a site and building. They then put together a specific proposal for a Duncansville plant, exactly what National was seeking and acceptable pricewise.

When the announcement was made that a major expansion of a leading Johnstown industry had been successfully courted by the Altoona Chamber of Commerce, Johnstown's leadership and citizens were outraged. Ransom Reeder, assistant director of District 13 of the United Steelworkers of America, charged, "The men that should have been working to keep the new plant here were asleep at the switch."

It was later shown that the chamber had been working hard to find a site to meet National Radiator's needs. After the Altoona victory announcement, correspondence unmasking the chamber's efforts was made public but it revealed that the community's industrial development team had failed to offer a suitable site. The Johnstown chamber had lost a visible contest to Altoona, a humiliating defeat. Logical explanations were a waste of time.[215]

A month later, the Johnstown Industrial Development Corporation (JIDC) was founded. The Johnstown Industrial Development Commission was disbanded, and the new corporation began to operate in January 1951—"old wine in a new bottle." Roland Dunn was the key staff person. The JIDC, a stock corporation (ten dollars per share), would purchase sites and industrial buildings for lease to suitable industrial prospects.[216]

Roland Dunn resigned as executive secretary of the chamber in October 1951. Del Roy Wurster assumed the position in March 1952.

V. POSTWAR MEDIA DEVELOPMENTS: NEWSPAPER, RADIO AND TELEVISION

After Anderson Walters's death in 1927, the Anderson Walters Trust (Walter Krebs was the principal trustee) was established following the settlement of a protracted acrimonious lawsuit between Jessie Octavia Woodruff Walters (Anderson Walters's widow) and W.W. Krebs, her nephew. The trust then owned the Johnstown Tribune Publishing Company. In 1934 the company acquired both the *Johnstown Democrat* and the remainder of the stock in WJAC, Inc., which it had begun acquiring in 1932. The three media entities—*Johnstown Tribune*, *Johnstown Democrat* and WJAC—all became fully owned subsidiaries of the Johnstown Tribune Publishing Company. The two newspapers were combined into the *Tribune-Democrat*, first published on September 8, 1952.

During the war, Krebs and John Tully, WJAC's station manager, began planning for a peacetime future—FM radio and television. In March 1945, WJAC, Inc., purchased the Bailey Building facing Lee Hospital on Main Street. Its top floor alone could provide two and a half times the studio and office space formerly used in the Tribune Building.

As soon as the FCC approved an FM license in January 1947, the station began moving into its newly modernized space. A permit to operate a television station was granted later that year.

Investing in a television station in the postwar years was risky. While everyone believed the industry would grow successfully, it was still new. There were few television sets in what was to become the WJAC-TV broadcast area, mostly owned by people already viewing a Pittsburgh station. The necessary capital investments were large and delivery of studio and transmission equipment was slow because the manufacturers were filling heavy orders from all over the nation.

WJAC constructed a 161-foot broadcast tower on Laurel Ridge above the Conemaugh Gap. The tower would serve both FM and conventional television broadcasting.

Broadcast FM began on May 22, 1948, to diffuse a stronger, clearer signal that would reach throughout Westmoreland, Indiana, Somerset and Cambria Counties and beyond. In the beginning, WJAC-FM and WJAC-AM were broadcasting identical programming.

WJAC television began broadcasting on September 15, 1949, with three hours of coverage beginning at 7:00 p.m. There were only 3,000 receiving sets in the viewing area. Four years later, there were 675,000 sets. In October 1952, WJAC-TV was allowed to boost its broadcast power and was moved from channel 13 to channel 6. By September 1951, about 170 communities in four states were receiving WJAC television.[217]

WJAC-FM and WJAC-TV both lost money in the beginning. Krebs once seriously considered selling both stations. J.C. Tully and others prevailed upon him to stay the course. In time, the stations became profitable.

The Johnstown Economy from the End of World War II to the Vietnam War

I. Postwar Churning

In April 1940, the Johnstown workforce was suffering from late Depression unemployment. From a workforce of 78,700 men and women, 14,200 (18.4 percent) were unemployed. The war caused a labor shortage. At its end, about 3,000 people (3.6 percent of the workforce) were unemployed.

For months after the war, shifting workforce data was difficult to understand in a meaningful way. The economy was changing from war to peacetime production. By mid-1947, there were some 7,000 unemployed people in a Johnstown-area workforce of 83,400—an unacceptable 8.4 percent.[218] By mid-1948, 75,300 people in a workforce of 81,600 were employed, leaving nearly 8 percent unemployed.[219]

The general mood of Johnstown's postwar leaders was upbeat and confident. The area's largest concern, Bethlehem Steel, employed over 17,000 people, including its coal, coke and railroad workers. U.S. Steel had a Johnstown workforce of 2,400.

There was also a rich assortment of steel and other metal concerns—fabrication, welding and machine shops producing such things as boilers, radiators, brake beams, machinery parts, motors, pumps and even hospital furniture. Both Hiram Swank and Haws continued producing refractory products largely for the steel industry. Together they employed some three hundred workers in postwar Johnstown. There was a large diversity of bakeries, meat processing firms, lumberyards and planing mills. The Goenner Brewery still produced a local beer.

As had been true at the beginning of the century, there remained many locally owned and locally controlled firms that did business with one another.

Apparel and Textile Products

Following such early textile apparel producers as the Johnstown Shirt Factory and the Buser Silk Corporation, Goldstein and Levin (later Cay Artley) had opened a factory in Johnstown in 1936 to produce women's dresses. As the firm grew, it became the nucleus of a significant

textile center in Johnstown. Thanks to a few local businessmen and the efforts of the chamber of commerce, Bestform Foundations of Pennsylvania was launched at Johnstown in February 1944. From a fledgling beginning with 5 employees, Bestform enlarged its workforce to 400 by 1946—an employment level that remained constant until the 1960s when the firm moved out of its Hornerstown plant into a new building in the Cambria City Urban Redevelopment Project. By 1963 Bestform had about 625 employees. A similar concern, Bali Bra, got started in Geistown in 1953 with a workforce of 200.

The Korean War

In early 1950, the unemployment rate of the Johnstown Region (Cambria and Somerset Counties combined) hovered around 10 percent. The labor force totaled 105,000.

On June 25 1950, the North Korean army invaded South Korea. By early July, American troops were fighting in Korea.

While there were tragic losses and domestic hardships, the Korean War was not as all-consuming as had been the two world wars. Men were drafted, reserve units were activated and there were local casualties, but the pace of Johnstown living continued almost as if there were no war at all. There was neither rationing nor major shortages other than housing. The educational plans of Johnstowners were interrupted only sporadically. The few civil defense drills were nonevents. Meanwhile the Johnstown economy boomed.

By September, the average unemployment rate for the first six months of 1950 had been cut in half and Johnstown was removed from the critical unemployment list, the E-list. By November 1950, the unemployment rate was 3.6 percent—exactly the same as in July 1945 before Japan surrendered. With the Korean War raging throughout 1951, the Johnstown economy was brisk and its unemployment rate remained near 3½ percent. Most of the unemployed were women.[220]

As 1952 ended, the Bethlehem Steel Corporation had almost 20,000 total employees in Cambria County including all its operations—steel, coal, coke, limestone and subsidiary railroads. The U.S. Steel Corporation's local workforce had reached more than 2,650. The two corporations were employing more than one-fifth of the area workforce.[221]

The 1951–52 Steel Strike was a national issue. Some 600,000 American steelworkers walked off their jobs in wartime, prompting Harry Truman's seizure of the industry, an action judged illegal by the U.S. Supreme Court. Lasting fifty-three days, the strike distorted upwards otherwise low unemployment figures.

In late July 1953, a cease-fire order effectively ended the Korean War. While a post-Korean War downturn was not immediate, the local unemployment rate again began to mount. By January 1954, almost 12 percent of the two-county workforce was unemployed. One year after the war, Johnstown's two-county unemployment rate hit 19.4 percent, the highest percentage for any month since the Great Depression.

The Mills Are Running: All's Right with the World

In 1950 Bethlehem's new president, Arthur Homer, had announced a multimillion dollar modernization program for its Johnstown Works.[222] By July 1953, Johnstown's Bethlehem

Works had a rated capacity of 2.2 million tons per year. The open-hearth furnaces had been modernized and were capable of producing larger ingots of better quality. The Johnstown Works were equipped with modern mold yard cranes and bigger ingot buggies. Diesel locomotives had replaced the CBL steam engines. Johnstowners were told repeatedly that the local Bethlehem plant was on a par with the best steel mills anywhere and the modernization would continue.[223]

Similar reports fueled an upbeat attitude about the U.S. Steel plant at Moxham, a plant producing steel manufacturing hardware for other U.S. Steel plants. As the corporation modernized and added new plants, many of the newer components were produced at Johnstown. The Moxham plant continued making specialty rail trackage and switches and producing hardware for the atomic weapons program. After the Korean War, its employment remained around 2,500.[224]

About the time the fighting in Korea ended, Congressman John Saylor announced that the Johnstown two-county region once again merited a "surplus labor" designation, a dubious distinction that would make it easier for local firms to get government contracts.[225]

A Time of No Importance

The several years immediately following the Korean War were comparatively slow ones in civic terms. Except for unemployment, things seemed to be in good order. Bethlehem had announced early in 1953 a major office building addition at Walnut and Locust Streets.[226] The downtown's retail merchants had not yet been challenged by shopping malls.

II. AN ECONOMIC DEVELOPMENT PROGRAM

Civic Priorities

In late March 1953, the chamber of commerce surveyed its membership to establish and prioritize goals the organization would pursue. Better traffic flow and more parking downtown led the list. The second was industrial development. Municipal consolidation ranked third. The items next faded into a timeworn agenda—more quality hotel accommodations, vocational training, the airport, better highways and tourism promotion.[227]

Industrial Development

In February 1953, two separate groups of communities in northern Cambria County had organized industrial development programs. Leaders in Patton, Barnesboro, Hastings and Carrolltown were undergoing changes in the coal industry that were eliminating jobs. Similar ailments were affecting the mainline communities of Gallitzin, Portage, Lilly and Wilmore. Young people were leaving. Suggestions for the Johnstown Chamber of Commerce's industrial development efforts to reach out and serve these scattered communities went unheeded.[228]

The chamber continued to suffer its 1950 National Radiator humiliation.[229] In early October 1953, during the "silly season" before a local election, the city council urged Mayor Ned Rose to set up a public session to address industrial development. Chamber bashing remained a political

tactic in Johnstown. Eddie McCloskey, then a councilman, revoiced his longstanding chamber disdain. After repeating that the chamber had no capacity to attract industry, he stated, "It's up to the city council to find it."[230]

A conference held on October 21 probably achieved its political posturing purposes and drew attention to the floundering Cambria City urban redevelopment effort, a project to furnish industrial sites if the controversies were overcome and its plan was accomplished.

Frank Piazza, Penelec's industrial sales manager, eloquently explained the need for sites that met the exacting requirements of modern industry. Labor representatives vowed financial and other assistance. Joseph Gorman, president of Standard Steel Services and a man soon to become a Johnstown school director and later a county commissioner, sparked a short but heated clash when he charged the chamber with having been "asleep in bringing industries here."

Piazza defended the chamber and explained, "Some of the industries that have located other places did not come to Johnstown because we did not have proper sites."

An old myth was later resuscitated. For years some Johnstown people had imputed that both the Bethlehem and U.S. Steel Corporations were sabotaging local industrial development efforts to monopolize the labor supply. Joint denials were made by both Andrew Fisher, Bethlehem's general manager, and Thomas Riley, general superintendent of U.S. Steel.

Fisher's statement described Bethlehem's industrial development program. The company was aggressively trying to attract industries that would use the steel it was producing, an outreach that sought to get such industries into the Johnstown region.

Riley stated bluntly, "U.S. Steel has never kept any industry out of any town."[231]

Walter Krebs, the session chairman who had researched what other communities were doing, announced that a revitalized industrial development program needed three things:

1. A new organization totally dedicated to industrial development.
2. A top man to devote full time to it.
3. A program focused on the trading area—Cambria and Somerset Counties.[232]

Johnstown's industrial development efforts often faced a "neither/nor" dilemma. People were supportive when the economy was soft and the need was apparent. During bad times, however, the money to finance a good program was hard to raise. In flush times, interest waned. The 1954 reawakening faded away.

Two years later in July and August of 1956, the chamber launched another effort to secure a full-time industrial development staff person. A target goal of $25,000 was almost reached. The plan was to raise a similar sum every year as an ongoing civic activity.[233]

The president of the Johnstown Chamber in 1957 was Theodore "Ted" Focke, chief executive officer of the National-U.S. Radiator Corporation. By May the chamber had renamed itself the Greater Johnstown Chamber of Commerce, signaling an intention to promote both the city and the outside area. It had also created an industrial development division. On May 22, the first full-time director was named: Edward Bilinkas, vice-president of an industrial development consulting firm in Newark, New Jersey.

Bilinkas immediately familiarized himself with a recent 1955 state initiative, the Pennsylvania Industrial Development Authority (PIDA), a low-interest revolving loan program

to finance industrial sites and buildings. Bilinkas also set about getting local governments to designate the chamber's industrial development division as their official public agency for economic development. The chamber also received a state grant of $15,400 to help pay for its work. In October 1958, Bilinkas's division created a nonprofit corporation, Diversification Incorporated, to acquire sites for lease or sale to industrial prospects.

With Ted Focke as the chamber's president, the organization took credit for the National-U.S. Radiator Research Building adjacent the new state rehabilitation center on Goucher Street built at the time.[234] Bilinkas and his industrial development division were also praised for helping local businessmen form the National Bending Corporation, a Ferndale concern using a patented machine and process to bend specialty bars. The chamber had also assisted the expansion of the Bali Bra Building at Geistown.[235]

During the gloom of 1960, Bilinkas resigned. Chamber leaders concluded he had not brought enough new industry to Johnstown.[236]

III. A NEW RESPONSE TO AN OLD CHALLENGE

Bad Times Abound

The late 1950s and early 1960s were harsh times economically around Johnstown. Unemployment remained consistently high. In July 1958, the unemployment rate was 18.8 percent and the monthly average for the entire year was 15.7 percent. In January 1959, the rate was 19.2 percent and the 1959 annual rate was 16.5 percent. In 1960 the annual average rate was 14.3 percent. The worst year in this time frame was 1961. Four months of the year featured unemployment rates above 20 percent, and the annual average rate was 18.2 percent.

The community also suffered through the 1959 Steel Strike (from July 15, 1959, until January 4, 1960), the longest in the industry's history. Being another nationwide strike, there was no bargaining in Johnstown and little "choosing up sides." Everyone wanted a settlement.

The long, deep local recession raged between 1958 and 1964. In addition to massive unemployment in the coalfields, the steel industry was weak. During the Korean War, the bi-county employment in the metallic industries alone (excluding that of steel company coal, coke, limestone and subsidiary railroads) often exceeded 20,000. During the gloom of the 1958–64 recession, the same number often dipped down to around 13,000. In both 1961 and 1962, the average employment in "metals and metals products" had dropped to 12,800. The highest number ever again reached in the same category was 17,000, a level to occur during the Vietnam War.[237]

At a time when the national population was growing, the census enumerations of Johnstown City and of both Cambria and Somerset Counties were declining. Meanwhile the urbanizing region was posting a small gain, indicating that people from the city and other parts of the two counties were moving to the Johnstown suburbs.

Population Change—Johnstown Region 1940–1960

	1940	1950	1960
Johnstown City	66,668	63,232	53,949
Greater Johnstown (city plus eighteen suburban localities)	108,461	110,180	112,641
Cambria County	213,459	209,541	202,576
Two-County Region	298,416	291,354	279,658

Challenge and Response

Johnstown community leaders understood the challenge. The community was severely distressed, located in Appalachia and suffering from long-term unemployment. The city government and its redevelopment authority by the end of Walter Rose's third term (early January 1960) seemed ineffective.

Johnstowners had also begun to feel a trace of envy toward their neighbor city to the east. The Altoona community had conducted a successful fundraising campaign using the slogan "Jobs for Joe." As early as 1957, Altoona Enterprises was boasting that since 1950, it had attracted eleven new industries that created 3,600 jobs. Meanwhile many people in Johnstown had never heard of the Johnstown Industrial Development Corporation.[238]

The chamber of commerce boasted of aiding the Bali Bra Building expansion at Geistown, but the organization really needed a major economic development coup—landing a new major industry. Such good fortune did not materialize in the 1950s and early 1960s. An explanation persisted that Johnstown lacked outstanding industrial sites.

Any thought given to an industrial park was premature. The Johnstown Industrial Development Corporation had almost no money. Indeed W.W. Krebs and others had personally guaranteed some of the mortgage debt to facilitate the Bali Bra Building expansion.[239]

The Fund Drive

In January 1960, the long steel strike was finally settled. Dr. George Walter, a youthful and no-nonsense sociology professor from UPJ, had become mayor. Once sworn in, he began a badly needed shake-up.[240] At the same time, John Stockton, an insurance broker and the son of Herbert Stockton (the education reformer), became president of the Johnstown Chamber of Commerce.

In February Stockton announced the chamber had developed an ambitious goal, a campaign to raise $1 million solely for industrial development. Guided by a professional fundraising firm and led by Parker Lawson, president of the United States National Bank, a number of solicitation committees were established. The campaign slogan was "This is for you."

By September, the fund drive had generated pledges of $1,088,951—well "over the top." By November 1961, the JIDC had made mortgage loans both to Page Bedding and to Bali Bra.

The Industrial Park

On October 1, 1963, the chamber announced it had purchased a 265-acre tract in Richland Township located along both Elton Road and the approved right of way for the forthcoming freeway, Route 219. The Berwind-White Coal Company had sold the land for $120,000. The purchase was made possible thanks to money from the fund drive. The site was soon provided with grading, landscaping, access roads and utilities. It had everything but railroad service. For this reason, the Johnstown Industrial Park could accommodate only light to medium industry—not steelmaking or heavy manufacture. Raw materials and finished products would be moved by truck.

In April 1965, the Friendly City Box Company became the park's first occupant. It had bought a five-acre parcel for $37,500 and soon built a 12,000-square-foot plant.

The transaction presented an irony for the industrial development program. Ostensibly the park had been justified to bring new firms into the community. In reality it was used to relocate an existing Johnstown firm from the city into a suburban community. The press announcement covered the dilemma by stating that if Friendly City Box had not been able to expand into something like the new park, it would have been forced to leave for another city.[241]

IV. King Coal's Abdication

While the total employees of the two steel corporations accounted for nearly one-fifth of the two-county workforce, the mining industry in 1950 and 1951 employed another one-fifth. The industry, however, soon took a downturn.

The 1950 and 1960 Annual Reports of the Pennsylvania Department of Mines revealed that more than 20,275 people, mostly miners, were employed in the Cambria-Somerset County coal industry in 1950. By 1960, only 6,560 were employed. In 1950 the two counties produced 12,449,000 tons. By 1960 the same counties produced 8,883,300 tons. In ten years production had been reduced by nearly 29 percent, while coal employment had fallen by more than two-thirds.

Area coal was losing out to natural gas for commercial and home heating. Railroads serving the Johnstown region had begun phasing out coal-burning locomotives in the late 1940s. By 1953, the diesel changeover was accomplished. Technological improvements in steelmaking were reducing the amount of coal needed to produce any given quantity of steel. In addition, the coke produced at Johnstown was using less local coal and more coal imported from Greene County and West Virginia, changes to satisfy new steel industry coke specifications.

The reduction in coal employment was also a result of increased mechanization, better mining machinery, more strip mining and a reduction in the numbers of coal companies themselves due to corporate mergers and shutdowns. In 1950, 145 coal companies were listed as having one or more operations in Cambria County. By 1959, there were only 81. As the number of concerns was reduced, fewer companies were filling the same orders. High cost and marginal operations were closed. The fewer, more efficient mines were producing increasing tons per man-hour.[242]

V. NATIONAL RADIATOR'S FAREWELL

The National Radiator Corporation had become a small conglomerate as a result of its August 1927 merger with Union Radiator of Johnstown, plus several other Northeast firms. In 1940, National Radiator also acquired the Century Specialty Company (Century Stove) located in Moxham.

The 1927 merger had brought with it corporate culture clashes, power struggles and other types of internal feuding. Struggling to survive the Depression several years later, National Radiator was forced to work out a major reorganization with creditors.

In June 1952, Robert Waters retired as National's president but remained board chairman. Theodore "Ted" Focke, a vice-president with the Curtis-Wright Corporation, was named president.[243]

Another Corporate Merger

Just before Christmas in 1954, it was announced that the directors of both National Radiator and the U.S. Radiator Corporation of Detroit had agreed to merge. The two firms were somewhat equal in size. National was showing a profit, while U.S. Radiator had posted a small loss. Two-thirds of the stockholders of each firm had to approve the deal for it to take effect. Johnstown was believed to be better suited than Detroit for the corporate headquarters.

Six weeks later, Robert Waters, perhaps recalling the feuding twenty-seven years earlier, sent a letter to all National stockholders explaining his strong opposition. The letter mentioned an offer for him to serve as a consultant to the new corporation if he would vote his 30,000 shares for the deal.

Things got ugly. When Waters sought to see the proxy authorizations, he was denied access. After petitioning the Cambria County Court, Judge George Griffith issued a restraining order against company officials. This gave Waters the access he was seeking.

Despite Waters's opposition and procedural delays, the vote on March 15, 1955, was successful. Waters was immediately ousted as board chairman. The new entity would be called the National-U.S. Radiator Corporation headquartered at Johnstown. Ted Focke was president and CEO. Of the three thousand company-wide employees, five hundred were working at Johnstown.

The new corporation apparently prospered. It also began manufacturing boiler and other heat exchange equipment for the Crane Corporation, a major customer.

The Crane Corporation

In late December 1959, it was announced that the Crane Corporation planned to acquire the National-U.S. Radiator Corporation for $15 million plus Crane's not assuming certain corporate assets. Stockholders agreed to the plan.

The surviving entity, the Natus Corporation, would have almost $19 million in cash, a few securities and some accounts receivable but little else. There was talk of Natus starting a new industry in Johnstown. While there were many local stockholders, only one was an officer and member of the board, John dePass, the treasurer. The chairman was William T. Golden, a well-known New York investor and dealmaker.

In 1961 Natus acquired a controlling interest in the Kirkeby Corporation, a hotel chain enterprise. The name was then changed to the Kirkeby-Natus Corporation, and it became a real estate and investment business with no Johnstown interests.

Focke remained as Crane's chief executive officer in Johnstown throughout the first seven months of 1960. On August 2, he resigned. Crane's next Johnstown manager was George Burley, a Crane vice-president from Chicago whose residence at the Fort Stanwix Hotel signaled a lack of Johnstown commitment. He was followed by Robert Casner.

From all indications, there was little warmth between the Johnstown community and the Crane hierarchy. The new leadership team persistently moved local production to other Crane plants, phasing out locally made products. The powder metals unit B.T. Du Pont had initiated and nurtured was sold to the Glidden Corporation in January 1961. By 1963, Crane's Johnstown employment had dropped to 260, approximately one-half its workforce prior to the Crane buyout. In mid-January 1965, Crane announced it was ending all Johnstown operations.[244]

VI. MISCELLANEOUS DEVELOPMENTS

Other Industrial Matters: Bethlehem and U.S. Steel

Between 1960 and 1966, the Bethlehem Steel Corporation had made a few notable investments in its Johnstown Works. In 1961, the Air Reduction Sales Company installed a $5 million oxygen generation plant primarily to furnish oxygen to the Bethlehem "E" blast furnace in the lower works. The plant converted 66,000 cubic feet of air per minute into 675 tons per day of nearly pure oxygen for "atmospheric enrichment in blast furnace production." The remainder went for other plant purposes. The "E" furnace with its new oxygen enrichment upgrade was fired up in November 1961 and was an instant success. Bethlehem engaged the Air Reduction Company for a second but smaller oxygen plant on the other side of the two furnaces using oxygen.

The Gautier Division had not been modernized in any significant way since 1923. In September 1961, an announcement described the forthcoming installation of a modern "11-inch mill," technology said to be essential in producing the exacting bar specifications of modern industry. The older ten-inch and the nine-inch mills were obsolescent.

In August 1963, the new 11-inch mill went into production. The new $18 million facility was described as the most modern of its kind anywhere. It could convert a heated billet into a high-quality, hot-rolled bar in forty seconds. Three months earlier, a new 8-inch bar mill, costing $3 million, began operating. Bethlehem had also made huge improvements to its 46-inch, 18-inch and 134-inch (plate) mills and had invested $6 million in air pollution abatement at the Franklin open-hearth plant. In addition, the corporation had recently spent $25 million to open its Mine-Thirty-three near Ebensburg and $5 million to open Brookdale Mine-Seventy-seven at Mineral Point.[245]

Increasingly the U.S. Steel plant at Moxham was engaged in fabricating special industrial plant equipment for other U.S. Steel plants. In December 1961, the Moxham plant finished the first of two mammoth 119-ton ingot tilting-pot cars, each capable of shuttling 20-ton ingots. The plant also produced rolling stock for the NASA space program.[246]

The Penn Traffic Metamorphosis: The Merger

A significant development in Johnstown involved the merger of the century-old Penn Traffic Company (PT) with the SV (Super Value) Corporation of DuBois. Penn Traffic had seven hundred shareholders, many of whom were from Johnstown. SV was much smaller.

Founded in 1949, SV operated a chain of ten Riverside Food Markets in western Pennsylvania, including one outside Johnstown on Scalp Avenue. Being the older and larger of the two, the merger plan called for PT to have seven of the eleven board members of the new corporation. The corporate headquarters would be moved from Philadelphia to Johnstown with a branch in DuBois. The firm's name would be the Penn Traffic Company. Approved in December 1961, the merger was effective February 1, 1962.

Prior to the merger, the only PT outlet was its downtown store, but the company had been seeking to broaden its outreach by creating a number of "combination stores"—stores that would sell both groceries and general merchandise in scattered western Pennsylvania locations. The merger provided grocery outlets that could be expanded into "combination stores."

The standard new PT combination store had sixty thousand square feet, of which forty thousand were used for general merchandise and the remainder for groceries. There were two cash registers situated between the two areas, one for merchandise and the other for groceries.

This change in the PT business model was a precursor to the company's continued diversification, the phasing out of its downtown store and the development of scattered outlets in shopping centers and malls. In Johnstown, the first new combination unit was in the Westwood Plaza.[247]

Crown American Corporation

During World War II, Andrew Gleason did legal work for the army. One of his projects was acquiring a small residential development for expanding a military facility. Rather than demolish a number of homes, the army physically moved them, effectively reestablishing the neighborhood at another location.

When the Johnstown Housing Authority sought to acquire the site for the second phase of its Oakhurst Homes Project, Gleason recalled his army experience and proposed physically moving the thirty-nine homes to a new location. Residents who chose to do so could reoccupy their same housing structures at the new location. Thanks to this approach there was no loss in dwellings to establish the public housing site.

Gleason founded the Crown Construction Company in late 1950 specifically to fulfill this need. He was its president and one of his Republican loyalists, Joseph Farkas, a member of the Johnstown School Board, was the beginning vice-president and general superintendent.

In 1951 Gleason also hired a young Frank Pasquerilla first as a payroll clerk and next as a junior engineer. Pasquerilla had recently been president of the Dale-Ferndale Young Republican Club and had also been an inspector for the Pennsylvania Highway Department. Born of poor but industrious Italian immigrants, Pasquerilla had no college education or formal engineering training. After Pasquerilla became its president in 1953, Crown prospered. Gleason, a busy attorney, sold him the company in 1961.

Likeable, smart, risk-taking and hardworking, Pasquerilla had been president of the Johnstown Junior Chamber of Commerce in 1950. In 1953–54, he served as president of the Pennsylvania statewide chapter, and in 1955, he became vice-president of the U.S. Jaycees.

During the first several years of Pasquerilla's association with the company, Crown undertook small jobs, including subcontract work. By 1957 the company was building individual office buildings, markets and even a three-story research laboratory in State College.

In 1961 the Crown Construction Company and a sister corporation, Fran-Mark, were retained by various landowners of the Westmont Drive-In Theater and nearby tracts to develop a shopping plaza on a site assembled through a system of long-term leases. Crown was also chosen to construct Penn Traffic's new store and some of the other plaza buildings.

During the 1960s, Crown moved aggressively into shopping center and mall development while continuing to construct buildings in the greater region. The company also began developing Holiday Inn motels. To facilitate these activities, Pasquerilla founded a number of separate corporations, each to fulfill a project. By 1965 these enterprises were strong enough to merge and thereby provide greater equity to support larger development loans. The eight corporations came together as "Crown Incorporated," but it continued to be known as the Crown Construction Company.

By July 1968, Crown had become the fifty-seventh largest builder of its kind in the United States. It had seven hundred employees, including seventy at the new headquarters office in the old post office building on Market Street, acquired in 1967. In 1972 the company renamed itself the Crown-American Corporation, signaling that it had become a mall and hotel development and management company that no longer did contract construction.[248]

Gee Bee Outlets

At about the same time that the newly merged PT Company had opened its first new combination store in Indiana, Pennsylvania, the Glosser Brothers Company opened a similar store, Gee Bee, in Greensburg. Its success prompted a second store, a 100,000-square-foot merchandise and food outlet located on Scalp Avenue across from the Richland School.[249]

Births, Deaths and a Reincarnation

In 1953–54, the Goenner Beer Company in Cambria City, founded around 1870, ceased operations. There had been forty-two employees. The last of Johnstown's breweries, Goenner was a victim of plant consolidations. Fewer, larger breweries were outperforming the smaller local operations.

The Brown-Fayro Company was underway in 1925 through the merger of the Fayro Machine Company with the Brown Equipment Company. The Brown-Fayro factory and foundry on Sheridan Street produced such coal mining equipment as pumps, hoists and mine cars. Employment was usually around one hundred. The company was sold first to the Pittston Company in 1948. In 1954, soon after its acquisition by Sanford-Day, Brown-Fayro was shut down.

A long-standing Cambria City firm, the Pennsylvania Cigar Company disappeared around 1958. Its thirty employees, mostly women, had produced Solitas, cigars that sold for a nickel each.

The Brooklyn Hospital Corporation, a seventy-five-employee Hornerstown firm that had manufactured metal hospital furniture and equipment since 1928, ceased operations in 1958, and its 62,000-square-foot building at Oak and Murdock Streets was sold in 1959 at a sheriff's sale.

To some degree the Brooklyn Hospital Equipment Company demise was related to the birth of a new and similar firm, United Metal Fabricators, a small and growing manufacturer of metal furniture, cabinets and hospital furniture and equipment. Its plant was located in Richland Township. The board of directors and beginning management were mostly hands-on factory workers including many former employees and supervisors of the Brooklyn Hospital Equipment Company.[250]

In 1960 Howard Picking Jr. and Harold Miller created the Miller-Picking (MP) Corporation. Its factory in Hornerstown was to produce the "Toonboat," an unsinkable sporting boat incapable of capsizing. Miller-Picking was also producing "the Pickway," a funeral director's wagon. The ventures were apparently unsuccessful and Miller-Picking went into a sort of corporate hibernation.

In 1961 the firm was revived. Its five employees began producing and marketing custom-designed air-conditioning and heating equipment. The MP units were generally targeted at size and capacity niches overlooked by well-established air-conditioning companies. By January 1966, the company had two separate Johnstown factories with a workforce nearing one hundred employees. The Miller-Picking Corporation purchased a twenty-one-acre site on Route 53 north of Davidsville and constructed a forty-thousand-square-foot plant.[251]

EDUCATIONAL DEVELOPMENTS IN THE 1950s, 1960s AND 1970s

I. JOHNSTOWN AND THE PENNSYLVANIA SCHOOL DISTRICT REFORM LEGISLATION

In 1949 the Pennsylvania School Code was amended to provide for "jointures"—agreements between two or more school districts to permit a high degree of cooperation. In August 1951, the Stonycreek Township School Board signed a jointure agreement with the Johnstown School District. The jointure almost created a new district. Use of school buildings, teaching and the like were all coordinated by the city's superintendent under a joint operating committee (school board members representing each district) almost as if there were only one school system. Pupils from Stonycreek Township and the city attended the same schools and were treated alike. There were, however, two distinct school boards. Each owned and maintained its school buildings, approved an annual budget and levied the taxes to finance it. Jointures could be rescinded.

Pennsylvania had some 2,500 school districts, the vast majority being too small for them to develop sound educational programs. It soon became state policy to promote jointures and other combinations.

While the idea of two discrete districts functioning to bring about a unified educational program would seem like a blueprint for chaos, the Stonycreek-Johnstown Jointure worked with amazing harmony. The city had surplus, although antiquated, schoolroom space. Stonycreek needed school buildings. The city's high school in the 1950s was top-notch. Each entity benefited.[252]

The County Superintendent and County School Board

The school superintendent of Cambria County from 1936 until July 1963 was Arthur Stull. Born and raised in Dale Borough, Stull was a career educator who had once taught in the Johnstown schools and had later been supervising principal for the Dale Borough schools.

The county superintendent served as superintendent to all the school boards in Cambria County except the Johnstown School District. As such, he was a consultant, a general overseer,

a point of contact for state financial aid and an enforcer of state standards and mandates. Stull and his staff were responsible for over fifty school systems.

Every four years the county superintendent had to stand for reelection at a public convention of all the board members from every school district in the county. If they all showed up, there would have been about 280 directors, each having one vote.

There was also a seven-member county school board chosen in a way similar to that of the superintendent. The members' six-year terms were staggered, meaning that in five years out of six, one director was chosen, unless there were vacancies. In the sixth year, two were chosen.

A statutory requirement that each class of school district must have at least one representative guaranteed the city one of the seven seats. That member was picked by the convention of all county directors and was not necessarily a nominee of the Johnstown School Board. Throughout the era of school district reform, the Johnstown representative was Richard White, a Bethlehem steelworker and union official.

The politics of the county school board during the school district reform era (1949–66) are veiled by elapsed time. The Johnstown School District had one of seven members only because the code guaranteed it the one seat. The city's district had over one-third of the county population and almost one-third of its public school pupils. The nineteen municipalities in the Johnstown urban area had over half the students in Cambria County and accounted for well over half of its population yet had only the one member to represent them on a seven-person board. The other six board members were from Ebensburg, Nanty Glo, Patton, Dunlo, Barr Township and Cresson—northern Cambria County localities.

There was also the unmentionable issue of *Brown v. Board of Education of Topeka*, a leading case under consideration in the United States Supreme Court. Even before its May 1954 decision, people sensed the outcome, but no one knew how the ruling might be applied around Johnstown.[253] Since the Johnstown School District was the only school system with a significant black population, the way to halt integrating the suburban schools was to isolate the Johnstown School District from the others.

By 1953 the county superintendent and school board were required to develop countywide plans to spell out possible (not mandatory) school district groupings for "jointures, mergers, and unions" of school districts under their cognizance.[254] No future jointure could take place unless authorized in the plans. The plans could be amended.

In July 1953, the State's Council of Public Instruction seemingly "rubber stamped" the plans developed by the county superintendents and their school boards. The Johnstown region's part of Stull's plan, first approved in July 1953, was as follows:[255]

> Unit 8—East Conemaugh, East Taylor, Franklin, Conemaugh Township
> Unit 9—Richland with most of Geistown, Dale, Daisytown
> Unit 10—Ferndale, Lorain, Middle Taylor, West Taylor
> Unit 11—Westmont, Upper Yoder, Southmont, Lower Yoder
> Unit 13—Johnstown City (no mention of Stonycreek Township)

Petitions and Adjustments

In August 1954, the Conemaugh Township School Board and the Greater Johnstown District had reached a "jointure" accord primarily to allow Conemaugh Township high school pupils to attend Johnstown Central High School. Conemaugh Township School Board members argued that since Stonycreek Township was in a jointure with the city, Conemaugh should have the same privilege.

To this, Stull unveiled his true posture by stating emphatically that the same (city-Stonycreek) jointure would have been rejected if its consummation had not been finalized before he and the county board could have prevented it.

The Conemaugh Township Board then sought to contract with the Johnstown District to educate its high school pupils on a tuition basis. Stull did everything possible to prevent these eleventh- and twelfth-grade students from attending Johnstown's Central High School and encouraged their enrollment at Franklin's high school. To counter this, the Conemaugh Township Board announced that the Franklin tuition would not be paid using Conemaugh school funds.

The impasse got ugly. In early September 1954, sound trucks began passing in front of the homes of Conemaugh Township pupils whose parents favored their attending the Johnstown school. Spotlights were pointed at their houses and the crowd booed and taunted the occupants. Nick Strippy, a coach, was reported to have been the demonstration's ringleader.

In August 1957, West Taylor Township entered into a jointure with the city district. The county school board and the state approved the jointure probably because both West Taylor and the city wanted it and no other district objected.

In May 1958, an Upper Yoder, Westmont and Southmont Jointure was approved.

In October 1958, East Conemaugh, Franklin and Conemaugh Township established a jointure to take effect in July 1959. East Taylor Township was left free to enter the arrangement if its board wished it, but there was reluctance for East Taylor and Conemaugh Township to cooperate. East Taylor then sought to send its high school students to the city schools on a tuition basis, and the city agreed to accept them.

For reasons of economy, the city school board in March 1960 decided to discontinue taking tuition pupils from all other districts beginning with the 1960–61 school year, an action affecting East Taylor and Lower Yoder Townships. The former immediately entered the jointure with East Conemaugh, Franklin and Conemaugh Township. Lower Yoder Township in turn entered a jointure with the city district effective July 1961.[256]

School System Redistricting and Reform

Act 561, signed by Governor David Lawrence in September 1961, sought to bring about the permanent elimination of over two-thirds of the school districts in Pennsylvania. It mandated that each county school board prepare a plan for reorganizing its member districts' boundaries to guarantee an average daily pupil population of 4,000 or more in each surviving school district. In certain specified situations, the population might be less than 4,000 but never below 2,500.

Act 561 created a nightmare for the Cambria County School Board. The only school district in Cambria County with 4,000 pupils was Johnstown, and only the Westmont Hilltop and Central Cambria Jointures exceeded the 2,500-pupil minimum.

Washing his hands of it, Arthur Stull stated that it was the function of the superintendent's office "to procure data for the county board to study in arriving at a plan." County school board members voiced optimism that the act would be repealed.

The county board next developed Plan A, providing for all of Cambria County to become one school district. While there was genuine support, it was partly motivated out of a desire for the county board to present something easy to fashion that would be rejected in Harrisburg.

Other groupings were proposed. Richard White, the Johnstown member, announced the only plan he would support was one that united the several school districts in the Johnstown area.

Pressures to get the law rescinded were fought by Governor William Scranton. Compromise legislation, Act 299 of 1963, extended the deadlines by one year, meaning until July 1, 1966, and eliminated the 2,500-pupil minimum requirement.

Indications were that many plans and ideas were considered, some seriously and some as posturing foils. In the end the existing jointure arrangements were solidified into new school districts with a few modifications. None of the new districts had four thousand pupils except Greater Johnstown. The Ferndale Area School District was made up of four separate boroughs and one township, none of which was contiguous with any of the others. All five bordered the Greater Johnstown School District.

The Greater Johnstown School District consisted of Johnstown City, Stonycreek Township, Lower Yoder Township, West Taylor Township and the small bit of Geistown Borough that once had been in Stonycreek Township.

The Richland School District served Richland Township and most of Geistown.

The Ferndale Area School District consisted of Ferndale, Dale, Brownstown and Lorain Boroughs, as well as Middle Taylor Township.

The Conemaugh Valley School District consisted of East Conemaugh, Franklin and Daisytown Boroughs, plus Conemaugh and East Taylor Townships.

The Westmont-Hilltop School District was made up of Southmont and Westmont Boroughs and Upper Yoder Township.[257]

II. GREATER JOHNSTOWN SCHOOL DISTRICT (GJSD) EDUCATION IN THE 1950s, 1960s AND 1970s

Dr. Frank Miller

In December 1953, Dr. Roy Wiley, the popular Johnstown school superintendent, died. In July 1955, Dr. Frank Miller, an assistant superintendent at Erie, assumed the post.

Miller found that he was heading a school system that had recently (1951) entered its first of three jointures. He also found that he was responsible for the educational program of the school district, yet there was another important official, the "secretary to the board," who reported directly to the board—not the superintendent.

The board secretary was responsible for finance, school buildings, grounds maintenance, the custodians and the cafeterias. The superintendent was responsible for instruction and student health. The secretary would deal with finances and school buildings. Since Wiley had successfully

fought against political pressures influencing the appointment and promotion of teachers, the board had continued naming janitors, custodians and cafeteria workers.

The fusion of buildings and grounds maintenance with finance under the board secretary tended to postpone new construction to avoid a strain on district revenues. If the superintendent, for example, believed that antiquated and poorly maintained school buildings impeded quality instruction and the learning taking place within them, he might antagonize the secretary who, while responsible for both finance and buildings, had no responsibility for education.

Completed in 1927, Garfield Junior High School was the newest of the city's twenty-nine buildings. The most recent physical wing addition made to any Johnstown school had been done in 1929. The district's physical plant was old and shabby. Schoolyard space was inadequate, and the tax rate remained flat at nineteen mills.

During Miller's early tenure as superintendent, school enrollments were fairly uniform from year to year. The population decline in Johnstown City was offset by a wave of postwar baby boomers reaching school age in the 1950s.

"Schools for a Greater Johnstown"

By 1956, Miller had found out the way things worked and did not work. He proposed that a professional survey, analysis and recommended plan for the Johnstown School District be undertaken. Having received his doctorate from the University of Pittsburgh, Miller quietly arranged for the "joint operating committee" to recommend to the district board that the University of Pittsburgh's School of Education do the work. The recommendation was approved.

Between September 1956 and the summer of 1957, a team of six professionals from the University of Pittsburgh produced "Schools for a Greater Johnstown." Released in August 1957, the 185-page report provided a penetrating description of the school district, its administrative organization, the buildings, finances, operations, school enrollment trends and the jointure implications.

The study recommended a reorganization that would subordinate the school secretary under the superintendent. It suggested a program both to phase out many school buildings and to construct fewer, larger and more modern ones on bigger schoolyards.

The report noted that on average Johnstown School District teachers were older than a representative peer group from other Pennsylvania third-class city districts and had less post-secondary education. A larger percentage of the teachers were Johnstown natives than similar districts' teachers had been natives where they were teaching, a revelation hinting that Johnstown's faculty was more insulated from new ideas.

The report also recommended that the long-standing practice of committee meetings being closed to both the public and the news media be terminated. The real work of the school board was happening in closed committee sessions. Meetings of the full board, open to the public, were quick and perfunctory, usually consisting of "rubber stamp" ratification of recommendations made in the committee reports.[258] Decisions were being made in small pieces. The board was not looking at bigger, cross-functional policy questions.

The dual management structure and its school board with its committee system were keeping everything working like the operating parts of a motor. "Schools for a Greater Johnstown" was suggesting the whole machine was obsolete.

Two of the more trenchant statements betray the study's theme:

> *The reason Johnstown has been able to forestall the crisis this long seems to be two-fold: (1)*
> *Outmigration and an aging population have combined to ease the problems of classroom space,*
> *and (2) Public apathy in Johnstown has been at an all-time high, with a resulting lack of concern*
> *over outmoded and deteriorating facilities.*[259]

The report was greeted with applause by the press and it probably appealed to younger, more idealistic professional educators. For all practical purposes, however, nothing happened because of "Schools for a Greater Johnstown." The new Westwood Elementary School, built in 1959 by the Lower Yoder Township School District, became the newest Johnstown school system building, thanks to the jointure in 1961.[260]

Superintendent Wayne Vonarx and His Reforms

Dr. Frank Miller's retirement resignation in July 1967 ended his twelve-year tenure. Meanwhile the board chose a successor, Dr. M. Wayne Vonarx, superintendent of the Milton Area District. Vonarx immediately pushed for an update of the 1957 plan to be done again by the University of Pittsburgh's School of Education. State law mandated that districts like Johnstown prepare and adopt a general long-range operating plan by July 1, 1969. Vonarx's recommendation was accepted, but the work was never done by the University of Pittsburgh.

Greater Johnstown School District Enrollments (1954–1975)

Year	Elementary	Secondary	Total
1954–55	5,862	4,246	10,108
1955–56	5,728	4,560	10,288
1956–57	5,808	4,500	10,308
1957–58	6,241	4,625	10,866 (West Taylor Jointure)
1958–59	6,211	4,714	10,925
1959–60	6,136	4,843	10,979
1960–61	6,050	4,945	10,995
1961–62	6,566	4,810	11,376 (L. Yoder Jointure)
1962–63	6,485	4,850	11,335
1963–64	6,250	4,982	11,232
1964–65	5,972	5,001	10,973
1965–66	5,946	5,050	10,996
1966–67	5,798	5,015	10,813
1967–68	5,638	5,019	10,657
1968–69	4,880	5,162	10,042
1969–70	4,983	4,983	9,966
1970–71	4,743	4,326	9,069 (Vo-tech opens)

Educational Developments in the 1950s, 1960s and 1970s

Year	Elementary	Secondary	Total
1971–72	4,562	4,216	8,778
1972–73	4,463	4,109	8,572
1973–74	4,294	3,904	8,198
1974–75	4,030	3,707	7,737

Within eight weeks of becoming superintendent, Vonarx was urging a major change—"individualized prescription instruction" or IPI, a new approach advocated by many progressive educators. Vonarx had pioneered IPI at Milton. It included team teaching, students learning from fellow students and elementary pupils working and learning at their own pace instead of following curriculum schedules. A major point of contention involved eliminating "walled" classrooms and replacing them with large open areas, each having several clusters of pupils.

Vonarx proposed to use the Cypress School in Moxham (recently vacated thanks to the new UPJ campus) as a temporary research center. Pupils and teachers alike from the Kernville and Hornerstown sections would be initiated into the new approach. Vonarx expressed certainty that the research center program would be financed by special grant funds. He also sent high school principal Albert Rubis to witness the Milton program in action. Rubis came back with glowing reports.[261]

Almost every Vonarx recommendation generated controversy. By November, not only had Vonarx embarked upon a school reform initiative in a tradition-bound district, but he was also pushing hard to close down a number of school buildings. In 1967 the Osborne Street School (built in 1894) was closed. By 1968 the Dibert (1872), the Horner Street (1883) and the Somerset Street Schools (1891) were all demolished. Their former pupils were reassigned to the two old Meadowvale Schools as well as to the reactivated Cypress Avenue research center. A much larger new Meadowvale School was designed to replace the discarded elementary schools. Its interiors were configured specifically to accommodate Vonarx's IPI program. The absence of walled classrooms was controversial.

The plan to be submitted by July 1969 was Vonarx's plan. It called for completion of the new Meadowvale School by 1970, a new senior high school by 1973 and either a new middle school or a new elementary school by 1974. Also proposed were many innovations for Central High and improvements to both the Cochran and Garfield Junior High Schools. The Vonarx plan aroused both public and school board opposition. The need for any new high school was questioned.

The school district's planning dilemmas were driven by four general factors: forecasts of declining enrollments both in the Johnstown district and in the parochial schools; the loss and demolition of the Joseph Johns Junior High School in 1970 because of urban redevelopment; the possible loss of many district students to the new vocational-technical school scheduled to open in September 1970; and state standards for existing school buildings, which dictated either big expenditures or closings.

With the completion of the new Meadowvale facility in January 1971, school closings and the demolitions that usually followed continued at an accelerated pace—Hudson Street (built in 1895), "old" Meadowvale One and Two (both 1900), Village Street (1908), the Tanneryville School (1913), Park Avenue (1891) and Riverside (1922) were shut down. Also in 1971, the

Washington Street or "Prospect School" (1922) closed after a federal district judge had refused to impose an NAACP-sought injunction to halt its demolition.

When almost anything unpopular was proposed, Vonarx was identified with it. The Johnstown School District had been limping along incrementally for years. Previously, old school buildings were rarely shut down and only when there was no alternative.

When Vonarx arrived, things started happening. Justified or not, Wayne Vonarx was becoming controversial and unpopular among many factions. He had professional admirers, but well-meaning educators considered him overbearing, cagey and inflexible.

Some of Wayne Vonarx's difficulties stemmed from the gross inequality in the way his IPI program was applied. The new Meadowvale Elementary School was a case in point. Designed to accommodate 1,365 pupils in its thirty-five "open space" areas, the modern school had attractive interiors, was air conditioned, had a swimming pool and offered a new school library and modern cafeteria. Except for the smaller Westwood School in Lower Yoder Township built in 1959, all the other elementary schools were antiquated. If there was merit to the "individualized prescription instruction" concept, less than one-third of the district's 4,743 elementary pupils could have possibly experienced it. Unfair to the other two-thirds, the situation created two different groupings of pupils, all of whom would be coming together in the junior high schools. Almost everyone was for or against IPI. There was no way to settle the debates. IPI was not evaluated by impartial expertise.

By 1971 a "get Vonarx" movement was underway, principally led by Democrats seeking to fill three school board vacancies in the general election. The ringleader was Jack Buchan, an insurance executive. Others were Dr. Robert Klemens, a physician, and Ron Stevens, an office equipment sales representative. Buchan was claiming that the school district was suffering from poor morale among teachers and students alike and that the school buildings were deplorable.[262]

All three Democrats were elected in November. A campaign to embarrass Vonarx took place, but there were insufficient votes to dismiss him.

Wayne Vonarx had been weathering a storm throughout his seven-year tenure. Seeking to oust him, school board members were taking actions that usurped his responsibilities and prerogatives. Vonarx obviously believed the school directors were making a mess of things. He had also weathered a twenty-day teacher strike in September 1971 that was halted by court injunction. Only fifty-eight years old, Vonarx announced his retirement in September 1973 to be effective July 2, 1974.[263] He died in March 1978 while vacationing in Spain.

Superintendant Don Zucco

Early in 1974, Don Zucco, the supervisor for academic affairs at the vo-tech, was in a quandary over what he should do. He had just been offered the superintendency of the Greater Johnstown School District to succeed Vonarx. Having been a teacher and a junior high school principal in the district, he knew the intrigue, petty politics, problems and extreme conservatism plaguing the system. Only thirty-three years old and on sabbatical pursuing a doctorate, Zucco—who wanted the job—was pondering whether to accept the board's eight-to-one vote offer.

He visited his one-time sociology professor, George "Doc" Walter, for advice. By 1974 Walter had been mayor twice and a school board member back in the 1950s. He was sage, civically positive and practical.

Educational Developments in the 1950s, 1960s and 1970s

With Walter's customary profanity deleted, the conversation went approximately as follows:

"Make it work, Don, so they [i.e., school directors] need you more than you need them. Then you've got to know when and how much to compromise."

"What do you mean, Doc?"

"If you ever think you're going to have it your way all the time, you'll be crazy and they won't keep you. Then if you cave in to everything they want, they'll get rid of you."

"How do you know when and how much to give in?"

"You either figure it out or you won't last."

Zucco accepted the position, but he often returned to his mentor's Delphian advice in what was to become an ongoing search for fickle and unseen walls of discretion.

Soon after becoming superintendent, Zucco chartered a bus and took his administrative staff to Harrisburg for face-to-face meetings with the very officials and staff of the Pennsylvania Department of Public Instruction that his team was dealing with daily. The idea was to improve staff-to-staff relationships.

The school board was continually divided into shifting factions. The classical model of directors setting policy and the superintendent and his staff carrying it out had long since become so misty no one could have told what was policy and what was administration. If a school board member had someone in mind for a teaching position, good educational policy meant hiring that person—at least as seen by the director making the recommendation.

Among the first directives Zucco was given was to get rid of Vornax's IPI program. Zucco urged that there be an independent, competent evaluation. No such evaluation was forthcoming. The school board knew that IPI was a fashionable innovation beloved by many outstanding educators. Had there been merit in IPI, they did not want to know it. They wanted IPI eliminated.[264]

The IPI could not have been readily eradicated from the district. All the classroom space in Meadowvale was "open," meaning without conventional walls. Although there was some effort to generate classroom cubicles by using bookshelves and primitive space dividers, some features of IPI continued until the building was closed temporarily in 1982 for asbestos encapsulation. (Reconstruction to provide conventional walled classrooms was not done until the mid-1990s.)[265]

The school directors could do little to nothing about the steady and precipitous decline in enrollment that had started in the mid- to late 1960s, well before Zucco became superintendent. The enrollment declines together with the continued need to use old school buildings created a need to make improvements to the very buildings that would soon have to be closed.

In March 1976, the Pennsylvania Department of Labor and Industry ordered the school district to close the top floors in five schools—Bheam, Chandler, Cypress, Oakhurst and Woodvale, the latter being used only for special education classes by the Intermediate Unit (IU-8). The directive also specified extensive remodeling needed for many buildings.[266]

Even prior to the 1977 Flood, a district committee had recommended that the fifty-year-old Central High be closed and that Cochran Junior High be converted into a regular high school, meaning that within approximately a single decade, the Greater Johnstown School District would have gone from having three junior high buildings to one.[267]

During Zucco's tenure, the district's school closings continued—Bheam (built in 1914) and Oakhurst (1919) were both closed in 1976. The Maple Park School (1922) in Walnut Grove was shut down in 1977, and the Coopersdale School (1900 with an addition in 1906) was closed in 1983.

The high school was extensively damaged in the 1977 Flood when some of the lower floors and the building's heating and ventilating equipment were submerged. Even had the flood never occurred, the building would have been abandoned. Despite protests and widespread community nostalgia, Central High School was shut down in June 1980.

Zucco had inherited an antiquated physical plant. He had to address the controversial IPI program that he was under orders to eliminate. The enrollment declines—often around four hundred pupils per year—continued throughout his tenure. He had to deal with the problem of interfacing with the vo-tech at a time when there was competition with it for fewer and fewer students. During his tenure, the district's tax base remained flat while costs were rising with steep inflation. There was also the 1977 Flood.

Against internal opposition, Zucco maintained a full-time program for gifted students. He also advocated and developed such special initiatives as an alternative school for likely dropouts, a unique "Systems Training for Effective Parenting" (STEP) program and even an innovative special program for probable child abuse victims.[268] He occasionally took small groups of students to lunch at area restaurants to stay abreast of what they were doing and thinking.

During Zucco's superintendency, Dr. Levi Hollis, a black educator, was hired as director of secondary education. Hollis later became assistant superintendent and eventually superintendent.[269]

James Hargreaves, a retired principal of the new Meadowvale School, stated that Don Zucco was an outstanding superintendent, the best he ever worked with throughout a lengthy career in education. "If you had an idea and he liked it, he world work tirelessly to get it accomplished," Hargreaves stated. "If he didn't think much of it, he'd say so and tell you why. You always knew where you stood. The kids came first."

Zucco readily acknowledged that some of the things the school board directed him to do were quietly ignored. He considered some of the directives so counterproductive, he simply refused to carry them out.

In 1984 Zucco was named president of the Johnstown MRI Corporation, a consortium of several area hospitals established cooperatively to share the then new and expensive magnetic resonance imaging technology.

III. THE GREATER JOHNSTOWN AREA VOCATIONAL-TECHNICAL SCHOOL

The enactment of the Manpower Development and Training Act (MDTA) in 1962 revived interest in establishing a separate vocational-technical school for the Johnstown area. To some this meant a vocational high school. To others it meant a post-secondary technical school. Others sought one institution for both purposes.

In April 1962, Richard White, a school director, raised the issue of a separate vocational-technical school. A motion was passed directing that the matter be studied carefully.

Dr. Frank Miller later reported that of the 610 seniors soon to graduate, about 100 were expected to pursue higher education. Another 150 would enter commercial and sales careers. The remaining 360, while lacking job skills, would be seeking employment.

By June, Joseph Casale, local manager of the Pennsylvania State Employment Service, and Howard Hill, the chamber of commerce staff vice-president, were both pursuing ways a

vocational-technical school could be established. The issue faded away when it was discovered that the MDTA could not fund vocational school buildings.

Meanwhile Frank Miller, the school superintendent, had assembled a committee of leading business and industrial leaders and was getting staff assistance from Sinclair Powell, executive director of the Greater Johnstown Committee.

Powell circulated a letter to all the school districts in the Johnstown region together with the Windber and Conemaugh Township Districts in northern Somerset County. The letter sought each district's interest in a joint facility that would offer a high school technical diploma, up to two years of post-secondary vocational training and adult retraining. Powell soon extended his inquiry to all Cambria County.[270]

This early planning for a vocational-technical school took place during the frothy times of school redistricting. Since any vo-tech school and program would have to be supported by several school districts, its establishment would both complicate and be complicated by the emerging redistricting.[271] The Johnstown city council enacted a resolution of support, but wanted the facility in the city. The county school board, having flirted with the idea of establishing a single countywide school district, began advocating one technical school for Cambria County.

By October 1964, the controversy was so divisive there was concern that nothing would be accomplished. The county school board called for a mid-December convention of all the school directors in Cambria County. Each board was expected to state its position on the vocational-school issue.

Prior to the countywide convention, school board members from every district in and around Johnstown had a caucus of their own convened by the chamber of commerce. They passed a unanimous resolution for a single areawide vocational school to serve the Johnstown region, including Windber and Conemaugh Township in Somerset County. The resolution comported to the state's plan for vocational schools, which called for two separate Cambria County institutions.

The threat by the county school board had stimulated a spirit of unity among the Johnstown area boards. They proceeded to develop and adopt the principles for establishing a joint-operating committee, especially in light of the new redistricting plan that was to take effect in July 1966. This agreement provided for representation and cost sharing in proportion to the tax base of each school district relative to the total of all the tax bases of the participating districts. Each member district was also guaranteed at least one representative on the joint-operating committee.[272]

By late January 1966, the articles of agreement had been adopted by all the school boards that composed the vo-tech service area.[273] In September, the first full-time administrative head or director, Robert Kifer, was appointed. Kifer had been director of vocational-technical education for Armstrong County's schools.

Kifer became the head of a program under development that would be conducted in a facility neither designed nor built on a site that was not yet chosen. It was his responsibility to determine what instruction would be needed, for whom and how many and what facilities would be needed to accommodate future programs. This was done largely through surveys of commerce and industry and by polling student intentions.

In November 1966, the operating committee approved the purchase of a ninety-acre tract (Baumgardner Farm) in Richland Township near the University of Pittsburgh at Johnstown's new

campus. Including mineral rights, the cost was $116,000. By May 1967, a massive new facility was planned with costs around $6 million for the building alone.

The costs began to frighten the board members of the newly formed Conemaugh Valley School District. In early 1968, its board began to explore withdrawing from the program. There was concern that if Conemaugh Valley pulled out, the vo-tech initiative might collapse, but the other districts remained steadfast. In March Conemaugh Valley was allowed to withdraw. The vo-tech would still become a reality.[274]

The Pennsylvania Department of Public Instruction approved the construction plans in April 1968. In September, bids were received revealing that construction alone would cost $7 million. With shop equipment and other furnishings, the vo-tech's cost was approximately $10 million.

The building had been designed to accommodate 1,500 full-time day students plus a number of adults seeking special instruction. There were thirty-five shops, plus classrooms for conventional tenth- through twelfth-grade academics. The Greater Johnstowen Area Vocational Technical School opened in early September 1970 with 1,184 regular daytime pupils.

The vo-tech had been planned and developed during a period of enrollment stability in the Greater Johnstown and the suburban districts. The new school served to mitigate potential overcrowding that was anticipated in some districts. The new vo-tech facility and its programs were welcomed additions on the educational scene. The member school districts began encouraging visits by vo-tech staff to recruit potential students. Bus trips were chartered for pupils to look over the new school to help them decide whether to attend.

It quickly became apparent that many of the best students, superior athletes and student leaders were choosing vo-tech. In addition, even had there been no vo-tech at all, forecasts of future high school enrollments revealed declining pupil populations.[275] This was especially true of the Greater Johnstown School District, which was actually experiencing a drop in enrollment from 9,069 in 1970–71 (just after the vo-tech had begun) to 7,251 in 1975–76, an average decline of 360 pupils per year (K–12).

In the first year of vo-tech's operation, the area school districts, including Greater Johnstown, had experienced a loss of approximately 437 total pupils, while the vo-tech had grown from 1,184 to 1,446—an increase of 262 regular students as of the beginning of its second year.

Just before the 1972–73 school year, the directors of the Greater Johnstown School District had begun to debate what its policy toward the vo-tech should be. Some of the directors agreed with Dr. Robert Klemens, who believed that no student planning to go to college should attend vo-tech. Joseph Piukowsky, an early vo-tech champion, disagreed. He believed the school should be open to any qualified student who wanted to attend.

Jack Buchan charged that the vo-tech was not doing its primary job of educating vocational pupils. "We got a cancer up there, and if we don't do something about it, it's going to kill this school district," he stated.

The Johnstown district soon began drafting and adopting guidelines restricting which pupils could and could not attend the vo-tech. The ostensible purpose was to prevent college-bound students from enrolling, but there were other subtle impediments. Visits to the school, presumably to help students decide whether to attend, were restricted to those who had already filed

applications, a sort of Catch-22. Any positive recruitment by the vo-tech staff was thwarted—a radical departure from the encouragement granted when the school first opened. The district also adopted quota limits. No more than 889 pupils from the Greater Johnstown School District could attend in the 1972–73 school year, and the directors announced that it was their intention to impose even greater limits in future years.[276]

In October 1972, after the beginning of vo-tech's third year, Dr. Robert Klemens began advocating that Johnstown's restrictive policies should become those of the school itself. They would affect pupils from all the member districts. Limitations would then be made as to the categories of pupils to be accepted at vo-tech. He also advocated that severe restrictions be imposed on the recruitment by the vo-tech staff and leadership.[277]

As time passed, it became increasingly obvious that the vo-tech enrollment was remaining much steadier than that of its member districts, especially Greater Johnstown. The city's school board explored methods to require a reduction in the numbers of its pupils attending vo-tech proportionate to its overall pupil decline, but such a policy would have violated the articles of agreement. The home districts' boards, Greater Johnstown in particular, also wanted control over which students could attend. This was always rejected because such a policy might have made the vo-tech into a "dumping ground" for poor, disruptive students.[278]

IV. The University of Pittsburgh Junior College at Johnstown

For many years the Johnstown Board of School Directors held annual "teachers' institutes" every summer to upgrade instructional skills. Each session lasted a little more than a week. In time the school board also began encouraging teachers to attend colleges and normal schools during summer breaks. In 1921 it began subsidizing tuition and other costs. Continuation of teachers' education also became a state mandate. Every few years the Pennsylvania School Code was amended to raise teacher certification requirements and to encourage more teachers either to become college graduates or minimally to finish a two-year normal school.

During World War I and the immediate postwar years, the school board began importing faculty from Penn State, Indiana Normal School and the University of Pittsburgh to give summer classes to its staff and any interested public. In 1921 the board also paid out $28,000 for seventy of its teachers to take summer courses away from Johnstown.[279]

The Pennsylvania School Code was amended in 1921 to require a significant upgrade in minimum teacher qualifications by 1927. As a result, teachers from all over Pennsylvania began flocking to colleges and normal schools during summer vacations.[280] Even before the 1921 law was enacted, the *Johnstown Tribune* in March 1919 had advocated the establishment of a normal school in Johnstown.[281]

A Branch Program for Johnstown

At a school board meeting prior to the fall semester in 1921, Superintendent Stockton made a public statement that a state normal school was needed in Johnstown as a desirable but perhaps

unrealistic objective, given the existence of Indiana State Normal School, Pennsylvania State College and other institutions near the city.

In June 1923, with the strong encouragement of S.J. Slawson, the new school superintendent, the University of Pittsburgh arranged with the city school district to establish a branch program in Johnstown, informally called the University of Pittsburgh Junior College at Johnstown, which began on July 2, 1923, in the high school downtown. There were four faculty members from Pittsburgh. Courses were given in basic economics, sociology, English composition and current problems. One week before the opening, over thirty students had enrolled.[282]

The following fall and winter, Slawson continued the ad hoc college extension program. While primarily for schoolteachers, courses were open to anyone. Instructors were brought in from Penn State and the University of Pittsburgh.

Slawson and his school board reached agreement with the University of Pittsburgh for a branch campus, to be called the University of Pittsburgh Junior College at Johnstown. The school board's attorney, Percy Allen Rose, ruled there was no legal authority for a school board to contract with a private university for a branch campus. George Fockler, a member of the city's school board who also served in the state legislature, secured the enactment of Act 62 of 1927. Governor Fisher's signing it into law provided the statutory authority.

When the new Central High School Building opened officially in the fall of 1927, space had already been set aside to provide for the junior college. A freshman class of 141 students was enrolled, and on September 26, the University of Pittsburgh Junior College at Johnstown opened legally as well as reopened in point of fact.[283]

From this September 1927 beginning, the junior college occupied the west wing of the one-year-old Central High School Building on Somerset Street. Including 40 women, enrollment continued to rise, reaching 166 the first year. Most of the student body was local but there were attendees from surrounding counties. No degrees were given. After taking the first two years locally, students finished degree requirements at the Pittsburgh campus, where they would graduate.

From its opening until 1933, the executive head was Stanton Crawford, a biology and zoology instructor. Technically renamed the Johnstown Center of the University of Pittsburgh, the struggling institution managed to survive the worst of the Great Depression, during which faculty pay had to be reduced. In 1932 and 1933, enrollment had dipped to 150 regular plus another 150 part-time students.[284]

World War II brought new challenges. Enrollment had fallen to about one hundred, the theoretical minimum to justify keeping the school open. Women students outnumbered men. Had it not been for nursing education, the Johnstown Center would have been forced to close for the duration.

The Postwar Surge of Students

The fall semester of 1945 produced a hint of the huge student influx soon to take place. Veterans were discharged in droves. The GI Bill aided their schooling. There were 264 full-time students exclusive of those enrolled in the after-hours program. By February 1946, the college announced

it would accept another 120 students for the spring semester, an indication that the institution was planning for about 385 full-time students, nearly double earlier enrollment peaks and a figure expected to grow.

The Cypress Years

C.A. Anderson, the new administrative head in the postwar period, requested from the Johnstown School Board the full use of its Cypress School in Moxham. Since the college was beginning to crowd Central High School and was paying rent to the district based on enrollment, the school board was favorable.

By February 1946, the school district had retained architect Henry Rogers to develop preliminary plans for refashioning the Cypress School into a small college. The conversion would provide classrooms and laboratories, a gymnasium-auditorium and a larger library area than at the Central High Building. In September 1946, the Johnstown Center was relocated.[285]

Enrollment continued to surge. In both 1947 and 1948, the Johnstown Center had just over one thousand students. This crest slowly faded as war veterans moved to the Pittsburgh campus to finish their education.

The College Matures

In March 1958, the University of Pittsburgh began upgrading its branch campus program in general. The Johnstown Center was renamed the Johnstown College of the University of Pittsburgh. As such there would be a local president who would report directly to the chancellor.

The first president was Theodore Biddle, who had been serving as dean of men at the University in Pittsburgh. Biddle confided to a close friend, "I am being sent into exile in Johnstown." These misgivings, however, either quickly faded or were completely suppressed. Soon after arriving in July 1958, Biddle became a crusading champion for the college.

The upgrade in status also created an advisory council or board, a local blue ribbon group to advise the president on policy for the local institution and to promote good community-college relations. The board would also assist in fundraising.

Biddle raised other hopes. More than any of the earlier administrative heads, he added courses and expanded the curriculum. Biddle also voiced a goal of the Johnstown College's evolution into a four-year institution to enable students to receive their undergraduate education in Johnstown without necessarily transferring to Pittsburgh.

By 1959 the Johnstown College had about five hundred full-time students. The course offerings had become sufficiently diverse and complete for many of its students to remain in Johnstown for three of their four undergraduate years.

A New Campus

In October 1959, State Senator Irving Whalley, a Windber Republican, proposed that the Johnstown College receive a $1 million grant to start work on a totally new campus. While Whalley's initiative was not successful, the senator had crystallized a goal—a new campus.

Aerial view of the new campus of the University of Pittsburgh at Johnstown in the summer of 1967. Krebs Hall is to the right. Biddle Hall is to the left. The student union building (with a cafeteria and athletic facilities) appears at the lower center left. The library had not been constructed when the photograph was taken. *Courtesy of University of Pittsburgh at Johnstown.*

One year later in 1960, the Wilmore Coal Company, an affiliate of the Berwind-White Coal Company, donated 136 acres of land in Richland Township for a campus. Isolated and difficult to reach, the site was about seven miles from Johnstown's downtown.

While generous, the Wilmore gift was also a shrewd investment decision because it would spur the development of streets and other urban infrastructure needed to develop other land Wilmore owned in the area.

In November 1960, Helen Price, a well-known local artist and author, died and bequeathed an undisclosed sum toward the development of a new Johnstown campus. Her initial gift brought forth an advisory board motion made by Charles Kunkle Jr. that a campus development fund be established.

In November 1962, Dr. Edward Litchfield, the university's chancellor, unveiled plans for a new campus on the site. The estimated cost was about $6 million. The community agreed to raise $1.2 million toward the goal. The remaining moneys would come from federal facility loans for dormitories and from other public and some private sources.[286]

Educational Developments in the 1950s, 1960s and 1970s

In August 1964, George Love, a Johnstown native and chairman of the Chrysler and Consolidation Coal Corporations, announced his family's gift to the University of Pittsburgh—most of the equity in the Fort Stanwix Hotel on Main Street. The building would first be used as a dormitory for Johnstown college students. The proceeds from its later sale to the Johnstown Redevelopment Authority for the Market Street West Urban Renewal Project would be added to the campus development fund.[287]

Work on the new campus actually commenced on October 14, 1964, in the form of a land clearing ceremony featuring Edward Litchfield, the chancellor; Walter Krebs, chairman of the advisory committee; and Fesler Edwards, campus fund drive chairman, together with their committee members.

In December 1965, contracts were awarded for ten new structures—six academic buildings, three dormitories and a combined student union–physical education facility—all to be ready by September 1967.

On Friday, September 8, 1967, the new campus went into use. The formal dedication took place on Tuesday, September 26, exactly forty years after the University of Pittsburgh Junior College at Johnstown had opened. Former President Eisenhower received an honorary doctorate from the University of Pittsburgh and delivered an address.[288]

CIVIC REFORM INITIATIVES

During the mid- to late 1950s, both the Johnstown municipal government and many civic organizations were floundering. The long-standing urban redevelopment of Cambria City was progressing slowly if at all. Little was happening to finish the decades-old sewer system. Parking and traffic problems choked downtown although no visible solutions were enacted. Gambling thrived, a condition generating ceaseless rumors that it was protected by City Hall. The earlier postwar efforts by the chamber of commerce to improve industrial development seemed inadequate.[289]

Most community leaders believed things needed to change. They had a strong belief that ineffective municipal and civic institutions were stifling economic growth and perpetuating community stagnation. There were several civic initiatives. Those in the mid- to late 1950s generally failed. Things improved somewhat around 1960.

I. THE UPPER YODER TOWNSHIP ANNEXATION EFFORT

In spite of many past annexation-consolidation campaigns, there had been no major additions to Johnstown City since Oakhurst Borough was added in 1919. The loss of Johnstown city population since its peak in 1920 had been showing up as gains in suburban boroughs and townships. In November 1956, Johnstown's school superintendent, Frank Miller, advised the school board that of all children born in the school district in the twelve-month period six years before the latest school opening, only 39 percent had enrolled in its first-grade classes. Meanwhile in 1954, Upper Yoder Township had opened a new elementary school building on Goucher Street. Two years later, a six-classroom addition was underway to accommodate another 180 pupils. Similar imbalances could be found throughout the Johnstown region.

Many business and civic leaders, born and raised in Johnstown, had migrated to the suburbs—chiefly to Westmont, Southmont or Upper Yoder Township—upwind of the smokestacks and with quality space for development. While most managers and professionals lived in the suburbs, their firms and offices remained in the city.

Both the Johnstown city government and its school board had become nearly debt free since the war, while the suburban communities were borrowing heavily to finance new schools and urban infrastructure. Being part of Johnstown was seen as a way to spread the fiscal burden and improve credit ratings for bonds financing these projects.

There was also a belief that larger population figures applicable to central cities boosted community prestige and influence in general and would attract business outlets as higher population thresholds were reached. Annexation advocates noted that if Johnstown had been united with its urban region by April 1, 1950, it would have registered a census population of 110,000, making it the fifth largest city in Pennsylvania. The interstate highway program, authorized in 1956, was also taking shape. In its initial forty-thousand-mile corridor configuration, every city in the United States whose 1950 population was 100,000 or larger had been placed on the proposed system. Meanwhile Johnstown's efforts to attract Interstate 80 ("the Shortway") to the south were failing.[290]

In late 1956, a number of organizations began endorsing consolidation. Any role the chamber of commerce may have assumed was behind the scenes. The Cambria County Board of Realtors, the AFL Building and Construction Trades Council and the Home Builders' Association of Greater Johnstown began advocating area consolidation. Ransom Reeder, sub-regional director of the United Steelworkers, and Andrew Fisher, general manager of Bethlehem Steel's Johnstown Works, both issued statements of support. The *Tribune-Democrat* continued its editorial backing.

Upper Yoder Township had been growing rapidly. Its developing areas were undergoing sanitary sewer installation. The township's sewer authority had recently marketed $750,000 in bonds serviced by costly front footage assessments and connection charges.

In December 1956, Mayor Rose, City Engineer Wilson and four councilmen met with Upper Yoder residents and township officials, many of whom had just organized an Upper Yoder Citizens' Committee to promote the township's total annexation into Johnstown. It was made clear that the city's policy of three cents per square foot of residential property plus a modest tap-in fee would apply to township sewer installations after annexation when the city would assume responsibility for Upper Yoder's bonds, an arrangement generally understood as a better deal for township residents.[291]

By February 1957, an Upper Yoder Residents Annexation Opposition Group was founded. Its members expressed frustration because the Johnstown news media consistently supported annexation and consolidation. The paper stated editorially that the opposition groups tended to be secretive, refused to divulge their leaders' names and advanced no compelling arguments in support of their stand. To counter this assertion, Ray Patton Smith, an attorney and a former U.S. commissioner, wrote a letter to the editor stating that the "destruction of progressive Upper Yoder Township would be a crime." Smith's letter, however, advanced no analytical or factual reasoning.[292]

Under the law at that time, Upper Yoder, a second-class township, could be annexed by bona fide petitions signed by three-fifths of the taxable township inhabitants together with a majority

of the property owners "in both number and interest." The petition drives had to conform to given time limits and "sunshine" (open public meeting) requirements. Once the petitions were presented, the city council was free either to act favorably by ordinance or to reject them. Any favorable ordinance would next undergo court review. If everything were done correctly, an annexation decree would be promulgated.

The opposition group set about to secure petitions for merging the Menoher Heights and Coon Ridge Road areas into Westmont Borough, "in the event the annexation of Upper Yoder Township to the city was successful." The petition was signed by 216 people and was presented on February 25 to the Westmont Borough Council. Some people had signed petitions both to join the city and to join Westmont. The proposed partial annexation into Westmont complicated things legally and created public confusion about what was happening.

By early March, John Brett, an accountant and chairman of the citizens' committee supporting annexation, announced that his group had almost reached its goal of 1,620 signatures, a target that exceeded the legal requirement based upon official township records. Things came to a head on Monday, March 4. The Upper Yoder petitions were filed with the city asking it to annex the whole of Upper Yoder Township. At that same time, additional petitions were presented to the Westmont Council seeking the borough to annex the Goucher Street area in addition to the two sections sought earlier. The controversy could only be settled in court.[293]

Between May and July, the annexation cases were heard by the Cambria County Court. Westmont successfully intervened as a party in the township annexation case. Upper Yoder Township next argued that many taxpayers and tax properties existed that were not on its books at all. The scandalous admission raised the question of whether the requirement for a legitimate petition meant sufficient numbers of signatures of those actually on the tax rolls or had to include people who had evaded enrollment. The township next began parading forth people it called "taxpayers" who had escaped paying township taxes.

Annexation advocates argued the citizens' committee had relied on official township records and had exceeded the required signatures. The township was arguing that the rolls were incomplete and the true signature requirements had not been met.

In December 1957, the Cambria County Court sided with the township and ruled that the required number of signatures had not been satisfied even though the citizens' committee had been given some leeway to bring forth more names. The court also ruled that the effort to annex parts of Upper Yoder into Westmont was also invalid. An appeal to the Pennsylvania Supreme Court, not filed within the prescribed time limits, was withdrawn. Things remained the same.[294]

II. THE COUNCIL-MANAGER CHARTER CAMPAIGN

In the November 1957 election, Johnstown voters both authorized a charter commission and elected its nine members by an overwhelming majority. These included a broadly representative group—an important Democrat (Hiram Andrews), the Jaycees (James Foster Jr.), organized labor (Richard White), the clergy (Reverend Thomas Cawley), women's groups (Sarah Bernet) and two lawyers (Marlin Stephens, a Republican, and Charles Boyle, a Democrat). The chairman was Thomas Riley, U.S. Steel's general superintendent.

Almost handpicked, the group quickly formulated the charter's dominant feature—a council manager plan of local government. Under this form, the elected council would appoint a professional city manager who would operate the city government as a business and hopefully end what was seen as the crazy nonsense of the commission plan mandated by Pennsylvania law since 1913.

In late July 1958, the commission scheduled a public forum. All city hall Republicans boycotted the meeting, complaining that the charter commission planned to require that all questions from the audience be in writing. Questions from the floor would not be addressed.

John Torquato and his Democratic Party openly favored the manager plan, probably because the Republicans had controlled the mayor's office since 1936 with the exception of John Conway's 1940–43 term. The Republican Party was officially neutral. Andrew Gleason personally stayed out of the issue, probably because he was the Republican candidate for secretary of the Pennsylvania Department of Internal Affairs.

Dan Shields, an independent Republican just elected to the council, opposed the charter. By law the charter commission was to receive a modest contribution from the city budget to further its work. No such funds were made available. Shields acted in his typical style when he asserted that if council manager government was established, the first city manager would be John Torquato.

On November 4, 1958, the charter commission's proposal was defeated by 9,793 to 8,860.[295]

III. THE PENELEC HEADQUARTERS CHALLENGE

In late April 1959, the Pennsylvania Electric Company (Penelec) announced it would construct a new corporate headquarters facility to unify four scattered Johnstown offices. Penelec had abandoned its postwar plan for one large downtown building.

The announcement was a good news challenge to the community's civic fraternity. Remembering the 1950 National Radiator loss to Altoona, Johnstown leaders could not permit another community to recruit away the Penelec headquarters with its five-hundred-employee payroll, an economic development coup for any locality.

By June, Penelec's new president, Louis Roddis, announced the plan in more detail: construction of a massive headquarters complex in Cambria City. Penelec already owned some of the site—a substation was to be relocated. It was also purchasing the John Walters Lumber and Building-Supply Company. Another strip of land along Broad Street between Sixth and Tenth Avenues would be required, necessitating modification and expansion of the Cambria City Urban Redevelopment Project.[296]

Since the original Cambria City Project (B-1) had been poking along for seven years, there was an uphill challenge in getting authorization for the addition, itself technically another project—B-2. Federal officials were insisting the redevelopment authority had to demonstrate more satisfactory progress on B-1 before they would approve B-2.

The Redevelopment Authority–City Government Feud

Under Pennsylvania law, the mayor appoints city redevelopment authority board members. Since Mayor Walter Rose was a Gleason loyalist, the redevelopment authority had become

Broad Street in Cambria City before urban redevelopment. Taken on or about November 1, 1950, this photograph shows Broad Street looking west from its junction with Chestnut Street and Roosevelt Boulevard. The Immaculate Conception Roman Catholic Church steeple is near the center on the northern (right) side. Across the street is St. Mary's Convent. Holtzman's Department Store is the fourth building on the southern side. Everything visible on the southern (left) side was cleared away in the 1960s through Cambria City Urban Renewal Projects B-1 and B-2. *Courtesy Johnstown Area Heritage Association.*

captured by the Gleason faction of the Republican Party. Gleason's law partner, Norman Krumenacker, was both city solicitor and solicitor for the authority. Their law firm had the contract to do the title searches for about 150 project parcels. Jesse Wynn, a long-standing Gleason Republican, was authority chairman. In June, he announced his resignation to take the salaried position of authority assistant executive director.

The revived community interest in expediting the urban renewal program had put city council members on the hot seat, yet they were powerless to force the redevelopment authority to act with dispatch. The city could withhold matching funds, refuse to undertake redevelopment-related public works or decline to pass ordinances or resolutions required by the authority to further its program. Such non-cooperation would delay, not expedite.

By late June 1959, the city council itself was criticized for the authority's foot dragging. Having won the Republican nomination for mayor, Dan Shields was facing a young college professor and decorated war veteran, George "Doc" Walter, then president of the school board. Shields had decided his chances were better if he struck out against the Gleasons, who had no use for him anyway. Meanwhile the Republican council, excluding Mayor Rose, had become increasingly anti-Gleason.

Council sought to arrange a meeting with the authority board and its executive director, Rexford Glaspey, to review the addendum application needed for the Penelec office complex.

Favorable action by the city council was required prior to submission. When no one from the authority showed up to state the case and answer questions, Shields went on a tirade: "If the executive director, a $10,000-a-year man, can't come here of his own free will, how can we get the show on the road?"[297]

Shields next began suggesting that Norman Krumenacker's serving as both city solicitor and attorney for the redevelopment authority involved a conflict of interest. On July 9, by a four to one vote (Mayor Rose voted no), the council fired him as city solicitor. In addition to Shields, there were two other "rebels" among the Republicans—Raymond Johnson and Emilio Grandinetti. Having shown its anti-Gleason bent, the council endorsed the B-2 application.[298]

The anti-Gleason revolt had far-reaching implications. Shields began bluffing about withholding $250,000 in city matching funds destined for the redevelopment authority. Had this happened, the program probably would have shut down. There was also a purge of Gleason loyalist employees from the city payroll.

While the attack on the redevelopment authority took place during the early phases of a local political campaign, a time when almost nothing makes sense, it frightened Johnstown establishment leaders who were determined to achieve the Penelec headquarters project. The Johnstown area economy was very troubled throughout this period and the lengthy steel strike was just getting underway.[299]

The Greater Johnstown Committee (GJC)

After World War II, community betterment organizations made up of uniquely influential leaders were created in some major cities. Their memberships were limited to chief executives and senior partners of the larger, more prestigious corporations and professional firms, oftentimes labor bosses and other important people. The Allegheny Conference on Community Development had helped bring about Pittsburgh's postwar "renaissance." In 1954 the *Tribune-Democrat* had editorially urged the creation of a similar group in Johnstown to overcome a general malaise that perceptive citizens sensed had enveloped the community.[300]

In 1959 such an organization was started in Johnstown—the Greater Johnstown Committee (GJC). Its chief organizer was Howard "Pick" Picking Jr., a tireless Johnstown booster. Picking had been a funeral director who changed careers in 1945 when he took a position with the Johnstown Savings Bank. In 1957 he became the bank's president.

In April 1959, around the same time as the Penelec headquarters announcement, Picking began assembling a nucleus of top Johnstown leaders into a new organization. Among many others, they included Leonard Black of Glosser Brothers, Jack Crichton, George Greene, Owen Griffith, Fesler Edwards, Frank Pasquerilla, Frank Phillips, Charles Kunkle Jr. and Alvin Shrott.

Picking had a belief that the chamber of commerce, trying to be "all things to all people" as he stated, had become ineffective. Earlier he had been chamber vice-president and felt some bitterness when not chosen as next president. Picking believed he was passed over because everyone knew he would have shaken things up.

The petty fiefdoms that seemed to abound at city hall disgusted Picking, who would characterize their essence as self-service, not community improvement.

Picking identified, cultivated and worked at being on good terms with all sources of power and influence—political and labor leaders and those with money, brains and general prestige. He often arranged for two people he respected to work separately on an issue with neither knowing the other was doing the same thing. He then compared their efforts, selecting what he liked.

Picking would nitpick endlessly until things were the way he wanted them. A poor public speaker, he was nonetheless effective in small groups. He was often harsh toward opposition unless that opposition represented power, in which case he would work around it.

Picking had been in touch with Bill Boucher and Jeff Miller, respectively staff director and chairman of the Greater Baltimore Committee. The GJC in Johnstown was modeled in microcosm after the larger, very effective Baltimore organization.

By early October the GJC had been formed. Its first chairman was Louis Roddis, Penelec's president and CEO. The choice of Roddis served to highlight a goal—the successful completion of the Penelec headquarters project. The top leaders of Johnstown would remain focused on Cambria City (both B-1 and B-2). Nothing would be allowed to stand in the way.

In mid-January 1960, the GJC hired its first executive director, Sinclair Powell, an ex-city manager and a former urban redevelopment executive director. Through the GJC, "establishment" leaders would be reaching out to the city government and to the other municipalities in the urban area offering expertise to help define and implement a community improvement agenda. The GJC would focus on business and government issues.

There was criticism over the creation of another civic group. Concern was expressed that the GJC might dry up the multipurpose chamber of commerce, which was broader in scope and had a much wider and larger membership because it was not limited to community heavyweights. The GJC vowed to avoid competition with other civic groups.[301]

IV. THE WINDS OF CHANGE: MAYOR GEORGE WALTER'S ADMINISTRATION

The 1959 election for mayor pitted a young new face, George "Doc" Walter , against an old-style master politician, Dan Shields. Walter charged Shields with "gutter politics." Shields answered Walter had "gutter language." (Walter cussed a lot.) Indications are that Shields had engaged an investigator to check into Walter's Blair County past but found no "dirt."

To recruit more Democrats prior to the election, John Torquato had conducted a special voter registration crusade in the city. In September he announced there were 14,628 Democrats to 12,122 Republicans. "This is the first time in history," he stated, "that the Democrats have had a better than 2,100 majority...People are sick and tired of the comics going on at city hall."

Shields countered, "The burning issue of this campaign is this: Are there enough Torquato Democrats in the city...to elect his boy, Walter?"[302]

"Doc" Walter won in a three-candidate race beating Dan Shields 11,053 to 7,720, part of a general Democratic sweep. In addition to the mayor, the two other councilmen elected were both Democrats—Ed Schellhammer, a capable young lawyer blind since boyhood, and Dell Comiskey, a returning former councilman. Two non-Gleason Republicans remained on the council, Raymond Johnson and Dan Shields. After the election, Shields and Walter got along fine.[303]

A New Vision

In his January 4 inaugural address, Walter talked about a "truly Greater Johnstown." Perhaps sensing the extreme difficulties of bringing suburban boroughs and townships into the city, he announced, "It would be a happy conclusion to my administration to have Johnstown and its neighbors working harmoniously together for a truly Greater Johnstown."

George Walter's swearing in as mayor ushered forth a period of progressivism in the community. Johnstown turned upbeat. The months-old national steel strike ended on his inauguration day. The chamber of commerce soon afterward launched a successful fundraising drive to raise $1 million for industrial development, a sum that greatly exceeded more modest past efforts.[304]

The Sewerage System

Mayor Walter and the council turned immediate attention to completing the sewerage system. Not only was the state mandate still in effect, but the city had also received approval for a $250,000 grant to aid construction of the long-awaited sewage treatment plant, an award subject to cancellation if the city failed to take action by mid-April 1960.

The sewerage system involved several complicated issues. Johnstown's plant would be serving not only the city but also many suburban localities. In addition, the big trunk lines that extended through most of Johnstown had been installed over many years largely at city expense. To Mayor Walter and the council, outside municipalities should be paying charges based on their own volumetric usage of both the new plant and these lines.

By March 9, the city council had decided to revive the long-dormant Johnstown Municipal Authority founded in 1941, and to procure a new fifty-year charter. Its tenets would also be changed to allow appointment of board members living outside the city to give representation to suburban areas served by the system.[305]

By mid-June 1960, the authority had opened bids on the Dornick Point Plant. After the project was bid a second time in August, the prime contractor was Berkebile Brothers of Johnstown. Groundbreaking took place on September 13. The construction cost was $938,000. Other specialized equipment and change orders raised the final figure to $2,583,750, including the extension of a new interceptor line into the plant site.

The last major cost was the authority's purchase of the trunk lines already extending through Johnstown. This price was $1,540,160 and the money would be used by the city to complete its several remaining sewer installations. The municipal authority used temporary loans to finance its earlier work, but in February 1961, revenue bonds totaling $5 million were sold by competitive bidding to finance the entire program.

During the first eight months of George Walter's administration, the decades-old sewer project had been rekindled and was underway, and by December 1961, the plant was in full operation with the exception of sludge incineration.[306] In addition, after extensive meetings and negotiations, nineteen area municipalities had begun to cooperate with one another.[307]

A Jolt to the Urban Redevelopment Authority Program

On February 12, 1960, Mayor Walter fired Herbert Beegle, James Hanson and George Hoover, the three officers of the five-member urban redevelopment authority. Walter's justification was that he had heard many complaints about the authority's lackluster performance. He also stated the authority had failed to keep him apprised about its activities. The mayor quickly appointed Warren Reitz, Robert Parsons and Allen Brotemarkle to replace them. These actions involved uprooting a Gleason-aligned agency of the city government.

Herbert Beegle, the ousted chairman, stated that "the mayor's ill-advised action" would be contested. He also said that it was unfortunate that uncertainty was injected into the city's business at such an important time in the program, a veiled admonition that Walter's action would delay and perhaps jeopardize realization of the proposed Penelec Headquarters Center.[308]

The issue needed to be settled in the courts. If the authority were improperly constituted, all its actions, including property acquisitions, demolition contracts and transfers of property for later reuse, would be subject to challenge.

On March 15, the Cambria County Court upheld Walter's dismissals. There were still other issues. Norman Krumenacker, the authority's solicitor under the former board, refused to furnish title certificates for many acquired properties because of a dispute over the contract between his law firm, Gleason and Krumenacker, and the new authority. In addition, the Cambria Court decision was appealed.[309]

In January 1961, the Pennsylvania Supreme Court upheld the Cambria County Court's ruling supporting the mayor's dismissal authority in a four-to-three decision. A few days later, in an almost unprecedented turn, the high court reversed itself with several justices withdrawing their opinions. Walter's actions had become null and void.[310]

By this time, the original term of George Hoover, one of the three fired by Walter, had expired, giving the mayor an appointment of his own. Walter had no choice but to allow Beegle and Hanson to be reseated. Suspecting the masterful wheeling and dealing of Andrew Gleason was behind the high court's turnabout, he called for a legislative investigation—a plea that went nowhere.

Meanwhile, Walter wrested control of the redevelopment authority. Norman Krumenacker resigned as solicitor and was replaced by Gilbert Caroff. To clear the decks for an investigation into his management practices, the authority suspended Rexford Glaspey, its executive director. Sinclair Powell, the new executive director of the Greater Johnstown Committee, filled in as acting executive director. Cited with mismanagement, Glaspey was fired and Powell continued to manage the agency until February 1961, when Michael Flynn, Walter's development coordinator, was appointed to the post.[311]

The Cambria City project next moved into high gear. Numerous property owners had difficulties establishing clear title to their holdings. Many residents owned the structures that had been built upon lots actually owned by other people or corporations, a result of ground-rent situations. After demolition and site clearing, there was public criticism of vacant land remaining where people earlier had lived and done business.

Over the course of time in both B-1 and B-2, 179 parcels were acquired, 212 families and 54 individuals were relocated, 72 businesses were moved and 274 structures were demolished. The street pattern was changed, and at long last the redeveloped site was sold for new uses.

In addition to the Penelec Headquarters Center, the twin projects created a seven-acre site for a huge Bestform Plant built and leased by Diversification, Inc., the development corporation of the chamber of commerce. Sites were also made available for General Telephone Company, Westinghouse, Better Tire Sales and a Minute Car Wash. By 1967 both B-1 and B-2 had been closed out.[312]

Planning Initiatives

After World War II, federal agencies began administering more programs that authorized grants and loans to local governments. Regulations increasingly required these undertakings to comport to community planning, a dictate especially true of the Housing and Home Finance Agency (HHFA), the precursor to the U.S. Department of Housing and Urban Development (HUD) established in 1965. HHFA administered the urban renewal program.

There had been no postwar community planning prior to 1958 in either Johnstown or Cambria County, a factor that delayed Cambria City's redevelopment. In 1958, however, the city retained a consulting firm, Community Planning Services, to develop a comprehensive plan. Its preparation was motivated primarily to fulfill urban renewal requirements, not to bring forth a vision for the future city.

With the election of George Walter as mayor and the almost simultaneous establishment of the Greater Johnstown Committee, planning was promoted as important for Johnstown regardless of federal requirements.

In June 1960, the GJC announced a seventeen-point platform to help the Johnstown area address its problems. The GJC also raised sizeable money to hire the Pennsylvania Economy League to conduct financial and efficiency studies of Johnstown's government and school district and to help pay for the planning efforts.[313]

The GJC and the mayor both began urging the creation of a Regional Planning Council to develop a plan for the entire urbanizing area. The council would be made up of officials from the city and suburban municipalities. Each locality would make a small appropriation to finance the organization.

The city joined the effort in April 1961, and by mid-June at least fifteen area municipalities were members. In time, the council became the Cambria County Planning Commission.[314]

Public Acquisition of the Johnstown Water Company

In June 1958, the Bethlehem Steel Corporation informed Johnstown officials that the city might acquire the Johnstown Water Company for $13 million. The price was determined by Morris Knowles, Inc., a reputable Pittsburgh consulting-engineering firm.

The city council immediately sought proposals from potential fiscal consultants to advise its members on the feasibility of the acquisition. Council's choice was an investment firm that would market municipal bonds needed to buy the system. The bonds were to have been sold on a negotiated basis, not competitively bid. When Bethlehem and Johnstown Water Company officials learned about the arrangement, they suggested to the city that whoever might be giving advice should not stand to profit from the deal.

City officials were indignant that the seller was telling them they should not be free to choose whatever advisor they wanted. This reaction alerted the steel company, itself a water customer (as were many of its employees), that there was hanky-panky afoot. Bethlehem next withdrew the offer for the time being.[315]

Just before Christmas 1962, the Bethlehem Steel Company once again offered to sell both the Johnstown and Saltlick Water Companies to the city. The actual offering price, approximately $12 million to Bethlehem, would be the "net proceeds from a bond issue of $12.5 million." Bethlehem would be absorbing the cost of feasibility studies and appraisals, as well as the bond sales and discount costs, keeping whatever funds remained. Bethlehem also insisted that the bonds be marketed by competitive bidding.[316]

The offer also spelled out an inventory of the reservoirs, water rights, almost fourteen thousand acres of watershed, together with the treatment, storage, pumping and distribution systems. Bethlehem was not willing to give up its mineral rights, a sticking point with the city council.

The city contracted with Gannett, Fleming, Corddry and Carpenter, Inc., to update its 1959 engineering evaluation of the Johnstown Water Company. It also retained a group of local realtors to appraise the land, caretakers' homes and other buildings.[317]

The Municipal Authorities Act had been amended in the 1940s to require that whenever a local government alone or two of them acting jointly were giving authorization to a municipal authority to acquire a regulated public utility, each governing body had to approve the matter by a favorable vote of at least two-thirds of its members. Since Eddie McCloskey and Dell Comisky were both opposed, the deal could not go through as contemplated. As such, water supply could be a function of neither the Johnstown government nor its municipal authority.

No such restriction applied if three or more municipalities were making such an authorization. A majority vote by three or more councils would suffice.[318]

Since McCloskey and Comisky remained adamantly opposed, the council led by Mayor Walter set about to create a new municipal authority consisting of three municipalities served by the company.

The makeup of the authority and its board was the product of extensive negotiations and compromise. In addition to the city, Southmont and Westmont were selected as founding municipalities of what would become the Greater Johnstown Water Authority, governed by an eleven-member board. Each of the three incorporating municipalities would name two of its own citizens plus one citizen from another water customer locality. Finally there would be two board members at large chosen jointly, one from the city and one from the suburbs.[319]

There was concern about how to retain the officers and staff of the Johnstown Water Company while protecting them from the vicissitudes of local politics. This would be accomplished through the creation of the Laurel Management Company, founded in the late summer of 1963. Charles Kunkle Jr. was president and its other officers and employees were from the Johnstown Water Company. Having the blessing of the Bethlehem Steel Corporation's top management, Laurel's officers sought a forty-year management contract, but the new authority board members wanted a shorter, five-year term.

Formal closing took place on February 11, 1964. Bethlehem actually received $11,464,788 for the two companies. Authority operation began at 12:01 a.m. Wednesday, February 12. Since no corporate income taxes would be paid under public ownership, a 4 percent rate reduction was immediate.[320]

V. CONSOLIDATION OF GREATER JOHNSTOWN

Most Johnstown business and professional leaders continued to press for a unified city—the consolidation of all urbanized boroughs and townships into Johnstown. Civic organizations were offering resolutions of support. The *Tribune-Democrat* consistently editorialized favorably. Even when consolidation was momentarily forgotten, the newspaper would feature an article keeping the issue alive.

In October 1962, during a cycle of civic vitality and accomplishment, interest in consolidation rekindled. The Johnstown Regional Central Labor Council and six steel locals adopted resolutions of support. The Kiwanis Club made consolidation its priority goal. The Greater Johnstown Committee began to devise an overall plan to bring about the eventual unification of the urbanizing area.

In October 1963, a "central coordinating committee" was established, consisting of representatives from nearly thirty civic organizations that supported consolidation. Charles Venner, representing the Kiwanis Club, was named president. Albert Roess, an insurance executive, was vice-president.

The city council next passed a resolution expressing a willingness to merge with "any and all municipalities" that petitioned for consolidation. The vote was four to one. Eddie McCloskey, a constant maverick, voted no.

There were many consolidation opponents living in the suburban areas where annexation into Johnstown was under serious consideration. Most remained silent. With few exceptions, establishment leaders were entirely supportive, including the steel mills' top executives, leading bankers, Louis Roddis of Penelec, Frank Pasquerilla, newspaper and television management, top lawyers and so forth. People who opposed consolidation feared ostracism by the elite.

There was also the matter of race, especially during the school district reform era following the 1954 *Brown v. Board of Education of Topeka* decision. The suburbs were predominantly white, and most blacks lived in the city. To merge with Johnstown might have led suburban school systems to combine with the Greater Johnstown School District, which had more black and less affluent pupils. White suburban residents opposed consolidation quietly out of racial and social class concerns without voicing their reasoning. Content in their suburban world, opponents were not moved by more abstract community improvement, civic pride and social justice arguments.

When the League of Women Voters sponsored a debate on the subject in March 1963, the opponents brought in an outside expert, Milton W. DeLauncey, executive secretary of the Pennsylvania Association of Township Supervisors. As reported in the pro-consolidation *Tribune-Democrat*, DeLauncey's leading argument was, "We would be safer from communism if Greater Johnstown were not consolidated," a patently absurd posture.[321]

In November 1966, a movement to unify Westmont with Johnstown City began, led by an Improve Johnstown Association, or IJA. The chairman was Richard Mayer, publisher of the *Tribune-Democrat*.

The campaign aroused opposition. Wilbur "Wid" Schonek and Frank Pristow began speaking out against Westmont's joining the city. Schonek was using two arguments: Members of Johnstown's power elite were intimidating their employee subordinates, including their families, into signing petitions. Schonek and Pristow claimed to be sticking up for the less fortunate. In addition, Schonek voiced a sweeping but often correct generalization: Increased size brings on

higher taxes. By isolating itself from Johnstown's many problems, Westmont would probably maintain lower tax rates. The Schonek-Pristow team named themselves the Truth Committee.

Proponents were confident they could present petitions with adequate signatures. The IJA leaders were mindful of the Upper Yoder campaign seven years earlier when numerous taxpayers surfaced, although their names had never been on the tax rolls.

In late November and early December, 172 volunteers began circulating the two kinds of petitions. The first type had to be signed by at least 50 percent of all property owners "in number and interest." The second needed authentic signatures from 60 percent of all taxable inhabitants residing in the borough. Volunteers went door to door and manned a campaign headquarters in the Westwood Shopping Center.

By early January the IJA leaders announced that both types of petitions had been signed by more than enough legitimate property owners and taxpayers. The instruments were presented to the borough council on February 13, 1967. Meticulous counting and authentication commenced.

On that same day several Southmont residents announced they would also be conducting a petition drive for consolidation into Johnstown. Dr. William Hargreaves, Frank Pasquerilla, Charles Price and Wallace Williams headed the movement.

The Southmont group tried a different approach. It arranged for the Southmont Borough Council to undertake a straw vote referendum on the consolidation question in the May primary. On May 16, 703 voted in favor while 522 voted against consolidation. While nonbinding, the vote gave confidence and legitimacy to Southmont's drive.

In May 1967, the Truth Committee proclaimed that the Westmont petition drive had failed, an announcement precipitating charges that borough officials had leaked otherwise confidential tallies to the Truth Committee. When Ron Stephenson, news anchor for WJAC-TV, used the term "pilfered" to describe how Schonek acquired the information, Schonek threatened a $1 million lawsuit against the station and Stephenson personally. After a testy confrontation at the WJAC office, no lawsuit was filed.[322] The IJA next began seeking more signatures, a quest that was only marginally successful.

While divided on the issue, the borough council did not favor Westmont becoming a part of Johnstown. Faulty or inadequate petitions provided the easiest way to justify taking no action; but even if the petitions had sufficient bona fide signatures, the borough council would not have been required to petition Johnstown for annexation.

In September, Westmont's council opened its records to the Truth Committee and the IJA. While the tally was close, the borough had determined the petitions were insufficient and the council took no action. On December 12, 1967, the matter was declared "closed."

A similar fate occurred in Southmont Borough, where IJA leaders had delayed filing the petitions temporarily in hopes of electing a more pro-consolidation government. In July 1968, the Southmont Borough Council also ruled its petitions were inadequate. A formal decision to do nothing was made on September 9, 1968.[323]

The Constitutional Convention and the New Article IX

The anomaly of Southmont's citizens voting 703 to 522 in favor of consolidation, only to find that the borough council was meticulously invalidating petitions, seemed ironic to the

IJA. Knocking on doors in search of signatures, tracing absentee property owners, finding one spouse willing to sign while the other refused and chasing down multiple owners were not the ways of democracy. Residents who owned no taxable property or who otherwise were not taxpayers could not be counted. The entire process seemed archaic in the extreme to consolidation supporters. IJA leaders soon came to believe that voters should decide the consolidation questions in an election.

During the thick of the consolidation campaigns, Pennsylvania citizens had voted in the spring of 1967 to establish a constitutional convention empowered to propose amendments to the state constitution. A favorable vote of the Pennsylvania electorate in a subsequent election would adopt the changes and amend the constitution.

Two prominent Johnstowners, each active in the IJA and Greater Johnstown Committee, Frank Pasquerilla and Fred Cunningham, were elected to the constitutional convention in November 1967. The convention's work began immediately. Pasquerilla was a co-chairman of the Local Government Committee, and Fred Cunningham served on its Annexation and Boundary-Change Subcommittee.

The constitutional convention recommended a clause that mandated the legislature to enact uniform legislation to govern "annexation, merger, and boundary changes" of Pennsylvania local governments. "Uniform" meant the procedures would apply the same across all categories of local government—boroughs, townships and cities. If the legislature failed to adopt such a statute, there would still be a remedy. Article IX, Section 8 read, "The electors of any municipality shall have the right, by initiative and referendum, to consolidate, merge, and change boundaries by a majority vote of those voting thereon in each municipality without the approval of any governing body." The voters of Pennsylvania approved the new Article IX on April 23, 1968. The stage was then set for another consolidation effort.[324]

The West Hills and City Consolidation Referendum[325]

The long-standing goal of uniting the municipal city with the true socio-economic city was seen to be readily attainable. Although the legislature had ignored its constitutional mandate to enact uniform legislation addressing "mergers, annexations, and boundary changes," Johnstown's leaders could recall Southmont's straw vote in 1967. Members of the Greater Johnstown Committee and other leaders genuinely believed that when put to the test, the electorate of the three West Hills localities and the city itself would vote to unite and form a new city.

Just before Thanksgiving in 1969, the Greater Johnstown Committee decided it would sponsor an important undertaking—the consolidation of Westmont, Southmont, Upper Yoder Township and the city itself. To succeed, a favorable vote in the May 19, 1970 primary would be required. Once successful, future efforts would seek a united Greater Johnstown. By mid-December 1969, referendum petitions were signed.[326]

The effort had to be much broader than Greater Johnstown Committee membership. A Truth Committee on Consolidation was formed. Its initial chairman was a Southmont resident and Penelec foreman, Patrick Brady. There was soon a membership of 850 people representing the four municipalities. Their names appeared on April 17 in a large two-page newspaper advertisement with a theme: LET'S GET TOGETHER AND BUILD A NEW CITY. Members went door

to door to persuade them to vote favorably. There were also coffee klatches often with Phillip Chamberlain, the executive director of the Greater Johnstown Committee, as speaker.[327]

The Greater Johnstown Committee (GJC) raised a campaign fund of $50,000. Some of the money was used to retain Ed Kane, a Johnstown native and media consultant located in Indianapolis who returned to Johnstown for the consolidation campaign. The GJC fund also financed TV spots, newspaper advertisements and the preparation and distribution of other materials. It also paid for a study as to the probable effects of consolidation upon local tax rates and fiscal matters.

A leading event in the consolidation campaign was a two-and-a-half-hour TV debate aired live by WJAC on Friday, April 24. Dr. William Hargreaves, chairman of the GJC, and Frank Pasquerilla, then president of the Johnstown Chamber of Commerce, spoke in favor. Harry Finley, an insurance agent and an amateur editorial writer for WARD radio and TV, together with G. Martin Fox, the treasurer of Southmont Borough, constituted the opposition. WJAC's news director and anchor, Ron Stephenson, moderated.

The proponents stressed the need to modernize the community to address its major problems—an aging, "worn-out" core city losing its promising young people. A new, united city with a bigger population base would get more attention in Washington and Harrisburg. They reasoned that a municipal government accountable to the true and total city would be much better for Johnstown over the long term.

Opponents suggested that taxes in the suburbs would go up. It was also stressed that there was no way provided in the law for the new government to come into being since the legislature had not enacted the statutes required by the recent constitutional amendment. Pasquerilla and Hargreaves had stated that once the referendum was successful, the leaders of the four localities would meet together and decide what the new government would be, a weak argument because there was no statutory basis for such a compact, even if the municipal leaders somehow agreed to one.[328]

The opponents to consolidation also formed a committee—the Truth Committee on Annexation. The term "annexation" was deliberately pejorative in that it suggested the three suburban localities would be absorbed into the existing city (an annexation), not joined together into what might become a totally new municipality (a consolidation).

A leader of the Truth Committee on Annexation was Wilbur "Wid" Schonek. While there were other members, they were never identified. Unlike the proponent Truth Committee on Consolidation, the opposing Truth Committee on Annexation did not register as a political organization with the Cambria County Election Office.

Another significant opponent surfaced, a man not affiliated with the Truth Committee on Annexation, Robert Waters, a member of the Greater Johnstown Committee and the former CEO and later board chairman of the National Radiator Corporation. Waters had adamantly opposed the merger of his National Radiator Corporation with the U.S. Radiator Corporation in 1955. Once the merger took place, he was summarily fired as chairman.[329] After the Crane Corporation's acquisition of the National-U.S. Radiator Corporation and its shutdown in Johnstown several years later, Waters had every reason to be antagonistic toward mergers. Waters wrote several letters to the editor that were published in the *Tribune-Democrat*. He also took out a large advertisement in the form of a similar letter published on April 28, about three weeks before the voting.

In his advertisement letter, Waters made two basic assertions: taxes were certain to go up in the event of consolidation, and no one knew how the new municipality would be governed—what representation the West Hills area might have on whatever new council would come into being or what would be the basic form and structure of the new government.

Waters, a bachelor, ended his letter: "When you go to cast your vote, remember this: A 'marriage' of municipalities, like that of individuals, is easier to get into than to get out of. And for a suburb that might change its mind about wanting to be married to a city—there are no divorce courts for unscrambling an unhappy political alliance. Therefore, until you know what you are getting into, vote NO on consolidation."

A major development in the consolidation drive involved an opinion signed on April 2 by Warren Morgan, a deputy attorney general. The question had been put to the attorney general's office by then State Representative John Murtha about the future status of the Westmont-Hilltop School District if the three West Hills municipalities and Johnstown City united.

Morgan's opinion letter, released at a Westmont-Hilltop School Board meeting on April 13, indicated that if the consolidation took place, the two school districts also would merge—a lightning rod opinion that killed all hope of referendum success.

Wayne Wolfe, a member of the Greater Johnstown Committee and solicitor for the Westmont Hilltop School District, knew immediately that Morgan's opinion was legally incorrect. The opinion was challenged and on April 17, 1970, the attorney general's office invalidated its April 2 opinion and wrote that the consolidation would not affect the schools.

The damage, however, had been done. Thomas Nesbitt, a former Upper Yoder Township supervisor and a retired Bethlehem Steel office worker, stated at a meeting of the Truth Committee on Annexation that the city was trying "to get our schools." It was also reported that "some teachers in the Westmont Hilltop school system had told their pupils that consolidation would mean they would be bussed to the Washington Street and Hudson Street Schools."[330]

Patrick Brady stated that the campaign was much uglier than newspaper accounts had indicated. He had personally received critical phone calls effectively accusing him of seeking to integrate the suburban schools.[331] Race had become a dominant concern, but it was a subject always mentioned discreetly among friends.

Most members of the volunteer fire departments in the West Hills areas were opposed. An ambulance was driven over the streets prior to the campaign bearing a sign stating that consolidation would end free ambulance service.

The Upper Yoder Township supervisors prepared an eight-page brochure that was critical of consolidation. It was mailed to all township residents prior to the referendum.

Opponents also charged that Johnstown's elite leaders were trying to "ram consolidation down their employees' throats." Some of the last-minute opposition literature read: NO ONE WILL BE LOOKING OVER YOUR SHOULDER WHEN YOU CAST YOUR NO VOTE IN THE VOTING BOOTH.

Consolidation failed. The city voted overwhelmingly in favor in the three ballots (one for joining with each of the three municipalities). The margins were nearly the same in each of these three tallies—approximately 10,600 in favor to about 865 against. The Westmont vote was 1,974 to 1,148 against; Southmont voted against by 878 to 475; and Upper Yoder was against by 1,580 to 887.

Most members of the Greater Johnstown Committee were stunned. They had already prepared for a victory party to be held at the GJC offices in the Swank Building. The party that went on until the late evening was not a happy event.[332]

While consolidation of the Johnstown urban area into a single municipality remains a distant goal among many Johnstown civic leaders, there have been no serious activities to achieve it since the 1970 defeat.

VI. A STRONG-MAYOR CHARTER INITIATIVE

By the early 1970s, Johnstown's city government had declined into near moribund ineffectiveness. In January 1971, Mayor Kenneth Tompkins and Councilman Robert McKee, both Republicans, had been indicted in the Teleprompter scandal. Tompkins later pleaded guilty and resigned as mayor. McKee was convicted soon afterward. The city had been disgraced nationwide.

That same year the Pennsylvania Crime Commission's report about Johnstown was also released.[333] Among other things, it had recommended that the city get rid of the commission form of government. The Pennsylvania Economy League had already made the same suggestion, and the change had been a long-term agenda item of the Greater Johnstown Committee. Many of its members believed that the circus-like antics of city officials had contributed to consolidation's defeat the previous year.[334]

The Charter Commission Takes Shape

With the support of the Greater Johnstown Committee, Gene Swetz, its executive director, proceeded to put together a seven-person slate, each member of which would circulate and file a petition for election to a charter commission. Another petition to force a referendum on whether to create a charter commission was also circulated. Everything would be decided in the fall election.

On November 2, 1971, the Johnstown City electorate voted to establish the commission by an overwhelming margin. Its seven members were also elected: Patrick J. Casey, Robert Davis Gleason, Saul Griffin, William Dill, Thomas Heider, Curt Davis and Andrew Tilly. There were no women. Griffin and Tilly were black.

Believing that a favorable vote on the charter itself would be more likely at the spring primary, the commission worked expeditiously to get a proposal on the ballot for an April 25, 1972 referendum. Hearings were conducted throughout the city. By February, the commission had decided to propose Mayor Council Plan A as provided in the Third Class City Optional Charter Law.[335]

Of the five members then on the city council, only Paul Malinowsky supported the new charter. Herb Pfuhl Jr., the Republican mayor who had just taken office in January, was neutral. Democrats George Arcurio Jr., Victor Bako and James Malloy opposed the change. The political leaders John Torquato, Robert Gleason (uncle of Robert Davis Gleason, a charter commissioner) and Wid Schonek—all of whom lived outside the city—were noncommittal, preferring to let the city's voters decide for themselves.

On April 25, Johnstown voters approved the change by 5,992 to 3,167—almost a two-to-one majority. The new system would be taking effect in early January 1974, a year and eight months following the referendum and just over sixty years after the old commission form had gotten underway in December 1913. Holdover members of council would serve out their terms. Since Mayor Herb Pfuhl sought to become the first "strong mayor" in the new government, he was required to undergo another party primary race and runoff election in 1973 for the four-year term.

There would be nine council members elected at large, a net increase of five, excluding the mayor. The increased size was intended to provide more seats to make it easier for newly annexed or consolidated areas to have representation. The mayor would appoint the department heads and manage the city. The council would both enact ordinances, including the annual budget, and pass resolutions. The mayor could veto an ordinance, and a minimum two-thirds vote by council was needed for override. The city treasurer and controller remained with no change in duties. The council would continue to appoint the city clerk. Neither the whole council nor its individual members were to engage in the management of the city, the exclusive responsibility of the mayor.[336]

VII. THE PENNSYLVANIA REHABILITATION CENTER: THE HIRAM G. ANDREWS CENTER

As World War II was ending, the state of Pennsylvania enacted Act 345, the Vocational Rehabilitation Act of 1945 creating a Bureau of Rehabilitation in the Department of Labor and Industry. The act's purpose was to provide a state program to rehabilitate people who were severely handicapped or disabled due to congenital defect, disease or injury. The goal was to help them become self-sufficient, employed and able to care for themselves. Since the clientele would be made more independent, rehabilitation would lessen public dependency.

The fledgling bureau soon found itself contracting with private institutions for services. By the late 1940s, it was also sending about seventy-five clients per year to Virginia's pioneering institution, the Woodrow Wilson Rehabilitation Center near Staunton.

By 1952 the State Board of Vocational Education had begun to advocate Pennsylvania's developing its own comprehensive rehabilitation center modeled somewhat after Virginia's facility.

At the April 1953 meeting, it was announced that Governor John Fine had requested that funding for a Pennsylvania center be provided through the General State Authority (GSA), a state agency that issued bonds and constructed public facilities for lease to commonwealth agencies and institutions. This led to Act 166 of 1953, a statute that authorized the GSA to locate and construct a Pennsylvania Rehabilitation Center.

The General State Authority consisted of a board aided by a small staff. Its president was the governor. The eleven other members were all senior state officials and legislators. In 1953 and 1954, there were ten Republicans and two Democrats. Hiram Andrews from Johnstown, the House minority leader, was one of the two Democrats on the GSA board.

Efforts were made by leaders in Lewistown, Altoona, Williamsport, Harrisburg and Danville to attract the facility to their community. Hiram Andrews contacted Walter Krebs to seek his assistance in locating the institution at Johnstown.

Krebs immediately called Andrew Gleason, who agreed to do all he could in the community effort. Andrews had informed Krebs that the community would have to furnish a suitable site at no cost to the state. Krebs agreed that the Tribune Publishing Company would guarantee the availability of such a site. There would be a community fund drive to finance it, but ultimately his company would be responsible should the fund drive fail. A fifty-acre site on Goucher Street in Upper Yoder Township was proposed.

Gleason immediately went to Harrisburg and lobbied the General State Authority board. He began with his friend Charles Barber, the auditor general, and then went to the others. "They all came aboard," Gleason stated.[337] At its meeting on August 23, 1954, the GSA determined by unanimous vote that the Pennsylvania Rehabilitation Center would be located at Johnstown. The original cost estimate was $2.5 million. A fund drive, conducted by the Johnstown Chamber of Commerce to raise the $125,000 needed to purchase the site, was successful.

Construction began in February 1956. When completed three years later, it had cost about $10 million including $1.5 million for equipment and furnishings. The initial building covered eight acres and had a medical wing with forty-eight beds. There were three vocational-training wings, a cafeteria that could seat 450, both a swimming pool and a small therapy pool and an auditorium-gymnasium. An open-house ceremony and dedication was held on April 16, 1959.

In 1967 a major expansion was authorized. Construction began that July for a two-phase $3.5 million expansion. The first phase was a new wing dedicated in late April 1969. The second phase, largely a dormitory area for double rooms, was completed in June 1971. The additions added more space to the building, which now covers twelve acres.[338] During the first year of operation, the Pennsylvania Rehabilitation Center admitted three hundred clients. It was renamed the Hiram G. Andrews Center on July 12, 1979, by statutory enactment.[339]

ALL POLITICS IS LOCAL: POLITICAL DEVELOPMENTS FROM 1950 TO 1980

I. CHALLENGES TO JOHN TORQUATO

The 1956 November election in Cambria County featured a sweeping victory for President Eisenhower over Adlai Stevenson. Eisenhower carried the county by 4,500 votes, despite a Democratic registration advantage of over 18,000. In the race for state senator, Ernest Walker, a Republican, beat the incumbent senator, John Haluska, by 3,000 votes. Walker, an attorney and popular war veteran, became the first Republican to serve Cambria County in the state Senate since 1924. Another Republican, John Saylor, was reelected congressman for a fifth term. The 1956 election also marked the first time he actually carried Cambria County. Previously Saylor had needed Republican majorities in Indiana and Armstrong Counties to win.

Seven weeks after the GOP sweep, Torquato, then secretary of the Department of Labor and Industry in Governor George Leader's administration (1955–1959), was returning to Johnstown from a Washington trip. At Breezewood, a state trooper stopped him. Torquato's approval was needed to release some records. A fund Torquato had administered was being investigated. The matter was leaked to the newspapers. Leader next publicly asked Torquato to resign. Torquato refused and was fired.

Exactly what precipitated Leader's outlandish action is not publicly known. Torquato was not charged with any misfeasance or malfeasance. Hiram Andrews, the Democrat's whip and an ex-speaker of the House, said that Torquato was made a scapegoat. Torquato made no verbal attacks against the governor and vowed to continue supporting the Democratic Party.

By March, a revolt was underway in the Cambria County Courthouse. Seven leading Democratic officeholders, coincidentally none facing imminent reelection—District Attorney David Wolfe, Recorder of Deeds Dennis Westrick, Register of Wills Michael Hartnett, Prothonotary Joseph Dolan, County Commissioners Thomas Owens and Pat Farrell and Clerk of Courts David Wess—all signed statements renouncing Torquato's party leadership. In addition, two Democratic judges, Ivan McKendrick and Alton McDonald, both stated Torquato should resign as county chairman. When asked to comment, many local officials

were "absent." Only Hiram Andrews made positive statements about Torquato and reminded everyone that the county chairman remained in charge of patronage.[340]

Torquato weathered the tempest. He never criticized another Democrat publicly. Torquato orchestrated slates of candidates for Democratic primaries, and once any Democrat was nominated, Torquato's organization supported that person.

In the May 1957 primary and the November run-off elections, all slated Democratic candidates in the state and county races won although none of the anti-Torquato rebels faced reelection until 1959.

Torquato also faced some unproven charges in an investigation of kickbacks received from the purchase of road cinders. Five men received jail terms. Nothing implicated Torquato.

By May of 1958, Charles Hasson, an Ebensburg attorney, sought the chairmanship of the Cambria County Democratic Party but his effort fizzled. John Torquato, the chairman since 1942, was reelected.[341]

Challenges to the Gleason Leadership

In March 1958, the GOP State Steering Committee had named Andrew Gleason to be the party's slated candidate for secretary of the Department of Internal Affairs. The choice brought an immediate rebuff from Morgan Jones, a Johnstown attorney and member of the Republican State Committee. Jones wired George Bloom, the Republican state chairman, "Can't support any ticket with Gleason."

Jones next announced publicly, "We've been waiting for twenty years for Gleason to get his name on the ballot, and now that it's on, we'll show him what we can do, and the vote won't be favorable."

Another Republican was seeking the same nomination in the May 1958 primary, an Albert Pechan from Armstrong County. Gleason won by five thousand votes in the Cambria County primary but Pechan had amassed over seven thousand votes. In the November election, Gleason lost his home county to Genevieve Blatt by about the same margin as the respective party registrations.

Democrats usually controlled the county courthouse throughout the 1950s and 1960s, thanks to the voter registration advantage orchestrated by Torquato's deft leadership.

The Johnstown municipal government was very often controlled by the Republicans but there had been a three-to-two Democratic advantage on the council from 1954 until early 1958 when Dan Shields and Raymond Johnson, both "independent" Republicans, were seated following their November victories. That July, Emilio Grandinetti, a Gleason-organization Republican, was appointed to finish the term of Raymond McDermit, a recently deceased Democrat. This then gave the Republicans all five council seats, including Mayor Rose. Three of the members—Rose, Louis Saylor[342] and Grandinetti—were considered Gleason loyalists.

The deference of the council to the Gleasons proved thin. As discussed in the previous chapter, Norman Krumenacker, serving as both city solicitor and redevelopment authority attorney, was fired in July 1959 as city solicitor by a four-to-one vote. Mayor Rose, the sole opponent, had been unable to stop Dan Shields's coup.[343]

The eruption indicated a breakdown in a patched-up harmony fashioned within Cambria County Republican ranks in 1956 when factional leaders—the Gleasons, Walter Suppes, Bill

Heslop and others—made an informal peace pact at the urging of George Bloom, Pennsylvania's GOP chairman.

The Republican Party leadership had supported Kenneth Tompkins for mayor in the 1959 primary when Dan Shields, the Gleasons' nemesis, had won. The Gleasons then "washed their hands" of the city election, placing Raymond Johnson and Emilio Grandinetti in charge of their effort. After George Walter defeated Shields, the Democrats had a three-to-two majority on city council and maintained a big majority on the Greater Johnstown School Board.

The Republican Party in Cambria County sought once again to revive itself. A concerted effort was energized to elect ex-Mayor Ned Rose to the state Senate in 1960 but Haluska won by a narrow margin. Another promising young Republican, Cecil Leberknight, also made a close but unsuccessful race against Hiram Andrews. These close contests had occurred in the same 1960 election when Kennedy had carried the county over Richard Nixon by fourteen thousand votes. The only important Republican success belonged to Congressman John Saylor.

In February 1961, City Councilman Dan Shields, a Republican for fifty-three years and seeking reelection, bolted the Republican Party and became a Democrat. Ten weeks later, he died.[344]

James Malloy was appointed to finish Shields's term. Eddie McCloskey was elected for four years in 1961, while Malloy was defeated in a tight race by Howard Deardorff, a Republican. The Democrats maintained a majority on the council but this included McCloskey in his twilight years when he was irascible and unpredictable.[345]

A Republican Bounce

The 1962 primary and general election season proved a good era for the Republicans. Cecil Leberknight actually defeated Hiram Andrews, the eighty-six-year-old Democratic legend who had been in the legislature for twenty-four years, twice serving as speaker of the House (1955–56 and 1959–62). Richard Green, a young lawyer and former president of the Cambria County Young Republicans, defeated Louis Rovansek, a seven-term state legislator.[346]

The Cambria Independent Democrats: The CIDs

The anti-Torquato movement continued to smolder. By 1962 various anti-Torquato factions had congealed into the Cambria Independent Democrats (CIDs). One leader was Robert Lynch, a business education teacher at Johnstown High School. Lynch, reputed to have been smart but caustic, made a bid for the state Senate in 1964 but was badly beaten in the primary.[347]

Lynch was chairman of the CID organization in 1963 and 1964. He also had an interesting co-chairman, Louis Coppersmith, an attorney whose mother was a sister of the founding Glosser Brothers. At this time, Coppersmith disliked Torquato intensely.[348]

Party chairmen were chosen in even-numbered years following the spring primaries when the district committeemen and committeewomen were all elected.

The CIDs' primary objective was to remove Torquato from chairing the Cambria County Democratic Party. The CIDs made continuous exhortations for Torquato to resign voluntarily. If not, they wanted the chairman chosen by popular vote in the primary and not by a majority vote of the district committee members at party conventions. The strategy was rooted in a belief

that Torquato would lose such an election.[349] The CIDs wanted secret balloting at the party convention when the chairman was elected, a proposal Torquato opposed. Torquato had a lot to say and to do with who ran and who was elected to the district committees. Those he handpicked for the slates in turn supported him. Torquato also controlled many state and county patronage jobs and could influence certain municipal and non-teaching school district appointments. Torquato would neither resign nor be replaced.

The 1963 local and county elections marked the climax of the CID's anti-Torquato movement. Six of the ten candidates endorsed by the CIDs were nominated in the primary over the party slate.[350] The CIDs endorsed neither judgeship nor city office candidacies. Torquato's organization won only four primary nominations at the county level.[351]

The question next arose as to what support the Cambria County Democratic Party would give to CID-endorsed candidates who had won in the primary. At a meeting of the county committee the matter was not resolved. The usual October pre-election, twenty-five-dollar-a-plate dinner was called off. At an August party meeting, Torquato attacked the CIDs as a group but no individual members.

Prior to the election, however, Torquato reverted to his accustomed ways and urged, "Vote the straight Democratic Party ticket." The 1963 CID revolt contributed to some rare Republican victories at the courthouse. Ted Metzger, a popular and dynamic campaigner, defeated Michael Hartnett for register of wills. Eldred Jones also beat Spear Sheridan, a Torquato loyalist, for county treasurer.

The CIDs had begun to wane in 1964 and 1965. The group had failed to oust Torquato, its primary objective. After a Torquato courtship, County Commissioner Joseph Gorman broke away, claiming CID leaders were trying to dictate to him.[352]

Party Influence Wanes: The 1964 and 1968 General Elections

The November 1964 general election was wildly uneven. President Lyndon Johnson carried Cambria County over Barry Goldwater by 55,183 to 26,281, a significantly greater margin than the Democratic registration advantage.

Despite the Democratic sweep, Republican Assemblyman Richard Green beat the incumbent state senator, John Haluska, by 45,085 to 35,950.[353] U.S. Representative John Saylor once again carried Cambria County. Many Democrats had voted for Saylor as well as for Green.

Cecil Leberknight's support of Governor William Scranton's unemployment compensation reform legislation fomented the wrath of organized labor, which had united in opposition. Having voted against it, Green was elected to the state Senate in 1964, while Leberknight was badly beaten by Joseph McAneny. Organized labor proved it could be a powerful bloc in Cambria County when there was a galvanizing issue.

The 1968 general election, a local victory for the Democrats, was not a triumphant one for Torquato. Hubert Humphrey outpaced Richard Nixon by eight thousand votes but the Republican, Richard Schweiker, won the county over Joseph Clark by seven thousand votes for the U.S. Senate. Party loyalties were breaking down.

The most telling defeat to Torquato's machine took place in the 1968 spring primary when Louis Coppersmith, an anti-Torquato CID ringleader, defeated former Mayor George Walter,

a Torquato loyalist, for state senator. Once nominated, Torquato and his team supported him fully. Coppersmith next beat Richard Green in a close election. He would keep the seat for three consecutive four-year terms until 1980, when Coppersmith lost in the primary to Mark Singel, Wid Schonek's son-in-law.[354]

The Rise of John Murtha

In 1968 a decorated Vietnam War veteran, John Murtha, made his first race—a bid for Congress against the incumbent, John Saylor. Asked to run by the Democratic leadership, Murtha was unopposed in the primary but lost, as expected, to Saylor in November. Murtha, however, gained valuable campaign experience and contacts.

Edward McNally, president of the McNally Tire and Rubber Company, had first been elected to the legislature in November 1960 and assumed a leadership role in securing Johnstown-area highway improvements. A popular Democrat, McNally was reelected in 1962, 1964, 1966 and 1968. A few days after his final win, he died.

A special election to fill the vacancy was held in May 1969. The Republicans put up Ted Metzger. The Democrats named John Murtha. Both were popular and excellent campaigners. Murtha won and was reelected in November 1970 and in 1972.

John Saylor, a congressman since September 1949 and reelected in November 1972, died unexpectedly in Houston, Texas, on October 28, 1973.

A special election was scheduled for February 5, 1974. The Republicans put up Harry Fox, the late congressman's administrative assistant. Torquato and his Democrats named John Murtha. Murtha won a close election.

Murtha soon had to undergo the reelection cycle for a new term. After winning the nomination, he again faced Fox. This time Murtha's victory margin was bigger—89,193 to 64,416. Murtha has been consistently reelected ever since.[355]

The Rules of the Game

Politics in the Johnstown area and indeed all Cambria County is part art form, part sport and entertainment and certainly serious and important business. In the postwar era through the 1970s, there were no underlying policy differences between Johnstown or Cambria County Democrats and Republicans. The two local parties might differ on national or perhaps state issues filtering down from Washington or Harrisburg, but there were no divisive local partisan issues as, for example, Prohibition had been a half-century earlier.

The local political parties were governed by their county committees. In the spring primaries of even-numbered years, each precinct in the county chose both a committeeman and committeewoman to represent its area at the party conventions. In the mid-1960s, there were 202 precincts in the county, meaning there was a potential for 404 committeemen and women for each party. The party committee members also served to communicate problems, ideas, developments and voter sentiments to their respective chairmen and officers.

Torquato labored assiduously to make certain every precinct had both a man and a woman delegate, people loyal to him. The Republicans did not have complete wall-to-wall representation.

In the summers following the even-year primary elections, the party committees met and chose the county chairman and other officers. Because tedious work was necessary to assure there were always delegates running for the precinct committee slots, the system entrenched an established party leadership. A rebel group such as the CIDs or anti-Gleason factions would have needed to have built an infrastructure of factional loyalists in sufficient numbers to capture the party machinery, a nearly impossible feat because Torquato and the Gleasons could deliver favors and jobs. Not assured of success, revolt leaders could only make vague promises about improving things. Rebel recruits would have had concerns about being purged or blacklisted if an uprising failed.[356]

The parties served to recruit and screen potential candidates from running against one another in the party primaries. For example, Herbert Pfuhl Jr., a Republican city councilman, expressed to Andrew Gleason an interest in running for mayor in 1967 against the incumbent Republican, Kenneth Tompkins. Gleason persuaded Pfuhl to run for county treasurer instead. Pfuhl took Gleason's advice and won. Tompkins was also reelected. Gleason had avoided an intraparty contest in which at least one of his loyalists would have lost.[357]

The parties' cadres helped candidates circulate nomination petitions, distribute campaign literature and plant political signs. On primary and run-off election days, party workers checked off voter lists to make certain their members had all voted. They offered people rides to the polls, babysitting and similar favors.

As a general rule, a "good" candidate would be a white male who was both well known and had no potentially embarrassing history or baggage. A war record was a decided plus. Making policy proposals or advocating reform issues would probably have done a candidate more harm than good. Being against things that were deemed bad would generally have been helpful, but one had to be careful not to upset some unknown faction. A successful theme might have been, "I can do it [i.e., ongoing activity] better than he can." In this there would have been little interest in focusing upon the wisdom of what was actually being done.[358]

In 1969 Paul Malinowsky and George Arcurio campaigned for "law and order," although Johnstown had one of the lowest crime rates in the United States. Both were elected.

Wid Schonek

Richard Green's successful races, first against Louis Rovansek for assemblyman (1962) and later for the state Senate against John Haluska (1964), brought an independent Republican, a self-made and wealthy businessman, Wid Schonek, into a kingmaker role.[359] Green was the first of a number of political figures Schonek aided.

Originally from Lower Yoder Township, Schonek had served in various township posts—school director, elected auditor, justice of the peace and delinquent tax collector. He had also been chairman of the Cambria County Young Republicans.

"When I ran against John Haluska, Wid would show up at my house at 5:00 a.m. and get me out of bed," Richard Green recalled.

We'd then go together to mine portals even up in the northern parts of the county. The miners had cheerful, upbeat looks on their faces. I handed out little metal bands to wrap around their ankles

to tighten the lower part of their work pants around their legs. They had "Vote for Dick Green" written on them.

Then we'd come back to Johnstown and stand as close to the steel-mill gates as we could get when the shifts changed. The steelworkers had somber, unhappy looks about them.

Wid stood by me and worked with me. He helped pay my campaign costs. I was the first of a lot of people he supported. He never asked anything for himself. He didn't care if you were a Republican or a Democrat. If he thought you had good common sense, thought you could win, and he liked you, he'd probably help you financially and in other ways. [360]

Schonek later aided Milton Shapp in his two races for governor (1966 unsuccessful and 1970 successful). Two of Shapp's campaign aides later worked for a youthful Joe Biden (born in Scranton, Pennsylvania) in his 1972 campaign for U.S. Senator from Delaware. Remembering Schonek, they asked for his help. Schonek obliged, loaned Biden the use of his airplane and helped him in other ways. His friendship with Senator Biden lasted until Schonek's death.

John Torquato recommended to Governor Milton Shapp that Schonek be named to the Pennsylvania Harness Racing Commission, a reward for his role in Shapp's 1970 gubernatorial campaign. In early 1972, Shapp obliged but the appointment was short-lived. On June 30, 1972, Shapp dismissed him. "This is the first time in my life I have ever been fired," Schonek remarked. The informed opinion was that Senator Louis Coppersmith had insisted on Schonek's removal and the governor needed Coppersmith's support for his income tax revisions and other legislation. Schonek had supported Richard Green in the close 1968 race when Coppersmith had beaten him. [361]

Andrew Gleason says that Schonek was shrewd and often effective in swinging otherwise close elections his way. He had no big machine-style organization but had a roster of worker loyalists, usually those indebted to him for favors. They talked up Schonek's candidates within their respective circles. Schonek would give them money (always cash) and they would go out and work for a candidate or for or against an issue. His son-in-law, Mark Singel, estimated that Schonek's cadres in Cambria and Somerset Counties combined had once numbered around two hundred people.

"He wanted to be seen as a power broker," Andrew Gleason said. "You could count on what he told you. He would spend big when he needed to." [362]

Schonek was controversial and decidedly opinionated. He often resented people who had college educations and those from upper-class families. When anyone disagreed with him, there was usually a falling out that never healed. He occasionally uttered racist and anti-Semitic slogans aloud, even in public places. The Johnstown branch of the NAACP once wrote Governor Milton Shapp, urging that Schonek not be named to the Pennsylvania Harness Racing Commission. While this may have been a clever ploy by Louis Coppersmith (a member and attorney for the Johnstown NAACP branch), the complaint was rooted in a racial discrimination issue involving Schonek's adamant refusal to lease his rental housing units to blacks. [363]

Schonek maintained a "dirt file" on people. Whether he ever used its contents to pressure anyone is not known. "He was all about getting even," Mark Singel said. "He had a common touch and good instincts about people. He could read their 'dark sides' and understood what motivated them. He couldn't grasp lofty, ideal policies except in a context of opposition to

something that he perceived to be wicked and wrong. He could pick likely winners and insisted that they work hard to get elected. He did favors all the time but there was an expectation of future loyalty. He was always about the chase—never the aftereffects."[364]

Johnstown City Political Developments

In 1963 Kenneth Tompkins, the Republican nominee for mayor, defeated Joseph McAneny and became mayor in January 1964. Tompkins was tall, large, intelligent and decidedly overbearing. When one disagreed with him, he immediately treated the individual as an outcast ignoramus. He did favors for his friends and was known for sending his city ordinance officer and bagman, David Cornelius, to collect various payments he expected. To his credit, he presented himself well and made a good advocate for the city.[365]

In the 1967 primary and general elections, the Democrats had backed Paul Malinowsky to run against Kenneth Tompkins for mayor.[366] Tompkins won but Malinowsky still had two more years of his council term to serve.

In 1971 former city councilman and County Treasurer Herb Pfuhl defeated Kenneth Tompkins in the Republican primary for mayor. In November Pfuhl won out over Paul Martin, the Democrats' nominee. James Malloy was also elected. Pfuhl would be the sole Republican on the five-member council. Another Democrat, Charles "Kutch" Tomljanovic, owner of a chain of pizza shops, became city treasurer after defeating seventy-nine-year-old James Parks, a Republican city treasurer since 1942. With the exception of Pfuhl, 1971 belonged to the Democrats in Johnstown City.

The New Faces

On November 6, 1973, Mayor Herb Pfuhl Jr. was reelected mayor under a strong-mayor form of city government.[367] He had defeated Donald Hanley by almost twelve hundred votes. Pfuhl had promised to be a full-time mayor. Hanley, manager of a building supply firm and chairman of the Johnstown Redevelopment Authority, could make no such claim. "I feel Pfuhl did tie a kite to Hanley's tail on the full-time issue," Torquato confided.

The Fall of John Torquato

In November 1970, Patrick Gleason, a thirty-six-year-old Johnstown attorney, ex-city solicitor (1967–70) and the biological nephew of Andrew and Robert Gleason Sr., was elected as a Republican to represent the Seventy-first District of Cambria County in the legislature. Pat Gleason was reelected in both 1972 and 1974.

In its 1974 session, the Pennsylvania House of Representatives created a House Select Committee on State Contract Practices with a charge to probe allegations of abuse in state agency contracting. Its work took place during the first of Milton Shapp's two terms as governor (1971–74). Shapp was a Democrat.

Patrick Gleason was the committee's chairman. Indications are the committee, nicknamed the Gleason Committee, was tenacious and aggressive in its work.[368] Numerous accusations began

surfacing from the proceedings. Being a select committee, it ceased to exist as soon as the 1974 session had ended on November 30, 1974.

Shortly after the select committee had disbanded, its summary report was sent to Richard Thornburgh, the U.S. district attorney for western Pennsylvania. Thornburgh transmitted the material to the FBI. Copies of the report were also sent to the Pennsylvania Crime Commission and to the ten county district attorneys in whose areas of cognizance there had been suggestions of irregularities. This included Caram Abood, then district attorney for Cambria County. Abood was quoted as saying that the Gleason Committee's report had covered a period of more than ten years and had dealt with "a very controversial area involving both political parties." Abood suggested that when Gleason had given the report to federal and county prosecutors, he had terminated an investigation that was still incomplete and needed to be ongoing. Gleason replied that such continuation was impossible because his committee had ceased to exist on November 30, 1974, and he was certain it would never be reestablished.

Rumblings about the Gleason Probe continued to surface in the news media throughout 1976 and 1977. On November 1, 1977, a federal grand jury in Pittsburgh handed down a thirty-one-count indictment against John Torquato and two PennDOT supervisors based in Cambria County, John George and Harold Stevens. The three men were accused of extracting contributions from truck and other equipment owners as a necessary precondition for getting leasing contracts.

Torquato expressed surprise although he acknowledged he had known about the investigation. Coming one week before the November 1977 election (the odd-year municipal and county elections), Torquato charged at a party rally that the entire thing was a GOP plot. "We haven't done anything that the Republican Party hasn't done for years…I don't want you to get the idea that because your chairman is under a cloud that it will affect the Democratic Party. I'm used to it. I've been the whipping boy for twenty-six years."

In February 1978, a federal grand jury returned other indictments against Torquato—twenty-three counts of technical mail fraud. Torquato was charged with having hired a full-time secretary to work for him at the county Democratic Party office in Ebensburg when she was paid through the state payroll as a chief clerk. Because her paychecks had been mailed to her for what was seen as an illegal arrangement, the alleged practice was cited as "mail fraud," a federal offense.

On June 29, Torquato and his two co-defendants were found guilty of the equipment leasing extortion charges. The other indictments underwent trial several weeks later in 1978. On September 7, Torquato was judged not guilty of mail fraud.

Torquato was fined $10,000, made to pay court costs and was given a five-year prison sentence. He appealed to the Third U.S. Circuit Court of Appeals, arguing that he had been selectively prosecuted because the state legislative probe had revealed that a Republican committee official in Cambria County had also extorted funds from PennDOT contractors during the administration of Republican Governor Raymond Shafer. The appeal was denied in October 1978. A second appeal was also unsuccessful. Torquato served twenty months of a five-year sentence. He died on April 21, 1985.

By the time his first trial was getting underway, Torquato had already decided not to seek reelection as chairman of the Cambria County Democratic Party. At the party convention in

June 1978, he backed Bill Joseph, his top aide for twenty years. Joseph was elected chairman by a substantial majority.[369]

Local Political Parties in Decline

When reviewing the histories of the two local political parties, one concludes they both had been in decline since the mid-1950s. Voters increasingly were picking and choosing among candidates rather than voting straight party tickets. Various schisms and independence movements also had taken their toll in party effectiveness.

Increased use of media advertising, especially television and radio, required huge sums of money and reduced the need for street workers. Wid Schonek in the 1960s, 1970s, 1980s and beyond would pay generously toward the campaign expenses of those he favored. There was no party loyalty requirement with Schonek—only a vague understanding that those he helped would become part of his team.

Patronage jobs have been all but eliminated by civil service reform laws and collective bargaining considerations. As governor from 1979 to 1986, Dick Thornburgh eliminated many patronage practices. Various federal anti-discrimination statutes, rules and rulings have also worked against patronage, thereby contributing to the parties' declines.[370]

Highway Developments
in the
Post–World War II Era

There were no bypasses around Johnstown prior to the mid-1960s. Major highways passed through the heart of the city. Route 219 from Ebensburg entered downtown by way of Prospect and the viaduct. A traveler from Altoona usually approached Johnstown by the Mainline Highway or Route 53, which came into the city through Frankstown Road, a steep roadway well known for runaway truck accidents. Travelers from Bedford used Route 56, a two-lane road that passed through Windber and Scalp Level. Just before reaching Dale Borough and the city's central business district, drivers made a lengthy steep descent. Route 56 eventually headed through the West End. As Haws Pike, it continued to Seward and into Indiana County. The Menoher Highway proceeded through Westmont, becoming a narrow winding mountain road that snaked its way across Laurel Ridge to Ligonier. Route 219 from Somerset approached downtown by using Franklin Street.

Lacking ways to circumvent the city, the through traveler found a congested, horse-and-buggy-era street system rendered even more complicated thanks to rivers, bridges and railroad tracks. The Route 56 Bypass, the Kernville Expressway and the modern 219 freeway had not yet been built.[371]

The leading Cambria County roads had been improved from 1910 to 1930 when a goal had been to keep vehicles out of the mud and to bridge streams. Two-lane roads were standard. Communities, large and small, were to be accessed, not avoided or bypassed.

As time moved on, most major highways in the area became congested. Through traffic helped choke city streets. Adding a third or even a fourth lane was expensive. The very roadways themselves had attracted the commercial development that needed to be acquired and demolished to widen them.

A Strategic Overview of the Highway Situation

Johnstown's strategic interests lay to its east and west. Nonetheless from among the earliest area highways designed and built for automobile use, the east-west roadways had been located in ways that consistently avoided Johnstown. This was partially because of an early policy to install roads that would interconnect county seats, but it was also due to the steep mountain ranges that were

oriented from the northeast to the southwest. The William Penn Highway, Route 22, passed ten miles to Johnstown's north. The Lincoln Highway, Route 30, had been routed about twelve miles to its south. Both were east-west roads.

The earliest goals of Johnstown's road enthusiasts had been to secure good connections to the east-west corridor highways. As such these roads themselves became quasi-destinations in Johnstown's highway thinking. Ultimate destinations, other cities, had to be reached through these connector highways.

The Pennsylvania Turnpike

The most significant highway to affect Johnstown in the post–World War II era was the Pennsylvania Turnpike, which passes thirty-one miles to the south of the city. Its linear location had been determined by what was left of William Vanderbilt's South Pennsylvania Railroad (SPR) of the 1880s, a line originally intended to parallel and compete with the Pennsylvania Railroad (PRR). Actual construction of the South Pennsylvania was well underway when it was halted by J.P. Morgan. While not entirely intact, the SPR roadbeds, semi-finished tunnels and remaining rights-of-way defined the turnpike's first link, a connection between Irving (southeast of Pittsburgh) with the Middlesex-Carlisle area, fifteen miles west of Harrisburg.

There were no origin-destination surveys or innovative highway planning concepts used to locate this toll road. Feasibility studies were done to justify decisions already made. The turnpike was put where it went because the old, unfinished railroad bed was largely intact in the mid-1930s and could be quickly used. While part of a Pittsburgh-to-Harrisburg corridor, the initial section would be passing largely through rural areas near small towns. It also avoided such Pennsylvania cities as Latrobe, Johnstown, Altoona, Hollidaysburg and Huntingdon.

The turnpike became a focal policy of Governor George Earle's (1935–39) "Little New Deal" and was aided by such federal agencies as the Public Works Administration (PWA), Reconstruction Finance Corporation (RFC) and the WPA. After its enabling legislation was enacted, the Pennsylvania Turnpike Commission was appointed in 1937. The first section, Irving to Carlisle, was constructed in only two years, from October 1938 to October 1940.[372]

Once a successful toll road is opened, it becomes virtually impossible to construct an upscale highway to parallel it nearby. For this reason, the Pennsylvania Turnpike has contributed to Johnstown's extreme highway isolation.

There were no timely civic expressions of concern that the turnpike, passing through sparsely populated parts of the state and avoiding major urban centers, might prove harmful to Johnstown and other cities. There were no resolutions of protest by the city government or chamber of commerce, and no analytical editorials appeared in Johnstown newspapers. The U.S. Bureau of Public Roads had made some concept proposals for a modern, coast-to-coast, non-toll freeway to pass through the Lincoln Highway corridor near the city. Johnstown leaders apparently knew nothing of this visionary concept or they otherwise might have rallied to support it.[373]

After there had been three years of planning, engineering and intergovernmental negotiations, plus ten weeks of heavy construction on the turnpike itself, the Johnstown Chamber of Commerce Highway and Parks Committee in December 1938 decided to petition the state seeking the abandonment of the "South-Penn" (SPR) alignment and the substitution of an "air-line" route

located closer to Johnstown. The text of this futile gesture included information about reduced mileage and other advantages of the new proposal.[374]

In all probability, the Pennsylvania Turnpike had been unstoppable. Among other things, its purpose was to create badly needed jobs during the Great Depression. Even a timely crusade to unite several communities seeking to reroute the highway closer to Johnstown would probably have been ineffective.

In April 1953, John Thomas Jr., an ex-county commissioner and chairman of the Johnstown Chamber of Commerce Highway Committee, began advocating a toll road from Johnstown to Harrisburg. Thomas's plan, a proposal to upgrade the William Penn Highway, was never seriously considered.[375]

To Johnstown, the Pennsylvania Turnpike was a strategic curse. Its passing thirty-one miles to the south of the city had become a deterrent to obtaining a quality east-west highway that would serve the community's needs.

The Shortway Issue

Even prior to the enactment of the 1956 highway legislation that authorized the Interstate Highway Program, there had been lobbying efforts to construct an east-west freeway or "Shortway" across north central Pennsylvania from Stroudsburg in the east to Sharon in the west, an area comparatively rural and underdeveloped. The Shortway would be connecting the industrial Midwest with the industrial Northeast with a direct route. As such, it would avoid Pennsylvania's own industrial heartland. In addition to a coalition of communities along its corridor, Pennsylvania officials and legislators were coaxed by Ohio, Indiana, Illinois and Michigan interests to the west and New Jersey and New York interests to the east to build a "short" connection between them. Pennsylvania's industrial heartland—the likes of Johnstown, the Mon Valley and Altoona—had to contend with the "Turnpike argument." Deflecting east-west traffic onto a freeway located nearer to the turnpike inevitably would siphon away much of its toll-paying traffic. Far to the north, the Shortway would affect the turnpike's traffic only slightly.

The *Tribune-Democrat* editorialized extensively against the Shortway. The community, however, did nothing either to fight it or to try rerouting its corridor closer to Johnstown. Worse yet, no intercity pooling of interests or anti-Shortway coalition was created with Johnstown as a participant, although Philadelphia interests had opposed the highway vigorously.

By June 1957, the Shortway corridor, Interstate 80, proposed by the State of Pennsylvania, received federal approval. A high-priority interstate, the 313-mile-long freeway was dedicated in September 1970. At Du Bois, its closest point, Interstate 80 is 87 miles north of Johnstown.[376]

As had been true of the earlier east-west roads, the Lincoln and William Penn Highways, Johnstown was straddled anew, this time by modern freeways—the Pennsylvania Turnpike to the south and the Shortway (I-80) to the north.

Once again, the policy formulations of Johnstown's civic leaders became that of treating these highways as destinations. The goal became securing a modern freeway from Somerset to Du Bois. If Johnstown was not to be served by a quality east-west freeway, it would seek a freeway to connect itself directly to each of these superhighways.

The new Route 219.

The Bypasses

The 1950s became a time of bypass construction around urban areas. Two of the first bypasses in the Johnstown region were the rerouting of Route 56 around Windber and the relocation of Route 22 from Mundy's Corner to a point east of Ebensburg to enable a through passenger to avoid the county seat. The bypass around Windber and its rerouting at Scalp Level became part of the eventual upgrading of Route 56 itself.

Modern Eisenhower Boulevard from Scalp Avenue (Route 56) to the Riverside Bridge was part of a patched-up arrangement to bypass Route 56 traffic around Johnstown onto the Haws Pike.[377]

Modern 219

In January 1957, two years after George Leader became governor, an important meeting took place in the office of Joseph Lawler, the secretary of highways. Attending were John Torquato, then secretary of labor and industry, and both Hiram Andrews and Philip Lopresti, veteran Pennsylvania legislators. Also present were Del Roy Wurster, the chamber of commerce executive secretary, and Edward McNally, a tire dealer and chairman of the chamber's Highway and State Affairs Committee. Aside from politicians like Torquato and Andrews, McNally was the leading local advocate for better roads.[378]

130

Work began in May 1962 on the Geistown Bypass, the first piece of the four-lane freeway Route 219 at Scalp Avenue. This aerial photograph was taken around the autumn of 1962. Scalp Avenue and the Richland High School are in the foreground. Courtesy Johnstown Area Heritage Association.

The local delegation was seeking two things—a Route 56 Bypass around Johnstown to connect Scalp Avenue with the Haws Pike and, more important, a modern 219 to go from Somerset Borough to Ebensburg. Such a road would provide Johnstown with rapid access both to the Turnpike and to Route 22. It would also be a bypass to enable north-south traffic to move around the city without having to pass through it.[379]

The secretary agreed to have the district engineer study the feasibility of the proposals. Lawler next revealed that his highway department was nearly finished with an important bit of preliminary engineering—a project to extend Roosevelt Boulevard from the Washington Street Bridge south to the area of Johnstown Central High School where it would connect with the Easy Grade Highway to Westmont.

While Johnstown community leaders expressed frustration between 1957 and 1961, a time of plan finalization when little visible road construction was occurring, the department's engineers had settled on a unified plan both to address many bypass needs and to provide one alternative approach leading into the city. It would also overcome the need to use the existing Routes 219, 53 or 56, each of which involved precipitous descents into the city's core. The concepts were fashioned by the Pennsylvania Highway Department.

Although there had been earlier news leaks, the concept was unveiled officially in November 1960. The Johnstown Bypass would be a four-lane, north-south expressway from Route 56 (Scalp

Avenue) to a Solomon Run Access Road (modern Route 56 Bypass)—a new freeway with a gentle grade to follow the Solomon Run stream valley into Walnut Grove ending at the foot of the steep Bedford Street hill. The north-south part of this arrangement would be a short piece of a much longer freeway system, which Pennsylvania highway officials and politicians had been seeking to include in the interstate system as a new Route 219 connecting the Turnpike at Somerset with the Shortway at Du Bois. As such, the Johnstown Bypass, an integral part of a Somerset to Ebensburg corridor, would solve many of Johnstown's access and bypass problems with one new road system.[380]

In June 1961, the Pennsylvania Highway Department held a public hearing on the extension of Route 219 north from its committed terminus at the Solomon Run Access Road all the way to Route 22 between Mundy's Corner and Ebensburg. Support was enthusiastic. It was also stated unofficially that this proposed fourteen-mile segment would be part of a future freeway to link Somerset and Du Bois.[381]

In May 1962, actual construction began on the first piece of this overall 219 plan, the Geistown Bypass. The project was in two parts: the first, a section of 219 proper, extended from Route 56 northward to the beginning of the Solomon Run Access Road (Route 56 Bypass). The second was the Solomon Run Access Road itself, first configured to end in the city's Walnut Grove section near the foot of the steep hill on Bedford Street. This system of new expressways was opened to traffic in September 1964.

At this same time, the Pennsylvania Highway Department announced its intention for construction to begin on Route 219 from the Solomon Run Access Road (Route 56 Bypass) north to Lambs Bridge near South Fork.

In the 1962 race for governor, the two candidates—Richardson Dilworth, a Democrat, and William Scranton, a Republican—both pledged the completion of a new Route 219 from Somerset to Du Bois as well as the extension of the Solomon Run Access Road (Route 56 Bypass) above Kernville to link up with the new Roosevelt Boulevard extension near Johnstown's Central High School.[382]

On March 16, 1964, Henry Harral, the secretary of highways under William Scranton, spoke to a group of Johnstown civic leaders assembled by Andrew Gleason. Harral's speech detailed the status of proposed highway developments affecting Johnstown:

> The extension of the Solomon Run Access Road as far as Adams Street was undergoing preliminary design.
> The Roosevelt Boulevard Extension was tentatively slated for bidding in late 1964.
> Location studies for the Kernville Expressway from Adams Street to the new Roosevelt Boulevard terminus were underway.
> The section of Route 219 from the Solomon Run Access Road north to Lambs Bridge (near South Fork) was already scheduled for bidding.
> The section of 219 from Lambs Bridge to Route 22 near Ebensburg was undergoing final design.

Henry Harral had outlined what was probably the most impressive road construction program affecting the Johnstown region in its history.[383]

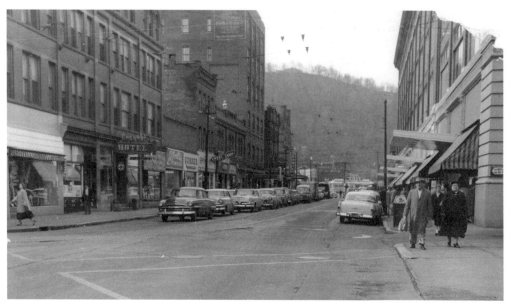

Washington Street looking west from the Public Safety building in the autumn of either 1956 or 1957. The Penn Traffic Building is to the right and the tall building near the center is the Hendler Hotel. Everything on the left side of the street up to the public library (currently the Flood Museum) has been removed for new uses or parking except the LaPorta Flower Shop. *Courtesy Johnstown Area Heritage Association.*

In June 1966, Governor William Scranton spoke at the dedication of the second piece of Route 219—the section from the Solomon Run Access Road north to the Lambs Bridge area, a highway that enabled Mainline (Route 53) traffic to enter and leave Johnstown by the new Solomon Run Access Road instead of having to use the precipitous Frankstown Road. The governor also announced that a Route 219 freeway from border to border was a Pennsylvania goal.

Work also got began on 219 South toward Somerset. Unlike most road construction projects, the work was generally completed ahead of schedule. There were six separate sections. Five were opened in December 1969. The final section, almost 5½ miles long between Jerome and Route 30, was opened in late June 1970.[384]

The Route 56 Bypass and the Cross-Kernville Expressway

The commitment to extend the Solomon Run Access Road (Route 56 Bypass) as far as Adams Street and to construct its continuation as an elevated overpass through Kernville so as to link up with the lengthened Roosevelt Boulevard proved much easier to contemplate than to implement.

A major design and safety problem had to be addressed in the vicinity of Johnstown's Central High School. A five-way intersection was avoided thanks to a costly decision not to permit Mill Creek Road, Menoher Boulevard, Somerset Street, Roosevelt Boulevard and the end of the Kernville Expressway to come together near the school building. The overpass was designed to bridge over this already complicated intersection.

Both parts of the overall project, the Kernville Expressway and the access ramps to and from Adams Street, were estimated to cost $7.8 million. A total of 354 properties were acquired and 278 structures were demolished and cleared. Construction on the Route 56 Bypass section, 1.23 miles in length, was underway in late April 1970. Work on the Kernville Expressway was started in the early fall of 1970. The entire project was dedicated and opened on November 2, 1972.[385]

The End of the New Corridor Freeways

While there had been "fits and starts," no major obstacles surfaced to obstruct the goal of securing a four-lane freeway from Somerset to Ebensburg. Parts of this new highway received supplemental funding through the Appalachian Regional Commission.

Further extensions of Route 219, both south into Maryland and north to Du Bois and beyond, encountered a continuum of obstacles—enormous costs, environmental constraints, forecasts of low traffic volumes and competition from Route 220, another north-south highway not far to the east.

In March 1964, Johnstown leaders were active in helping to establish the Route 219 Association, a coalition of people and organizations seeking a modern freeway to extend from Maryland through New York State. The organization also supported the upgrading of 219 from Bluefield, West Virginia, in the south to Niagara Falls in the north. W.W. Krebs was Johnstown's representative during the association's early years.[386]

The State of Pennsylvania had made repeated efforts to have Route 219 included in the Interstate Highway Program. Such a designation would have provided a funding ratio of 90 percent federal and 10 percent state. In February 1970, thirteen congressmen, including John Saylor, introduced a resolution seeking the designation in the U.S. House of Representatives. Opposed by the U.S. Department of Transportation, the resolution was unsuccessful.[387]

THE STENCH OF CRIME

George Walter-Ferdinand Bionaz Crusades

Just after becoming mayor in January 1960, George Walter found an envelope in his office containing $400 cash. On the first Monday of the next four months, other mysterious envelopes also appeared. Before they stopped, $2,000 had turned up. Walter sent the money and the envelopes to the police for investigation.

Earlier during his 1959 campaign for mayor, four vending machine company officers offered political contributions. Knowing their reputations, Walter turned them down. One of the men, Frank Mikesic, was known for moving gambling money into political campaign coffers.

A Leonard Fischler offered Mayor Walter the vice-presidency of a nameless corporation. Seven years after his first term as mayor had ended, Walter testified: "And as we talked later, he [Fischler] suggested how much easier it would be if we operated 'controlled gambling'; where we would arrange for each one of the numbers banks to contribute one victim for each term of court. And as a matter of fact, we could go so far as two numbers writers per bank, which would have been eight arrests per term of court."[388]

District Attorney Ferdinand Bionaz testified that shortly after his election, two envelopes had turned up in his offices with a total of $1,000 in them. Both were found shortly after he had been meeting with Joseph Regino and "Mutt" Lewis. The two men were hoping to develop a system for giving $2,000 to each of the two major political parties every year, plus a large contribution to leading charities. In exchange, slot machines would return to Cambria County unmolested. Bionaz rejected the offer.

On May 25, 1960, the badly decomposed body of Joseph "Pippy" DiFalco was found in the Conemaugh Reservoir near Blairsville. DiFalco, a minor Johnstown gambling figure, had disappeared on February 7. An autopsy revealed he had been killed with something long, thin and sharp, perhaps an ice pick. The murder has never been solved.

In June George Walter issued a public statement denouncing gambling and proclaiming his policy toward it: "The laws of Pennsylvania have established that the writing of numbers, the sale of treasury tickets, the operation of coin machines and betting on athletic events is illegal. When I took the oath of office to serve as mayor, I accepted the responsibility for the enforcement of those laws. They shall be enforced."[389]

The first chief of police under George Walter was Charles Griffith, an honest and strict disciplinarian. Raids were conducted. District Attorney Ferdinand Bionaz prosecuted the cases diligently, but Walter believed the city's resources were inadequate to stamp out gambling. City detectives and their families were menaced with anonymous, threatening calls mentioning the DiFalco murder.

Walter believed and often stated that Johnstown's gambling trade was a small outcropping of a vast organized crime web. On September 13, 1961, he contacted U.S. Attorney General Robert Kennedy hoping to get federal assistance to fight the Johnstown gambling trade.

After the Pennsylvania Justice Department issued a statement saying that six unnamed counties in Pennsylvania were "under surveillance due to their inadequate anti-crime enforcement" efforts, Walter announced, "If Cambria County isn't one of the six counties, it ought to be."

On May 9, 1963, the Pennsylvania State Police conducted extensive raids in Johnstown. The results revealed there was much more gambling in the city than people had imagined. Again on Thursday, November 7, a combined coordinated federal and state sweep resulted in the raiding of twenty-three Johnstown establishments and forty-three arrests. These places were all over town.[390]

Kenneth O. Tompkins

In June 1960, the city council reactivated the dormant Johnstown Parking Authority. Mayor Walter named its five board members. Kenneth Tompkins, owner-manager of the Cambria Office Equipment Company and chairman of the chamber's Traffic and Parking Committee, was appointed. In 1961 Tompkins decided to run for city council as a Republican.

After his primary victory, Tompkins began his campaign by maligning Mayor George Walter. He charged that Walter and the Democrats on the council had been highhanded and overly generous to the Johnstown Cable TV Company when it received a franchise to string wires over city streets. He contrasted Johnstown's fee income with Altoona's, where the cable company paid more. Tompkins later charged there had been a payoff when the franchise was awarded.

Although Tompkins was defeated, the mayor insisted that he appear before the council and substantiate his charges. About one week after the election and represented by Attorney Richard Green, Tompkins charged that when City Solicitor Samuel Di Francesco and his son, Samuel Di Francesco Jr., had represented the cable company to seek the franchise, there was a conflict of interest. He also asserted that the company made gifts of whiskey to city policemen.

Walter pressed Tompkins for evidence of a payoff. Tompkins made no further elaboration, and the cable television matter faded away.[391]

In 1963, two years later, Kenneth Tompkins ran successfully for mayor. Soon after his inauguration, the police department underwent a major shakedown. Fred Lydic and Milan

Habala, two of the police officers who had been making gambling raids in Walter's administration, were summarily demoted. Sam Coco was promoted to captain of detectives. Coco had earlier been demoted from the rank of detective sergeant after it was learned that he had induced a false confession from a suspect. Coco's association with Joseph Regino, an alleged crime figure, was well known.

Many policemen informed the Pennsylvania Crime Commission during its 1971 investigation into the Johnstown Police Department that while he was serving as captain of detectives, Coco—not Chief Robert Burkhard—actually headed the department. Coco gave out orders that no gambling establishments were to be raided without his approval. A fleeting indication of the way things were done during Tompkins's two administrations was revealed through the sworn testimony given by Peter Duranko, who was "running" a gin rummy game at the Democratic Social Club in 1966. Coco told Duranko he could run the game only if he contributed to the "campaign fund." David Cornelius, the city ordinance officer and Tompkins's bagman, assessed a twenty-five-dollar charge and collected it.[392]

Shortly after becoming mayor in 1964, Kenneth Tompkins and District Attorney Ferdinand Bionaz set up a joint strike force to suppress the rackets in Johnstown. The arrangement fell apart. Bionaz also was working with the state police. In late March 1964, state and county detectives made gambling raids in Johnstown.

Tompkins immediately issued a public statement denouncing the district attorney and his actions. Specifically he expressed anger over not being forewarned about raids.

Tompkins often made statements that there were no rackets in Johnstown. "The big syndicates are not operating here," he reiterated.

To counter Tompkins's repeated assurances, the *Tribune-Democrat* arranged with an unidentified "gambler" to serve as a news source for an article describing his making bets throughout the city. Between 9:30 a.m. and 3:32 p.m. on May 11, 1965, the man told of placing ten bets, each at a different place, including one inside city hall.

Obviously focused on the mayor, the newspaper got Tompkins to repeat earlier assurances that there was little to no gambling in Johnstown and what there was of it was small and not syndicate connected. His statement was featured on the same page in a side-by-side juxtaposition with the "gambler's" article.[393]

The Cable TV Scandal

In early 1960, shortly after George Walter became mayor, the city council adopted a resolution giving Fulton Radio Sales of Hancock, Maryland, the right to operate a cable antenna television (CATV) system and to erect and maintain lines over Johnstown's streets and alleys. This was in an era when most CATV companies were in the simple business of receiving broadcast television signals through large antennas for retransmission into homes and businesses through cables strung above streets and alleys. CATV companies generally provided more stations and better TV reception to their customers than could otherwise be receieved with rooftop and chimney antennas. The city had made few demands on the Fulton Radio Sales Company. Its local subsidiary, the Johnstown Cable Television Company, was paying little municipal revenue.

In 1961 the Teleprompter Corporation bought the Johnstown concern. During the next several years, this simple company grew and prospered, and city officials were criticized for allowing the company to operate for so little revenue.

After he became mayor in 1964, Tompkins and the council began pondering what to do about Teleprompter and its near-monopoly. In early 1966, city officials decided it would grant a new and exclusive CATV franchise by competitive bidding. This triggered a strong objection from Irving Kahn, president and chairman of Teleprompter. He advised the council that his firm would not submit a bid because he considered such a process to be illegal. Kahn also maintained Teleprompter had developed a vested property right in Johnstown that could not be rescinded. Another competing company might be franchised, he acknowledged, but its rights could not be exclusive. When making the latter concession, Kahn knew that two competing CATV companies could not coexist. With Teleprompter already in business, another fledgling company would fail.

Apart from the legalistic posturing, bids were received from several companies on February 2, 1966. The council voiced a concern that if it awarded an exclusive franchise to one of the bidders, a serious problem would surface because Teleprompter would remain in Johnstown.

On January 24, roughly one week prior to the bid opening, Mayor Tompkins and two Republican councilmen, Howard Deardorff and Robert McKee, met with Kahn at a Johnstown motel to discuss the franchise issue. After having some drinks with Tompkins and the councilmen, Kahn was reported to have said something like, "If you gentlemen will look favorably on this contract for me, we will pay you $7,500."

Tompkins and the two councilmen withdrew to the bathroom for a brief discussion. After they returned, the mayor stated, "We will accept this if you will pay us $5,000 apiece." Kahn immediately replied, "Okay."[394]

A closed session of the city council was held in the afternoon following the bid opening. Kahn presented the council a special proposal from Teleprompter, which he insisted was not a bid. At this meeting, the council rejected all bids that had been submitted and then accepted the Teleprompter proposal by a four-to-one vote. Herbert Pfuhl Jr., recently elected to the council, voted "No." After the closed-door meeting was over, Pfuhl stated, "If we negotiate with one, we should negotiate with everyone. I certainly feel this is a sham."

In addition to Tompkins, the three other councilmen—J. Howard Deardorff, Paul Malinowsky and Robert McKee—voted to accept the Teleprompter proposal. They all expressed a concern that any other course of action would have led to a costly lawsuit the city would have lost.[395]

Four years later, an alert IRS agent in New York uncovered what appeared to have been cancelled bribery checks as part of another investigation. They were turned over to Whitney Seymour, U.S. attorney for the Southern District of New York. On Thursday, January 29, 1971, Mayor Kenneth Tompkins, Howard Deardorff and Robert McKee were indicted by a grand jury in New York City on charges of bribery and conspiracy in connection with the 1966 franchise award. Irving Kahn was separately indicted.

In October 1971, Tompkins and Deardorff both pleaded guilty. Robert McKee retained F. Lee Bailey to represent him and was tried later. Tompkins became a witness against Kahn and McKee.[396] Both were found guilty and went to prison. Having cooperated in the investigation, Tompkins and Deardorff were given probation. Deardorff was not on the council when

convicted. Tompkins resigned as mayor on October 11, 1971, two and one-half months before the end of his second term.

Victor Bako, commissioner of accounts and finance, became mayor for a few days, as provided by state law. The council next appointed George Walter, who served as mayor for about two months. One of his first official acts was to demote Chief Coco. Coco resigned immediately.

The Pennsylvania Crime Commission Revelations

The Pennsylvania Crime Commission, created by Act 235 of 1968, was an investigative, fact-finding body with powers to conduct hearings, subpoena witnesses, administer oaths and take testimony. The commission was charged with issuing reports describing criminal activities throughout Pennsylvania and recommending ways to improve law enforcement and criminal justice.

The commission released its first publication, "Report on Organized Crime," in July 1970. Among the many findings was an allegation that Johnstown was beset with illegal gambling operations affiliated with the Pittsburgh Cosa Nostra "family" of John Sebastian LaRocca. The report stated that there was little effective policing in Johnstown because of a "general absence of quality law-enforcement leadership."

The January 1971 indictment of Mayor Tompkins and two other councilmen doubtless altered the agency's work priorities, and in February, April and June of 1971, the commission undertook a sustained inquiry about Johnstown. It received sworn testimony from thirty-four people—present and past public officials, law enforcement officers, alleged criminals and "collectors of protection monies." Some 1,500 pages of testimony were recorded.

Many people used the Fifth Amendment to refuse answering questions. Several who had been accorded immunity from prosecution cooperated with the commission and its staff.

In late October 1971, the Pennsylvania Crime Commission issued its thirty-five-page work "Report on the Conditions of Organized Gambling and the Administration of Criminal Justice in Johnstown, Pennsylvania, 1970–71." It was printed verbatim by the *Tribune-Democrat* on Saturday, October 30.[397]

The report documented widespread gambling activities in Johnstown apparently shielded by Mayor Tompkins and his chosen police force leaders. For example, between January 1968 and October 1970, the state police made twenty-four gambling arrests in Johnstown while city police had made only two. Johnstown police officers did conduct a number of "dry run" or "show" raids with nothing turning up. These were often followed by statements from Mayor Tompkins that there was no widespread gambling in Johnstown.

Speaking at a Republican rally, Andrew Gleason, a GOP leader in Cambria County, labeled the report a "political document" and said its contents were "a ridiculous mishmash." Some Democratic leaders were also negative about the report.[398] The webs of organized crime and its local offshoots are confusing even as described in the commission reports. The key participants are discussed as follows:

Joseph Regino was linked with John Sebastian LaRocca, who was said to have been the mafia boss in Pittsburgh. Several Pennsylvania Crime Commission documents state LaRocca

had attended the 1957 underworld bosses meeting at Apalachin, New York, but other reports (including extensive *New York Times* coverage of the meeting) do not list him as having attended at all. LaRocca's brother, John L., was the treasurer of P. and C. Amusements, a Johnstown pinball machine firm headed by Regino.

George Bondy was a bail bondsman. He was said to have been in charge of the Johnstown outlet for an illegal lottery, Empire Treasury Tickets, an operation based both in Scranton and Philadelphia. Bondy provided much of the bail bonding for those arrested in the Johnstown area for gambling. He also paid many of their fines. The Pennsylvania Insurance Department later revoked his bail bond license.

The crime commission reported that there were two Johnstown "numbers banks"—the G.I. Bank was said to have been composed of two sub-banks, one run by a Peter Pagano, and the Dean Dallas Bank, named for its operator. Pagano was linked with a major gambling operation centered in New Kensington outside of Pittsburgh. Gabriel Mannarino, a crime figure who had been present at the Apalachin meeting in 1957, headed this operation. The Pennsylvania Crime Commission findings subordinate Mannarino to LaRocca. Other experts downplay LaRocca.[399]

There were also extensive football pools, sports books, "raked" card games, coin machine gambling and the like. The Crime Commission report portrayed a vast network of petty gambling activities with numerous willing players. The systems were lucrative and lots of money was said to flow in various ways into the pockets of susceptible political and public officials.

Conference-type meetings were held from time to time among local and other western Pennsylvania crime bosses. Some took place at the Shangri-La Lodge on Woodmont Road outside Westmont in Lower Yoder Township, a bar and restaurant then partially owned by Mrs. Joseph Regino. Other meetings were apparently held at a farm owned by Peter Livolsi, a local labor leader. Testimony was given that John Sebastian LaRocca, Gabriel Mannarino, Michael Genovese, Nick Stirone and Antonio Ripepi—all from the Pittsburgh area—attended these meetings from time to time.

Implications of Criminal Syndicates in Johnstown

While local criminals were involved in gambling and probably corrupted susceptible public officials, they apparently avoided the hard crimes. The true story behind the "Pippy" DiFalco murder is not known. Aside from this homicide, there does not seem to have been violence associated with crime in Johnstown.

Narcotics were sweeping the nation as a pandemic in the mid-1960s. The Bondys, Reginos and their associates did not get into this sort of business. Indeed, they may have found it repulsive. The most negative impact of Johnstown's crime web probably was to stifle civic reform. Charges that Johnstown gamblers had fought such initiatives as the council manager charter campaign in 1958 were probably true.

A New Day at City Hall: Johnstown Launches the Strong-Mayor Plan

Staged to be festive, upbeat and well-attended, inauguration ceremonies for Johnstown's mayors were meant to convey buoyant optimism to the community. While each was different, all shared common features—flowers and banners, lapel carnations and corsages, band music, patriotic themes and ecumenical invocations and benedictions.

When Herbert Pfuhl Jr. became the city's first "strong mayor" on January 6, 1974, blissful trappings could not overcome a gloom engulfing Johnstown. Fifteen hours earlier, a returning Allegheny Commuter airliner had crashed near the end of a runway at the airport. Eleven people were killed. Six others were severely injured. Nearly everyone attending the inauguration knew personally someone lost in the tragedy.

"Loud talk and ballyhoo will not solve our problems," Pfuhl stated in his inaugural address. "My pledge to you is to provide an administration which will be responsive to the needs of... Johnstown."

The keynote speaker was W.W. Krebs, who described the old bicameral councils replaced sixty years earlier by the currently maligned commission form of government. He predicted that the strong-mayor form would prove to be beneficial "if we all make up our minds that it is going to work."

Krebs's speech marked his last public appearance. He soon headed south for a winter vacation and died in Naples, Florida, on March 26, 1974.[400]

The Strong Mayor

The strong-mayor plan of local government presented a sharp contrast to the old commission form. Holdover councilmen such as George Arcurio, Victor Bako and Jim Malloy had each headed an organizational unit of the municipality. A councilman under the old system was seen as a full-time job. Distinctions between policy and administration were meaningless. The city functioned like an outdated piece of machinery. A unit leader might tinker and make little changes here and there, but there were no radical overhauls other than personnel changes— closely watched balancing between political pressures and organizational effectiveness. Each councilman compromised, fought and traded back and forth with his peers to perpetuate his own discrete departmental staffs and budgets. On rare occasions, a councilman such as the then-

late Eddie McCloskey became so much of a maverick that the other four members would lessen his budgetary appropriations, positions and meaningful responsibilities. Such denuding stripped away campaign workers and political contributions for a later election.

Of the old councilmen, Arcurio, Bako and Malloy had opposed the strong-mayor form; Paul Malinowsky eventually supported it; and Herb Pfuhl, the mayor under the old system now reelected as "strong mayor" in the new, had remained neutral. Paul Malinowsky had run for mayor as a Democrat in the 1973 spring primary. After his defeat by Don Hanley, Malinowsky supported his fellow councilman and mayor-commissioner, Republican Herb Pfuhl, for mayor. His support explains Pfuhl's appointment of Malinowsky, a Democrat, as an "administrative assistant." Malinowsky's responsibilities were with parks and recreation.

Pfuhl made two other appointments: Bill Heslop, district manager of the Pennsylvania Manufacturing Association, was named director of administration, and Harold Jenkins, an aggressive innovator with the street department, was made director of public works.

A major issue developed over the city solicitor—whether the mayor or the council made the appointment. The Optional-Charter Law for Mayor-Council Plan A reads that the council "shall provide for the manner of choosing the city solicitor." The administrative code as drafted and adopted read that the mayor named the city solicitor with "the advice and consent of the city council." Pfuhl wanted Richard Green, his longtime friend and an ally of Wid Schonek, also a Pfuhl supporter. The solicitor appointment was an important one because most major proposals under consideration by the city had legal ambiguities or ramifications.

Rather than to vote no on Pfuhl's choice of Green, a few of the councilmen tabled the action ostensibly because Green was already solicitor for the Greater Johnstown School District. Serving as city solicitor might be a conflict of interest. A few councilmen changed their stance, and Green was confirmed after Wid Schonek contacted them.[401]

The council soon began meeting in the evenings. At first Pfuhl and his staff assistants personally attended to participate in the deliberations. After several months, they stopped going. "Pfuhl didn't want us there," Harold Jenkins stated, "and he wasn't about to show up himself."[402]

Generally speaking, the honeymoon period for the new administration lasted throughout the first year. The leading complaints had to do with the mayor's letting contracts without consulting council. Under the city's new law, the council could not award contracts but could enact an ordinance regulating the manner in which contracts had to be awarded—the sort of thing the council was not equipped to do proficiently. Pfuhl summarily awarded the insurance brokerage business to the Gleason Agency. Robert Gleason, its president, was the Republican county chairman.

Pfuhl also awarded community development consulting contracts to Mullin and Lonergan, a planning firm. By controlling the technical expertise dealing with a complicated federal initiative, Pfuhl was able to shape the policy options in the Community Development Block Grant Program. The consultants were working for the mayor. The city council was told, "This is the way it must be." Councilmembers complained that they had learned about contract awards in the newspapers and were never consulted about them.

The three council holdovers from the commission form of government, especially Victor Bako, felt like all powers had gone to the mayor. The fact that there were nine councilmembers was irrelevant. In Bako's view, the council in the new system had little to do.[403]

When George Arcurio Jr., the former commissioner of streets and public improvements and after January 1974 only a city councilman, looked at the new 1974 budget, he remarked, "They've taken away all my people."

Jim Malloy must have also felt some grief. As commissioner of parks and public property, he had been working toward extensive renovations to Roxbury Park. Federal and state grants totaling $350,000 were secured. The work began in the summer of 1973. While started under Malloy's direction, the project was completed by the Pfuhl administration the next summer.[404]

The Sewerage System Takeover

The city business administrator, Bill Heslop, had previously been a commissioner on the Johnstown Municipal Authority, a city authority with representation by citizens of suburban localities served by the regional sewerage system.[405] Heslop was intimately familiar with its operation and finances. By law, when the authority became debt free, the system would revert to city ownership and control. Heslop knew that the system was both making money and building up enough cash reserves to retire its debt.

Pfuhl saw the sewerage system as a potential moneymaker. The council generally agreed. City Solicitor Green, knowledgeable in municipal bond matters, set about to orchestrate the takeover.

A major issue had to do with the city's forcing the municipal authority to use surplus funds to retire its debt. Suburban authority members, all opposed to the Heslop-Pfuhl scheme, began to reason that if the authority had accumulated surplus reserves, its rates were too high and refunds were in order. They also argued the system needed improvements that would not be forthcoming if its cash reserves retired debt. There was, however, bond indenture language requiring surpluses to be used to retire outstanding debt.

Pfuhl's dilemma was that the city had to control the system to have dominion over the surplus funds needed to retire the debt, while the debt needed to be retired for the city to control the system and its funds. The Catch-22 situation was resolved by Johnstown's obtaining a mandamus compelling the authority to retire the debt after it had been directed to do so by the city. John Hugya, a member of the authority, asked if he had to vote yes. Authority Solicitor Samuel Di Francisco answered, "Yes." Hugya resigned immediately.

On May 1, 1975, the city government took over the sewerage system. As it happened, there had been sufficient cash reserves to retire all outstanding bonds.[406]

The Bus Crisis

During 1945, the last year of the war, the Johnstown Traction Company had carried almost 20,000,000 revenue passengers.[407] In almost constant declines year by year, this number drifted lower. In 1973 the company carried only 1,846,168 revenue passengers. In less than thirty years, usage had declined by 90 percent.

General postwar affluence had led to increased automobile ownership. Each fare increase caused a decline in bus ridership. Meanwhile, the company's aging equipment was becoming more worn. The energy crisis of 1973 and 1974 brought a spike in fuel costs. The Johnstown Traction Company was losing money. Bankruptcy seemed inevitable.[408]

At the June 1974 meetings of the chamber of commerce and the Greater Johnstown Committee, Glen Reitz, president and general manager, described the company's plight. Reitz announced that as things stood, its operations would soon end. A month later, in July 1974, Reitz predicted that without some sort of bailout, the buses would stop running in late August.[409]

The immediate challenge was to halt an impending shutdown. The Pennsylvania Department of Transportation operated a transit assistance program, through which federal funds could be granted to local public agencies to underwrite up to two-thirds of the net operating losses of transit operations. An eligible agency would have to provide the remaining one-third match and then use the funds to contract with the service provider to subsidize transit continuation.

Through the constructive prodding of the chamber of commerce and its president, James M. Edwards, the city agreed to serve as the local lead agency, but Mayor Herb Pfuhl insisted that Johnstown would not underwrite the costs for suburban municipalities.[410]

With a September shutdown looming, the fourteen municipalities served by the Johnstown Traction Company were represented at a meeting on August 20 to address the crisis. T. Fred Young, county planning director, presented some cost-sharing numbers addressed at generating $100,000 of local support for a $300,000 subsidy program. Young's allocations for each municipality were based upon proportionate population counts within given distances of the bus routes together with the miles of bus routes in each municipality.

Mayor Pfuhl and the city immediately agreed to appropriate $48,000. In reasonably rapid order Stonycreek Township, Ferndale, Brownstown and Westmont followed. Southmont and Richland Township belatedly joined. The remaining localities that were getting bus service—Dale, East Conemaugh, Franklin, Lorain, Scalp Level and Windber Boroughs together with both Upper Yoder and Lower Yoder Townships—all refused to participate the first year.

This strange admixture of participating and nonparticipating localities created a no-win situation for the bus company. Reitz had to devise a pattern of routes for those localities that were contributing subsidies while denying service to the others.[411]

With the arrival of 1975, a new round of service agreements was needed. It was self-evident that the purchase of service system was a patched-up, stopgap arrangement. The buses were continuing to deteriorate, ridership was falling and the situation, with some localities participating and others refusing, was an absurdity.

On December 22, 1975, the city council passed a resolution by a narrow five-to-four vote, creating the Johnstown Transportation Systems Authority (JTSA). The JTSA was Herb Pfuhl's idea. There was a seven-member board. Its executive director, Wid Schonek, served without pay. The new authority proceeded to develop a contract with City Coach Lines of Jacksonville, Florida, to manage and operate the transit system following the Johnstown Transit Company's takeover.

Meanwhile a new county commission took office in January 1976. Its members were Ted Metzger, T.T. Templeton and Joseph Roberts. Unlike their predecessors, the new commissioners took an active interest in mass transit. In early July 1976, they created the Cambria County Transit Authority. Its board was to have three members from the city, four from suburban areas outside and two from other parts of the county. A showdown between the city and the county was inevitable.

Under the federal transportation legislation, each metropolitan area was required to create a "coordinating committee" of state and local leaders involved in various aspects of public transportation—highways, transit and aviation. Such a local group, the Coordinating Committee for the Johnstown Area Transportation Study (JATS), had begun to function in 1965. Its approval for each transportation-related project or activity located in Cambria and Somerset Counties has been necessary for federal transportation fund eligibility.

In the event of an impasse between the city and the county, the controlling vote on the coordinating committee was that of a representative of the Pennsylvania Department of Transportation.

Whether the Johnstown Transportation Systems Authority or the Cambria County Transit Authority would be the designated recipient for federal Urban Mass Transportation Administration (UMTA) funds had become an important and controversial question. The issue was resolved officially on July 28, 1976. By a vote of three to two, the coordinating committee designated the county's authority as the recipient agency for UMTA funds.[412]

Incensed by the defeat, Pfuhl threatened that the city would not cooperate in future purchase of service agreements. His reasoning was that if the bus system had been confined solely to the city, it could have operated without a loss, and the regular bus routes serving suburban areas were responsible for the "red ink." Using this logic, Pfuhl refused to sign the purchase of service agreement for an extended period. His posture on the transit issues brought forth a well-remembered, heated exchange with Teddy Metzger. Pfuhl finally yielded and signed the agreement in November 1976.[413]

In early September, Harold Jenkins, the city's public works director, was named staff manager of the Cambria County Transit Authority. The new organization had to secure two interim county loans and several UMTA grants to subsidize operations, finance the acquisition of all assets of the Johnstown Traction Company and modernize the bus fleet and its maintenance facilities.

The Cambria County Transit Authority acquired the assets of the Johnstown Traction Company in May 1977. The total costs, including those of the closing itself, were about $1.6 million.[414]

Clashes by Night

The strong mayor versus the city council conflicts in Johnstown would eventually escalate into serious altercations. Over time, they became ongoing community features.

The most plausible explanation stems from the fact that of the five councilmen (commissioners) in the previous government, three remained on the new nine-member city council. The mayor and his subordinates were now performing what had once been their administrative chores. In the old regime, five councilmen, including the mayor, met in executive sessions to discuss the forthcoming agendas prior to each upcoming council meeting, giving them an opportunity to keep abreast of what was happening. There was no process for ongoing communication in the new local government system.

In May 1975, former Mayor Dr. George Walter was running for city council in the Democratic primary. At a party rally, he stated, "I have read the new Third-Class City Code and nowhere

do I see that the change of government provided for a king or dictator." After Walter became a councilman, his attacks continued.[415]

In late December 1975, the city council approved a general fund budget of $5,847,663 with a half-cent tax hike. Pfuhl immediately vetoed the budget ordinance, charging the council with fiscal mismanagement and holding secret meetings.

Pfuhl gave many sound reasons for his veto—inadequate appropriations to cover mandatory labor arbitration awards, supervisory personnel receiving less pay than their subordinates and no pay raises for non-union employees.

Nonetheless the council voted six to two to override Pfuhl's veto. The situation had quickly deteriorated into one with no give and take between the mayor and the council. They were scarcely talking to each other.[416]

Council next sought to revise the administrative code to give to itself the sole authority to appoint the city solicitor. Pfuhl vetoed the ordinance and the council overrode the veto. The matter was immediately challenged judicially. Pfuhl was upheld. The court ruled that the council could not take back for itself the sole authority for naming the solicitor, after having earlier established a procedure for mayoral appointment with a council advise and consent role.[417]

A Restrained Militancy: Johnstown's Postwar Black Community

The evening before Armistice Day in 1947, Dr. Burrell Johnson, a dentist and president of the Johnstown branch of the National Association for the Advancement of Colored People (NAACP), addressed his membership. Johnson presented a summation of the status of Johnstown's black population, a postwar balance sheet.

On the assets side, Johnson judged that the school systems were good ones and most teachers were sympathetic to the problems of race relations. There was even one black instructor in the Johnstown system (then employing almost four hundred full-time teachers). Some community chest agencies had non-whites on their boards—the Teen Canteen, Girl Scouts, YWCA and Family Welfare Society. Johnson stated that the black community had good media relations. Race was not mentioned in crime reports. Newspaper editorial policy was described as fair. There was no discrimination in public theaters. There were African American officials in some labor unions. Two black instrumentalists performed in the Johnstown Symphony Orchestra.

On the liabilities side, Johnson detailed some significant items: Local blacks were experiencing poor industrial job opportunities with little chance for upgrading. There was segregation in housing, including a number of "restricted areas." Most restaurants refused service to blacks. (Seven restaurants in Johnstown were open to them.) Many office buildings would not rent to African Americans. There were no black women in training at Johnstown hospitals. Many labor unions practiced discrimination.[418]

There were other indications of subtle discrimination Johnson might have added. Johnstown had no black lawyers and only one black physician, Dr. Moses Clayborne. The hospitals employed no black nurses or medical technicians. (Marion Holton Patterson, trained in Pittsburgh and hired by Mercy Hospital in the early 1960s, became Johnstown's first black hospital nurse.)[419] Local stores and shops hired no African American sales attendants or office staffs. Indeed, when the Glosser Brothers Department Store hired non-white women to serve in its coat check room, the change created a sensation. All the good hotels were closed to blacks, as were the public and semi-public swimming pools.

Diminutive Enclaves

The Johnstown black community has always remained a small fragment of the overall population. When the city's census count peaked in 1920 at 67,323, there were 1,650 African Americans, about 2½ percent of the population. As the central city lost population from decade to decade, the overall black population rose slightly, except from 1980 to 1990. The following tables depict these trends in Johnstown, its urbanizing area as a whole and all of Cambria County:

Summary Data about Black Community

Johnstown City	Population	Number of Blacks	Percentage Black
1950	63,232	2,218	3.50
1960	53,949	2,655	4.92
1970	42,476	2,688	6.33
1980	35,496	2,705	7.62
1990	28,134	2,517	8.95
2000	23,906	2,561	10.71

Johnstown Urban Region[420]			
1950	110,180	2,936	2.66
1960	112,641	3,377	3.00
1970	99,494	3,152	3.17
1980	92,508	3,194	3.45
1990	79,379	3,010	3.80
2000	72,520	3,075	4.24

Cambria County			
1950	209,541	3,093	1.48
1960	203,283	3,600	1.77
1970	186,785	3,454	1.85
1980	183,263	3,378	1.85
1990	163,029	3,734	2.29
2000	152,598	4,322	2.83

One can readily discern from the data above that the vast majority of blacks both in the urban region and in Cambria County have lived in Johnstown.

Political Powerlessness

The comparatively small size of the black population has served to work against its members getting elected or appointed to public office. Those who were first to be successful are discussed below:

In March 1947, Percy Johnson, a black restaurant proprietor, was appointed to serve as Fourth Ward alderman (magistrate) to fill a vacancy caused by the death of Edward Levergood. Unopposed in the November election, Johnson became the first black person ever to occupy a governmental position in or near Johnstown. After Johnson died in office in November 1956, Governor George Leader named Miss Pauline Gordon, a black mortician, to succeed him.[421] In 1963 Raymond Hemphill, then a city street worker, won a Republican Party nomination for school director in the primary, but he was defeated in the November election.

On July 30, 1979, James Malloy Jr. resigned his seat on the Johnstown City Council to become city recreation director. On August 8, Saul Griffin was appointed by the remaining council members to fill the vacancy. Serving until the reorganization meeting in January 1980, Griffin became the first black city councilman.

In the autumn of 1984, Dr. Levi Hollis was named acting school superintendent for the Greater Johnstown School District. Soon afterward he was confirmed as superintendent. Hollis was the first African American to hold a major public office in the Johnstown area.[422]

In the general election on November 3, 1987, Victoria King and Julius Porcher both won elections to the Greater Johnstown School Board. As such they were the first African Americans ever to win against opposition in a runoff election for an ongoing position anywhere in the Johnstown area.

In July 1991, James McMillin resigned his seat on the Johnstown City Council. In a bizarre action, the remaining councilmembers appointed Allen Andrews to replace him. (The matter was bizarre because the councilmembers did not realize that procedurally they had actually made the appointment.) Meanwhile Andrews was already a candidate for the two-year seat. On November 5, he won. When this happened, he became the first black person to win an elected seat on the Johnstown City Council.[423]

As of this writing, there has never been an African American elected to a row office in Cambria County, the county commission or to a judgeship. No black person representing Cambria County has ever served in either the Pennsylvania Legislature or the U.S. Congress.

The NAACP Johnstown Branch

There had been organizations of blacks in Johnstown extending back to the early part of the twentieth century. During World War I, the Johnstown branch of the National Association for the Advancement of Colored People (NAACP) was formed.[424] By 1934 the local branch had become sufficiently rooted to host the Pennsylvania State NAACP Convention.

Indications are Johnstown's NAACP organization was nonmilitant in its approach, especially in the Depression, wartime and early postwar years. Newspaper accounts of the meetings gave the names of new officers as the rosters changed. NAACP meetings often consisted of a speaker to discuss a timely topic. Clergymen always played a leading role.

By the late 1960s there were about five hundred members, roughly half being white, although most white members were inactive. When the national dues were increased in 1970, the membership dropped precipitously to just over three hundred. The "Black Community Survey" (1969) had stated that all people generally viewed as leaders of Johnstown's black community were board members of the local NAACP.[425]

The Turbulent Years

In December 1955 a black seamstress, Rosa Parks, refused to yield her bus seat to a white man in Montgomery, Alabama. Her defiance precipitated a twelve-month bus boycott by the community's blacks. The protest ended when the company reversed its segregation policy. Through a form of civil disobedience, a black community in the Deep South had overturned a timeworn practice offensive to its members.

Through the bus boycott, the civil rights movement had taken on a nonviolent, civil disobedience approach championed by Martin Luther King and his newly formed Southern Christian Leadership Conference (SCLC). Sit-ins, boycott demonstrations and various voter registration drives followed throughout the late 1950s and 1960s.

When the Black Panthers and other more militant groups in the mid-1960s began to espouse black power and more revolutionary and potentially violent strategies, the Johnstown NAACP branch adopted a resolution rejecting these approaches. "The local branch does not condone, advocate, or support this type of action (i.e., black power and violent protest), nor does the branch recognize or adhere to the philosophy underlying this action."[426]

On April 4, 1968, Martin Luther King was assassinated in Memphis. Riots erupted in forty-one major cities. Throughout the tense week, Johnstown remained calm. A curfew had been imposed. Liquor stores, bars and clubs were ordered closed for a short while. King was eulogized at an Interfaith Memorial Service conducted on Tuesday, April 9 at the Franklin Street Methodist Church. Perhaps in response to reliable rumors that Black Panther and Black Muslim members from other cities were visiting the community and reaching out to Johnstown blacks, the local NAACP once again publicly reaffirmed its nonviolent policy.[427]

Employment Betterment and General Human Relations

In the 1937 steel strike in Johnstown, most black workers endeavored to continue working. They apparently had little use for unions at that time. One concludes that black steelworkers employed in Johnstown during the Great Depression were uniquely fortunate compared to most non-whites in general. The idea of going on strike in the mid-1930s at the urging of union leaders they did not trust probably seemed absurd to them.

Franklin Roosevelt's Fair Employment Practices Commission (FEPC) was created during World War II by a presidential executive order. Its purpose was to prevent racial and other discrimination in the execution of federal wartime contracts. The FEPC probably had beneficial effects for Johnstown's blacks but there is no ready documentation. Truman's postwar efforts to legitimize and strengthen the FEPC by statute were consistently defeated in the U.S. Senate. The Civil Rights Act of 1964, however, became landmark legislation. Through this law, far-reaching fair employment practices were made mandatory. Full-time equal opportunity staff directors and support personnel began to be hired by the larger employers in Johnstown.

In the postwar period, Pennsylvania was off to an early start in efforts to end discrimination. In 1955 Governor George Leader signed into law the Pennsylvania Fair Employment Practice Act, which sought to outlaw all forms of discrimination in employment. It also created a Pennsylvania Fair Employment Practices Commission with rulemaking, subpoena and broad enforcement

powers. The commission was also authorized to "create such advisory agencies and conciliation councils, local or state-wide, as will aid in effectuating the purposes" of the law. In 1961 the legislature created the Pennsylvania Human Relations Commission (PHRC) and assigned to it all the powers, duties and staff of the Fair Employment Practices Commission. In that same 1961 session, the legislature also enacted the Pennsylvania Fair Educational Opportunities Act, which sought to end de facto segregation and discrimination in education, a responsibility also assigned to the Human Relations Commission. The commonwealth was unifying all anti-discrimination programs and agencies under its PHRC, which continued to create and work with local human relations advisory councils.[428]

In Johnstown, the local Human Relations Committee had been set up as an advisory group to the Pennsylvania Human Relations Commission (PHRC). In the mid-1960s nearly all its members were affiliated with the Johnstown branch of the NAACP. This committee would hear complaints, identify discriminatory situations and refer them to the PHRC for remedial action.

By 1971 the Johnstown city government decided to create a Human Relations Commission of its own, an action it could have taken earlier when the 1965 legislation became law. The city's commission accomplished little. Whether its creation as a toothless tiger was an effort to weaken the advisory committee set up by the PHRC was problematic.[429] The latter continued to function.

The NAACP Public Housing Desegregation Posture

Among the first aggressive pursuits ever undertaken by the Johnstown NAACP branch were its efforts to desegregate public housing. As early as 1940 and 1941 at the inception of public housing in Johnstown, it had largely been the low-income and slum-dwelling conditions of local African Americans that had first justified the public housing program and the authorizations of federal funds to finance it. Nonetheless, when the first placements were made, the tenants' selection committee was assigning only a small number of units to non-whites. Dr. Burrell Johnson persuaded Walter Krebs to help rectify the situation. Krebs contacted federal housing officials, who ordered that there be an equal unit allocation among whites and blacks in Prospect Homes.[430]

The severe wartime shortage of housing at all social and income levels became the basis of a policy to make public housing units available on a priority basis to meet wartime needs— accommodating workers employed in war-related industries and housing military families.[431]

Although there were 111 units available in the Prospect Homes Project by early 1943, the Johnstown Housing Authority (JHA) had difficulty getting a full quota of whites to occupy them. While never explained, one can only conclude that many whites were reluctant to move into a housing complex with blacks. As of January 1943, there were forty-six white and twenty-nine African American families approved for occupancy. When the white applicants were presented with leases to sign, some backed off. The African American families, eager to move in, readily signed the lease papers. The authority's need to maintain a set racial quota of blacks to whites was creating a backlog of blacks but an insufficiency of willing whites. This basic situation was contributing to public housing units going vacant even in housing-scarce, wartime Johnstown.[432]

The public housing program in Prospect was followed by the first Oakhurst Homes Project, creating one hundred new units in the city's West End. This general neighborhood was virtually all white and was located near the heavily ethnic Cambria City section.

With Oakhurst Homes expected to be available for occupancy in May 1943, the Johnstown Housing Authority (JHA) rescinded its quota limitations on black families in Prospect Homes. The other families who needed and qualified for public housing would then be assigned to Oakhurst Homes. A number of black families would be occupying new (safe, sanitary and decent) housing at rents they could afford. Eligible white families, reluctant to move into Prospect Homes, then began occupying the new units in Oakhurst. The JHA justified these assignments with arguments that the new projects were helping to meet wartime needs.[433] While a pattern of racial segregation was forming in Oakhurst Homes, no one dared to challenge it in wartime. The Prospect Homes project was somewhat integrated, but the initial racial quota plan was ignored.

After the war, the NAACP Johnstown branch began slowly to address the housing issue. By 1953 the organization was urging the JHA to "allocate homes in all projects on the basis of need—regardless of color, race, or creed." Various quota formulas were preventing some African Americans from moving into the projects. The JHA and its staff maintained there was no discrimination.[434]

In 1965 the JHA and the Johnstown branch of the NAACP reached an agreement following a complaint the branch had made with the Pennsylvania Human Relations Commission. The agreement provided that the JHA would strive to attain a racial balance among the tenants in each of its public housing projects. The NAACP was never satisfied that the agreement was taken seriously. A JHA policy preventing lateral transfers of tenants from any one complex to another explained why a more aggressive racial balancing program had not been implemented.

In late May 1970, the Pennsylvania Human Relations Commission (PHRC) reviewed the entire JHA program in a quasi-judicial proceeding. Testimony was introduced establishing that there was racial segregation in all public housing projects except Prospect Homes. Old Oakhurst had 1 black and 99 white families; New Oakhurst had 4 black and 296 white families; Coopersdale had 9 black and 153 white families; while Prospect Homes had 57 black and 53 white families. Very subtly, a pattern of segregation had set in.

In December 1970, the PHRC issued its ten-part ruling. Among a number of things, the JHA was ordered to assign new black applicants to the four largely white projects until minimum desegregation objectives were achieved. Black residents of Prospect Homes were to be moved at authority expense to any of the other projects of their choosing. The JHA was to report its progress to the commission every three months for the next five years. By 1974 it was evident that the segregation patterns in the several projects were ending.[435]

The NAACP and Other Johnstown Community Issues

The Johnstown branch of the NAACP challenged Johnstown City's Workable Program.[436]

The Johnstown branch also sought to have the school board close down the Joseph Johns Junior High School to achieve racial balance. There were three junior high schools in the Greater Johnstown School District. Garfield in the West End and Cochran in the Eighth Ward between

Hornerstown and Moxham were predominately white. The vast majority of black junior high pupils were attending the Joseph Johns School on Market Street.

The school board took only a limited action on the NAACP request because the fate of the school was settled in the Market Street West Urban Redevelopment Project. Had the school been closed by the school board, its acquisition price through urban redevelopment would probably have been much less. The Johnstown Redevelopment Authority acquired the school in 1970 and demolished it.

The NAACP also sought to keep open the Prospect School, slated for closing as part of the Greater Johnstown School District's desegregation plan coupled with its needs to phase out a number of schools. Many black families, opposed to their children being bused to West End schools, were seeking for a new model school to be built in Prospect with white pupils bused to it rather than black students being bused out. Prospect, however, was eventually closed.[437]

The Perkins Shooting Incident

At about 9:00 p.m. on Saturday, March 29, 1969, a Johnstown patrolman, Charles La Porta Jr., shot and killed Timothy Perkins, an unarmed fifteen-year-old black youth, in the alley behind the Arrow Furniture Company on Franklin Street. Apparently several black youths had been drinking when a city patrolman, Thomas Ricci, encountered them. He called for help. La Porta soon arrived. Ricci felt the two of them needed more manpower so he went to his police cruiser to radio headquarters. While Ricci was away, La Porta shot Perkins, killing him instantly.[438]

Word about the shooting spread quickly. There was an immediate fear of a major riot. Rumors also began circulating that mobs of blacks from Pittsburgh were heading to Johnstown to stir up trouble.

Hope Johnson and her close friend, Marion Holton Patterson, drove about Johnstown urging gangs of black youths to calm down. Other NAACP members did the same thing. The Johnstown branch and a new organization, the Black United Front, jointly established a rumor control center. Black churches were scheduling "night of prayer" sessions. In retrospect, Mrs. Johnson believed that the combined efforts were successful. "Some people were ready to set the town on fire," she stated.[439]

La Porta was immediately suspended. He was later indicted, tried and found guilty of involuntary manslaughter. His conviction was overturned by the Pennsylvania Superior Court.

The Perkins incident fomented bitterness in the community. Sam Coco, Kenneth Tompkins's police chief, was called a racist. Reverend W.M. Cunningham, pastor of the Cambria AME Zion Church, accused the police department of brutality and harassing young people. "Are churchgoers, teenagers enroute to home, hospitals or dances to be pounced upon and labeled purse snatchers, loud mouth bullies, troublemakers, and so forth, solely because they are assembled or are traveling on the street? It is the past practice of this city," Cunningham charged.

A Black Student Protest

A few weeks after the Perkins shooting incident, a group of black high school students staged a brief student revolt. Black students at Central High School together with a few students at

Joseph Johns Junior High had been seeking a program of black history and black studies. They wanted books and songs that were offensive to them discontinued from the district curriculum. Male black students pointed out that white students were growing sideburns while they were still forbidden to grow moustaches. They also protested the dress code, then about twelve years old. It forbade loud clothes and tennis shoes. Specifically they sought to be able to wear dashikis, brightly colored African-style shirts. They also wanted the school cafeteria at Central High to prepare black-ethnic food.

The students' demands were not taken seriously. In early May 1969, a student walkout was planned. Dashikis were produced in black households all over Johnstown. Led by Allen Andrews, a champion high school wrestler, together with Alan Cashaw and Daniel Perkins, the group walked out of classes and headed to the nearby Joseph Johns Junior High, where many of the younger black students burned their lunch bags, a protest in quest of soul food. Others joined the walkout. The group went to the Cambria AME Zion Church on Haynes Street where they read *Before the Mayflower*, a black history book.

When the high school principal, Don Irwin, showed up to talk with the group, he was denied entrance. He sent Bruce Haselrig to negotiate. Haselrig was admitted. There had been earlier threats of expulsion and graduation delays. The protest, however, ended with the one-day walkout. There were no reprisals. Students won the right to wear dashikis and tennis shoes. Moustaches were also allowed, although the school curriculum was not altered to include black history and there were no changes in school cafeteria menus. Pastor W.M. Cunningham used the occasion to counsel the group about how to seek and negotiate reasonable demands.[440]

THE CENTRAL BUSINESS DISTRICT UNDER SIEGE

I. DOWNTOWN DOMINANCE

Penn Traffic set a new record on October 6, 1955—the biggest one-day sales volume in the company's 101-year history. Despite rain, more than 24,750 people had entered the store. The success was auspicious. What was good for Penn Traffic was good for downtown.[441]

From the postwar era to the mid-1950s, Johnstown's central business district continued its century-old role as the commercial and professional core of the urban region. Everything perpetuated its ascendancy. All regional highways were routed through downtown as was every trolley or bus line in the Johnstown Traction Company system. The two major department stores, Penn Traffic and Glosser Brothers, easily the most complete shopping institutions in a fifty-mile radius, were located near each other downtown.

There was also the J.C. Penney store occupying the former Merchants' Hotel on Main Street, a building completely converted and refurbished in 1938 and 1939. The Sears Roebuck store was across the street in the former John Thomas and Sons complex. Sears had moved there the year after the 1936 Flood when John Thomas and Sons, then a Johnstown retail firm for over seventy years, downsized and moved into the Capitol Building on Franklin at Vine for a last ditch stand. It folded in 1939, but came back as a furniture store at 410 Vine Street until closing in 1972.

There was also Foster's at Bedford and Main, another long-standing Johnstown establishment, specializing in upscale household goods and furnishings, women's and infants' clothing and bridal wear.[442] Across Bedford Street was the Swank Hardware Company. It sold hardware, appliances, select furniture and sporting goods.

Among the chain stores was F.W. Woolworth, facing both Main and Franklin Streets and somewhat encircling the First National Office Building on the corner. Grant's occupied a large new building extending from Main to Lincoln along Park Place. It had been constructed "half and half" in 1952—half of the building was placed in full usage while the other half was demolished and rebuilt. The Kresge Store was located at Main and Park Place where Nathan's

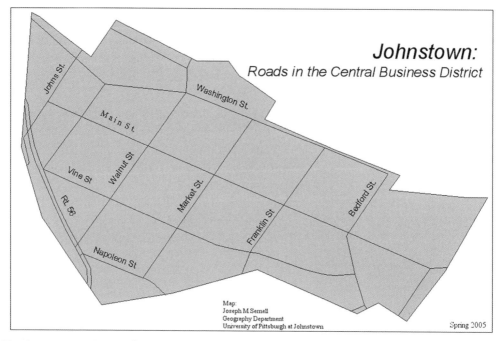

Map of major streets in Johnstown's central business district.

had once been in what would later be called the Jupiter Building. Up the street on Main, there was McCrory's, a remnant of one of the first chain stores in the nation.

The major banks—the U.S. National, Johnstown Bank and Trust and Johnstown Savings Bank—were headquartered downtown. In March 1959, the Dale National Bank placed a branch on Franklin, and in 1970 the Moxham National Bank opened an office next to city hall.

Downtown was also home to a major Ford-Lincoln automobile dealership, Suppes Motor Sales. In January 1936, Suppes Sales had moved into the former Johnstown Automobile Company Building at the head of Main Street, where it remains in 2006.[443]

The Pennsylvania Electric Company, the Pennsylvania Telephone Company, the Johnstown Water Company and the Johnstown Suburban Gas Company had their offices downtown.

As per the 1954 Johnstown City Directory, seventeen of the twenty-three Johnstown-area jewelry shops, twenty-seven of the thirty men's and women's clothing stores and all thirteen shoe stores were located downtown. Of the twelve unused furniture establishments, nine were downtown including the largest, Penn Furniture.

By the mid-1950s, the Fort Stanwix on Main Street, built in 1915, remained the most prestigious Johnstown hotel. The Capitol at Main and Walnut Streets, a venerable institution reconfigured in 1892 from the post-flood remains of the old Cambria Club, still had a timeworn respectability despite tattered furnishings and ongoing mortgage and tax problems. Less esteemed were the Hendler and the Crystal Hotels on Washington and the smaller Royal Hotel on Main. The Johnstown area had several outlying motels or motor lodges but they were insignificant in the 1950s.

The leading motion picture theaters, especially the Cambria, the Embassy and the State—the three that presented almost all premier showings—were located on Main Street.

All major office buildings in the urban region were downtown. These included the First National, the Swank (Hardware) Building, the U.S. National Bank Building, the Wallace Building (the Ellis Building prior to 1950), the Fisher Building and the Bethlehem Steel Offices on Locust Street. In 1954 Bethlehem Steel Corporation began constructing its new five-floor office addition on Locust Street.

Other important downtown facilities included the Johnstown Tribune Publishing Company, the WJAC-Radio and TV facilities, the YMCA, the City Hall and Public Safety Buildings, Point Stadium, the War Memorial, public library and Lee Hospital.[444]

A special 1961 survey of the city center revealed the area had 1,479 establishments that employed about 13,000 people who actually worked downtown.

The central business district was home to 4,032 people in 1960, a drop of 604 since 1950. Its population was elderly, although there were young people who had not yet started a family. The average family size of those living in the center city in 1960 was 2.2 people when the citywide average had been 3.2 people.

II. Problems and Plans

Hints of Problems

Few new additions had been made since the late 1920s. The major buildings constructed during this period had been a Glosser Brothers's addition, facing Locust Street (1931); the U.S. Post Office and Federal Building (1938); the Pennsylvania Telephone Building on Locust (1938); the Tribune Publishing Company addition on Locust (1940); the War Memorial Arena (1950); and the new Grant's store on Main Street (later McCrory's, 1952). The roster represented approximately one significant new building every four years. While there were smaller structures added here and there and some refurbishing, downtown was wearing out faster than it was replaced.[445]

A subtle trend had also begun to occur. Estates, investors and absentee landlords increasingly owned center-city properties for income purposes. Their income streams often made good investments. So long as the rents continued to flow unabated, there was little incentive for an owner to invest in major modernization. There was also no reason to sell the properties unless an offering price was unusually high. The general situation contributed to downtown's slow deterioration.[446]

Most central business district lots were too small for modern, functional usage. A number of them had their origins in Joseph Johns's 1800 plan for Conemaugh Old Town—the First and Second Wards. Johns had an obsessive fixation with sixty-six-foot widths for lots and many streets. Over the years many parcels had become further subdivided. Some of those that had remained intact or had even been enlarged were the homeplaces for prominent Johnstown families such as the Lintons, Loves and Lees, sites that housed respectively the American Legion, the Fort Stanwix and Lee Hospital.

The tiny lots were becoming increasingly dysfunctional. They either made it difficult and costly to assemble more optimally sized parcels for modern commercial use or they encouraged wastefully thin buildings such as the Johnstown (Bank and) Trust Building, Mayer Apartments, Hendler Hotel, Landmark Building and others.

Downtown streets were often clogged with traffic. Parking was a constant problem. Many buildings had shabby appearances often blighted with advertisements painted on their exterior. Signs often hung over the sidewalks in a no-win competition with other signs. Commerce in the 1960s and 1970s was dictating a need for wider, more expansive spaces in areas that could be accessed without hassle or parking difficulties. Such amenities were absent in Johnstown's downtown.

In the mid-1960s the Kresge Corporation began changing its basic business model. The more successful Kresge locations became Kmarts while Kresge outlets in marginal, declining areas were designated Jupiter Discount Stores and their merchandise mix was lower in quality and price. In late 1965, Kresge's at 426 Main Street became a Jupiter Discount Store.

Changes Here and There

In June 1955, the Penn Traffic Company purchased the Capital Hotel at Walnut and Main Streets. After demolition, the site became a parking lot.[447]

In the spring of 1959, the former A&P supermarket at 217–219 Franklin Street was refurbished for two new uses—a Dale National Bank branch and the Greater Johnstown Chamber of Commerce.[448]

Also in 1959, a group of local investors led by John Crichton developed the thirty-seven-unit Towne Manor Motel at Lincoln and Johns Streets, across from the Point Stadium parking lot.[449]

In April 1959, Woolf and Reynolds, Inc., a seventy-year-old men's and boys' clothing store at 526 Main Street, went out of business. Several local investors acquired it in June 1961. The building remained vacant until the L.A. Surplus Clothing Company leased it two years later.[450]

Johnstown lost an important landmark in December 1959 after the Trans-America Theater Corporation announced a plan to demolish the sixty-nine-year-old Cambria Theater across Main Street from the Fort Stanwix and to construct an eight- or nine-floor motel with shops. The theater was demolished but the site eventually was used for a Burger King.[451]

In January 1961, Glosser Brothers acquired the B&O Tavern and the Johnstown Cut Flower, Inc., at 506 and 508 Washington Street. Six months later, the company began demolishing the properties at the Washington-Franklin corner and erected the Glosser Annex.[452]

In July 1963, the Geis Furniture Store at 141–143 Clinton Street was closed for good after having been in business since 1894. Karl's Beauty Supply House occupied most of the building in July 1966.

The Karl's move was a result of the Penn Traffic's acquisition and demolition of three properties between 314 and 324 Washington Street—also the site for the Family Store (clothing), the Johnstown Paint and Glass Company, the Quirk Apartments and Century One-Hour Cleaners. The changes gave Penn Traffic a large parking lot extending from the Hendler Hotel to the library (Flood Museum in 2006).[453]

In June 1963, the large WJAC Building in the Berkley Hills section of Upper Yoder Township was finished. After the WJAC offices and studios had moved out of 329 Main Street, the building was sold. Downtown lost an important activity but WJAC gained functional, convenient space.[454]

The former post office on Market Street at Locust had been used for federal offices after its new replacement had opened in 1938. Adjoining city hall, the City of Johnstown acquired it

in 1966 for $109,500 but learned that office conversion was costly. In March 1967, the Crown Construction Company purchased the building for its headquarters.[455]

In March 1972, the U.S. National Bank acquired three properties on Franklin Street between Vine and Lincoln. With the sole exception of the AAA Building, the bank then owned everything between Lincoln and Vine and Franklin Street and Park Place. As soon as it owned the entire site, the bank demolished everything on it.[456]

Foster's, a long-standing Johnstown institution, closed in 1960. The property was demolished in 1973 for the Senior Citizens' Center of Cambria County, constructed in 1974.[457]

The Cambria Savings and Loan Association once boasted of being founded in 1870. In 1940 the institution moved from Kernville into the Porch Building on Franklin Street. In 1950 it constructed its own building at 225–227 Franklin between Arrow Furniture and the Porch Building. Cambria Savings and Loan eventually acquired everything along Franklin Street from the new chamber office to Vine Street.

In January 1974 the Cambria Savings and Loan Association demolished Arrow Furniture for its expanding building. A new entrance was provided at what had been Apple Alley. In March 1977, Cambria Savings and Loan announced its plan to demolish the Capitol Building at Vine and Franklin, an action carried out in April 1978, months after the flood.[458] The result was a vacant excavated area dubbed "Minno's Hole," after Cambria Savings and Loan Association President George Minno. The excavated space persisted for several years until the association added an enclosed parking and drive-in area with upstairs offices.[459]

In the early 1970s, the Swank Hardware Company, a Johnstown institution at Bedford and Main since 1862, began experiencing hard times and was reorganized as a subsidiary of K and S Hardware. In 1973 Swank Hardware quietly vanished. Its first-floor space was briefly occupied by the Universe Furniture Company.

Another major downtown development was the U.S. National Bank's new headquarters complex extending from Main at Franklin to the Penn Furniture Company and eventually to the corner of Lincoln Street. The project had been in the talking and planning stage for years.

In August 1976, the bank announced it was exercising its options to acquire both the First National Building and the Woolworth Building next door. The two were demolished in late October 1977. Groundbreaking for the new five-story banking and headquarters complex tied into the older U.S. Bank Building took place in April 1978.[460] The project was finished in 1980.

The Penn Traffic Department Store on Washington Street never reopened after the 1977 Flood. Converted into an office building, it became the site of the Johnstown office of the U.S. District Court of Western Pennsylvania in 1989 and the U.S. Drug Intelligence Center in August 1993.

The Central Business District Plans

The planning proposals described earlier contributed to the design concepts used in the Solomon Run Access Road (Route 56 Bypass) and the Cross-Kernville Expressway, which were opened to traffic in November 1972.[461]

The comprehensive plan done by Community Planning Services (CPS) of Monroeville was finished in the autumn of 1961. Before its completion, many people in the community were familiar with the recommendations that were fashioned. Its downtown component was

proposing that the entire central business district be demolished except the War Memorial Arena. The plan was also advocating a loop highway to encircle most of downtown. There also were recommendations for extensive parking. The core of the downtown area would be used for commercial purposes with all residential structures eliminated. The CPS firm was proposing that the entire central business district become a large, modern shopping center augmented by commercial offices.[462]

The extreme impracticality of the CPS downtown program was recognized immediately. Even before its completion, the Greater Johnstown Committee began urging the preparation of a new CBD plan to be done by a seasoned planning firm with extensive downtown revitalization experience. The GJC also offered to pay nearly half the $37,000 cost. The state and the Johnstown Parking Authority paid the remainder.[463] Buchart Engineers, a firm from York, was retained. Work began in April 1961.

In late May 1962, the new central business district plan was unveiled at a major public meeting, where it received an enthusiastic reception by community leaders.

The Buchart Plan assumed the eventual achievement of the Kernville Expressway then under study by the Pennsylvania Highway Department. The plan also made far-reaching recommendations—the clustering of shopping, professional offices and civic and governmental activities near one another. Extensive parking recommendations were made. Single- and double-family dwellings were discouraged, and most parts of downtown having them were proposed for demolition. Apartment buildings, however, were encouraged. A civic center complex was proposed that would encompass a new City Hall and Public Safety Building, an office building for community and semi-public agencies, a new library and a museum.

The Buchart Plan also recommended that Main Street between Market and Clinton be made into a pedestrian mall. Those sections of Park Place and Locust Street adjacent to Central Park would become a "Park Plaza"—a canopied pedestrian area. Implementation was expected to take twenty years and cost $26,750,000.[464]

Although the central business district plan had been enthusiastically received initially, Wallace Williams, a leading realtor, soon decried a lack of interest displayed at several public presentations.[465] As time passed, the public simply forgot the plan.

III. DOWNTOWN URBAN REDEVELOPMENT

Market Street West

In the late spring of 1962, the Buchart Downtown Plan was becoming a talk topic for civic club luncheons. The Johnstown Redevelopment Authority had begun executing B-2, its Cambria City project for the Penelec headquarters complex. Members of the Greater Johnstown Committee and the Redevelopment Authority began visioning a downtown urban redevelopment project.

George Walter, Johnstown's mayor for over two years, had been the force expediting the sluggish Cambria City renewal effort. Walter's leadership had made him a hero among civic leaders but a rogue to people uprooted and forced to sell their homes and business properties. A major complaint was that the old, ethnic neighborhood had become large vacant lots that

Above: Market Street West urban redevelopment project at the Main and Market Street corner in the winter of 1967–68. The view of city hall is toward the northeast. Not yet demolished is the Yee Sing Laundry. After clearance the corner property housed the headquarters and customer facilities for the Johnstown Savings Bank and later UPMC-Lee Hospital, acquired by Conemaugh Health Systems, Inc., in 2005–06. *Below:* Aerial view of Johnstown's downtown in the summer of 1968. Market Street extends horizontally across the center from the Crown Building (old post office) and city hall to the Joseph Johns Junior High School at the far right. Construction of the Johnstown Savings Bank complex is underway. The large building facing Market Street just to the right of the center is the former YMCA. *Photos courtesy Johnstown Redevelopment Authority.*

remained unused. His urban renewal support had contributed to Walter's 1962 primary defeat that ended his hopes of replacing Congressman John Saylor.

By February 1963, the Johnstown Redevelopment Authority was preparing another "survey and planning application" for federal funds to develop another project—one in downtown. The application required city council approval.

Meanwhile, Walter had the council's backing for an acceptable course of action—the redevelopment authority could proceed with a project but there must be no vacant land left sitting around downtown awaiting development. The redevelopment authority was told to secure commitments for a property's reuse before demolishing what was on the site.

In March 1963, the details of the next urban renewal project were unveiled—encompassing an 18½-acre tract bounded by Main and Napoleon between Market and Walnut Streets plus a small area between Napoleon and the river west of the War Memorial. Joseph Johns Junior High School would be acquired but not the War Memorial. In April the council voted three to one to authorize the application, a request for planning funding and a preliminary project authorization. Eddie McCloskey voted no.[466]

There was a lull for many months while the Urban Renewal Administration in the HHFA processed the application. Approval finally came and in March 1964, the redevelopment authority and its consultant, Keith Swenson with Beckman, Mueller, and Associates of Pittsburgh, proceeded to lay out the detailed project scope and recommendations and refine earlier cost estimates.

A major problem involved the fate of the sixty-seven-year-old Joseph Johns Junior High School. The school district reform proposals were still unsettled, making it impossible to know the classroom needs of any district including those of Greater Johnstown.

Various planning proposals had reached a major crossroad by April 1965. There was conflict even among Johnstown's civic leaders and downtown boosters. Frank Pasquerilla, chairman of a downtown GJC subcommittee, expressed concern that another major retail outlet might locate in the project area.

The Fort Stanwix Hotel was another dilemma. Then owned by the University of Pittsburgh and partially used by UPJ students as dormitory rooms, its fate remained unsettled. If demolished, the viability of another hotel or motel in Market Street West would be enhanced. Its demolition would also force a decision by Lee Hospital whether to expand into the space or yield a prime hospital expansion site to another use.

Both the Johnstown Savings Bank and the U.S. National Bank expressed interest in the new site surrounding the parklet at Main and Market Streets. The former sought to create its new banking complex there, while the U.S. National wanted it for a two-level services building.

Another controversy had to do with whether to select a development corporation to be responsible for the reuse of the entire site. Such a firm would acquire all the land in the project for redevelopment after clearance, recruit new occupants, design and construct buildings and other new facilities for them and sell or lease the new premises.

Once a decision had been reached to choose a sole development corporation, an issue arose whether to choose Urban Properties, Inc., a Pittsburgh firm that had submitted its proposal by the advertised deadline and had a local representative, John Sroka, who was familiar with the project. George Zamias, the local representative for Milton Schwartz Associates from Philadelphia, asked

the redevelopment authority to delay selection until his client could submit a proposal. Although there were those who saw no reason to choose a development firm at all, Urban Properties of Pittsburgh was selected.[467]

In February 1966, the Market Street West Project proposals were exposed to community review at a public hearing held before the city council, a program requirement prior to seeking federal loan and grant authorizations to be used for actual implementation. The hearing went from 10:00 a.m. until 3:40 p.m. with two intermissions.

The project was supported by all the mainstream organizations—the chamber of commerce, the Jaycees, the Greater Johnstown Committee and others. Dr. Biddle, the president of University of Pittsburgh at Johnstown, announced by letter that the Fort Stanwix would not be needed after the autumn of 1967, when the new Richland campus would be opened.

On March 1, 1966, the city council unanimously approved the redevelopment authority's plan and authorized filing a loan and grant application.[468]

In early 1967, just after the project went into more concrete forms of implementation, the redevelopment authority and the city faced another hurdle, "workable program" recertification—a responsibility of the city government itself, not the redevelopment authority.

Ostensibly the workable program was a sort of municipal pledge to assure that the community was working diligently to pursue comprehensive programs to prevent slums and urban blight from recurring. The elements included code enforcement, zoning, comprehensive planning and sound programs for relocating people displaced by government action. There was also a housing element—a program to provide safe, sanitary and decent housing at prices people could afford. A citizen participation element sought to guarantee that there were processes to enable anyone in the community to be involved actively in helping to fashion its civic and other agendas.

The mid-1960s was the era of Martin Luther King's nonviolent marches, sit-ins and voter registration drives. In 1965, what had been the Housing and Home Finance Agency (HHFA) became the U.S. Department of Housing and Urban Development (HUD). Its first secretary was Robert Weaver, who was black. In many cities, including Johnstown, the workable program had become a pressure point for blacks to pursue previously neglected agendas—minority representation on boards and commissions, the establishment of biracial commissions and other measures. Like Johnstown, the power elite in many communities supported urban redevelopment. Through the workable program requirement, the community would have to satisfy many minority demands to achieve the recertification necessary for urban renewal to proceed. For this reason, the workable program requirement in Johnstown became controversial, politically difficult and a factor of delay in pursuing Market Street West, especially in 1967 and 1968.[469]

In January 1967, the redevelopment authority began acquiring properties and relocating people and businesses. Urban Properties presented and received approval for a small, enclosed shopping complex, the Centre-Towne Mall.[470]

A controversy developed over the choice of Johnstown Savings Bank to acquire the area around the parklet near Main and Market extending up to Lincoln Street. Its reuse price was $75,000. Even John Torquato expressed outrage that both a threat of condemnation and $480,000 of public money had been used to acquire and clear the site, which in turn was sold to a bank for one-sixth the cost of delivering it. "I strongly oppose a land grab of this type," he wrote.[471]

In January 1968, the Fort Stanwix was purchased from the University of Pittsburgh. After demolition, Lee Hospital acquired the site for expansion.

Another major dispute smoldered between the authority and its development firm, Urban Properties, ostensibly about an office complex the authority was hoping to erect. Urban Properties claimed it had been unable to secure the necessary financing. The upshot was that Urban Properties resigned from its role, which was assumed by the redevelopment authority staff.[472]

The controversies that erupted because of Market Street West were enormous. On one occasion, the entire redevelopment authority threatened to resign unless the body received a vote of confidence from the city council. The council complied.[473]

By February 1971, the redevelopment authority had completed all land acquisition, relocation and demolition within the project area except Lee Hospital, the State Theater and the First Presbyterian Church—three properties originally slated to remain. Thanks to Market Street West, 150 families, 136 single people and 72 businesses or commercial and professional offices were relocated, and 145 structures were demolished. The project made almost twelve acres of land available for new development.[474]

In addition to the developments already mentioned, the Jonel Construction Company built a seven-floor, $1.5 million residential apartment building at Lincoln and Walnut Streets. At Walnut and Vine, the American Red Cross erected a $550,000 chapter headquarters and regional blood center. Across Vine from the Red Cross Building was the Centre-Towne Mall and Gee Bee Supermarket, with a large parking lot to serve them both. The Walnut Apartments, a twenty-four-unit development, was constructed next door.

The Crown American Corporation came to the rescue of the project after an earlier hotel development proposal fell through. Crown constructed and became the owner and manager of the 135-room Sheraton Motor Inn (currently the Holiday Inn) located between Lincoln and Vine on Market Street. Across Vine Street from the Sheraton Inn, George Zamias, a Johnstown developer, constructed a three-story office building. Next door on Market Street, Crossgates, Inc., of Pittsburgh developed and built the Joseph Johns Towers, a ten-story, 165-unit apartment building that cost $3,137,410.

The final development within the Market Street West area was the Veterans Memorial Park. The small site was acquired and completed by the Cambria County War Memorial Arena.[475]

From its initiation to completion, Market Street West had taken ten years. A rundown part of town was cleared and several important new facilities were added. Countless small land parcels were reconfigured into twelve new ones, each averaging about an acre. Aside from a few small alleys that were closed, the street system remained unchanged. Tax revenues generated from the area were increased following urban redevelopment.

The Main Street Project: The David Glosser Memorial Library

As Market Street West became a reality, locating a new public library in its boundaries was considered but could not be arranged to the satisfaction of the library board.

The redevelopment authority next proposed a small, single-purpose project on Main Street between Walnut and Morrell Place back to Ebbert Alley. The area contained the John Conway Funeral Home, Belvedere Hotel, a physician's office and a medium-sized parking lot. Compatible

The southeastern corner of Washington and Market Streets in the autumn of 1956 or 1957. Surveys revealed that the preferred location for the Washington Street Parking Garage was a site convenient to both the Penn Traffic and Glosser Brothers Department Stores. The corner area was acquired and cleared in 1970 and redeveloped into the Act One and Act Two Theaters, a restaurant and the Washington Street Parking Garage. *Courtesy Johnstown Area Heritage Association.*

and adjacent to Market Street West, the Main Street Urban Renewal Project was guided by a contract between the library board and the redevelopment authority.

The authority negotiated with landowners and in April 1970 was awarded a grant for $289,000 from the Pennsylvania Department of Community Affairs for site acquisition and clearance. Groundbreaking occurred on October 30, 1970.

Led by Robert Miller, library board president, and Robert Rose, vice-president and solicitor, the new library was financed through several funding sources. The David Glosser Memorial Foundation donated $348,000; federal grant funds totaled $406,000; and Cambria County appropriated $80,000. Funds were also recouped from selling the previous building on Washington Street. The library cost $1,183,000. Named after David Glosser, a philanthropist and businessman who had died in 1964, the new facility was dedicated on October 8, 1971.[476]

The Washington Street Project: Parking Garage

Throughout the planning for Market Street West, attention had been focused on Johnstown's inadequate parking. Surveys indicated the place of greatest need was the area between the Penn Traffic and Glosser Brothers Stores.

In early 1969, the Johnstown Parking Authority announced its intention to construct a four-level, 306-car garage along Market Street between Washington and Locust, next to the General Telephone Company's regional office building. The parking authority had been developing a plan

to acquire a small privately owned parking garage, plus other adjacent realty, and then to swap some of the land for other property owned by the telephone company. Such a deal would accommodate the new garage as well as a building addition the company needed for its latest equipment.

To finance the $1.5 million garage, the parking authority secured a $685,000 grant from the Economic Development Administration. It also marketed municipal revenue bonds.

Lacking a staff of its own, the parking authority in September 1969 requested Johnstown Redevelopment Authority assistance in an undertaking called the Washington Street Urban Redevelopment Project. Again there was no U.S. Housing and Urban Development Department (HUD) involvement.

Negotiations and later condemnation proceedings got underway in June 1970. After securing the site and relocating the businesses, groundbreaking occurred in mid-February 1971. The garage was dedicated in October 1971.

There remained a forty-two-foot strip of land along Market from Washington to Locust Streets. Development proposals were sought. The Zamias Real Estate Company was selected to develop the area. The Act One and Act Two twin movie theaters, with a common entrance and a restaurant, were constructed on the eleven-thousand-square-foot parcel.[477]

IV. SUBURBAN SHOPPING FACILITIES AND THE RICHLAND MALL

Shopping Plazas, Shopping Villages and Shopping Centers

After World War II, Stephen Siciliano, George Minno and Ralph Willett had developed the Westmont Shopping Center across Goucher Street from their residential development on what had once been the Johnstown Municipal Airport. The Westmont Shopping Center became the nucleus for a cluster of retail and service outlets developed by Stephen Siciliano, John Siciliano's son, on nearby properties facing Entrance Drive, Theater Drive and Lyter Drive. This momentum continued with the nearby development of the Westwood Shopping Plaza on what earlier had been the Westmont Drive-In Theater.[478]

Stephen Siciliano had also been busy in the East Hills area especially after postwar improvements had been made to the Windber Road (Route 56). His Bel-Air, Inc., had earlier constructed a small shopping center on Scalp Avenue in Richland Township just east of Geistown Borough. In October 1956, an announcement was made that a major expansion would accommodate four new tenants, including the W.T. Grant Company.[479] Frank Pasquerilla was treasurer of Bel-Air. His Crown Construction Company built the $1 million Bel-Air Plaza addition.

In early 1963, after the Johnstown Bypass and Route 219 issues had been resolved and the new UPJ Richland Campus was planned, Siciliano announced the University Park Shopping Village, a second major development on Scalp Avenue. It would be three hundred thousand square feet with extensive parking. Glosser Brothers, the first major tenant, divulged its plan to open a hundred-thousand-square-foot food and department store in the complex.[480]

Immediately across the new Eisenhower Boulevard from the University Park Shopping Village, in 1966 Frank Pasquerilla developed a Grant City Plaza Shopping Center on an eleven-acre site. The major tenant was a Grant's store.

In none of these developments did a major downtown Johnstown store close when opening an addition in a suburban shopping complex. Penn Traffic, Glosser Brothers and Grant's all remained downtown.

In May 1964, however, Sears Roebuck broke ground for a new 87,000-square-foot store in the University Park Shopping Village. Although it had been in downtown Johnstown since 1928, Sears departed in January 1966 when its Richland facility opened.[481]

The Shoe Falls: The Richland Mall

On February 11, 1972, two young men, James O'Rourke and James Streeter, formed the Unimich Development Corporation. Its capitalization, everything the men had, was $1,100. They had been working for a Grand Rapids, Michigan shopping center developer. Just after Unimich was founded, the two partners did some marketing surveys in central and western Pennsylvania.

Born in Stoystown, O'Rourke was a 1964 graduate of the University of Pittsburgh. His mother was living in Elton, east of Richland.

The partners got a business friend to back a loan for $10,000. The two-man Unimich Corporation then proceeded to develop a 620,000-square-foot shopping mall with enough parking to accommodate 2,700 cars. The 35-acre site was in Richland Township on Elton Road near the industrial park and the Elton Road Interchange on Route 219.

O'Rourke and Streeter added three more partners—Steve Clause, Ron Sabin and Ray Kisor—and arranged two loans totaling $160,000 from the Somerset Trust Company.

On April 30, 1972, Unimich signed its first land purchase option. Fifteen more would follow. The project was then announced to the public. Zoning issues were faced and resolved. Out-of-court settlements were reached to lawsuits instituted by nearby property owners. Without publicity or fanfare, a legally vesting groundbreaking took place on April 30, 1973, exactly one year after the first property option had been signed and on the very day the Johnstown community had begun celebrating its All-America City designation for 1972. Bethlehem Steel's cutback announcement in June did not faze the dauntless partners.

By late January 1974, the Unimich Corporation, operating locally as the Richland Mall Associates, had signed three major anchor store tenants—Sears, Kmart and Penn Traffic. Commitments had also been secured from eighty-seven other smaller shops and outlets. Less than 20 percent of the projected floor space remained uncommitted. Kmart's Richland Mall venture marked its first experience in an enclosed shopping mall. Sears would be giving up its comparatively new facility in the University Park Shopping Village. Penn Traffic was a Johnstown tradition in itself.

With the plans, cost estimates and signed letters of intent, the partners were able to secure a construction loan of approximately $6 million.

Work was ongoing on the Richland Mall even as the shops were preparing their merchandise displays. Most outlets were ready for business by mid-October 1974 when Kmart and Penn Traffic began promotional ads. Sears conducted something of a pre-move sale at its University Park site during the last week in October in preparation for its mall opening early in November. The Richland Mall was fully operational by the busy Christmas season.

Only a very few downtown establishments migrated to the mall. Aside from Penn Traffic, Hanover Shoes, the Hello Shop, Household Finance Corporation, Richmond Brothers (men's clothing), the Singer Corporation, Thrift Drugs and the Johnstown Savings Bank opened branches there. By 1976 only three had closed their downtown operations—Hanover Shoes, Richmond Brothers and the Singer Corporation.

From a roster of the early mall tenants, many were national and regional franchise operations such as McDonald's, Hickory Farms, Waldenbooks and similar entities.[482]

V. DOWNTOWN'S REACTION AND RESPONSE TO THE RICHLAND MALL

"I'd be telling you less than the truth if I told you we weren't concerned. I can assure you that by no means are we going to run scared. The backbone of any business is competition, and we're not afraid of competition." Jay Clark, chairman of the Downtown Johnstown Retail Committee, gave the above statement about one month before Richland Mall opened. No retailers in the downtown knew how the mall would affect them. Richard Corbin, vice-president of the Penn Traffic Company, had a unique viewpoint since his company would have outlets both downtown and in the mall. Penn Traffic would continue its historic store "unless there was an unexpected, drastic decline." Corbin added, "When you look at the size of the mall, you know it has to have an effect on something…It will bring in new shoppers from outlying areas, but not enough of that is likely to trickle downtown to offset the business loss in the beginning. The initial effect will level off after a few months."

The mall's opening coincided with the transit crisis—the beginning phase when the bus company faced a shutdown and incipient bankruptcy, a situation seemingly bothering downtown merchants more than those in the mall.[483]

The city also began experimenting with primitive mall concepts—a pedestrian mall during the All-American Amateur Baseball tournament in mid-August. A portion of Main Street was closed off except for one bus and emergency vehicle lane. The experiment was such a disaster, it was halted by 3:00 p.m. the first day. Traffic had been tied up, loading and unloading was impeded and merchants complained incessantly.[484]

Indications are that the initial impact of the Richland Mall was mixed. It served to dissuade new downtown investments and to cause merchants to relocate when an opportunity presented itself. Rumors that the Penn Traffic Store downtown would close were persistently denied. On two occasions in 1977—both prior to the July flood—the *Tribune-Democrat* ran survey articles quoting downtown merchants and others as to how they were faring. Statements ranged from optimism to unequivocal pessimism.

Downtown suffered another loss, not related to the Richland Mall arrival. The Grant's store on Main Street closed in February 1976. The national chain went bankrupt.[485]

In 1977 the Greater Johnstown Committee proceeded to update the earlier 1961–62 plan. Its purpose was to document justifications for new downtown investments everyone wanted but no one in merchandising was willing to make.[486]

Main Street East

Mayor Herb Pfuhl Jr. often used the analogy that the downtown was to Johnstown as the core was to an apple: "If the core rots, so will the apple." Throughout his administrations, central business district revitalization remained a high priority.

On Monday, October 28, 1974, the very time of the Richland Mall openings, Pfuhl announced his preliminary vision of Main Street East, a small urban redevelopment project located between Main and Locust and from Clinton westward along Main far enough to take in the Rothstein Jewelry Building. The rectangular site would extend 238 feet along Main and Locust Streets and 264 feet along Clinton.

The first ideas called for a new department store. Everyone hoped a new J.C. Penney's would replace the older one at 535–539 Main Street slated for demolition in the project. Also proposed were a large parking garage, an office building and an enclosed shopping complex to extend along Cover Alley between Main and Locust Streets.

The city sought to use a private developer. John R. Hess, Inc., from Pittsburgh was given the contract. Hess agreed to acquire the cleared site and develop it.

On August 27, 1975, the city council conducted a public hearing about Main Street East. Civic organizations supported the plan. Representing on-site property owners, Attorneys James O'Malley and Donald Perry opposed it. The council voted overwhelmingly for the project.[487]

Throughout 1976 and early 1977, using Community Development Block Grant and Pennsylvania Department of Community Affairs funding, the Johnstown Redevelopment Authority proceeded to acquire the 1.4-acre site, relocate the tenants and demolish the buildings.

Peter Contacos, Coney Island Lunch proprietor, challenged the legality of the project and became a holdout. The Cambria County Court in March 1977 ruled against him. Contacos appealed to the commonwealth court. By July 1977, the month of the flood, the entire Main Street East site had been cleared except Coney Island Lunch. For many months, the Johnstown downtown had a large temporary parking lot. The Coney Island case was finally resolved in July 1978. The building was razed immediately.

Meanwhile the J.C. Penney Store had departed from Main Street and moved to the University Park Shopping Village where Sears had been.

The contract with John Hess, Inc., expired and was not renewed by mutual agreement. All told, through the Main Street East Project, the redevelopment authority had acquired seventeen realty parcels and had relocated twenty-two businesses, two families and seven individuals.[488]

After the 1977 Flood, the community faced enormous difficulties in developing the site. No department store could be recruited and the covered mall concept was judged infeasible. Using an Urban Development Action Grant as a loan from the city plus some of its own funds, the Johnstown Area Regional Industries (JARI) constructed a new Main Street East Office Building. The Cambria County Transit Authority jointly with the Johnstown Parking Authority developed a combined bus transit center and parking garage that connected to the office building.[489] Groundbreaking took place on March 29, 1980, and the complex was opened and dedicated on July 17, 1981.

Main Street West (Lee-Sheraton Urban Redevelopment Project) in 1979. The photograph shows the northeast corner of Main and Walnut Streets looking toward the two Bethlehem Steel office buildings. The gabled brick house was the Stephen J. Conway Funeral Home. Site acquisition and demolition had just begun. The project encountered difficulties and delays in property acquisition. *Courtesy Johnstown Redevelopment Authority.*

The Lee-Sheraton (Main Street West) Project

A second small downtown urban redevelopment project, primarily an undertaking to facilitate a significant Lee Hospital expansion, began in the post-flood era of 1978. Proposed was the removal of the six buildings located between Main and Locust Streets and Walnut Street and Adair Place.[490] After site clearance, a combined medical building with a parking complex would be constructed together with an enclosed overhead walkway connecting Lee Hospital with the new medical building.

Crown American Corporation had plans to expand its downtown Sheraton Motel by adding more rooms plus a new ballroom-convention facility. The enlargement necessitated replacing and even adding to the parking spaces lost because of the motel's new addition. Lee Hospital had agreed to sell Crown its parking garage situated between Lincoln and Vine Streets behind the motel property. Crown's expenditures on both the motel-ballroom expansion plus the garage purchase served to demonstrate that the federal funds used to finance the Main and Locust Street property acquisitions would also stimulate other private investments, an important consideration in securing Urban Development Action Grant (UDAG) approvals. In addition the proceeds derived from selling its garage helped the hospital finance its new $8 million office complex.

The application sought $5 million for both the Main Street East completion and for Main Street West. It was filed on February 1, 1978. On November 9, a $4.4 million grant was approved, covering both projects.

In early January 1979, the Johnstown City Council voted to approve the Lee-Sheraton (Main Street West) Urban Redevelopment Project. Property appraisals began immediately. Necessitating court action, the acquisition of some of the properties proved costly and time consuming. There were also air rights property complications inasmuch as the three-story R.F. Seifert Medical Arts Center was to be constructed above the 407-car garage that was technically owned by the

Johnstown Parking Authority. Groundbreaking occurred on November 25, 1981. Dedication took place on August 4, 1983.[491]

Public Housing for the Elderly

Fulton Connor, the executive director of the Johnstown Housing Authority, had stated repeatedly that there was an endless need for elderly housing units. In May 1968, planning began for a high-rise, public housing project to provide 234 dwelling units for the elderly. It would occupy the former Sears Roebuck site on Main Street, a property extending to Vine.

The authority was using the "turnkey" method. A private concern would acquire the site, erect the building to specification and turn it over to the authority in keeping with a contract. GKG Enterprises had been selected to do the first turnkey job.

On October 1, 1969, the contract with GKG Enterprises was finally approved. The project, the Vine Towers facing the Vine Street end of the property, was completed and turned over in January 1971.

A few days later, a second high-rise project was begun. The developer was Crossgates, Inc., of McMurry, Pennsylvania, the same firm building the Joseph Johns Apartments in the Market Street West Project. The building would be thirteen stories high and would have 252 units of varying sizes. Located adjacent the Vine Towers, the Fulton Connor Towers was finished in January 1972.

A third downtown elderly housing project was the Town House Towers placed at Vine and Stonycreek Streets. The eleven-story building had 120 units. Also a turnkey project constructed by Crossgates, work was underway in the summer of 1975. Townhouse Towers was finished early in 1976.[492] The three elderly housing projects are the tallest buildings in Johnstown.

Conclusion

From the postwar era through the period following the 1977 Flood, Johnstown's central business district declined. The very highways that were slow in coming to Johnstown eventually broke open a near monopoly that the downtown had in merchandising, professional services and commerce. While many downtown merchants and property owners probably sensed the inevitability of shopping malls and neighborhood shopping centers, they were powerless to combat them.

Meanwhile the downtown became increasingly obsolete. Market Street West was a success partly because it was pre-mall and pre-flood and did not focus on retail trade. The earlier Main Street East vision failed because there was little commercial interest in the modern spaces it would have created. An interesting and arguably promising proposal by George Zamias to seek a HUD discretionary grant (part of a post–1977 Flood recovery strategy) and other federal funding sources to undertake an urban renewal project to develop a 27½ -acre Point Park Mall in downtown was rejected by community leaders and eventually by the city itself.[493]

The Richland Mall, the suburban and neighborhood shopping centers, general population decline and devastation by the 1977 Flood collectively had softened the demand for downtown property. The urban redevelopment projects furnished the sites for much of the recent vitality in the central business district. These projects' sites combined constitute only a small percentage of downtown's total area.

THE BETHLEHEM CUTBACK ANNOUNCEMENT AND THE CREATION OF JOHNSTOWN AREA REGIONAL INDUSTRIES

I. TWENTY-TWENTY HINDSIGHT: THE AMERICAN STEEL INDUSTRY IN TRANSITION

The American steel industry and its second largest producer, the Bethlehem Steel Corporation, were both undergoing severe crises by the late 1960s. Total U.S. steel mill production had risen from almost 97 million tons in 1950 to 131 million by 1970. Accounting for over 46 percent of the world's output in 1950, U.S. production had dropped to 20 percent by 1970. New steel mills with the most modern technologies had been built overseas after the war. In 1955 iron and steel imports into the United States had been 1 million tons. They reached almost 18 million tons in 1968. Overseas markets for American steel were drying up while annual imports were more than seven times Bethlehem's Johnstown capacity of 2.3 million tons.[494] In addition, minimill producers were getting underway. Minimills melted scrap in electric furnaces and used continuous caster technology. Most were non-union.

The problems engulfing the American steel industry had multiple causes: industrial overcapacity, aging steel mills, slow depreciation write-off schedules that discouraged capital improvements, rising imports and high wages and benefits. New materials such as aluminum, ceramics and plastics were replacing or reducing steel usage.

There was also "Clause 2B" adopted in the 1956 collective bargaining agreement. It perpetuated "established labor practices"—work rules that could not be modified unless there was a change in underlying conditions.

The steel strike of 1959 lasted 116 days. It was prolonged because industry leaders had resolved to modify 2B. Steelworkers had resolved to keep it intact. Labor prevailed. During the lengthy strike, steel customers began doing business with foreign suppliers and the new minimills.

The Bethlehem Steel Corporation

While the American steel industry was facing severe challenges, the Bethlehem Steel Corporation had problems of its own. John Strohmeyer in his 1986 book *Crisis in Bethlehem* laid out a vast panorama of

causes, including an ingrown and insulated management. He portrayed lavish ostentation in a large new office building, golf course expenditures, company airplanes and other trappings of success and wealth. Strohmeyer believed the excesses served to reinforce a false notion of corporate omnipotence and discouraged prudent cost cutting and expenditure control.

Eugene Grace's 1950s effort to merge Bethlehem Steel with Youngstown Sheet and Tube had been blocked. The failure led Bethlehem to construct the Burns Harbor (Indiana) Mills on Lake Michigan. When work on Burns Harbor began in 1963, the cost estimate was $250 million and its annual capacity was to be 1.9 million tons, slightly less than Johnstown's Bethlehem Works. The new integrated mill, however, finally cost about $1 billion and was rated 3 million tons. By 1971 plans were underway to increase Burns Harbor to 4 million tons.[495]

Bethlehem's Johnstown Works

Bethlehem's Johnstown Works was seen as a "problem plant" for the company. Iron ore from Michigan and Minnesota destined for Johnstown had to be transloaded from ore boats to railroad cars for shipment. The Johnstown mills had aged. While a number of significant improvements had been made, they were usually incremental upgrades to existing units and infrastructure. Materials had to be moved excessively as ore and scrap were turned into steel, and the steel itself was finished for customers.[496] By the 1970s, more Johnstown products were shipped out by truck than by rail. Despite recent improvements, the road system serving Johnstown was described as "lousy."[497]

In addition, most of Bethlehem's Johnstown plant customers were located in the Midwest, especially Ohio, Indiana, Michigan and Illinois. Other plants, notably Burns Harbor, were better located to supply them.

In the mid-1960s, employment in Bethlehem's Johnstown Works usually ranged between 13,000 and 14,000. There were six blast furnaces, one being a ferro-manganese producer. There were usually eleven open-hearth furnaces during the era.

The Johnstown plant manufactured railroad freight and coal cars plus hundreds of different special bar shapes used in many products including children's sled runners, lawn-mower blades, window frames and automobile springs. The plant produced truck wheel rims, railroad brake shoes, heavy machinery plate and the steel used in over two dozen parts for many automobiles. Even steel wool was produced at Johnstown.[498]

Shifting Investment Strategy

By the late 1960s, open-hearth steelmaking, becoming obsolete, was replaced by technology developed in Austria called the Basic Oxygen Furnace, or BOF. BOFs were making better steel faster and with less manpower per ton than the open hearths. Their pollution was also easier to control.

Bethlehem was investing heavily at Johnstown in air-pollution technology tied to the old furnaces. In August 1972, the company announced it was spending another $8.4 million on pollution-control equipment in addition to more than $19 million already spent on a variety of anti-pollution devices throughout the mills.[499]

In 1965 the company had temporarily reopened its Rosedale coke facilities that had been shut down since 1958. There was no feasible air pollution technology for these older coke ovens. The

company had been in the awkward posture of cleaning up some facilities and then repolluting with others.

There were other seemingly contradictory capital policies affecting Johnstown. In the summer of 1967, Bethlehem announced it would install a continuous caster at Johnstown, the first anywhere in the corporation. By June 1969, three open hearths at Franklin had been demolished to make space for the caster.

Although much of its $15 million cost had been spent, the company announced in late November 1969 that it was halting the caster's installation. No reasoning was given, although there were as many rumors as possible explanations.[500] In November 1971, Bethleham announced its first caster would be installed at Burns Harbor.[501]

The Environmental Movement

The Bethlehem Steel Corporation had generally been compliant toward environmental cleanup. Its Johnstown Works, however, presented special problems—fitting technology onto obsolescent blast, sintering and open-hearth furnaces. If the open-hearth units were to be retired, much of the air and water pollution control equipment used with them would also be scrapped.

In addition, the new BOF and electric furnace technologies gave off reduced emissions and were better suited to pollution control. EPA and the Pennsylvania Department of Environmental Resources (DER) enforcement strategies were an inducement either to modernize Johnstown's mills or to shut them down.

In May 1973, the Pennsylvania DER filed a lawsuit against the U.S. Steel Corporation charging its Fairless Works outside Philadelphia with specific water and air pollution violations. The suit was a trailblazing action in Pennsylvania. Bethlehem's Johnstown Works would likely face a similar suit.[502]

The Bethlehem management was already under administrative orders to develop and implement a plan for attaining full water quality compliance by 1977. As for air quality, Bethlehem was given until September 1973 to file yet another plan detailing what needed to be done plus a timetable for attaining compliance by 1977.

The Bethlehem plan first called for the installation of two giant electric furnaces. Furnace E, the ferro-manganese unit, was slated to remain together with sufficient Rosedale oven capacity to supply its coke. This meant that most of the steel to be produced at Johnstown would be made from scrap.

There were differences of opinion within Bethlehem's top management over whether to add two electric furnaces or two new BOFs. The issue was a difficult one. The electric units would be used primarily with scrap. The BOFs would replace the open hearths and would need both ore and scrap.

As part of its June 1973 cutback announcement, Bethlehem disclosed it would install two electric furnaces at Johnstown. In May 1974, during a respite of good times, the company stated it would install two BOFs instead, an action continuing some blast furnaces and coke ovens, and changing the anti-pollution technologies.

The BOF decision was a product of the energy crisis of the mid-1970s, a crisis that had hurt Japanese steelmaking even more than American mills. Bethlehem soon began making plans

and preparing the heavy foundations to support two Basic Oxygen Furnaces (BOFs). Following the July 1977 Flood, however, the company reverted back to its plan to install two electric furnaces.[503]

Meanwhile in early 1976, the state's DER proceeded to file a lawsuit against Bethlehem, probably an action to hold the company's feet to the fire. Despite its indecisiveness, the corporation was moving ahead with anti-pollution technology at Johnstown.[504]

The Cutback Announcement

At the June 1973 luncheon meeting of the Greater Johnstown Committee, community leaders were given a shock. Three Bethlehem officials—Laurence Fenninger, James Robertson and Fred Bielefeld—announced the forthcoming reduction of Bethlehem's local workforce gradually from some 11,800 in 1973 to 7,100 by 1977, decreasing annual payrolls from around $130 million to about $90 million. Two electric furnaces would be replacing all the other furnaces except the ferro-manganese unit. Including environmental control equipment, Bethlehem's capital cost was estimated at $87 million. Plant capacity would be reduced from 2.3 million to 1 million tons. The plan would be operational by 1977.[505]

The announcement was difficult for Bethlehem Steel. President Lewis Foy, born in Somerset County, was raised at Johnstown. In the 1930s, he had partnered with Charles Kunkle in a golf driving range business near the old airport. Foy's wife was from the area and he had begun his Bethlehem career at Johnstown. After wartime military service, he returned to the company but was transferred to corporate headquarters at Bethlehem.

There was also a widely held belief among top management echelons that of all Bethlehem Steel Corporation operations, Johnstown had the best workforce. Foy pledged on July 11 "to keep the adverse effects…to an absolute minimum."[506]

The Community Reaction

The Greater Johnstown Committee meeting had been long and sobering. Afterward several members withdrew to the Sunnehanna Country Club to reflect and develop strategies.

Following the announcement, it became fashionable to bash the environmental movement as the root cause of Johnstown's crisis. State Senator Louis Coppersmith and Representative Patrick Gleason both denounced the environmental regulations as the basis for the forthcoming cutbacks. Coppersmith spoke of bringing action in the legislature to force either a moratorium on enforcement or extensions beyond the 1977 compliance date. The senator, however, was frustrated in his efforts to get a commitment from Bethlehem to maintain full employment and steady production if the environmental requirements and timetables were relaxed.

The *Tribune-Democrat* also blamed environmentalists for Bethlehem's cutback. An ad hoc organization, the Committee for Common Sense in the Environment headed by Roy Sell and Charles Vuicick, circulated a petition seeking "a sensible approach to environmental controls." Bearing more than eight thousand signatures, the petition was delivered to Mayor Herb Pfuhl Jr.[507]

The Community Wakes Up

Shortly before the cutback announcement, Johnstown had been designated an All-America City for 1972. The honor gave leaders a reputation to uphold.

About a week after the announcement, a delegation from Johnstown visited Foy at Bethlehem. The group was told that Bethlehem would help arrange and finance both a community survey and the development of a strategic plan. The Urban Land Institute would coordinate the work. The delegation was also told that if the DER would delay the effective date of its enforcement measures, Bethlehem would maintain full operations in Johnstown as long as it was profitable to continue them.[508]

If Coppersmith and other politicians could secure environmental enforcement delays, everyone would approve. There was a resolve, however, among community leaders to treat the cutback as a challenge. They were resolved to establish a first-rate economic development program.

The most senior leader of those who had met with Foy was W.W. Krebs, then seventy-nine years old. Krebs had been behind most economic development initiatives in Johnstown since 1929 when he had been president of the chamber. Both the Greater Johnstown Committee and the Johnstown Chamber of Commerce asked him to head a revitalized effort. Krebs agreed to be temporary chairman of an initiative called Jobs for Johnstown.[509] He named Frank Pasquerilla and Charles Kunkle Jr. as vice-chairmen. Others were Louis Galliker, president of the chamber of commerce; Dan Glosser, chairman of the Greater Johnstown Committee; Howard Picking Jr.; Andrew Koban, a United Steelworkers leader; and Leonard Black, president of Glosser Brothers, Inc.

The committee intentionally began inviting people from all walks of Johnstown to participate. Mayor Herb Pfuhl also established an economic council of local government leaders in the region. By mid-July there were 117 members participating in Jobs for Johnstown.

Johnstown Area Regional Industries (JARI)

By mid-July 1973, the committee had agreed to create a totally new organization—Johnstown Area Regional Industries (JARI). The JARI membership would be derived from people whose careers and interests were from a broad spectrum of the community.

Remaining independent of other organizations, JARI would cooperate with but not be a component of either the Greater Johnstown Committee or the Johnstown Chamber of Commerce.

JARI immediately sought a relaxation of the environmental deadlines. The idea was to keep as many Bethlehem workers employed for as long as possible to gain time until successes could be achieved from an aggressive economic development program. Governor Shapp pledged assistance. Everyone knew any delays in environmental enforcement would be temporary.[510] The U.S. Environmental Protection Agency (EPA) would enforce national mandates if the state did not. By August 1973, JARI was legally incorporated.

In early September, JARI elected officers. The first permanent chairman was Charles Kunkle Jr. The vice-chairmen were Gwynne Dodson, a recently retired president and CEO of Penelec; Frank Pasquerilla; and Andrew Koban. In February 1974, Michael "Mickey" Flynn,

executive director of the Johnstown Redevelopment Authority since 1960, was named JARI's executive director.[511]

A delicate finesse in the community was needed to unify the economic development organization. The chamber of commerce had previously established two subordinate corporations—Johnstown Industrial Park, Inc., and the Johnstown Industrial Development Corporation (JIDC). The former owned the industrial park, managed it and leased or sold the land. The JIDC was the corporate entity that administered Pennsylvania's low-interest loan program for economic development.

Both corporations and their holdings were transferred to JARI, effective January 1, 1976. JARI also created yet another corporation, the Economic Development Corporation (EDC), an action based on the recommendations of the Urban Land Institute. The EDC would actually do the work of economic development. JARI was then an umbrella organization to develop and maintain a strategic plan for the economy.

By stripping the Johnstown Chamber of Commerce of the economic development function, the JARI initiative had seemingly weakened the chamber. Its top staff member, John Burkhard, joined the JARI-EDC organization on a full-time basis in January 1976.[512]

The Urban Land Institute (ULI)

The Urban Land Institute began its evaluation in early September 1973, three months after the cutback announcement. A panel of eleven persons, mostly leading businessmen and community experts from around the nation, came to Johnstown. After taking a tour, they interviewed many Johnstowners.

The JARI leadership had been seeking from the panel a candid assessment of the Johnstown area as seen by outsiders with no local ties—the sorts of people who might be locating a business or industry somewhere. The panel was also asked to assess Johnstown's tourism potential, to recommend whether to undertake an economic study and to describe exactly what needed to be done to make Johnstown industrially competitive and attractive for economic development.[513]

The panel soon developed its first recommendations. In addition to the new Economic Development Corporation, the panel proposed the initiation of a community goals program to determine what kind of future people hoped to achieve in Johnstown over the next twenty years; the pursuit of county home rule; the involvement of more local government officials in JARI; the establishment of a regional intergovernmental cooperation program among local governments; and developing a new approach to municipal consolidation.

Based on interviews throughout the community, the panel concluded that many people did not believe Bethlehem was serious about its cutback. They did not believe retrenchment would happen. This observation became a leading challenge to community leaders. In an interview on WJAC-TV's *Viewpoint Program*, Charles Kunkle Jr. stated, "Our Number one priority…is to get the people…to believe this [job reductions] may happen."[514]

JARI's next effort was a fundraising campaign. An initial goal of $2,250,000 was set. The Bethlehem Steel Corporation pledged an immediate $100,000 and announced it would add another fifty cents to each dollar donated by the community. The fund drive chairman was Carl Gillespie and the associate chairman was Franklin Smith, Penelec's president. By June 25, 1974,

approximately $2,420,000 had been promised, and pledges were still coming in. JARI's drive had been a success.[515]

Spring in Winter

For reasons having to do with the nation's economy as well as a weak dollar, 1974 became a banner year for the American steel industry. In May 1974, Bethlehem announced it was reversing its previous cutback announcement, a decision based on hopes for special legislation and waivers to permit continued use of obsolescent equipment for a brief time without expensive anti-pollution retrofitting.

The company also reversed its decision to install two new electric furnaces. The good times in 1974 had boosted scrap prices. Bethlehem revived its plan to install two modern BOFs at Franklin. Meanwhile, Bethlehem continued to support JARI.[516] In July 1974, JARI and the Greater Johnstown Committee jointly commenced the community goals project recommended earlier by the Urban Land Institute.

In December 1974, JARI announced an important success. The National Valve and Manufacturing Corporation of Pittsburgh had agreed to occupy a shell building on a ten-acre site in the industrial park. It would employ fifty people immediately and expand to one hundred workers later.[517]

The Metropolitan Life Mideastern Regional Office

In 1974 the Metropolitan Life Insurance Company's leadership had reached a major corporate decision—to consolidate its insurance policy processing and payment work into eight large regional offices scattered around the nation—an initiative rooted in the office automation due to computers and cutting-edge technology.

For about a century, Metropolitan had also enjoyed a high market penetration in Pennsylvania. There were sixty-seven offices and more than three thousand employees in the Commonwealth serving the four million Pennsylvanians with Metropolitan coverage.

Because of the heavy concentration of policies and customers, one of the eight proposed centers, the Mideastern Regional Head Office, would primarily serve the commonwealth and would be located in Pennsylvania.

Metropolitan's site selection process began by considering every Pennsylvania city with a population of 50,000 or more. Because Johnstown's 1970 population had dropped to 42,476, no contact was made.

Edwin Barker, Johnstown's Metropolitan district sales manager, having learned of his company's plans and site-selection process, contacted JARI's new officers.

As soon as he learned of Metropolitan's initiative, Charles Kunkle, JARI's chairman, immediately sought help from Lewis Foy, chairman and CEO of Bethlehem Steel. Foy was also a member of Metropolitan's board of directors.

This important contact resulted in Johnstown's addition to the list of places under consideration. It was pointed out that while Johnstown City had a population less than 50,000 in 1970, its urban region had almost 100,000.

After a lot of show and tell activity, Metropolitan chose the Johnstown area for its Mideastern Regional Head Office. The announcement was made on July 1, 1975. The decision was based upon several factors:

> *The community had available a very promising and attractive site, a seventy-five acre tract that was a surplus part of the University of Pittsburgh at Johnstown (UPJ) campus. The property was sufficiently large to provide for future expansion.*
>
> *JARI had also acquired the Bali Building at Geistown, empty and ready for Metropolitan to use while its new Mideastern Regional Office was being constructed.*
>
> *Surveys revealed that Johnstown had an adequate pool of available office workers with good skills and a sound work ethic.*
>
> *Metropolitan had determined that postal service in Johnstown was excellent, a major consideration.*[518]

The more subtle factors in Johnstown's selection had to do with Lewis Foy's diplomacy for Johnstown and the fact that Charles Kunkle had known George Jenkins, Metropolitan's chairman, years earlier when they both had attended Deerfield Academy in Massachusetts.

The rezoning of the site was accomplished in record time. By October 1, 1975, over 150 local people had been hired and had started work in Metropolitan's temporary office in the former Bali Bra Building.

Work commenced in March 1976 on the 200,000-square-foot office building located east of the UPJ campus. Dedication took place on May 26, 1978, when Metropolitan already had a workforce of approximately 350 employees.[519]

The Abex Wheel Plant and the Quemahoning Industrial Park

In the months following the 1977 Flood, Bethlehem continued reevaluating its Johnstown Works. Its sixty-year-old wheel plant was using a costly, antiquated forging process to produce wheels for railroad rolling stock plus other circular forgings. In late June 1978, the company announced the plant would stop making wheels but would continue other products. Of the 400 employees, 260 produced wheels.

It was in Bethlehem's interest for another wheel producer to locate at Johnstown to supply wheels for its railcar shops, facilities the corporation had no intention of closing. Given its other Johnstown investments and the spate of troubles encountered throughout 1977, Bethlehem was in no position to upgrade its wheel plant.

At the time, the Abex Division of Illinois-Central Industries (IC Industries) was producing wheels efficiently at its Calera plant in Alabama. Using a foundry casting process, it was making and selling two hundred thousand wheels per year. George Belury, the Abex president, was bullish about railroad wheels.

Having information that Abex was planning a major wheel plant upgrade, Bethlehem officials began exploring a joint venture with Abex at the Johnstown wheel plant. JARI's officers were also urged to cultivate a partnership with IC Industries to attract any such new plant to Johnstown.

In May 1978, IC Industries (Abex) sent a team of officials to explore the wisdom of wheel manufacture at Johnstown. JARI's chairman, Charles Kunkle Jr., an avid and accomplished

golfer, confided that the group seemed more interested in playing golf than in undertaking a hardnosed evaluation. "When do we tee off?" seemed to be the leading question as soon as its members stepped off the company airplane on various trips. JARI officials worked with the team for several months and Congressman John Murtha was active in countless ways.[520]

Abex officers quickly ruled out using part of Bethlehem's Johnstown Works as a site. On November 20, 1978, the company announced it would build a new plant on a 192-acre Somerset County tract situated a short distance downstream from the Quemahoning Reservoir. The plant would be 360,000 square feet in size equipped with electric furnaces and a foundry. The wheels to be produced would be cast. The initial plan was for wheels-only manufacture, but Abex leaders were also thinking long-term. If wheel production near Johnstown proved successful, the company would add a wheel mounting shop and an 80,000-square-foot brake shoe plant.

JARI and its Economic Development Corporation undertook land acquisition and development. Grants were received from the U.S. Department of Commerce and from the post–1977 Flood state bond issue. There was also a Pennsylvania Industrial Development Authority (PIDA) loan. The Johnstown Economic Development Corporation loaned $1,750,000, and several Johnstown banks loaned $8,750,000. The Abex Corporation financed the costs of the machinery, working capital of $11,950,000 and much of the building itself. The total outlay reached $93,185,000.

A major groundbreaking ceremony took place on April 4, 1979. A special train carried people from the city to the new plant, the first passenger train to move over the Rockwood Line since passenger service was discontinued in 1932.[521]

The plant began producing wheels on June 30, 1980. For a short time there were 357 employees, each working one of the three daily shifts, seven days a week. George Belury's optimistic hopes of marketing 400,000 wheels per year, however, were shattered by the severe downturn in the steel industry experienced just after the plant had opened. By November 1981, wheel manufacture ceased "for an indeterminate time." In 1984 the Abex Plant began producing a modest output of specialty steel items and standard-grade ingots for the Bethlehem Steel Corporation. During the bad times there were layoffs and labor troubles.

The plant was sold to the First Mississippi Corporation in December 1988. As Stonycreek Steel, it produced specialty ingots, rolled ring products, dies, shafts, sleeves and heavy wall tubular products. First Mississippi operated the plant for about ten years, closing it down incrementally beginning in July 1999.[522]

ALL THE KING'S HORSES AND ALL THE KING'S MEN: THE 1977 FLOOD

I. A NIGHT OF HORRORS

Early Fears

The 1976–77 winter was a harsh one. Mountains around Johnstown were packed with heavy snow. There was a rush to buy flood insurance. Major businesses began reviewing their flood emergency plans.

The U.S. Army Corps of Engineers had already contracted to remove brush vegetation and sandbar deposits from the flood channels. On Wednesday, March 30, the Rotary Club featured Colonel Max Janairo, the corps' district engineer. Janairo was reassuring: although deep, snow deposits around Johnstown equaled about five inches of rainfall. "Had we had two inches of rain on top of that and a quick thaw, we would have had very severe flooding problems, not necessarily in Johnstown."

Janairo also discussed the aftermath of Tropical Storm Agnes in late June 1972, when parts of Pennsylvania had fifteen inches of rainfall compared with Johnstown's five to six inches. It was acknowledged that if the Agnes downpours 175 miles to the east had hit Johnstown, the results would have been disastrous.[523]

Springtime arrived. Johnstown had avoided the tragedy it was dreading.

Tuesday, July 19, 1977

While the mid-July heat had been oppressive, Tuesday, July 19, started like most other days. The Act One Theater was showing *Slap Shot* (recently filmed in Johnstown) while Act Two featured *Rollercoaster*. The Embassy on Main Street was offering *The Rescuers* and Walt Disney's *A Tale of Two Critters*. The Ferndale Volunteer Firemen's Jubilee was promoting rides for children at reduced rates. The Major League Baseball All-Star Game would be broadcast from New York City at 8:30 p.m.

Just before leaving work that afternoon, Leighton Wagner, the man who repaired the parking meters, checked the rain gauge atop the Public Safety Building, another of his responsibilities. It was working fine. The flask was empty.

Messenger Street near Oak Street in Hornerstown during the early morning of July 20, 1977. *Courtesy Johnstown Area Heritage Association.*

The Johnstown area weather forecast for July 19 had stated it would be "hot, hazy, and humid through Wednesday [July 20] with scattered thundershowers. Patchy fog developing toward daybreak today. Nighttime low in the upper 60s to low 70s; high today and Wednesday in the upper 80s to low 90s. Winds light and variable today, gusty during thunder-showers. Chance of rain: thirty percent through tonight."[524]

Chaos

Just before dusk, Mayor Herb Pfuhl and his family were eating supper on the patio behind their Roxbury home. The sky had been taking on an eerie, dark, heavy color. There were lightning flashes and thunderclaps, then rain—by most accounts sometime between 6:30 and 8:30 p.m. in the city.[525]

A short while later, the police department telephoned Pfuhl: There was sporadic flooding throughout Johnstown. Sams Run in Moxham had been troublesome. Basements along its course were flooded.

Accompanied by his son, Herbey, Pfuhl decided to tour the city and see what was going on. His car had a police radio. They first picked up Dominick Genovese, a city employee and friend. The three then headed toward Moxham but did not cross the low area at Du Pont and Central Avenues. It was flooded.

The rainfall was heavy and intense. Lightning flashes were rapid and continuous and thunder clapped loudly. Unwilling to enter Moxham, the Pfuhls headed through town toward the West End. In Cambria City near the Ten-Acre Bridge, they stopped to look at the water beginning to

flow rapidly in the Conemaugh River. Whether an illusion or some strange phenomenon, Pfuhl was convinced the water was flowing upstream.

They next picked up John Sprincz, a constable and president of the West End Ambulance Service who was directing traffic on Fairfield Avenue near Skateland. The streets were flooded. Pfuhl and his party continued touring the West End. Water was ponding beneath the underpasses but traffic still used them. The discharge from Elk Run, flowing through D Street and over Barron and Fairfield Avenues, was swift and getting deeper.

Hornerstown and the Solomon Run Drainage Basin

Most city streets were still passable but some were risky, especially in low places near streams. Pfuhl was advised by radio that things were getting bad in Hornerstown. He and his group next headed for the new Meadowvale School between Messenger and McMillan Streets, an emergency shelter in the city disaster plan.

They reached the building sometime around midnight. The janitor on duty had opened its doors earlier and people were already seeking safety inside. Others heading toward the building were braving flows of water cascading down the streets. The stream channel was inadequate to carry the flows. Crossing the streets was treacherous. Someone had taken the lane marker ropes from the school's swimming pool and secured them across McMillan and Messenger Streets for people to steady themselves while braving the waters.

Approximately one hundred people were inside the building. Soon the water level outside had risen above the base of the windows. Sensing the water might break the glass and flood first-floor space, everyone was urged to move upstairs. Just after the gathering had reached the second floor, a window collapsed, filling the ground level knee-deep with water. The move to the second floor probably averted a panic. This happened around 1:00 a.m., although the exact time is unknown.

Outside the isolated school building, chaos reigned. Robel Construction Company's facility near McMillen Street caught fire. Firemen were unable to save anything. The heavy downpour continued, as did incessant lightning and booming thunder.

Throughout Solomon Run's 5,500-acre drainage basin with its countless hollows and tributary streams, the waters cascaded downward. Currents were guided onto the new Johnstown Expressway (Route 56 Bypass) where the surges were accelerated on the descending pavement aprons. At curves and grade changes, the water passed down into Solomon Run itself. The current eventually became so powerful that it completely took away the Widman Street exit ramp and the Nightcap Lounge nearby. Several homes along Solomon Street were washed away. The others were damaged and the street itself was destroyed. Eyewitnesses inside the Solomon Homes Public Housing Project reported debris piles as high as the second floor and claimed the water outside had reached depths of fifteen feet. Most ground-floor apartment units were ruined. A gaping hole was torn into the side of one of the buildings.[526]

After passing through Walnut Grove, the raging flow raced down David, Arthur and Messenger Streets in Dale Borough and across Von Lunen Road into the city. It next continued down Messenger and McMillen Streets. Anything in the water's path faced destructive removal. Cecil Leberknight's home on Von Lunen was severely damaged while he had been busy at the borough building. His wife was rescued unharmed by volunteer firemen. Donna Wolf's home

The Solomon Homes Public Housing complex on July 20, 1977, after the intense flows had ceased. *Courtesy Johnstown Area Heritage Association.*

at the corner of Oak and Messenger Streets was completely razed. She was rescued around 3:00 a.m. by her young neighbor, D.J. Baumgardner. Shortly afterward, Doris Lichtenfels, who was living on David Street in Dale Borough, was swept down Messenger Street after her home had been wrecked by flood water, which had first pushed a station wagon into her living room. As she was carried past the Baumgardner home at the Oak Street intersection, she grabbed a tree. D.J. Baumgardner and his father, Fred, went to her rescue. With a rope tied around his waist, the young man reached Mrs. Lichtenfels and pulled her to safety. Lichtenfels's daughter, Becky, had also managed to find safety in another tree nearby and was rescued by firemen. Both mother and daughter each believed the other had perished.

Mrs. Lichtenfels's eighty-nine-year-old father, Robert Hershberger, had not escaped. His body was found in Ron Stevens's yard near Pine and Messenger Streets. Stevens and Mayor Pfuhl later moved his remains to a makeshift morgue in someone's garage, where they also saw the body of a young boy found near Gittler's Store.

Joseph Zapatochny and his family living at 717 Fronheiser Street escaped probable death by climbing into a dormer of their one-story home. While the house itself and everything inside was wrecked, the family somehow survived.

It stopped raining around 4:00 a.m. "I left Meadowvale at 4:45 a.m. July 20 to see the damage," Pfuhl stated. "I thought I was on another planet. I kept thinking that this couldn't be my city." The car he had been driving was ruined. Dominick Genovese accidentally stepped into an open manhole, permanently injuring his leg.

Still gushing down Messenger Street, the water resembled a massive hose stream. Homes were wrecked. Pavements had been heaved up. Cars and trucks had been tossed about like toys. Debris, mud, dead animals and devastation were everywhere.[527]

The damage in Walnut Grove, Dale and Hornerstown was caused by swift surface flows brought on by a prolonged, intense downpour throughout the steep Solomon Run basin.

The nearby flood channel in the Stony Creek River was adequate to carry the flow. Water had reached a depth of about two feet on Valley Pike, which follows the river opposite Hornerstown. The water did not overtop the river wall along Valley Pike, a wall higher than the street itself.

The 5½ feet of water in the M. Glosser and Sons Company sales office and warehouse on Messenger Street (between Horner Street and the river) came from the surges gushing down Messenger and McMillen Streets, not overflow from the river.[528]

Eighteen persons were killed by the flooding that took place within the Solomon Run Drainage Basin. Ten were from Dale Borough. Three had lived in the Solomon Homes project. One was from Oakland in Stonycreek Township. The Keck family that lived on Pine Street accounted for the remaining four.

Tanneryville: West Taylor Township

Laurel Run flows through Pole Hollow and empties into the Conemaugh River about six hundred yards past the city limits on Cooper Avenue. It has two other tributary sub-basins—Wildcat Run and Red Run. The entire watershed is approximately seven thousand acres. Between 1916 and 1919, the Johnstown Water Company had installed an impoundment, the Laurel Run Dam, 2½ miles upstream from the Conemaugh River. When full, the reservoir held about 101,000,000 gallons. The dam had survived the 1936 Flood with no problems.

The downpour that hit the Johnstown area on July 19 and 20 had been exceptionally heavy throughout Laurel Run's basin. Its rain gauge had recorded a downpour of 11.87 inches in about eight hours.

Ed Cernic Jr., chief of the West Taylor Township Volunteer Fire Company in 1977, recalls driving through Tanneryville earlier in the evening when the water flowing down Cooper Avenue had been almost two feet deep.

Around 10:00 p.m. on July 19, he and his father went to their motorcycle sales garage, then located on Cooper Avenue between the city limits and the Bethlehem Steel car shop facility (the former shell plant). Their place was near a small stream that typically trickled but was often bone dry.

On the night of July 19, the small brook became a raging torrent. Sensing its flow might cause a buildup in water pressure that would collapse his building's rear wall, Ed Cernic Sr. chiseled holes that penetrated the wall itself, allowing water to flow through the building and relieve the pressure. Thinking everything was safe, the Cernics departed.

Later several family members returned to the shop to look it over. They noticed through the plate glass windows that the water had risen several feet inside. Things were floating around. When they opened the door to enter, the current rushed forth, knocking down young Craig Cernic. The electric lights were still working. Despite the Cernic family's continuing efforts that night, the building and its contents were ruined.

Later the Laurel Run Dam collapsed. While there is disagreement, most people believe the break occurred around 4:00 a.m.[529]

The Cernics were in the area of their motorcycle shop when suddenly they became aware that something drastic had happened. Water in the Conemaugh was undergoing an unbelievably

heavy wave action and churning. They also witnessed a floating fuel tank and other debris moving upstream toward Coopersdale. The violence of what they were seeing frightened them. Having guessed the Laurel Run Dam had broken, the family members left by going uphill on foot.

Meanwhile the Tanneryville area was devastated and some residents were washed away. Buildings, homes, trailers, vehicles—every sort of thing—were ripped apart and carried off by gushing currents.

One of the most incredible survival stories involved the ordeal of eighteen-year-old Kenneth Gibson, son of Donald and Theresa Gibson of 679 Cooper Avenue. He had been swept away after the Gibson home collapsed. Soon finding himself in the Conemaugh River, he somehow caught a floating log. The current eventually carried him several miles downstream, just beyond Penelec generation plant near Seward. There he managed to grab a tree branch and swim to safety. People living nearby called an ambulance. Gibson was taken to a Latrobe hospital, where he spent two weeks recovering primarily from pneumonia. His mother and three siblings were killed.

Tanneryville had been the most devastated part of the Johnstown area. Twenty-eight homes were totally destroyed. Another seventeen were so severely damaged that they had to be torn down. Thirty-four of its citizens were killed or presumed dead. There were countless injuries and widespread destruction. The roads in and out had become so torn up and covered with debris and mud that they were completely unusable even by four-wheel-drive vehicles.

The upper sections of Tanneryville near Cardiff Street were reached on Thursday, July 21, by seven four-wheel-drive trucks that had used Routes 22 (west of Ebensburg) and 11020 over Dishong Mountain. The most heavily devastated areas were accessible only by foot or helicopter. The telephone system was knocked out. Two-way communication with the outside world was limited to citizens' band (CB) radios. As they searched for their dead and took emergency steps to survive, residents of Tanneryville felt cut off from the rest of the world.

The West Taylor Fire Hall had survived, although a large chasm had formed between it and the Ward Trucking Company. Ward's building remained but everything around it was ripped up. Selders Custom Kitchen was destroyed. The Jonel Construction Company had survived intact. Everything else downstream was either destroyed or severely damaged.

To make matters worse, the West Taylor Township Commissioners had earlier decided against federal flood insurance program participation. Its citizens and property owners were unable to purchase the insurance even had they wanted it.[530]

Franklin Borough

Like Solomon Run, Clapboard Run begins near Rager's Corner and the Johnstown Airport. It flows down through Wissinger Hollow and the northeastern end of Franklin Borough where it empties into the Little Conemaugh.

Richard Uzelac, president of the Franklin Borough Council in July 1977, recalls that the heavy rain and incessant lightning began around the time the All-Star Game had gotten underway— 8:00 p.m. for the pregame show and 8:30 for the game itself. As he and his mother watched television, they became aware that the storm outside was strange and unusually heavy. They lost electricity near the end of the game.

Soon Richard's brother, Sam, appeared at the door with his family. They lived on Main Street near Clapboard Run. Sam Uzelac was terrified at what was happening. He urged his mother and Richard to evacuate immediately and seek safety with their other brother, Donald, who lived in Bon Air, a subdivision above Franklin.

Reluctantly, Richard and his mother agreed. Somehow they managed to drive up Truman Boulevard, a street then flowing like river rapids and carrying debris. Miraculously the families reached Bon Air safely.

Just before sunrise on Wednesday, the rain stopped and a beautiful July day unfolded. Richard Uzelac walked down to Franklin. His brother's house at the northeastern end of Main Street and several nearby homes were completely destroyed. Jerry's Lounge, a well-known Franklin bar (used in making the then new film *Slapshot*), had vanished. A huge mountain of debris, about as tall as a two-story house, had formed near Clapboard Run's confluence with the Little Conemaugh River.[531]

No citizen of Franklin Borough had been killed, although the body of Howard Wilson, a young mechanic, was found there.

Moxham and Lorain Borough

Sams Run drains parts of Richland Township, Geistown, Stonycreek Township and Lorain Borough before flowing through Moxham between Ohio and Village Streets. The July 19 storm sent heavy flows down Sams Run destroying Valley Street in Lorain Borough and causing extensive havoc along the open walled channel downstream. Ohio Street was left in shambles. The businesses on Central Avenue between Village and Du Pont Streets were all damaged.

The U.S. Steel plant experienced some flooding and was left with deep mud deposits in the low sections downriver from the office building—between the plant entrance and the Central Avenue Bridge. The flooding in the plant itself resulted from overland flows coming through Moxham, primarily down Ohio Street, and the backflow caused by a bottleneck where the Sams Run channel discharged into buried drainage pipes then woefully inadequate to carry the flow. The Stony Creek's peak flow near the U.S. Steel plant was contained by the floodworks, having crested two feet below the top of the river channel along the plant.[532]

There were no Moxham or Lorain Borough fatalities directly related to the flood.

Downtown Johnstown

Around 11:00 p.m., employees of the *Tribune-Democrat* noticed water leaking into the ground level of their building on Locust Street. As time passed, conditions worsened and by midnight the water had begun rising up the steps inside the front entrance. At 12:50 a.m. the newsroom staff was allowed to leave. This was about the time that the water had first begun flowing out of the Little Conemaugh River and across downtown. Patrolman Charles Korenoski had witnessed this near the Walnut Street Bridge at about 12:45 a.m.

The Little Conemaugh's flood channel had been designed to accommodate a flow of almost 29,000 cubic feet per second. When it crested around 5:15 a.m., the river had been flowing some 40,000 cubic feet per second at the East Conemaugh gauging station. Since East Conemaugh

is over two miles upstream from downtown, the Little Conemaugh's peak flow would have been even greater as it passed through downtown. Indications are that the Little Conemaugh was cresting earlier and was flowing much more rapidly than the Stony Creek. These conditions would have meant that the waters that escaped from the Little Conemaugh's channel were flowing across the downtown from the northeast generally toward the southwest.

Walking through the flooded downtown would have been treacherous because of the currents. Elaine Mitchell, who was three months pregnant, a friend, Kim Tayse, and her husband, Jerry, decided to leave Mitchell's home at 536 Washington Street around 4:00 a.m. to seek safety at Lee Hospital. The currents made walking impossible so they managed to hold onto a partially submerged truck parked near Glosser Brothers Store. The waters had shattered a store window, giving the two women access to the building. Once inside, the two ladies were safe but were separated from Jerry Tayse.

Flood levels crested at 5:20 a.m. and began slowly to recede about ten minutes later. Water levels varied throughout the central business district. Water in the Johnstown Tribune Building reached desktop levels on the first floor. The flooding reached the level of the pedestrian walk signal at the Public Safety Building. It crested roughly seven feet above the sidewalk at City Hall. At the Towne Manor Motel on Johns Street near the Point, it was around ten feet deep. There was about five feet of water throughout the Centre-Towne Mall and some four feet in the Lincoln Tower Building.

The high water completely flooded Lee Hospital's basement and just about exactly reached the first-floor elevation. The cafeteria, food service, telephone system and certain mechanical equipment were located in its basement. Electricity was also lost. Lee Hospital faced an immediate crisis.

On call the night of the flood, Dr. Thomas Schaeffer was summoned. There were diabetics desperate for food. Schaeffer smashed into the then closed first-floor gift shop to get snacks for those who needed them. Patient IVs were maintained. He also made an amazing trip by boat from Lee Hospital to the Easy-Grade where he managed to hitch a ride to Memorial Hospital and fetch a pint of blood for a patient whose life depended upon it.

Johnstown's incline plane went into action, hauling without charge approximately 1,500 people up to Westmont.[533] Just about every basement in the downtown was flooded. Most ground-level businesses were ruined. There were no deaths among downtown residents. The four patient fatalities at Lee Hospital had been terminally ill.[534]

Woodvale

Johnstown's Woodvale section was severely inundated the early morning of July 20. While there were heavy surface flows coming down from Prospect Hill and Upper Woodvale, the major flooding was caused by the Little Conemaugh, which had begun breaking out of its channel walls just after midnight. Its waters continued rising until cresting at Woodvale around 5:00 a.m.

At the yardmaster's office below the Maple Avenue Bridge, the water had crested at a little more than six feet. The vast railroad mainline and yard area just above Lower Woodvale was covered about two feet deep. Since the tracks are as much as seven feet above Maple Avenue itself, some of Lower Woodvale was flooded nine to ten feet deep. The flood level reached 1,191

feet above mean sea level at the Swank Court Bridge, or about ten feet above the sidewalk. Some Woodvale homes and other buildings along and near Maple Avenue were flooded into their second-floor levels. At its peak, the flood covered the entire area from the mainline tracks and yard across Maple Avenue to the other side of the Little Conemaugh River.

As was true around much of Johnstown, there were wrecked cars, mud and all kinds of debris. A small house trailer, picked up by the current, floated down Maple Avenue toward downtown. At Swank Court it rammed into the second level of the Swank Refractories Building. After the floodwaters receded, the trailer remained aloft, jammed into a huge hole in the side of the building some ten feet above the sidewalk.

There were no fatalities in Woodvale caused by the flood. Homes and other buildings, however, were severely damaged.[535]

Cambria City

Considering that it lies adjacent the Conemaugh River and is low and flat, Cambria City, although badly flooded, fared comparatively well during the 1977 Flood. This is probably best explained by its being bordered by the Conemaugh River on one side and the Conrail mainline track fill on the other. Sheet flows of surface water coming off the hills and cascading through stream valleys could not strike Cambria City as they had done in the Solomon Run valleys, Franklin, Moxham and Tanneryville.

Flooding in Cambria City was caused by water rising from the Conemaugh River. It flooded the city garage at Power Street and Sixth Avenue by almost five feet. The water eventually reached six feet deep at the Penelec offices. The Ozog Funeral Home on Broad Street suffered some of the deepest water in Cambria City, around seven feet.

There were no flood-related deaths. Damage to homes, churches and other buildings was severe.[536]

Other Parts of Johnstown

There was damage done to Coopersdale Homes, a public housing project situated adjacent the Conemaugh River. Forty-one-year-old Shirley Bailey and ten-year-old Melissa Mitchell, both project residents said to have been visiting in Tanneryville, were missing and are still presumed killed by the flood.

A few businesses located between Cooper Avenue and the river were also badly damaged. Joe Pavlosky's Deluxe Catering Service at 209 Cooper Avenue, about 3,500 feet from where Laurel Run meets the Conemaugh River, experienced water eight feet deep and lost several trucks and a station wagon.

Cheney Run begins in Southmont Borough and flows into the Eighth Ward beneath Southmont Boulevard and Franklin Street. The stream is next carried alternately by improved channels and enclosed culverts. In the early morning of July 20, Franklin Street became badly flooded. Sanitary sewers backed up. Water got into the basement of Conemaugh Memorial Hospital, filling the tunnel walkway to the Nursing Education Building about three feet deep. An emergency effort salvaged medical records kept in basement areas.

There were no fatalities in the Eighth Ward. Automobiles parked around the hospital were ruined. Damage to homes and businesses was comparatively light.[537]

The West End sections of Johnstown experienced many emergencies. Surface waters flowing through Elk and St. Clair Runs soon overtaxed their channels and waist-deep water began flowing over D Street, across Barron Avenue and down through Fairfield Avenue. The underpasses at Fairfield, Delaware and Laurel Avenues became impassable. Basements and the first-floor levels to many buildings were flooded. Cars were washed around. There was one fatality.

Residents of Riverside, a part of Stonycreek Township upriver from Ferndale, began hoping they had escaped serious flooding. Water seemed to be staying in the Stony Creek. Observers then noticed the river quickly rising. Volunteer firemen began getting everyone out of their homes. One lady had to be rescued by boat. Homes in the lowest elevations were flooded almost up to second-floor levels. A few houses were moved off their foundations. There were no Riverside fatalities.[538]

Paradoxes

The 1977 Flood was a result of heavy downpours in steep topography. Intense summer thunderstorms are usually short-lived. This one kept going.

In the Laurel Run Basin, 11.87 inches of rainfall had fallen in less than eight hours. The rain gauge on the Public Safety Building recorded about ten inches. Almost twelve inches fell around the airport in Richland Township, an area in the headwaters of Solomon Run, Sams Run, Peggys Run and Clapboard Run.

Except for its northern areas around Windber and near Johnstown, Somerset County got little rainfall. Only 1½ inches had fallen at the North Fork Reservoir situated about eight miles from where there had been nearly twelve inches of rainfall. Boswell had less than one-half inch. The Quemahoning Reservoir had not been full before the rain started on July 19. It remained below its filled capacity until well after the storm had ended.

Just over two inches fell at New Florence to the west in nearby Westmoreland County. Ebensburg, Cambria's county seat, recorded 4.63 inches.[539]

The waters rushing rapidly down small valleys and hollows, whose normal streambeds had been greatly overtopped, behaved in ways that defy understanding. There were numerous instances of debris avalanching. Trees were uprooted and blown over. Utility poles came down. Huge rocks were undermined and started rolling down steep slopes. These kinds of things were happening throughout the Johnstown region at nighttime during incessant lightning and booming thunderclaps. People were witnessing strange occurrences never seen before. Continuous lightning flashes produced a sensation of fleeting daylight at night.

Water reached varying levels at nearby places on the same horizontal plane. Accounts were often inconsistent. Some were probably unintentional exaggerations.[540]

There remains a backwater or back-flow controversy in Johnstown to this day. At issue is the degree to which the collapse of the Laurel Run Dam contributed to the flooding in Coopersdale, Cambria City and even Johnstown's downtown. There were people downtown who reliably reported seeing floating automobiles and other debris moving upstream during peak flow periods. Dr. David Wojick, an engineer, contended that if the Laurel Run Dam had not failed on July 20,

the Cambria City section of Johnstown would have escaped flooding. Stream-flow hydrologists, however, concluded that the effects were not great, but the controversy has not been definitively resolved.[541]

The waters were moving cars around as if they were corks. Since the front engine of most vehicles is heavier than their rear part (trunks serving as air pockets), they were often tilted up in the back. They then were stuck against walls, buildings, trees, other cars and even parking meters. After the waters had receded, the vehicles often remained perched, usually front down and rear up.

Debris piles also were baffling. Some were higher than the waters forming them had reached—a result of rapid flows that had collapsed buildings and tall structures.[542]

Confusion and Communications Failure

During the early morning hours of July 20, no one knew the whole picture of what was going on. Areas such as Tanneryville, Woodvale, the Solomon Run basin and parts of the West End were isolated from the others. Severe flooding, damage and deaths were also happening beyond the immediate Johnstown area—in Windber, Scalp Level, the Seward area, in parts of Indiana County and elsewhere.

As the evening progressed, people began losing electric power. This happened as basements flooded, poles and lines toppled and the lightning or other causes activated circuit breakers. Utility personnel also instigated safety measures by shutting off power. Penelec reported that fifteen thousand customers lost electricity.[543]

The same was true of telephone communication—some homes and places had it while others did not. As the night wore on, more and more telephones went out of service as poles were knocked down and subsurface conduits and lines were flooded. *Tribune-Democrat* employees were receiving incoming calls but could not dial out.

Just after the All-Star Game was over, WJAC-TV began its late news broadcast. Steve Richards, a television newsman, announced, "The Johnstown district is in a state of chaos and confusion at this hour! Flooding is reported in many areas. Power lines are down and communities in scattered areas are without electrical service." Richards urged people not to travel.

The National Weather Service did not declare a "flash flood warning" until 2:40 a.m. Wednesday.

Beginning at daybreak on July 20, WJAC-TV could not broadcast for the next thirty-five hours because the link to its transmitter on Laurel Mountain had been severed. Other radio stations also went "off the air" for varying reasons. Only WJAC-Radio maintained uninterrupted programming throughout the disaster, broadcasting a continuum of emergency announcements, flood victim advice and missing person information.

The *Tribune-Democrat* struggled to keep its presses rolling. Only 5,000 copies of the usual 33,000 morning run of the Wednesday, July 20 edition were delivered. The remaining copies were trapped in the building.

Temporary arrangements were made for the newspaper's staff to operate out of the WJAC Building in Upper Yoder Township and for the printing to be done by the *Tribune-Review*'s presses in Greensburg. While operations were difficult, the local presses did print the Friday, July 22 edition.[544]

Emergency Service Limitations

Sometime around 11:00 p.m., lightning knocked out the broadcast transmitter at Daisytown, causing the radio system operating from the Public Safety Building to go down. A backup radio was next used that provided some unreliable communications until 5:10 a.m. when the system was judged useless. By 2:30 a.m., communications between the city's base station and its police and fire vehicles had become unworkable. Vehicle-to-vehicle communications, often spotty, continued. Just before midnight, the West Hills Police Network also got knocked out for want of electric power.

Richland's emergency radio network remained operational, but served only its township police department and the three volunteer fire companies. The system, however, was not tied into any other state or local network. At the time of the 1977 Flood, Richland was policing Scalp Level, a borough hit hard by the storm.

Not only were the communications systems failing, but the city itself and the surrounding suburbs were chopped up into island pockets that could not be reached safely. The underpass at the Old Stone Bridge had become impassable. The other West End underpasses became so flooded no vehicle could make it through them. By early morning, it was impossible to drive through most of Woodvale, as Franklin and East Conemaugh were cut off from Johnstown City. To make matters worse, a support pier to the Franklin-East Conemaugh Bridge was undermined and the span had to be closed to traffic. The Johnstown Expressway (Route 56 Bypass) was becoming hazardous by the early morning hours. Both the Solomon Run and Sams Run Valleys were impassable from Richland and Geistown all the way down to the Stony Creek River.

Fire Chief Charles Krumenacker learned some of these lessons the hard way. After he had set out in his wife's car during the storm to help recover an assistant fire chief's car stuck in the Fairfield Avenue underpass, he proceeded to reach fires and other emergencies as best he could. Having failed in most cases, he and two other firemen eventually spent the night in the Suppes Ford Building on Main Street.[545]

The Ash Street Fire Station's log for early July 20 describes the saga of a crew that received a call at 1:23 a.m. to transport an invalid from the Solomon Homes Housing Project to Meadowvale School. The truck and crew retrieved a Mr. Cover but soon found the Widman Street Bridge had become impassable because of a downed pole. After finally getting the pole dislodged, the truck made the crossing before the bridge vanished. Finding themselves on the Route 56 Bypass, they headed up toward Richland. As they headed up the expressway, they found it impassable. Debris and huge boulders were swept onto the pavement, some of which was undermined. The men next turned around and drove down the expressway stopping to rescue people stranded in their vehicles. They next left the expressway at Bedford Street and headed toward the Meadowvale School. At the Golde and Ash Street intersection, they concluded there was no way to cross over Messenger Street because of its current. They next delivered Mr. Cover and other people they had rescued to a church near Golde and Fronheiser Street and continued by a circuitous route. They used Singer and Frankstown Roads through Conemaugh Township to the airport, went back down Lunen Street through Moxham and then proceeded by way of Grove Avenue and Ash Street to the Robel Construction Company

fire. Here they helped firemen from the Oakland Fire Company pump water onto the fire that was already out of control.

Richland Police Chief Jim Mock and Sergeant Mike Goncher were almost killed near Scalp Level when their cruiser became caught in a swift current. They did escape but their vehicle was destroyed. Similar frustrations were experienced by all sorts of emergency service personnel throughout the long night. The Richland police dispatcher had become so busy taking calls and dispatching vehicles that there were no entries in the logbook after 1:06 a.m.[546]

Penelec activated sixty utility crews that were called in from its operating territory. Forty of its service trucks, damaged by the flood, were restored by a team of nineteen mechanics. By 2:00 p.m. on Thursday, July 21, twelve thousand customers' power had been restored. By early Saturday, only one thousand customers remained without electricity.

During the fateful night, there were countless heroic rescues. Many were trapped in automobiles that were floating around or were stuck somewhere. After his brief tour with Mayor Herb Pfuhl, John Sprincz linked up with Charles Korenoski, a city patrolman. The two pulled a woman and her six-month-old son out of a car before it was washed away. They later urged an elderly couple to vacate their mobile home. When the couple refused, Sprincz and Korenoski each physically pulled them out like a sack of potatoes and took them to a safe location. The mobile home soon disappeared.[547] Volunteer and city firemen also made countless rescues, as did numerous citizens who were never honored for their heroism.

II. The Return to Normalcy

Wednesday, July 20, 1977

The rain stopped falling around 4:00 a.m. Wednesday. At daybreak, a beautiful day unfolded. Venturing out to see what the storm had done, people saw the mud, filthy water, wrecked houses, stray animals, ruined automobiles, heaved-up pavements, downed trees and branches and other remnants of widespread destruction. The human reactions were shock, disbelief, grief, anger and a sort of dazed withdrawal in a few cases. Many people were worrying about family members, friends and neighbors who were unaccounted for. There was no ready way to locate them. Just about all the telephones were dead. Both the electric power and natural gas systems were out almost everywhere in and near the city. With no running water in many places, drinking water was scarce. Uncanned food was spoiling.

There were those in need of immediate rescue from rooftops, trees or other places reached for momentary safety during the flooding.

Many houses in the flood-ravaged areas were no longer habitable—some beyond repair while others needed major rehabilitation before anyone could safely live in them. Occupants frequently did not know whether their dwellings were safe. Many were reluctant to vacate visibly unsafe homes for fear of looting. There was also widespread concern that natural gas might be escaping from damaged appliances or through unlit pilot lights. There were also worries about explosions from gasoline fumes or sewer gas rising into homes and buildings. People were admonished to boil water before drinking it. With the utilities out of commission and everything wet, boiling water was rarely possible.

The Johnstown Expressway (Route 56 Bypass) several days after the 1977 Flood. *Courtesy Johnstown Area Heritage Association.*

Clean water and ice were needed everywhere. The shoes and clothes that many people were wearing were dirty and wet. Home furnishings were ruined. Food in refrigerators was perishing. Many were cut off from their regular medicines, insulin, oxygen or other treatments.

Seemingly out of nowhere, contractors began showing up offering their services. These ranged from some with sound qualifications to unscrupulous jacklegs out for fast bucks from those in desperate circumstances.

Rumors and concerns circulated. What had the flood done to the mills? What had it done to other places where people worked? Immediately after the flood, no one knew the facts.

In addition to widespread anxiety, many people had immediate needs. No one in authority knew the scope of seemingly endless problems.

Looting and Sightseeing

Near daybreak while the waters were still deep, nameless looters appeared downtown. Dr. Thomas Schaeffer had seen them when he was returning to Lee Hospital from his trip to Conemaugh Memorial. He even described them as well prepared, having brought poles with them to test for missing manholes and dangers lurking beneath the floodwaters.

From their office windows in the Tribune Building, reporters witnessed the looting of the Camera Shop on Park Place. Toby Sweeney wrote that he was watching as "eight to ten young people ransacked the windows of United Jewelers, 412 Main Street...as if on a Christmas shopping spree." Reporters were also observing when "young people threw a rock through

a plate-glass store window and grabbed everything in sight." The looting had also hit James Jewelers on Franklin, the Jupiter Store on Main and Glosser Brothers. Firearms were reported stolen from Lou's Army and Navy Store and the Family Store.

"Some of the looters swam across streets to get to the merchandise first," Mary Zaller, a *Tribune-Democrat* copy editor, stated, "and some curiosity seekers just came to watch the show. It was disgusting."

News of the looting spread rapidly. When he learned of it early Wednesday morning, Mayor Herb Pfuhl instructed the police, "Shoot to kill!" Once the word was spread that the thieves might be shot, looting seemingly stopped—a result perhaps of having more police and national guardsmen on duty—but Pfuhl's draconian edict probably was a factor. There was a later news item, ostensibly from the district attorney, that nine persons had been arrested and charged with plundering during Wednesday and Thursday.[548]

The fear of looting caused many people to carry revolvers or other guns. Some storeowners visibly kept weapons on them and a number of people in flood-stricken neighborhoods and communities, fearful of strangers milling around, were also armed.

While no looter was shot, Pfuhl's order generated controversy. Leaders of the Pennsylvania State Police reminded its members that the department's policy was to shoot only when the officer's or someone's life depended on it. The *Philadelphia Daily News* editorialized sarcastically "Even orthodox Moslems only cut off a thief's hands…Apparently, Two-Gun Herb was too busy…to have absorbed the…lessons of Kent State and Attica."

FBI Director Clarence Kelly defended Pfuhl's order before a convention of Pennsylvania police chiefs at Seven Springs shortly after the flood. "If it [looting] is permitted to go uncontrolled, it could escalate into attacks against individuals," he stated.[549]

Sightseers also began to appear. One of the earlier orders issued by Pfuhl on Wednesday was to seal off Johnstown in an effort to prevent anyone from entering the city except those with good reason to be there. Not only were such people in the way of work being done, but they caused flood victims to feel like they were on display. A 10:00 p.m. curfew was imposed immediately and remained in effect for about a month.

The Vacating of Lee Hospital

Lacking telephones, adequate electric power and its usual kitchen facilities, there was no way Lee Hospital could function immediately after the flood. The hospital's administration had no choice but to remove its patients from the facility. Some could be released once their homes were proven safe and functioning. Others were transferred either to Mercy or to Conemaugh Hospital. New admissions were halted. Between Wednesday and Saturday, 227 patients were moved. Lee's emergency room remained open both during and after the flood.[550]

The Disaster Declarations

While trapped at Meadowvale School, Mayor Pfuhl declared the city a disaster area. By car radio, he had first contacted the city police dispatcher and directed him to inform Mike Kreskosky, the county civil defense director, that the Hornerstown part of Johnstown was

experiencing an extreme emergency. After he was reached, Kreskosky apparently requested the dispatcher to contact Pfuhl and ask the mayor to telephone him directly. The school telephone still worked. Pfuhl contacted Kreskosky informing him that the city was experiencing a serious disaster and that he had declared a state of emergency. According to Kreskosky, the call was made at 2:10 a.m. Just before 3:00 a.m., the county director telephoned the regional civil defense center at Selinsgrove.

The state's civil defense duty officer was Jack Glauner, who claims he contacted Elmer Schenk, Cambria County's assistant civil defense director. Schenk, however, claimed he had initiated the contact.

An hour later (after confirming the flooding disaster with the state police), Glauner contacted the state's civil defense director, Oran Henderson. Henderson sought more verification and then contacted Governor Milton Shapp, awakening him at 5:00 a.m. The governor immediately called out the National Guard.[551]

Shapp was flown to Johnstown after daybreak on Wednesday. He established a makeshift office at the airport and was given an overview briefing by James Mock, Richland police chief. The governor quickly declared "a state of extreme emergency" for a seven-county area including Johnstown.

Meanwhile a National Guard helicopter brought State Representatives Adam Bittinger and Bill Stewart from Harrisburg back to Johnstown. They arrived at the airport and were immediately taken on a disaster inspection tour.

Later that day, the governor made arrangements to visit WJAC's offices in Upper Yoder Township to meet with Senator John Heinz and Congressman John Murtha. Stewart and Bittinger were in the helicopter with the governor. They landed at the city golf course near WJAC. People were playing golf that Wednesday, the very day of the flood—an unfortunate contrast, considering distraught flood victims nearby who were facing homelessness and shock and were looking for missing family members and loved ones.

Shapp, Stewart and Bittinger went to the WJAC-TV offices where they met up with Senator Heinz and Congressman Murtha, who had arrived from Quantico, Virginia, in a helicopter authorized by President Carter. The officials next reviewed footage of the flooding that had been taken by WJAC camera crews.

Shapp believed that the footage was so outstanding, he wanted it seen by the president in hopes that the images would expedite a federal disaster declaration.

Heinz took the film to Washington later that day. The president viewed it and signed a disaster-area proclamation early Thursday, July 21. Among other things, it authorized federal assistance within a broad seven-county area—Cambria, Somerset, Indiana, Bedford, Westmoreland, Clearfield and Jefferson Counties. Blair County was added on July 29.

Governor Shapp, already experienced in flood emergency operations from the Tropical Storm Agnes disasters of 1972, took a hands-on approach and was decisive in expediting flood assistance. Using a temporary office at the airport, the governor spent days in and around Johnstown. When he knew something was needed, he made immediate arrangements to get it. Shapp knifed through red tape. He even used the hood of a truck as a desktop to scribble a note authorizing Mayor Pfuhl to enter emergency contracts without competitive bidding.[552]

Shapp spent Wednesday night at an Altoona motel. Early the next day, he held a meeting at the airport in Richland with representatives of the National Guard, the state police and Leonard Bachman, his secretary of health.

Shapp quickly discovered that many important highways were in shambles. He contacted Joseph Kassab, the recently retired Pennsylvania Transportation Department secretary. Kassab accepted Shapp's urging to lead a team to survey highway and bridge damage and develop a program of emergency reconstruction.

Among the various responsibilities of Ernest Kline, Pennsylvania's lieutenant governor, was to serve as chairman of the state's Civil Defense Council. Kline had the responsibility to coordinate all state activities and programs for flood relief and rehabilitation when Governor Shapp was not present. Like Shapp, Kline spent much time around Johnstown after the flood.

The Federal Disaster Assistance Coordinator

Richard Sanderson, the federal disaster assistance coordinator assigned to the seven-county area, arrived by helicopter around noon on Thursday, less than three hours after the presidential declaration. A native of Saxton in Bedford County, Sanderson knew the area well.

As the coordinating authority over all federal flood recovery and relief activities, Sanderson's assignment involved a new approach in U.S. disaster relief. Rather than to coordinate by mediating among participating federal agencies, Sanderson was delegated more hands-on authority to make the government's disparate activities function as a unified team. It was also his job to work harmoniously with local and state officials and private groups. His office was located in the General Kinetics Building on Goucher Street.

Among his earlier initiatives was arranging contracts to haul away the muck and debris that was cleaned up through many public and volunteer efforts. The federal coordinator and his staff also issued all press releases covering federal agency initiatives and activities.

Sanderson held regular meetings attended by representatives from all federal agencies involved in the recovery. The sessions were open to the news media and general public. There was some early resistance from a few agencies to operate in such an open way, but the reluctance was overcome by Sanderson's White House backing.[553]

The Disaster Relief Centers

Prior to the creation of a more coordinated disaster organization and the sites to go with it, the Richland Township Building on Luray Avenue had become an early emergency management center. The Richland radio network had remained intact and the building was near the airport, the governor's unofficial base of operations. The township building could also be reached by trucks and other vehicles coming from outside the area.[554]

The Johnstown City Hall had been badly flooded and its telephone system had been knocked out. On Friday, July 22, a "temporary city hall" was established in the Swank Building downtown where the city's business administrator, Bill Heslop, was in charge.

Sanderson and his staff immediately established a network of Federal Disaster Assistance Centers, each staffed with a range of experts representing about twenty federal, state and

volunteer agencies. Their role was to define the problems needing attention and to quantify the needs statistically. More importantly, the centers were to expedite flood victims getting the help and advice they needed.

Each center was organized as a "one-stop" institution. Among the centers' many functions were housing needs accommodation, food stamp distribution, assistance in filing all sorts of insurance and unemployment compensation claims, help with flood-related income tax matters and answering general inquiries.

There were soon seven centers throughout the region including five in and about Johnstown. At least one had day-care services for parents with children. There was also a mobile center that moved from place to place and a twenty-four-hour toll-free hotline.[555]

By the end of their first week of operation, 5,830 families had registered at the centers. Of these 1,221 needed help with housing problems, 1,579 were seeking SBA housing loans, while another 385 were pursuing SBA business loans. Food stamps were distributed to 2,826 families. The Veterans Administration assisted 547 ex-servicemen, and 2,295 individuals and businesses received IRS counseling. Social Security Administration workers aided 659 people. Red Cross assistance was extended to 1,177 families.

By the end of July, the centers had processed requests for assistance from a total of 12,700 flood victims.[556]

Outpouring of Assistance, Public and Private

"When there's a disaster, there are really two disasters," stated Monsignor Geno Baroni, an assistant secretary of the U.S. Department of Housing and Urban Development (HUD). "The first is the disaster itself and then the disaster of putting it back together." Baroni had served in several parishes in the Altoona-Catholic Diocese, including an assistant pastorship at St. Columba in Cambria City.[557]

As events unfolded, Baroni's insight proved correct. Public, semi-public, private and religious efforts from afar began coming to the aid of Johnstown and surrounding areas. At first, no one understood the scope and other details about the tragedy, especially what and how much of what was needed and where. The term "organized confusion" was often heard. Groups of people were seeking assignments when frequently no one could tell them what to do or where to do it. An Altoona contractor, Charles Feathers, had come to Johnstown on Thursday, July 21, with several trucks, a high lift and an offer of free help. Security officers prevented his entering the city.[558]

The National Guard

Governor Milton Shapp's mobilization of the National Guard had been immediate. By noon on July 20, helicopters were visible and frequent around Johnstown. Their highest priority was to rescue people still in danger and to deliver food, water, medicine and medical personnel where they were needed. They also transported corpses to a temporary morgue in the former Richland High School. Helicopters also ferried people in and out of areas unreachable by truck. There were twenty-nine National Guard helicopters, fifty-five pilots and eighty-five crew chiefs assigned to flood recovery work.[559]

The Richland Township Building on Luray Drive near Scalp Avenue became the helicopters' distribution center. Materials for transport were assembled on the Mason's parking lot across the street.[560]

National Guard units were pressed into immediate service as auxiliary policemen who accompanied state troopers. National Guard trucks and equipment were also used in cleanup work and to deliver food, water and necessities.

By the first weekend after the flood, other National Guard units from Pittsburgh, Harrisburg, Hazleton, Reading, Altoona and elsewhere had been sent to Johnstown. At peak mobilization, about 2,400 Guardsmen were serving throughout the eight-county area.[561]

The Pennsylvania State Police

Seventy state troopers were ordered to Johnstown early Wednesday, July 20. Upon arrival, they were immediately given designated areas. They also manned ten roadblock stations to prevent unauthorized people from entering flooded areas.

The number of troopers was soon boosted to two hundred, including six specialists in body identification. Three of the state's six police helicopters were also sent for rescue and other missions.[562]

The U.S. Army Corps of Engineers

Personnel from the U.S. Army Corps of Engineers first arrived in Johnstown on Wednesday afternoon, July 20—even before the president's disaster declaration, an early response needing no authorization. The corps was the local sponsor for the Johnstown flood control project.

The corps immediately began developing an overall damage assessment and interviewing qualified contractors. A total of sixty-six corps employees from the Pittsburgh District and other locations were flown to Johnstown immediately. Its local headquarters was in the vo-tech in Richland Township. In the beginning, the corps' contract work was focused on debris removal. Because it had been the hardest-hit area, the first contract was to remove massive debris deposits from the Tanneryville area. Awarded on July 21, actual work began two days later.

Debris removal commenced throughout the Solomon Run area. Contractors also began removing contaminated food and drug products from the downtown and other places. By early August, the U.S. Army Corps was administering twenty-eight contracts that involved 178 pieces of heavy construction equipment and 238 workers. This work was all accomplished by August 26, 1977.

The corps also entered into six contracts for demolishing a total of sixty-one structures located in Dale Borough and the city, work done between August 14 and September 15, 1977.

On July 21, there was concern that the Beaverdale Dam on the South Fork of the Little Conemaugh River might fail. Fearing a panic, Congressman Murtha immediately contacted corps officials and arranged to bring in dam safety experts to evaluate every dam in the area, including Beaverdale. A small team of experts was assembled, including a geologist from the Pennsylvania Department of Environmental Resources. Thanks to a National Guard

helicopter, the team inspected thirty dams from the air. Of these, six were given a careful ground survey inspection. No faulty dams were identified.

The corps also spent over $2,050,000 repairing and removing debris, sandbars and other deposits from its Johnstown channel works.[563]

The Salvation Army and the Red Cross

At 7:00 a.m. on Wednesday, July 20, while Johnstown was still badly flooded, the first Salvation Army mobile canteen unit was on its way from Greensburg. It was stocked with bread, meat, soup, donuts, coffee, tea and drinking water. Immediately afterward, similar vehicles from Altoona, McKeesport, Butler, Beaver Falls and Pittsburgh arrived in Johnstown and surrounding areas.[564] The Salvation Army also sent a special tank truck with built-in technology for treating otherwise undrinkable water. Its staff and volunteers not only supplied food to the many shelters being established, but they also did the cooking and distribution. One week after the flood, the Salvation Army reported it was serving about thirty thousand meals a day in various canteens and shelters throughout the region. By the fifth day after the flood, the organization had sent thirty trained staff and two hundred volunteers for flood relief.[565]

The Red Cross also sent mobile canteens. Akron, Harrisburg, Washington, Baltimore and Parkersburg, West Virginia, each furnished a unit.

For proper refrigeration, the Red Cross quickly transferred the Johnstown blood bank reserve from its downtown building to the Galliker Dairy in the industrial park. The Red Cross also undertook special blood drives over a large part of the nation to make up for the community's local needs since the Johnstown-area blood intake had to be halted for many days. The Red Cross answered countless inquiries about the fates of families and relatives. By July 30, it had issued disbursement orders totaling $600,000 for food, clothing, shelter and medical needs. The Red Cross also provided about $100,000 in cleanup supplies, including soaps, disinfectants, brooms, rags, mops, buckets and shovels. The organization furnished nursing services including drugs, eyeglasses and dentures. It even paid some funeral expenses.

A Baltimore disaster expert, Jim O'Donnell, was in charge of the Red Cross relief effort. The Red Cross spent $2.5 million toward the 1977 Flood throughout the eight-county area.[566]

Other Groups

Various volunteer fire departments in the region began contacting their counterparts in nearby areas that had not been flooded. Many sent men and equipment to stand by during the first several days of recovery. McKeesport and other cities assigned paid firemen and policemen for brief periods in Johnstown.

Soon all sorts of volunteers began giving assistance. Exactly how efficiently these well-meaning efforts panned out cannot be told exactly because the results were varied. To help improve communications, the Central Pennsylvania Repeaters' Association sent a team of about twenty amateur operators with radio equipment. They set up base stations at the hospitals, with the police chief, the mayor and at other locations. In a review session ten days after the flood, the group concluded that there had been so many other radio operators and so

much disarray, their resources were underutilized. Nevertheless, ham radio assistance proved invaluable.[567]

A group of volunteer workers from Fayette County, together with some county-owned heavy equipment, arrived in Johnstown on July 25 to help cleanup. County Commissioner Fred Lebder went to the city's Swank Building office seeking a confined area so his people and equipment could work together. "There was a hell of a lot of people running around in there and we waited for a long time—well only a couple of hours…Finally I grabbed someone and said we had come to work, at no cost to the city, and asked if we could have a block to begin with cleaning up. They told us to go ahead."

When the Fayette County team thought it was in Hornerstown, its members were actually in Dale Borough, another municipality. They spotted massive piles of debris and cleaned them up effectively. "I always had trouble getting around in Johnstown," Lebder observed. "I used to do some sales work up there. I was always getting lost."[568]

One of the most effective volunteer groups was the Mennonite Disaster Service. Over two hundred Mennonite men and women came to town at sunrise day after day and donated almost five thousand man-days to flood cleanup. They were well organized and served under an experienced leader, Amos Lantz. Only twenty-six years old, Lantz had three years of disaster relief experience. Bringing their own food, water, tools and supplies, the Mennonites went straight to work cleaning mud from the basements and floor levels of private homes, especially those of the elderly. Believing their work was pleasing to God, they sought no compensation.

The Seventh Day Adventists also made a major contribution. They volunteered approximately five thousand man-hours of labor to the cleanup and donated forty thousand articles of clothing.[569]

A large cadre of electricians from Allegheny and Beaver Counties brought their own tools and supplies and proceeded to make electrical repairs to private homes. Twenty-seven students, faculty members and townspeople from Wilkes College helped clean the city hall.

State Representative Stephen Reed from Harrisburg organized a team of eighty people from Harrisburg. Ten days after the flood, they spent a long weekend cleaning. A volunteer group from Pittsburgh and Allegheny County arrived with about 80 trucks and 160 volunteer workers. On July 29, another convoy, 15 trucks carrying food and relief supplies collected from Pittsburgh and Allegheny County, was sent to Johnstown along with county-owned equipment. A sizeable group from Lancaster County, including a volunteer contractor with a bulldozer, also arrived in late July and did extensive work in the Walnut Grove section.[570] The Community Service Corps of the Roman Catholic Archdiocese of Philadelphia's Department of Youth Activities sent a group of fifty young people from the Philadelphia area. Among other duties, the student delegation operated four mud pumpers loaned by the Philadelphia Fire Department.

Philadelphia's seventy fire stations were each furnished with a drop-off box for food and other donations. Philadelphia Bulletin trucks moved the items from the fire stations to a central warehouse for shipment to Johnstown.[571]

There were numerous other volunteer activities. Many were done as a sort of repayment for assistance their own communities had received from outsiders, including people from Johnstown, during disasters of their own.

The Shelters

The flood brought homelessness to hundreds. Many were reluctant to leave their damaged homes for fear of looting. Nonetheless people began flocking to emergency living accommodations established in churches, motels, fire halls, armories and schools.

About 275 people had arrived at the Richland Junior High School by Wednesday evening after the flood. The total reached 400 to 450 on Thursday. Civil defense workers hauled in emergency cots. Each classroom in the Southmont School could house 10 persons. About 100 people were immediately placed in empty dormitory rooms at the University of Pittsburgh at Johnstown. By Friday, July 22, campus dormitories could accommodate 1,000 victims.

The numbers being housed in temporary shelters and other accommodations fluctuated. People often departed to move in with family and friends. There developed a major problem of keeping track of people's names and special needs. One week after the flood, estimates of how many people were living in shelters were varied. The Red Cross claimed there were 2,800 people in all. The state health department estimate was more modest—between 1,000 and 1,200.[572]

By mid-August, plans were made to move some of the flood victims once again because the schools and UPJ would be reopening. Arrangements were then made to relocate 194 remaining victims either to the Torrence State Hospital near Blairsville or to the Somerset State Hospital, institutions with extra beds. Although controversial, there was no alternative.[573]

Immediately after the flood, the three elderly public housing facilities downtown, all high-rise buildings, were uninhabitable and had to be vacated. Over the next three weeks, the buildings were cleaned and repaired, and their elevators were restored. Occupants then returned. The same had been true of the Solomon Homes and Coopersdale public housing projects, many buildings of which had been heavily damaged.

The Mobile Home Controversy

By late July, plans were in place to bring approximately one thousand mobile homes into the eight-county area for installation in scattered locations. The units were first delivered to a staging area behind the East Hills Elementary School in Geistown. The sites were selected by staff from the U.S. Housing and Urban Development Department (HUD). Site leasing and development was assigned to the Army Corps of Engineers.

Leases were immediately obtained for thirty-two trailers in Geistown and another twenty-five in Franklin Borough. Controversies arose about some sites. The Lower Yoder Township supervisors objected to using the Westwood School grounds. This sparked a hostile rebuke from Johnstown school board members. John Buchan charged, "You're afraid of blacks…living near you."

Opponents countered that the units should go in Roxbury Park, the city's only quality recreation facility. Newspaper editorials berated those opposing the trailers, and Congressman Murtha worked to overcome the opposition.

Because of the impact on utilities, schools and highways, the plan was to establish many smaller mobile home parks scattered about—not a few larger ones. Eighteen parks were developed for 970 trailers. The largest, on Mount Airy Drive near the Solomon Run Firehall, had 150 units.

The smallest, in East Conemaugh, had only 11. There were 25 at the Mound in Westmont. The controversial Westwood School site had 58.

Work actually began on the first trailer park on August 11. By the end of August, all eighteen sites were under development. Two sites were finished on August 31. The last completion was accomplished on September 23, two months after the flood.[574]

The Search for Bodies

A gruesome flood recovery task involved searching for bodies in wrecked automobiles, debris piles along the Conemaugh River, amidst the acres of floating debris in Lake Conemaugh and elsewhere. Three special rescue squads arrived on Saturday, July 23. Two more came later. They went through many areas, carefully searching for bodies using trained German Shepherds. If a dog's behavior indicated a possible corpse in debris or mud deposits, a yellow ribbon marker was placed and the site would be carefully searched.

Remains were taken to a temporary morgue in the former Richland High School on Scalp Avenue where the coroner and other trained experts made the identifications crosschecking those missing with the names of the dead that had been identified.[575]

The Small Business Administration (SBA)

On Friday, July 22, two Small Business Administration teams began making surveys of Johnstown's commercial firms. For the most part they moved about on foot. Their assessment for the central business district revealed that 164 businesses had suffered major structural damage while 186 had undergone minor damage. In Moxham there were 5 with major and 7 with minor damage. Similar surveys were undertaken throughout the flood-impacted region.

Those covered by flood insurance generally had no difficulty filing and receiving claim settlements. Businesses without flood insurance were eligible for SBA loans at 3 percent for the first $250,000 and 6½ percent on the remainder. The SBA also had a low-interest loan program for homeowners not covered by flood insurance whose dwellings had been destroyed or damaged. As of September 8, the SBA had loaned about $6 million. By the first year after the flood, the SBA had loaned a total of $66.5 million to small businesses and $16 million to individuals throughout the multicounty area.[576]

Media Relations

Not only were there local radio, television and newspaper staffs to keep informed, but the Johnstown area was also swarming with visiting reporters. Judging from various newspaper bylines, at one time or another there were some fourteen reporters in from Philadelphia, six from Pittsburgh, four apiece from Altoona and Harrisburg, two each from Baltimore and New York and at least one reporter from Toledo, Washington, D.C., Greensburg and Lancaster. There were also reporters from magazines; the smaller newspapers of Indiana, Westmoreland and Somerset Counties; and public relations staff from relief organizations.

Mayor Pfuhl persuaded Ed Kane, a seasoned media-relations specialist with government experience, to serve throughout the recovery. Kane issued news releases and maintained close rapport with visiting reporters, some of whom actually stayed in his home following the flood when hotel and motel accommodations were unobtainable. This barrage of publicity was doubtless a factor in the outpouring of cash and other donations flowing into Johnstown.[577]

"You Can't Take the Politics Out of Politics"[578]

Although Johnstown's "silly season" usually begins after Labor Day, there are no hard and fast rules. Politics in Cambria County goes on all the time but at varying intensities. An event like the 1977 Flood put a spotlight on almost everyone in authority. Any such person also running for office would naturally showcase his or her influence, leadership and other talent. This included seeking to be praised for successes as well as ducking the blame for things that inevitably go wrong or seem to have gone wrong.

The primaries on May 17 had pitted the city treasurer, Charles "Kutch" Tomljanovic, a Democrat, against the incumbent, Herb Pfuhl, a Republican, in the race for mayor. Dan Shields had been a very effective mayor throughout the 1936 Flood and its aftermath, but he had been beaten in his 1940 reelection bid. The 1977 situation was also different in a number of ways. Unlike 1936, there was no WPA or CCC to help do the mayor's bidding. The federal government also had an ongoing disaster relief program with a professional coordinator and staff whose job it was to preside over a number of federal agencies to expedite relief and recovery.

The administrations in both Harrisburg and Washington were Democratic. Pfuhl was a Republican.

There were also lots of other public officials around to compete for the limelight. Governor Milton Shapp was all over the place, showing decisive and effective leadership. Lieutenant Governor Ernest Kline was frequently in the area. Senators John Heinz and Richard Schweiker also showed up from time to time. Jack Murtha, the local congressman, remained around Johnstown for days after the flood with his shirtsleeves rolled up and wearing rubber boots. Murtha was unrelenting in his pursuit of flood relief assistance.

All these officials were well positioned to win praise for the assistance the city and its suburban neighbors were getting. They were also not likely to get blamed for the many complaints made or for the screw-ups that inevitably occurred. This was because nothing would have been gained and a lot of high-level good will and monetary assistance might have been lost should they get berated.

Throughout his terms as mayor, Herb Pfuhl not only sought to be in charge for real but also to impart a perception to the public that he was the top boss over any situation involving the City of Johnstown. During the flood emergency itself and the cleanup and recovery phases to follow, however, Pfuhl's role was confined to the City of Johnstown.

Serious disasters had occurred in Franklin, Dale, Windber, Stonycreek Township, Scalp Level, Seward, Homer City, Robindale and Tanneryville in West Taylor Township as well as within the city. As many citizens of tiny Dale Borough, a tiny municipality surrounded by the city, had been killed by the flood as citizens of Johnstown proper. Being mayor of the city imparted no

sovereignty over any outside municipality whether flooded or not. Their citizens, however, were free to blame him for their distress. While no one kept a scoreboard of the commendations and censures, Pfuhl was blamed for a lot of things whether or not they were his doing.

The public in general had a lot to gripe about. People with water in their basements seeking help getting it pumped out were not satisfied with explanations that they would have to wait because others were worse off. Almost everything people took for granted and were accustomed to using had broken down. Even those whose homes and businesses had not been affected directly by the flood were seriously inconvenienced by streets and highways that had become impassable, bridges that were closed off, utility interruptions and other irritants. There were even a few cases of damaged homes that could have been restored getting demolished by overzealous contractors working for the U.S. Army Corps of Engineers.

A number of people who were living downtown became vocally critical of city policemen and firemen. They charged that no one had warned them to evacuate downtown even after it was known that water had begun rising out of the rivers. Louise New complained that the police "were cruising around in their cars as the water got higher…they didn't even open their doors." Mrs. New and Raymond Nasko, a resident of Union Street, waded over to a police cruiser and asked an officer where they were supposed to go. They reported that the officer inside merely looked at them and drove off.[579]

"It's still unbelievable that there are no damned communications," a local Bethlehem Steel executive bemoaned three days after the flood. "These National Guard—they're just traffic cops…If we were in a war—with the state police, the city police, and the national guard doing what they're doing, we'd lose." Similar complaints could be heard far and wide.

Dr. George Walter, an ex-mayor and a city councilman during flood recovery, believed there had neither been a good disaster plan nor effective execution of whatever plan there was. "I have been around the flood disaster headquarters for the past three weeks, and I've seen absolutely no evidence of any plan effectuated by the civil defense director," he commented at a city council meeting.

Another irritant had to do with restrictions on citizens' movement. The police labored to keep visitors out of areas that had been flooded—especially downtown Johnstown. Word got out that passes could be obtained at the Swank Building headquarters. Soon there was a mad rush of people seeking to pick up little rubber-stamped index cards used as passes. Clerks ran out of the cards. Those waiting became angry. A city official told everyone—including people who had been waiting a long time—"Get the hell out of here!"

There was also confusion as to exactly where the passes were needed. In some situations all a person had to do was show their driver's license. While the pass system was finally abandoned on Saturday, July 23, it had angered lots of people.[580]

Mayor Pfuhl had earlier served as an officer in the National Guard and had once been an aide to Nicholas Kafkalas. By 1977 Kafkalas had risen to become both a major general and the state's adjutant general in charge of the Pennsylvania National Guard. Pfuhl was also a personal friend of Joseph Latch, a lieutenant colonel in command of the Local 103 Armor Battalion. Pfuhl named Latch his "military advisor," an impressive sounding but meaningless title. The arrangement sought to convey a message that the mayor had some sort of true authority over a local National Guard unit. Another of Pfuhl's friends, Miles Shaffer, a political

supporter and the chairman of the Johnstown Redevelopment Authority, was a major in the same unit.

On July 20, a helicopter was assigned to the city, including the pilots to fly it around. Pfuhl states that this was initiated by General Kafkalas himself. Critics stated Pfuhl requested one. Pfuhl also had use of a National Guard jeep with a driver, something he badly needed since his own car had been ruined and a four-wheel-drive vehicle was helpful in moving over muddy streets.

Pfuhl's helicopter became an issue. The *Tribune-Democrat* reported that Pfuhl was flying friends and family around. (Both Pfuhl and Joe Latch emphatically denied there was any validity whatever to this assertion.) Since the helicopters were needed to carry food, medical supplies, water and ice to those desperate for them, a spirit of resentment was said to have developed. When the National Guard took the helicopter back on July 27, Pfuhl was reportedly told that if he needed a helicopter for an authorized purpose, he could submit a flight request "the same as anybody else."

Pfuhl was also accused of being stubborn. The U.S. Army Corps of Engineers had labored to begin an immediate cleanup in the city. This needed Pfuhl's approval, but it reportedly took two days to set up a meeting with him. The mayor was reported to have wanted things done his way—on a block by block basis—under his direction. The approvals took a couple of days to receive. In its post-flood report, the corps stated:

> *Johnstown Mayor Herbert Pfuhl, Jr. at first sought to perform debris clearance work in the city with municipal forces, volunteer workers, and local contractors alone. The FDAA whose policy is to respect local self-help efforts, waited for the Mayor to call for Federal aid. On several occasions, Congressman John Murtha and Corps representatives explained to Johnstown authorities how direct Federal assistance with debris removal could speed recovery and minimize human suffering. The mayor signed a resolution requesting Federal assistance on July 25, backdating it to July 23. This authorized Corps clearance of the Solomon Run area.*[581]

It was also reported that the Pennsylvania Department of Health needed Pfuhl's authorization for some service it was providing. He allegedly balked. Governor Milton Shapp immediately contacted the attorney general instructing him to take court action to mandate the mayor's approval. Pfuhl eventually backed down.

"The mayor has been a real problem," A.L. Hydeman, the executive deputy secretary of the Pennsylvania Department of Community Affairs, stated publicly. "A lot of people had trouble with him. He wanted to run everything…If this is all for publicity, he should know that nobody wins in a disaster."[582]

Whether he deserved to be or not, Pfuhl had become the perfect fall guy, a lightning rod to take the blame for the widespread frustrations, especially within the city. Pfuhl recalls vividly that shortly after the flood, a woman approached him when he was talking to several people in Walnut Grove. Pointing her finger at Pfuhl, she blamed the entire flood on him alone—as if the mayor had personally violated some divine law invoking the wrath of the Almighty onto the Johnstown area.

Several community leaders led by Howard Picking Jr. and Charles Kunkle arranged a dinner meeting at the Sunnehanna Country Club to discuss ways to circumvent Pfuhl in the recovery

process. They invited Richard Sanderson to attend. Picking was seeking to establish a separate, non-governmental board to manage the recovery and oversee the deployment of resources.

Afraid the recovery (which he sensed was coming together) might go awry if there were an effort to undermine Pfuhl, Sanderson immediately rejected the proposal. "The mayor was not a problem," Sanderson insists.[583]

Pfuhl's public relations troubles probably peaked on August 7 because of a lead article in the *Tribune-Democrat* written by Bill Jones, which appeared prominently on the first page of the Sunday Metro section. The article discussed the helicopter issue, Pfuhl's alleged recalcitrance and insistence that things be done his way.

Sanderson had already been working to patch things up. The very next day he held another interagency coordination session open to the public and the news media. He began the meeting by reading a letter from Pfuhl praising the cooperation between the federal and state governments in disaster work. Reference was also made to a letter that Governor Milton Shapp had just sent to the mayor, praising his cooperative attitude: "I would like to take this opportunity to thank you for your efforts on behalf of the citizens in the Johnstown area during the recent flood emergency. I am proud and pleased to know that many fellow Pennsylvanians were and are vitally concerned about the welfare of others in the Commonwealth. You are to be commended for exerting your best efforts to help so many of your fellow citizens."

After reading both Pfuhl's and the governor's letters, Sanderson continued, "I mention all this simply to let you know we're all in this together, and we can get a hell of a lot more done if we don't throw stones at each other. And I don't want any stones thrown from the federal side."[584]

The Light at the End of the Tunnel

On July 29, the tenth day after the flood, Congressman Murtha announced, "We have a number of problems but the immediate crisis is over." While there were countless tasks ahead, those in authority understood what remained and had assembled the personnel and resources to pursue restoring flood-ravaged areas to the way they had been. The shock of the flood was over.

Day in and day out, the cleanup progressed. Throughout late July and most of August, houses, churches and businesses were cleaned out and repaired. Buckets of mud were carried from basements and yard areas and dumped along the streets where it was picked up and moved to the approved landfills. Wrecked houses, downed trees, broken furniture and appliances, ruined clothes and spoiled food were hauled away. By August 16 when most of this debris removal work had been finished, the contractors had removed 300,000 tons of waste materials.[585]

Never forgotten was the mud everywhere. Usually containing sewage and trace amounts of coal, the mud typically had an indescribably noxious odor. It was hard to walk or even to drive through. After drying, it became a fine, dusty powder that soiled clothes, furniture and bed linens with a residue that was hard to wash away.[586]

The four tracks of the Conrail mainline were blocked by a massive debris pile near Buttermelt Falls below Parkhill. Rail passengers had to be bussed around Johnstown and freight movement through the city was halted. Railroad crews worked around the clock to restore service. Within the first day, two tracks of the mainline were reopened.

Around 9:00 a.m. on Monday, July 25, an explosion wrecked the Royal Plate Glass business on Washington Street. Eleven persons were hurt. Two had to be ambulanced to Lee Hospital for emergency care before being taken to Memorial Hospital where one of them, Abe McCary, died. While never firmly determined, the blast was believed to be caused by gasoline fumes rising through the sewers into the building. In addition to the injuries and death, a large section of the building collapsed. Nearby buildings were vacated.

About a week before Labor Day, the last debris removal contract administered by the Corps of Engineers was completed. By September 15, the final corps' demolition and removal contract was finished. Homes were being rebuilt while their owners were still living in trailers. Electric power and telephone service was almost completely restored. The community was functioning.

By the middle of August, Walnut Grove was getting potable water by an improvised temporary system of pipes and hoses installed along the sidewalks.[587]

The Pennsylvania Department of Highways quickly awarded contracts to restore the many federal and state routes throughout the region. Bedford Street had suffered extensive surface damage. Ohio Street from Lorain Borough down to Central Avenue had been torn to pieces. State Route 11020 (Cooper Avenue) through Tanneryville in West Taylor Township was utterly destroyed. Route 56 from Richland down to Scalp Level and Windber had been seriously undermined. Half the roadway extending along a section of D Street had been washed out, leaving a dangling guardrail. Only two lanes of the four-lane Johnstown Expressway (Route 56 Bypass) were safe enough to use. One of the piers of the Franklin-Conemaugh Bridge had been undermined, causing the deck to buckle. The bridge had to be closed until repaired.

The first contract for emergency highway reconstruction and bridge repair was awarded two weeks after the flood. Soon a total of thirty-seven different contracts totaling some $18 million in federal disaster funds had been let in Cambria and Somerset Counties alone. The contracts dealt with some seventy highways or bridges. In most cases a single contract addressed two or even more separate projects. The goal was to accomplish as much restoration as possible before winter, but much reconstruction was delayed until the spring.

By Thanksgiving, the Johnstown Expressway's four lanes had all been reopened. Most of Route 56 between Richland and Windber-Scalp Level had been restored. The Franklin-East Conemaugh Bridge project was completed. Ohio Street was finished. A temporary asphalt road served Route 11020 through Tanneryville. The permanent project was designed for construction in 1978.[588]

Another indicator of recovery progress was the departure of the federal disaster coordinator. While he would return for special purposes, Richard Sanderson left Johnstown on October 28, 1977.

III. COMMUNITY RESTORATION

Industry: Bethlehem Steel Corporation[589]

Bethlehem Steel's Johnstown workforce numbered around 11,500 at the time of the flood. Site preparation was well underway for two Basic Oxygen Furnaces (BOF) at the Franklin Works. Their cost was to have been $70 million, and together they were to have been capable of

producing 2.2 million ingot tons per year. Once the BOFs were in operation, the workforce was expected to remain approximately 11,500. The eight open-hearth units, obsolescent and costly to operate, were programmed for phase out. Bethlehem's Johnstown Works would remain an "integrated mill," meaning that it would take iron ore and convert it into finished and semi-finished steel products. Most people knew that without the furnaces, the scope of the Johnstown works would be dramatically lessened and the workforce would decline.

The year 1977 had already been disastrous for Bethlehem. During the first two quarters, the corporation had lost $75 million. Imported steel was flooding the United States at an increasing pace. Meanwhile, the corporation was continuing to invest heavily in EPA-mandated pollution control equipment. There had also been a long-lasting fire at Bethlehem's Slope Mine 33 near Ebensburg. A severe blizzard at Buffalo had forced Bethlehem to shut down its Lackawanna Mills. In April, the corporation had to cut its quarterly dividend to twenty-five cents a share. If the flood had to happen, there could have been no worse time for it than July 1977.

The flood devastated the Johnstown Works. Massive flows of water and debris had cascaded down Peggys Run at the western edge of Franklin. The three modern coke ovens (Nos. 17, 18 and 19) were so filled with mud and debris that it took more than six weeks to restore them. The existing open hearths, the blast furnaces and the work done for the BOFs, however, were not as seriously damaged as the coke ovens had been. The Lower Works and the Gautier Works in Johnstown had been submerged with several feet of water.

Soon after the 1977 Flood hit, general manager Tom Crowley estimated that the cleanup and resumption of operations would cost at least $35 million.

Installation of the new BOFs, about 60 percent completed before the flood, came to a halt. Bethlehem's top management did another review of everything. Rumors again circulated that Bethlehem would be severely curtailing its Johnstown operations.

At the beginning of August, the corporation announced it was cutting its workforce down to about four thousand and the BOFs would not be installed.

The news was like a coup de grâce to the stunned community. Already numbed by the flood, the second tragedy was hard to fathom. A front-page editorial appeared in the *Tribune-Democrat* on Monday, August 1, stating that Senator Richard Schweiker, Congressman Murtha, Governor Shapp, State Senator Louis Coppersmith and others had been talking with Lewis Foy in hopes that Bethlehem would rebuild and modernize at Johnstown. The editorial urged a public letter-writing campaign, exhorting Bethlehem Steel officials to upgrade the local mills.

A high-level meeting was held in Washington on Monday, August 1. Governor Milton Shapp, Senators Schweiker and Heinz, Congressman Murtha and Gregory Schneiders (President Carter's director of special projects) all met with Lewis Foy, Bethlehem chairman and CEO. Foy presented two alternative futures for Johnstown:

> 1. *Continue steelmaking at a reduced level. Operate mills and manufacturing operations consistent with steel production; or*
> 2. *Eliminate steelmaking and operate only certain finishing mills and manufacturing facilities.*

The first alternative was the better one. Approximately 7,500 jobs would remain—more than the 4,000 jobs with basic steelmaking discontinued. To pursue the first alternative, Bethlehem would

need a commitment from federal and state environmental authorities that there would be a two-year moratorium on mandates to install pollution control equipment at Johnstown.

Three days later, the requested moratorium commitments were finalized and announced publicly. Bethlehem would continue steelmaking for at least two years. The corporation would also reassess its Johnstown future.

Meanwhile the Bethlehem Steel Corporation continued cleaning up the plants, an enormous undertaking. In August it was announced that by mid-September most of the Johnstown Works would resume production "at the planned reduced level of 1.2 million ingot tons per year."[590]

The first resumptions were the rod mill, the wire mill and most parts of the axle and wheel plants. By late August, the No. 2 and No. 3 car shops at Franklin and the eleven-inch mill had resumed production. Parts of the Gautier Works went back into production during September. The car shop near Tanneryville was readied for an October restart. Hot metal production at Franklin was halted until the electrical motor systems were restored. There was also the need for coke. By mid-September all three Franklin coke ovens were restored, but only No. 18 resumed production. The Rosedale ovens were never reconditioned.[591]

Industry: The U.S. Steel Corporation

The U.S. Steel plant at Moxham was comparatively unaffected by the flood. No serious damage was done to any equipment. The general office building facing Central Avenue was not damaged.

The major problem encountered was mud deposits between the entrance gate area and the Stony Creek River near the Central Avenue Bridge. The large industrial buildings to the north of the entrance gate were filled with mud three feet deep.

Some units of the U.S. Steel plant never shut down. The cleanup was quick, and the entire facility resumed production within a week.[592]

Commerce

Downtown Johnstown came to a virtual halt following the flood. Nothing much was open. Basements and first-floor areas had been filled with water and mud. Despite their setback, most merchants vowed to return. Not only did they have to overcome the growing competition from shopping centers and the Richland Mall, none of which had been badly damaged, but the local economy also faced Bethlehem Steel uncertainties.

Just after learning of Bethlehem's decision to continue steelmaking for two more years, the community was given another blow—the Penn Traffic Company announced the closing of its downtown store, an action affecting four hundred employees. The Penn Traffic Store, a landmark for 123 years, had been a customer magnet that drew shoppers to the central city. With it gone, other establishments would suffer, not benefit. To make matters worse for the city, Penn Traffic announced the expansion of two area stores—one in the Richland Mall and the other at Westwood, both outside the city.[593]

Johnstown's other major department store, Glosser Brothers, was committed to remain. While busily supervising the cleanup of the basement and first-floor areas, the company's upbeat

president, Leonard Black, announced that the upper levels would be open for business as soon as possible using the undamaged merchandise already in stock.

For a short while many downtown proprietors were hesitant about their future plans—each trying to learn the intentions of the others. As one or more merchants decided to return, others were more emboldened. By the first week in August, McDonald's on Main Street was ready to reopen whenever the gas company restored service.

The *Tribune-Democrat* slanted its publicity to encourage firms to resume. In September the paper started a special Sunday promotion. Whenever a proprietor announced an intention to reopen, it was publicized. A large advertisement appeared listing all downtown businesses that were reopening. A once-closed establishment merely informed the newspaper it was coming back. No fee was charged. The list grew from Sunday to Sunday. There were 121 establishments listed on October 2. Three weeks later, there were 183. Glosser Brothers reopened in September. Most places had reopened by late October.

The flood had ruined the clockwork in most downtown parking meters. Until they were replaced or repaired, people parked and stayed put. With little turnover, parking remained a downtown problem.[594]

Public Facilities

The relatively new Glosser Memorial Library sustained about $1.1 million in flood damage. Books were ruined. Much of the first floor had sunk, necessitating concrete deck replacement. Wall plaster also had to be replaced.

The library sought a grant and received some insurance payments, enabling a limited reopening on October 10 when modest service resumed in the first-floor community room.

On October 23, 1978, Congressman John Murtha presented a check for $740,000 to the library from the U.S. Disaster Assistance Administration.

The Cambria County War Memorial Arena was reopened in January 1978 with new ice-making equipment. The arena had an annual operating loss of about $100,000, largely because of the flood.

The Dornick Point Sewage Treatment Plant went back into service on October 1, more than two months after the flood. Large amounts of untreated sewage continued flowing into the Stony Creek because an interceptor sewer line leading into the Windber treatment plant was blocked.[595]

The '77 Flood Relief Center

In the weeks after the flood, there had been an outpouring of charitable donations to flood victims and devastated communities. Such funds had often been sent through churches because it was believed church leaders would distribute the money wisely and honestly. Funds were also sent through ongoing charitable institutions such as the Salvation Army. The City of Johnstown also received $260,000 for flood relief.

Rather than for many parishes to administer separate relief efforts, the Johnstown Council of Churches created an ad hoc organization, the Interfaith Flood Task Force. In September, it adopted a budget of over $440,000.

A similar organization, the '77 Flood Relief Center, was established by the Altoona-Johnstown Catholic Diocese with encouragement from the Greater Johnstown Community Chest, which gave it $250,000, most of its reserve funds. Johnstown City also belatedly transferred most of its $260,000 flood relief donations to the '77 Flood Relief Center.[596]

In late September the Interfaith Flood Task Force and the '77 Flood Relief Center were united using the latter organization's name. The '77 Flood Relief Center's purpose was to help flood victims reestablish their lives and function normally. Generally any financial assistance given was intended to cover needs not provided by public programs. Staff of the center directed victims to whatever federal or state programs might meet their needs. The center did psychological counseling for people traumatized by the flood. It also became a nexus for lobbying in support of funding and improved programs for flood victims. The '77 Flood Relief Center was the largest voluntary private relief effort ever organized to cope with a single disaster as of late 1977.[597]

The first executive director was Gilbert Weakland. Its chairman was Reverend Stephen Slavic, pastor of St. Rochus Catholic Church in Cambria City.

The Pathway Back to Progress

Four days after the flood, a joint meeting was held between the Greater Johnstown Committee, Johnstown Area Regional Industries (JARI) and the Economic Development Corporation. The JARI Recovery Coordinating Committee was formed to develop a new and long-term community agenda for the period following physical restoration. The flood had halted all civic progress. JARI's Recovery Coordinating Committee was to get things back on track.

Three weeks later, the Cambria County Planning Commission announced it was developing a Somerset and Cambria Counties recovery plan to itemize needs and to identify necessary resources. Eugene Swetz and Dennis Munko, respectively the executive directors of the GJC and JARI, both labored to unify the work of the Recovery Coordinating Committee with that of the county planning office.

The JARI Recovery Coordinating Committee labored to develop a project list addressing Cambria, Somerset and Indiana Counties. It retained the consulting firm Hammer, Siler and George for assistance. The work was unveiled at a public meeting on November 17. Excluding an estimated $100 million in projects for the City of Johnstown, the price tag had reached $217.5 million. After unveiling its work, the committee ceased to exist.

On September 1, a few weeks after the founding of JARI's Flood Recovery Advisory Committee, Mayor Pfuhl convened a committee of his own, the Overall Economic Development Planning Committee (OEDP). The mayor's group, largely concerned with the downtown, had heavy representation from the chamber of commerce. Its first session focused on George Zamias's Point Park Mall proposal for the downtown, a concept to undertake a massive urban redevelopment project on a 27½-acre site, primarily between Walnut Street and the Stony Creek River.

The OEDP effort also used the Johnstown Redevelopment Authority to contract with Direction Associates of Montgomery County, Pennsylvania, to develop yet another plan for the central business district and with Gladstone Associates from Washington, D.C., to do the related economic analysis and market feasibility work. The Direction Associates Plan, finished in May 1979, called for a pedestrian mall in parts of both Main Street and Park Place to function in

harmony with the Point Park Mall. Also proposed was a system of canopies to cover the two walkways and a portion of Central Park, concepts that were soon forgotten.

Meanwhile Charles Tomljanovic had defeated Herb Pfuhl in the mayoral election. Tomljanovic had other priorities.[598]

The Wish List

The 1977 Flood created all sorts of personal and civic needs with staggering costs. The disaster assistance programs had complicated regulations governing what was or was not eligible. Generally governmentally owned and managed facilities and infrastructure could be returned to their pre-disaster conditions at federal expense. There were no provisions, however, for project enhancement. If the flood washed out a public road, that road could be replaced as it once had been. It could neither be widened nor upgraded. This would have required additional funding beyond that provided by the Federal Disaster Assistance Administration (FDAA).

Replacement of private dwellings and commercial buildings destroyed or damaged could be financed by federal flood insurance if the owner had taken out a policy with adequate coverage. If not, there was no federal program to replace or reconstruct the home other than through SBA or similar loans that would have to be repaid. The fact that a dwelling or other building had been destroyed or damaged in the flood did not serve to forgive an unredeemed mortgage or other type of loan obligation used in earlier financing. People with a flood loss and no flood insurance were stuck. If they chose to rebuild, they would still be responsible for paying off their outstanding mortgage while assuming the burden of a new one. Lots of people were in this "double mortgage" predicament. Many homes had larger mortgages than they were worth.

There was also a pervasive belief, based on encouraging statements from high-level public officials, that discretionary spending by federal agencies could and would be made available more freely to places that had been hit hard by the flood. Local political and civic leaders had been led to believe that since the Johnstown region had been devastated, federal and state agencies were favorably inclined to approve many funding applications that would have been rejected had the flood never happened.

On November 16, the Cambria County Redevelopment Authority was authorized to file an application for $25 million on behalf of twenty municipalities although there was said to have been only $5 million available through the Department of Community Affairs. Two days later, the JARI Flood Recovery Advisory Committee announced its goals as assembled by Hammer, Siler and George—$217 million for projects in the three counties, a tally that did not include the $100 million in needs announced on October 19 by Mayor Herb Pfuhl. Collectively the efforts were not constrained. All sorts of projects were sought. No one locally would eliminate anything.

In early January 1978, State Senator Louis Coppersmith attended a Flood Study Steering Committee meeting at the '77 Flood Relief Center and argued that the overall recovery planning was chaotic. "We can create an unmanageable group by having too many cooks stir the broth… Planning is too important to be left just to planners," he stated.

Coppersmith doubtless sensed that the various efforts to seek projects and programmatic activities funded at the state and federal levels were drifting into fantasyland. There was no realistic way to pay for the wish lists prepared. The well-meaning planners and civic leaders

would not reject and prioritize. Anything desirable that made sense was added to the ever-growing list.[599]

Something else was in the picture. Father Stephen Slavic, the chairman and an organizer of the '77 Flood Relief Center, was aggressively pushing for new funding to pay for things not allowed in federal legislation—especially housing costs for victims with no flood insurance whose homes had been wiped out or badly damaged. The JARI Recovery Coordinating Committee, however, had been focused on larger community concerns—improved highways and stream channel works to avoid future flooding and economic development initiatives.

While the JARI, GJC and Cambria County Planning Commission strategy was sensitive to human needs, it did not advocate programmatic changes requiring new legislation. It therefore did not satisfy Father Slavic.

The Tri-County Flood Recovery Coordinating Committee

A tenacious advocate for the economic and social welfare of flood victims, Slavic was aggressive and often caustic on their behalf. Believing that the Recovery Coordinating Committee's work was flawed, he sought a new beginning. Coppersmith's concern about "chaotic planning" provided the opening. Both Slavic and Coppersmith wanted a new organization—one with broad representation and that was willing to prioritize.

In January and February 1978, the Tri-County Coordinating Committee, largely a new union of leaders from JARI, the Greater Johnstown Committee, the Johnstown Chamber of Commerce and the '77 Flood Relief Center, was formed. Its chairman was Richard Mayer, publisher of the *Tribune-Democrat*. Charles Kunkle, the JARI chairman, also headed the subcommittee on housing and economic development. Father Stephen Slavic chaired the human needs subcommittee. The sessions, often quite heated, were usually held in the community room of the Friendly City Savings and Loan on Market Street. Slavic continually pushed for programmatic changes to bring about total coverage of all homeowner flood losses to be financed by either the federal or state government or both. Believing that the flood had victimized the viability and attractiveness of the entire community, Charles Kunkle advocated initiatives to help grow the economy and create jobs. Since he was also president of Laurel Management Corporation, the firm that managed the Greater Johnstown Water Authority, Slavic openly charged that Kunkle was responsible for the collapse of the Laurel Run Dam.[600]

Slavic's proposals were contrary to the philosophy of the new Federal Flood Insurance Program, enacted in 1972 following Tropical Storm Agnes. If the federal government became the insurer of last resort for flood disasters, homeowners would neither seek flood insurance coverage nor be dissuaded from building in flood-prone areas.

On Saturday, March 4, the Tri-County Coordinating Committee met with Congressman John Murtha and presented a number of resolutions rooted in Slavic's thinking. They recommended the federal government pay for losses to flood victims' homes and property whether the owners or renters had flood insurance or not. The resolutions read:

> *That funds be given to the individual citizen for the total pre-flood market value of their lost home and land…*

That grants be given to cover total pre-flood value of lost personal possessions.

That people needing to borrow money be automatically forgiven their unpaid balances on property and personal federal loans upon reaching age sixty-five.

That people needing to borrow money to make home-improvement repairs to flood-damaged sections of their residence who had carried a home-improvement mortgage prior to the flood, not be placed in double jeopardy; that governmental grants be made to cover the balance of the pre-flood home improvement loan of those homeowners who had to borrow a second time for the same improvements.

Murtha received the resolutions but advised the group candidly that there was little chance of their becoming law. "Favorable treatment, if received, would be a long, drawn-out process," he stated.

At this meeting, Richard Mayer announced that the group needed detailed documentation to justify whatever it was seeking. "We don't know how many houses were lost. We don't know how many people lost jobs. We don't know what the total damage caused by the flood adds up to."

The Tri-County Flood Recovery Coordinating Committee then set about a new task—undertaking and tabulating surveys to document the needs, work that was accomplished through the effort of Fred Mickel and his firm, Data Consultants.[601]

State Legislation: Act 51

Senator Louis Coppersmith introduced and won passage of Act 51 of 1978, a statute that made state grants available to people whose personal property (not homes) had been lost in the 1977 Flood. Each grant would have been a partial reimbursement not to exceed $4,000 per applicant. Governor Shapp had doubts about Coppersmith's bill (SB 1106) but let it become law without his signature. Believing the law unconstitutional, Shapp instructed Robert Kane, his attorney general, to explore a court challenge. He also ordered the Department of Welfare not to administer the law. Coppersmith was furious and stated publicly that Shapp should resign as governor.[602]

Shortly after Richard Thornburgh became governor in January 1979, Shapp's restrictions were overturned. There was no court test. While the law was a red tape nightmare, by December 15, 1979, approximately 1,700 people were receiving checks to pay for some of their personal property losses caused by the flood.[603]

State Legislation: The $50 Million Bond Issue

In the wake of the far-reaching floods caused by Tropical Storm Agnes in 1972, the Commonwealth of Pennsylvania had enacted Public Law 2019 at a special October 1972 legislative session. The statute had authorized the sale of $140 million in bonds for broad categories of flood recovery and relief. The wording had been generous in helping flood victims.

This statute gave Senator Coppersmith and other disaster-area legislators a precedent-setting instrument already in place. Rather than draft a new bill, they successfully amended PL

2019 to include the "Great Flood of 1977."[604] The revision also authorized a bond issue for $50 million, an increase above the $30 million first proposed. While the new higher amount did not reach the funding needs tallied by Fred Mickel and his team, the documentation had helped elevate the authorization to an amount that Coppersmith and his colleagues judged politically attainable. In addition, any unspent Agnes Flood funds (PL 2019) could be used for 1977 Flood recovery.[605]

Act 191 was cleverly worded to authorize the sort of program Slavic espoused. At least $30 million had to be spent on housing matters—compensation for losses, demolition, new construction, rehabilitation and relocation. On the other hand, no more than certain fixed amounts could be spent on street and traffic improvements, storm and sanitary sewers, recreation and economic development. Because of the wording, it would have been technically lawful to have spent all $50 million on housing alone.

The Pennsylvania Department of Community Affairs (DCA) was given rule-making power to clarify eligibility, administrative procedures and the like. A key provision of the law itself mandated that the appropriations to the Disaster Relief Fund be administered by the Department of Community Affairs through "urban redevelopment assistance," meaning that by law the local responsibilities had been assigned to the Johnstown Redevelopment Authority and to the redevelopment authorities of eligible counties—not to municipal or county commission bureaucracies.[606]

The Pennsylvania Department of Community Affairs was also requiring that the housing funds derived from the bond issue be spent in keeping with sound planning. This meant that each flood-afflicted neighborhood in the City of Johnstown as well as every other locality receiving any of the funding was to be the subject of a plan of its own developed by or for the relevant redevelopment authority. These plans would provide for street, sewer and recreation improvements to accompany housing restoration. They had to be approved by the planning commission and the city council in the case of Johnstown.[607]

The fact that the bond issue powers had been given to the redevelopment authority rather than to the city government angered Mayor "Kutch" Tomljanovic, who had set up a Johnstown Department of Community Development under his control.[608]

The general purposes of the bond issue's housing-related funds were as follows:

> To reimburse homeowners for their total losses meaning the pre-flood value of homes either destroyed
> by the flood or demolished after it by the U.S. Army Corps of Engineers or any public body.
> To pay the costs of homes being rehabilitated back to their pre-flood condition.
> To reimburse those who had already restored their homes.[609]

The rule-making process of the Department of Community Affairs took a long time, a delay that annoyed Father Slavic and his Human Needs subcommittee. Shirley Dennis, the first permanent DCA secretary to serve under Governor Thornburgh, recognized that $50 million was insufficient to meet all the needs. She favored developing a priority plan to aid those with lower incomes. Wanting no income-based priority system, Slavic and his group opposed the concept, arguing that the law had not provided for one. In the end, Slavic prevailed.[610]

State Legislation: Act 57 Of 1978

The state's capital budget program was also amended in 1978 through Act 57, which appropriated $22,256,000 to the Department of Environmental Resources for stream improvements to reduce flooding. Projects for the Johnstown area were $7,150,000 for channel work on Solomon Run; $715,000 for Bens Creek; $585,000 for work on the Little Conemaugh River at East Conemaugh; $1,170,000 to upgrade Sams Run in Moxham; $316,000 for a debris dam in Stackhouse Park; and $1,170,000 for work on Paint Creek in Windber and Paint Township.

The Johnstown Redevelopment Authority Program

Approximately one month after the flood, the city received a discretionary grant of $291,500 from the U.S. Department of Housing and Urban Development to implement a Neighborhood Recovery Program. Its purpose was to provide technical help to residential property and business owners or occupants as to what they should do to return to pre-flood normalcy. Mayor Pfuhl had assigned the work to the Johnstown Redevelopment Authority.[611] Flood victims in the city were given technical assistance with work specifications, contract wording and even advice in selecting contractors. The program was also used to determine which structures were so badly damaged they needed to be demolished and which could be rehabilitated.

The flood had also caused many homes to lose their furnaces and hot water heaters. Some also needed new doors, windows and insulation. Pfuhl had started an Emergency Flood Rehabilitation Program financed with federal HUD funds. He also assigned this undertaking to the Johnstown Redevelopment Authority with instructions to accomplish the work before winter weather.

Very shortly after the flood, the redevelopment authority hired a new executive director, Jay Goggin. Having held the same position in Pittsburgh for three years, Goggin was familiar with federal and state programs of urban redevelopment.[612] Aggressive and decisive, he worked well with Mayor Pfuhl, who continued his practice of assigning city-sponsored urban revitalization programming and the funds to pay for it to the redevelopment authority.

By December 1977, the Johnstown Redevelopment Authority staff had grown to nineteen, double its size during the execution phase of the Market Street West Project. The authority had also become heavily involved in implementing the Lee-Sheraton and Main Street East Urban Redevelopment Projects in and near the heart of downtown.[613]

During the latter months of 1979 and throughout all of 1980, the Johnstown Redevelopment Authority continued its very active program. In mid-February 1979, the authority was allocated $21,597,265 of the $50 million state bond issue. Of this $16,596,000 was for housing expenses—compensation for flood-destroyed homes, rehabilitation costs and relocation expenses. The remainder was for related matters—street work, sewers, planning and other projects spelled out in the neighborhood plans. By December 1979, the redevelopment authority programs totaled about $35 million, including the two urban development action grants (UDAG) for downtown redevelopment projects.[614]

Johnstown Redevelopment Authority: City Government Rift

Even prior to his inauguration after defeating Herb Pfuhl in November 1977, Tomljanovic had announced the creation of his own Department of Community Development. Since the mayor had a lot of authority over which city agency would administer the federal funds, he was in a position to do much of what he wanted, possibly the total elimination of the urban redevelopment authority and the reassignment of its duties to his own Johnstown Department of Community Development. Had the new mayor pulled this off, he would have been able to create a number of patronage jobs, one of his goals.

Tomljanovic, however, had to back down. By law, the $50 million bond issue funds for housing had to be administered by the urban redevelopment authority having jurisdiction where the funds were spent. Also under Pennsylvania law, municipalities like Johnstown City are empowered to acquire land for public purposes, but they cannot assemble such property with the intention of converting it into any private use or even other public uses different from the specific purpose for which it had been acquired. Redevelopment authorities, however, are not so constrained.

As time passed, the rift between the mayor and the redevelopment authority intensified until Tomljanovic eventually gained control of its board by appointing a new member each time a Pfuhl appointee's term expired.[615] Goggin resigned effective August 31, 1980, and was replaced by Fred Young, Tomljanovic's "administrative consultant."

Tomljanovic's "Rifle" Program

The City of Johnstown eventually received over $5 million in discretionary funds from the U.S. Department of Housing and Community Development to help in the flood recovery. After becoming mayor, Tomljanovic assigned much of this money to his newly established Department of Community Development.

Among the programs funded was a housing rehabilitation program, RIFLE, an acronym for Rehabilitation In Flood Located Estates. The program's guidelines, drafted jointly between city and HUD officials, provided grants and loans for home restoration to help individuals who owned or leased their flood-damaged dwellings located in one of seven flood-impacted neighborhoods. Each home proposed for the program had to satisfy criteria that its rehabilitation was feasible. There were also income guidelines that made everything progressively more generous for people and families of greater poverty. At least three bids were received from "qualified" contractors. The RIFLE program was underway in early June 1978.[616]

After Tomljanovic had control of the redevelopment authority board and Goggin departed, the new authority chairman, Robert Audey, was given a contract and paid $3,125 to examine the RIFLE program. He recommended that it be taken over by the Johnstown Redevelopment Authority. Tomljanovic agreed. While one might question a redevelopment authority chairman with no qualifications whatsoever being paid to make a recommendation impacting his own agency, there was merit in the suggestion. The state bond issue money would soon be used for housing programs, including one similar to RIFLE. These had to be administered by the redevelopment authority.

While RIFLE was handled by the redevelopment authority, a pattern evolved wherein phantom contractors submitted rigged high bids. There were also complaints and indications of shoddy and unfinished work.

In November 1981, former Mayor Herb Pfuhl defeated Tomljanovic and became mayor again in January. Audits and an investigation ensued. In 1983 and 1984, Gerald Long, the county's district attorney, was prosecuting a lengthy list of officials and contractors. After guilty pleas and verdicts, there were fines and jail sentences.[617]

The city was faced with enormous repayment obligations to the state and federal governments. After filing abortive lawsuits to reclaim funds lost through fraud, inadequate documentation and corrupt practices, the repayment obligations were forgiven. Johnstown's city government was suffering severe fiscal problems. Repayment was impossible.

Flood-Related Lawsuits

The 1977 Flood produced a number of lawsuits, the first having been filed in July 1978 by Donald Gibson, who had lost four members of his family when his Tanneryville home had been destroyed. At least twenty-two additional lawsuits were filed.

In July 1979, class action suits seeking a potential class of one thousand people were filed related to three groups of issues: the Laurel Run Dam failure, the Sandy Run Dam failure and the collapse of the Route 56 Bypass. Judge Clifton McWilliams Jr. decided against the class action approach. His decision was appealed to the Pennsylvania Supreme Court, which upheld McWilliams.

After several dates had been set but were continued, the trials were scheduled to begin on April 17, 1989, before Judge Caram Abood. The issues in the twenty Tanneryville cases were settled before the April 17 date. The final agreements involving the Sandy Run Dam failure and issues in the Solomon Run Basin were reached in late April 1990.[618]

EPILOGUE

The 1977 Flood had killed 85 people, destroyed 640 and damaged another 2,580 dwellings, wrecked 405 small businesses, caused 200 families to suffer a "total loss" (meaning bankruptcy), closed 100 miles of roads, destroyed or damaged 20 bridges, totaled 3,300 motor vehicles and contaminated 8.2 million pounds of food.[619] It had also precipitated another crisis for the beleaguered Bethlehem Steel Corporation, one that halted the installation of more modern technology at Johnstown, triggered a workforce reduction and expedited Bethlehem's eventual withdrawal from the community.

The disaster had also shattered a rallying cry the community had used for thirty-three years to dispel its flood-prone reputation. "Flood-Free Johnstown" was supplanted by a reverse slogan emblazoned on special license tags, signs and T-shirts: "Flood Free, My Ass."

Prior to the 1977 Flood some notable advances were being made in Johnstown's economic and social spheres. Unemployment rates had actually been dropping and the decades-old economic development initiatives and organizations had been reorganized and their funding replenished. Thanks to the National Valve and Metropolitan Life successes, the community's positive momentum was at last being restored. In various ways, the 1977 Flood stifled and delayed this progress.

The most significant policy issue to emerge after the 1977 Flood was rooted in whether to use the public and private assistance that was flowing into the Greater Johnstown region following the flood to focus upon human needs concerns or community-wide betterment, including future flood prevention. To some degree both general thrusts were pursued.

NOTES

12. LABOR RELATIONS DURING THE GREAT DEPRESSION

1. See part one, chapter 10, section VI, "The New Deal in Johnstown," 224.
2. Phillips, *From the Crash to the Blitz*, chapters 10 and 17.
3. Schlesinger, *The Age of Roosevelt*, 409.
4. The Committee for Industrial Organization (CIO) became the Congress of Industrial Organizations (CIO) in May 1938.
5. "J.L. Lewis Urges Industrial Union of Steelworkers," *Johnstown Tribune*, April 2, 1936.
6. "Lewis Will Direct Steel Union Drive," ibid., April 5, 1936.
7. Wechsler, *Labor Baron*, 57–58; "Steel Unionization Drive Is Launched," *Johnstown Tribune*, June 18, 1936.
8. Sofchalk, "Little Steel Strike," 9–10; see also part one, chapter 9, "The Steel Strike of 1919," 188.
9. "Steel Companies Openly Declare War on Lewis…Drive"; "Lines Drawn In Steel," editorial, *Johnstown Tribune*, June 29, 1936.
10. "It Happened in Steel," *Fortune Magazine*, May 1937, 91–95.
11. Dubofsky and Van Tine, *John L. Lewis*, 273–75. Names of the SWOC participants in the negotiations with Fairless vary slightly in different accounts.
12. "Bethlehem to Bargain with SWOC" and "Employee Representatives Named in Annual Election," *Johnstown Tribune*, March 22, 1937.
13. "SWOC Wins Its J. and L. Poll," ibid., May 21, 1937.
14. "Girdler Is Defiant," *New York Times*, June 25, 1937.
15. Sofchalk, "Little Steel Strike," 53; Bernstein, *Turbulent Years*, 479.
16. "Cambria Mill Hit By Railway Strike," *New York Times*, June 11, 1937.
17. "Cambria Workers Join Steel Strike," ibid., June 12, 1937.
18. "Bethlehem Faces New Rail Demands," ibid., June 13, 1937.
19. McPherson, "The Little Steel Strike," *Pennsylvania History*, 221–23.
20. During the entire strike, there were no indications of a split among the councilmen over strike policy. The council (commission) was solidly behind the mayor, a situation that rarely happened in Johnstown.
21. "Cambria Workers Join Steel Strike," *New York Times*, June 12, 1937.
22. "15 Injured in Riot at Cambria Mill," ibid., June 14, 1937.
23. "Business Leaders to Form Vigilantes Here If Rioting Continues, Meet Reveals," *Johnstown Tribune*, June 14, 1937.
24. "State Police Hold Johnstown Lines," *New York Times*, June 16, 1937.
25. "Johnstown Mayor Appeals to Roosevelt to Intervene" and "White House Silent," ibid., June 17, 1937.
26. "Workers Return to Cambria Plant," ibid., June 18, 1937.
27. "Strikers Protest Conduct of State Police to Earle," *Johnstown Tribune*, June 17, 1937.
28. "Johnstown Pleads For Aid of Troops," *New York Times*, June 19, 1937.
29. "Earle Blockades Cambria Plant," ibid., June 20, 1937.
30. McPherson, "The Little Steel Strike," 233. Among other things McPherson states, "Fagan who announced the miners' march, would have every reason to be in frequent contact with Lt. Governor Thomas Kennedy, who was also international secretary-treasurer of the UMW. There is no evidence to suggest that detailed planning had been done

for a miners' march and the announcement of plans to organize and transport 40,000 men to Johnstown in 24 hours therefore has the appearance of a bluff. Furthermore, the Governor's special investigating committee spent little time in Johnstown and their assignment might have been simply an excuse for some action by Earle."

31. "Johnstown Asks for Martial Law: 40,000 Miners," *New York Times*, June 19, 1937.

32. "LABOR: Mr. Roosevelt Helps a Friend," *Newsweek*, June 26, 1937, 13–17.

33. "525 State Police Ordered to Close Johnstown Plant," *Johnstown Tribune*, June 19, 1937.

34. "Earle Blockades Johnstown Plant," *New York Times*, June 20, 1937.

35. "Legal Fraternity Believes Martial Law Here Illegal," *Johnstown Tribune*, June 21, 1937.

36. "Johnstown Seeks Inquiry by Senate," *New York Times*, June 22, 1937.

37. "Editors Here Ask Three-Point Vote," *Johnstown Tribune*, June 23, 1937.

38. "Johnstown Asks the Nation to Aid in Fight to Save Workers' Rights," *New York Times*, June 24, 1937.

39. Blumenthal, "Anti-Union Publicity in the Johnstown Little Steel Strike of 1937," *Public Opinion Quarterly*, October 1939, 696.

40. "Back to Work Move Is Successful, Say Steel Committees," *Johnstown Tribune*, June 24, 1937; "More Men Align Themselves With Bethlehem Steel," ibid., June 26, 1937.

41. "Thousands on Job in Bethlehem Mill," *New York Times*, June 27, 1937.

42. "24-Hour Picketing Begun at Cambria," ibid., June 28, 1937.

43. "Back to Work Drive Continues On Increasing Scale," *Johnstown Tribune*, June 28, 1937; "Cambria Operations Back to Normal," *New York Times*, June 29, 1937.

44. "Blasts Shut Cambria Plant," ibid., June 30, 1937.

45. "Massing of Miners Set at Johnstown," ibid., July 1, 1937.

46. "Johnstown Girds for Strike Rally," ibid., July 2, 1937.

47. "Earle Pledges CIO Support; 12,000 at Johnstown Rally," ibid., July 5, 1937; "Turnout Fails to Equal Expectations at Rally," *Johnstown Tribune*, July 6, 1937.

48. See part one, chapter 5, section III, "The Decline and Fall of 'Fighting Joe' Cauffiel," 150.

49. "Shields, 13 Others Sued for $76,040," *New York Times*, July 3, 1937.

50. "Margiotti Plans To Ask NLRB Vote for Steel Plant," *Johnstown Tribune*, July 8, 1937; "NLRB Vote Will Follow Probe of Union Charges, According to Margiotti," ibid., July 9, 1937; "SWOC Charges Bethlehem Fathered Citizens' Move," ibid., July 13, 1937; "NLRB To Press CIO's Battle Against Four Steel Independents," ibid., July 19, 1937; "NLRB Cites Steel Firm for Alleged Violations," ibid., August 30, 1937.

51. I have made many attempts to locate Bloom's intermediate report, but the search has been unsuccessful. The hearings were covered on a daily basis by Johnstown newspapers throughout their happening.

52. *In re Bethlehem Steel Corporation and Bethlehem Steel Co. and the Steel Workers' Organizing Committee*, Cases Nos. C-170, R-177, 14 NLRB, No. 44, August 14, 1939.

53. *Bethlehem Steel Co. et al v. National Labor Relations Board*, Nos. 7503, 7538, Apl. D.C. 120 F.2d 641 (U.S. Court of Appeals for District of Columbia, 1941); "Bethlehem Loses Its Appeal of NLRB Ruling," *Johnstown Tribune*, May 12, 1941.

54. Bernstein, *Turbulent Years*, 490–94; McPherson, "The Little Steel Strike," 228–30; "Mayor, Called to Explain Use of Big Strike Fund, Tells Why He Destroyed Police Records," *Johnstown Tribune*, March 12, 1938; "Four Sets of Records Written Into Record…of Shields' Financial Dealings," ibid., March 14, 1938.

55. "Shields and Connor Cleared of Charges," ibid., September 8, 1938.

56. "Union To Demand Contract Because of Election Win," ibid., June 27, 1941.

57. "Local Plays Major Transportation Role," *Tribune-Democrat*, September 5, 1953; Williams and Yates, *Upward Struggle*, "Recent Chapters In Labor History."

58. "Bakeries in Local Area Halt Operations," *Johnstown Tribune*, May 2, 1938; "Predict This Section Will Be Without Meat Or Bread," ibid., May 3, 1938; "Packers Declare Demands Unjust," ibid., May 6, 1938; "Strike Is Ended," ibid., May 9, 1938.

59. "Company Picketed By Truck Drivers," ibid., January 4, 1935; "State Police Here to Stop Blockade of Truck Drivers," ibid., November 23, 1937.

60. "Shields Assures Garment Workers Police Protection," ibid., November 23, 1936; "Garment Factory Organizer States His Purpose Here," ibid., November 24, 1936; "Union Given Charter Here In 1945" and "Phone Union Organized During 1935," *Tribune-Democrat*, September 5, 1953.

61. "Traction Concern Employees Choose AF of L Union," *Johnstown Tribune*, August 26, 1941; "Traction Company Employees' Union Organized 12 Years Ago," *Tribune-Democrat*, September 5, 1953.

13. Leisure

62. "Theater Is Sold," *Johnstown Tribune*, April 16, 1904. The Cambria Theater had opened in December 1890 and was originally named the Adair Opera House.

63. "David Belasco In City," ibid., February 10, 1911.

64. "Lillian Russell Says W.C.T.U. Will Win Its Fight," ibid., October 6, 1913.

65. "Theater Parties for the Majestic," ibid., October 16, 1907; "Soon To Abandon Two-A-Day Shows," ibid., October 31, 1910; "Majestic To Be A Picture House," ibid., November 7, 1910.

66. "Moxham To Have Real Moving Picture House," ibid., April 18, 1913.

67. "Cambria Stock Season Draws Near To Close," ibid., May 3, 1912.

68. "'The Birth Of A Nation,' A Really Marvelous Photoplay Spectacle," ibid., November 9, 1915.

69. "Wonderful Triangle Films Start Monday," ibid., November 13, 1915.

70. "Mayor To Censor All Local Shows," ibid., April 4, 1914; "Question Now: What Is An Immoral Production?" ibid., January 16, 1915.

71. Vitaphone was an early "talkie" technology that involved phonograph recordings amplified and projected through a speaker system in a theater. The records were played in mechanical synchronization with the film projector so that speech and other sounds were coordinated with what was being seen on the screen.

72. "New Epoch in Theater Enterprise Marked by Cambria Management," *Johnstown Tribune*, March 2, 1927; "Local Interest in Vitaphone," ibid., March 10, 1927; "Vitaphone Opening At Cambria Theater Today" (also advertisement), ibid., April 25, 1927; "Vitaphone Scores Tremendous Hit," ibid., April 26, 1927.

73. "Theater Group Plans To Resume Early Next Fall," ibid., January 25, 1946; "Little Theater Unit Suspends Activities," ibid., January March 51; "Family Drive-In Theater, Mundy's Corner, Open," ibid., August 27, 1948; "Theater Closes Here, Building Sold," ibid., Janurary 3, 1951.

74. "Southmont People Hear Fritz Kreisler by Radio Telephones," *Johnstown Democrat*, January 15, 1922.

75. "Penn Traffic To Broadcast Daily Via the Wireless," *Johnstown Tribune*, December 16, 1922; "Penn Traffic To Sign Up Artists for Radio Work," ibid., January 4, 1923.

76. "Chapel Exercises by Radio Feature Program," ibid., February 18, 1924.

77. The call letters, WHBP, stood for the family names of officers of the Johnstown Automobile Company: William Walker, Harry Hosmer, George Brown and Phillip Price, the company president. Courtesy of Charles S. Price II of Johnstown.

78. "New Broadcasting Post Is Highly Complimented," *Johnstown Tribune*, May 16, 1925; "WHBP Symphonic Orchestra Tonight," ibid., June 3, 1925.

79. Full Page on Johnstown Automobile Company, ibid., February 3, 1927; "Radio Station Here Included in Big Hook Up," ibid., September 27, 1927; "National Hook Up Complicated Job," ibid., August 4, 1928; "Station WHBP Allowed Increase In Power," ibid., February 8, 1929; "Station WHBP to Join Big Network," ibid., February 28, 1929; "New Call Letters for Radio Station [WJAC]," ibid., June 14, 1929.

80. "Friendly City Association To Join In Picnic," ibid., July 27, 1926.

81. "1600 By Train to Penn Traffic Idlewild Outing," ibid., August 18, 1925; "Crowd of 8000 At Penn Traffic Idlewild Outing," ibid., August 12, 1926; "P.T. Outing Is Biggest Success of Annual Events," ibid., August 13, 1926.

82. Jean Crichton, "Music and Lights of Main Street," in Berger, ed., *Johnstown: The Story of A Unique Valley*, 667–98.

83. "Notable Speeches Mark Banquet," *Johnstown Tribune*, May 25, 1910. This joint Pittsburgh-Johnstown Meeting is also discussed in part one, chapter 6, section I, "The Chamber of Commerce," 152.

84. "Love's Orchestra Is First City Symphony," *Johnstown Tribune*, March 14, 1914; "New Symphony Orchestra... Musical Asset," ibid., April 6, 1914.

85. Personal interview with Carmel Coco on November 14, 2001. Carmel Coco of Johnstown, who began as a bassoonist with the Johnstown Symphony Orchestra in 1935, stated that the Cambria Steel Company in the first generation of the twentieth century made a special effort to recruit talented and proficient musicians as part of their workforce. This was certainly true in the case of Silvio Landino, who came to Johnstown around 1917, worked for the steel company and immediately assumed an active role in the city's musical life.

86. "A Real Home Orchestra," *Johnstown Tribune*, April 17, 1918; "Cambria Symphony Orchestra Gives Brilliant Concert," ibid., December 31, 1918.

87. "Plans For Symphony Orchestra Progress," *Johnstown Democrat*, January 1, 1922.

88. "Professor Roemer Is Given Honor By Schiller Chorus," *Johnstown Tribune*, February 26, 1927; "Symphony Society Will Meet Sunday," ibid., September 5, 1929; "Johnstown Symphonic Society, Prof. Hans Roemer, Director, To Give Concert Tomorrow," ibid., February 20, 1930.

89. "J.H.S. Orchestra Wins Title At Altoona Meet," ibid., May 2, 1931. Also a group photograph with listing of members by instrument. The twenty-one-member figure was derived by cross-checking the rosters of the championship Johnstown High School Symphony Orchestra with the start-up Municipal Symphony Orchestra.

90. "Soloists Are To Rehearse Tonight For Opera In May," ibid., April 11, 1922; "Grace Sefton Mayer Pleases All Hearers," ibid., May 18, 1923; "Musical Scores for 75 Players Creates A Problem," ibid., December 16, 1932; "Local Symphony Unit Will Assist Opera Endeavor," ibid., November 13, 1935; "Silvio Landino, Musician, Dies," ibid., April 19, 1949. Charles Wakefield Cadman (1881–1946) was a native of Johnstown who later moved to Pittsburgh, where he continued his musical studies. In time he developed an interest in American Indian music, which he studied

and scored. He composed at least two operas including *Shawnewis*, which was based on American Indian legends and tribal music. *Shawnewis* was performed at the Metropolitan Opera Company in 1918 and was revived in 1919. This made Cadman the first American to have composed an opera to be performed at the Met that was revived in a different season. Cadman later moved to California and was a founder of the Hollywood Bowl Orchestra. Cadman composed a number of serious works, songs and some musical theater. He came back to Johnstown occasionally and is now largely forgotten.

91. Papinchak, "A History of the Johnstown Symphony Orchestra," 1969. Papinchak's thesis is rich in its detail and among other things lists the names of the orchestra's roster for many seasons, gives budgetary data and program information up to the late 1960s.

92. The Municipal Symphony Orchestra's Board of Control at the time of its founding was Francis Dunn, chairman; Franklin P. Reiter, vice-chairman; Harry A. Hosmer, secretary; Campbell Patch, treasurer; Harry Koontz, business Manager; and Tom Nokes and James H. Brewer.

93. "Silvio Landino Symphony Head," *Johnstown Tribune*, November 24, 1932; "Orchestra Debut Thursday Evening at Garfield High," ibid., January 2, 1933; editorial, ibid., April 19, 1933.

94. "Musical Scores For 75 Players Creates Problems," ibid., December 16, 1932; "Symphony Group To Use Library of Prof. Landino," ibid., November 17, 1937.

95. Papinchak, "A History of the Johnstown Symphony Orchestra," 29, 31.

96. "Anticipate Record Crowd for Symphony Orchestra," *Johnstown Tribune*, April 18, 1936; "Season's Largest Audience Hears Symphony," ibid., March 18, 1937; "Symphony Group Figures Out Plan To Assist Talent," ibid., September 6, 1938; "Orchestra Group Moves to Expand Scope of Action," ibid., September 14, 1939; "Help To Maintain Public Orchestra is Sought in Area," ibid., August 31, 1940; "Season Opener—Symphony Audience Enthusiastic," *Tribune-Democrat*, November 8, 1961.

97. Hirschhorn, *Gene Kelly*, 24–51; Yudkoff, *Gene Kelly*, 2–46. Both of these biographies weave Kelly's Johnstown experience in and out of a bigger story focused upon his Broadway and Hollywood careers, and as such they are not precise about dates or time sequences. Hirschhorn's work benefited from personal interviews with Kelly. "Big Local Cast In Show at Nemo," *Johnsown Tribune*, June 26, 1932; "Nemo Radio Show To Be Innovative," ibid., November 18, 1932; "Kelly Studio of Dance To Reopen," ibid., September 7, 1934; "Kelly Revue At Embassy Theater," ibid., June 18, 1935; "Kelly Dancers Will Entertain at Lee Carnival," ibid., September 27, 1935; "Gene Kelly Has Feature Spot in Magazine Story," ibid., September 12, 1941.

14. AN ANTIQUE DRUM: JOHNSTOWN DURING WORLD WAR II

98. "New Administration Takes Charge Today," *Johnstown Tribune*, January 1, 1940; "Sheriff J.A. Conway Dies at 67," *Tribune-Democrat*, December 2, 1964.

99. "New Bond Financing Proposal Aired At Meeting of Council; Action on '40 Budget Delayed," *Johnstown Tribune*, January 3, 1940.

100. "Conway To Name Three Appointees To Housing Group," ibid., January 26, 1940; "Declaration of Need Made by City Solons On Housing Proposal," ibid., March 5, 1940.

101. Personal interview with Layton Wagner on March 15, 2002; "13 Theaters Here To Start Sunday Shows Tomorrow," *Johnstown Tribune*, November 16, 1940.

102. "Bethlehem Force Now Over 12,000," ibid., October 11, 1939; "Era of Continued Prosperity," ibid., January 1, 1941; "Cambria Plant Employment Figures Hit New High Peak," ibid., July 25, 1941.

103. "Johnstown Shows Big Gain," ibid., January 25, 1940; "General Business Shows 24 Percent Gain Here In 1940," ibid., February 3, 1941; "Johnstown Business Gain," ibid., January 30, 1942.

104. "WPA To Transfer Men to Airport," ibid., December 27, 1941.

105. "Community Campaign Over The Top," ibid., October 3, 1940; "Chest Campaign Total Boosted To $134,901 With Closing Reports," ibid., October 11, 1941.

106. "Personnel of City Draft Boards" and "Boards Are Busy In Area Placing Numbers On Cards," ibid., October 24, 1940; "First Group Of Conscripts From District," ibid., November 20, 1940; "Army Insists On Physical Fitness," *Johnstown Democrat*, February 8, 1941.

107. "Represent Federal OPM In This District," *Johnstown Tribune*, June 6, 1941.

108. "Boy Scouts Ready To Start Collection Of Aluminum," ibid., July 12, 1941; "Deliver 2 Tons Of Scrap To Local Center," ibid., August 2, 1941.

109. "Johnstown Moves Swiftly Toward Full Wartime Basis," *Johnstown Democrat*, December 8, 1941.

110. "Hundreds Offer Services During First War Week," *Johnstown Tribune*, December 13, 1941.

111. "Volunteer Wants A Chance At Hitler But Is Rejected" and "Sharp Increase In Sale Of Defense Bonds, Stamps Reflects Local War Effort," ibid., December 17, 1941.

112. Nozaki had turned himself in voluntarily at police headquarters on Monday, December 8. He had applied for U.S. citizenship earlier, but a recent law denying citizenship to Japanese-born people had prevented his naturalization. As far as anyone knew, Nozaki was the only native Japanese person in Johnstown.

113. "Departure of Men To Warfare Stirs Judge McCann," *Johnstown Tribune*, December 11, 1941.

114. "La Guardia Says Johnstown Would Be Air Raid Target," ibid., March 7, 1942.

115. "Air Raid Warning Test," ibid., March 14, 1942; "City Without Adequate Audible…Air Raid Warnings," ibid., March 16, 1942; "Whistle Proves Adequate In Two Nearby Boroughs," ibid., March 30, 1942; "Order Is Placed To Buy Air Raid Sirens For City," ibid., May 21, 1942.

116. "Recommendations On Defense Setup Accepted By City," ibid., August 7, 1942.

117. "Unattended Lights Is Chief Violation During Blackout," ibid., September 28, 1943.

118. "A Council Of Defense Agencies," editorial, ibid., November 25, 1942.

119. Andrew Shields had driven his father, President Roosevelt and others around Johnstown in August 1936. (See part one, chapter 11, section II, "Flood Protection for Johnstown," 246.)

120. "District Soldier Wounded in First Attack on Hawaii," *Johnstown Tribune*, December 18, 1941; "New Florence Sailor Killed In War Action," ibid., December 13, 1941.

121. "Chamber Asks Title Change In Movie Honoring Wagner," ibid., December 30, 1943.

122. "Italians Of Area With Mussolini, Telegrams Show," ibid., October 8, 1935.

123. Proving that something neither happened nor ever was is almost impossible. I could find no Johnstown ties to the German-American Bund, although this Nazi-front organization was well entrenched in Pennsylvania including Pittsburgh. See also Phillip Jenkins, *Hoods and Shirts*.

124. "New Facts About Germany Related By S.S. Umbreit," *Johnstown Tribune*, February 25, 1936.

125. "German-Austrians Shape Up Program," ibid., August 29, 1936; "German-Austrian War Veterans Meet Here," ibid., September 5, 1936.

126. Herbert Pfuhl Jr. interview on April 23, 2002.

127. "Aliens Report To Sign Up Under New Federal Act," *Johnstown Tribune*, August 27, 1940; "1300 Non-Citizens Register To Date," ibid., September 10, 1940.

128. "Over 1300 Aliens Of Enemy Nations Register In Area," ibid., February 28, 1942.

129. "Heidelberg Club Continues Operation as 'The Pinehurst,'" ibid., March 24, 1942.

130. "Horseshoe Curve Given Protection Against Sabotage," ibid., June 24, 1942; "Spies, Saboteurs, and Traitors?" editorial, ibid., July 3, 1942; "250 Aliens Seized In Sabotage Plot," *New York Times*, July 2, 1942; "Sneak Invasion," Week In Review, ibid., July 5, 1942. Former Mayor Herbert Pfuhl Jr. vividly recalls having attended a social occasion with his family and other people of German origin at the Turn Verein (Turners) on Railroad Street in the period after the Pearl Harbor attack. FBI agents entered and ordered everyone to stand and answer questions. They departed, having arrested no one. A reasonable assumption is that this "raid" was conducted in conjunction with the submarine sabotage plot against the Horseshoe Curve, but this cannot be verified.

131. "Dynamite Seized in Alien Arrests, FBI Leader Says," *Johnstown Tribune*, September 19, 1942; Dasch, *Eight Spies Against America*. One of the eight "saboteurs" who landed from German submarines, George Dasch, was a U.S. citizen who was seeking to get out of Nazi Germany and return to the United States. The submarine landing was his way of doing this. After landing, he turned himself in immediately at FBI headquarters and gave U.S. lawmen detailed information about the Nazi mission, enabling the FBI to be on top of this case. Despite his key role in aiding the FBI, Dasch was arrested, tried and imprisoned for many years. He reasoned and argued that J. Edgar Hoover's handling of the entire submarine landing affair was to boost both his own and the FBI's image. For whatever reason, the names of people arrested at Revloc and in Johnstown were not released to the media. The plot may have been for real or the whole thing may have been rooted in J. Edgar Hoover's bureaucratic megalomania.

132. "Local Gasoline Stations To Comply," *Johnstown Tribune*, August 2, 1941.

133. "8 Rationing Boards Prepare To Enforce Strict Regulations," ibid., January 1, 1942; "Tire Sale Quota Under Rationing Setup" and "Shortage of Golf Balls," ibid., December 31, 1941.

134. "OPA Eliminates Post Of Rationing Director," ibid., January 28, 1943.

135. "Sale of $5.00 Auto Stickers," ibid., June 3, 1942; "No Tax Stamp, No Gasoline," ibid., June 8, 1942; "3 Gas Rationing Offices Established," ibid., August 8, 1942; "Pleasure Driving Is Banned," ibid., January 6, 1943; "Cancel Local Hearing On Pleasure Driving," ibid., March 6, 1943.

136. "Gasoline Supply Nearly Exhausted In City," ibid., May 29, 1943; "Motor Club Requests Action In Gas Crisis," ibid., July 14, 1943.

137. "Point Rationing Brings War Home To Civilians," ibid., February 22, 1943; "Here Is What Each Family Must Know For Sugar Books," ibid., February 23, 1942.

138. "Bus, Street Car Passenger Load Up," ibid., December 7, 1942; "Share-Ride Plan Soon To Become Compulsory Here," ibid., November 5, 1942; "Share-Ride Plan Aired," ibid., November 25, 1942.

139. "Pupils To Plant Victory Gardens," ibid., February 23, 1942.

140. "12,300 Tons of Scrap Collected in Cambria County," ibid., September 28, 1942; "Success Seems Sure For Tin Can Roundup," ibid., February 19, 1943; "Tin Can Roundup Tomorrow," ibid., May 20, 1943.

141. Conversation with Dan Glosser, CEO of M. Glosser and Sons, April 24, 2002.

142. "Plan Collection of Used Hosiery In Local Stores," *Johnstown Tribune*, December 9, 1942.

143. "Bethlehem's Role in Defense Work Stressed," *Johnstown Tribune*, March 6, 1941.

144. "District Industries Set Production Records," ibid., December 30, 1944; "Local Plant Is Cited As Big Supplier of Steel Plate For All Bethlehem-Built Ships," ibid., July 19, 1945.

145. "To Build Munitions Plant Here," ibid., July 7, 1944; "Pick Coopersdale Site For Munitions Plant," ibid., July 8, 1944; "German War Prisoners Will Be Used…On Shell Plant Project," ibid., November 16, 1944; "Shell-Forging Plant Will Enter Production Monday," ibid., February 10, 1945.

146. "New Record Is Made In Enlarging, Lining Big Furnace," ibid., October 22, 1942; "Bethlehem Lowers Record By 2 Days," ibid., August 28, 1943.

147. "Lorain-Made Steel Used In Building Atom Bomb Plant," ibid., August 20, 1945.

148. "Air Chief Lauds Local Firm," ibid., March 26, 1942; "National Radiator Boosts Production and Capacity," ibid., January 19, 1946.

149. "Sylvania To Open Plant In Wess Building Here," ibid., January 27, 1945.

150. "New Industry Locates Here," ibid., February 20, 1942.

151. "Synthetic Rubber Program Owes Much To Work In City," ibid., December 24, 1942.

152. Barck and Blake, *Since 1900*, 478–82.

153. "Company and Union Officials Seek Settlement of Bethlehem Strike at Joint Conference," *Johnstown Tribune*, April 29, 1942; "Steel Production Here Is Returning To Normal Again," ibid., April 30, 1942; "Bethlehem Signs Union Contract," ibid., August 17, 1942.

154. "Coal Production Menaced," editorial, and "4000 Men On Strike In Mines Of District," *Johnstown Tribune*, April 27, 1943; "More Strikes Occur As Men Spurn Order Of Chief Executive," ibid., April 30, 1943; "All Mines Are Shut Down," ibid., May 1, 1943; "Miners Trickle Back To Jobs," ibid., May 3, 1943; "Full Scale Mine Work Is Resumed In District No. 2," ibid., May 4, 1943; "3067 Cambria Miners Disregard New Truce: Strike at Six Mines," ibid., May 19, 1943; "Mine Strikes Spread As Leaders of Union Seek To End Trouble," ibid., May 20, 1943; "WLB Denies Wage Increase For Miners," *Johnstown Democrat*, June 19, 1943; The Home Front, *Johnstown Tribune*, November 6, 1943. The general cost of living had risen about 15 percent between January 1, 1941, and May 1, 1942—a rate of about 10 percent per year. The cost of living determinations were at the root of the "Little Steel Formula," developed by the NWLB for the four "little steel" companies including Bethlehem—all done to contain inflation through wage and price controls. The formula sanctioned a 15 percent pay increase above the general wage structure in effect on January 1, 1941, but the new scale took effect in August 1942. The NWLB next began seeking to hold a line on salary increases across many industrial sectors by rendering decisions based upon its Little Steel Formula. Meanwhile, the UMW had already negotiated and was using a new two-year contract at about the same percentage of increase, but its effective starting date had been April 1, 1941. The NWLB began to assume that this earlier wage scale was at parity with the Little Steel Formula, and as such, future coal industry pay increases would be disallowed. During the 1943 coal strikes, John L. Lewis's posture from day to day is difficult to understand, as he probably vacillated in policy. Lewis, a Republican, generally opposed Roosevelt, especially his having a third term. He hated the Little Steel Formula and believed that coal miners were being jilted by its concepts. He disliked the NWLB although there was a minority of members he trusted. On the other hand, he also was very much opposed to wartime strikes that would imperil the war effort. In 1943 Lewis doubtless felt boxed into no-win policy choices.

155. DuBofsky and Van Tine, *John L. Lewis*, 415–444. This biography, sympathetic to J.L. Lewis, describes the complex situations facing him during the wartime coal strikes and other issues that cropped up.

156. "Traction Workers May Submit Case For Arbitration," *Johnstown Tribune*, August 13, 1942; "Trolley Workers Schedule Strike Here On Saturday," ibid., March 25, 1943; "Streetcar Shutdown May Be Averted Here," ibid., March 26, 1943; "Traction Strike Averted: Accept Arbitration Plan," ibid., March 27, 1943; "Little Hope Is Held For Early Settlement of Traction Strike," ibid., April 24, 1943; "Buses and Trolleys Resume After Strike," ibid., April 26, 1943; "Warren G. Reitz Renamed Traction Firm's President," ibid., May 3, 1943; "Strike Ties Up Trolleys, Buses; Workers Protest WLB Decision," ibid., June 14, 1943; "WLB Order In Traction Case," ibid., June 14, 1943; "Streetcars Run Again," editorial, ibid., June 16, 1943; "WLB To Discuss Traction Workers' Appeal," ibid., June 23, 1943.

157. "Strike of City Workers Starts; About 80 Out," *Johnstown Tribune*, August 21, 1944; The Home Front, ibid., August 8, 1944; "Garbage Piles Grow Higher," ibid. September 8, 1944; "Striking City Employees State Their Side of Local Controversy," ibid., September 9, 1944; "Council Plans Contract Collection Of Garbage; Court Action Impending," ibid., September 12, 1944; "Robel Begins Removing Accumulated Garbage: Union Orders Picketing," ibid., September 14, 1944; "Garbage and Politics," editorial, ibid., September 14, 1944; "Council Defeats Two Proposals To Settle Strike," ibid., September 20, 1944; "$15,500 Price Is Quoted On Garbage Disposal For Three-Month Period," ibid., September 26, 1944; "Municipal Workers End Strike; Assured Raise In '45 and Overtime Pay," ibid., October 7, 1944.

158. "City Will Pay Tribute To 'Buzz' Wagner" and "Write Finis To Diary," ibid., January 7, 1943.

159. "Sgt. Strank, Franklin, Killed After Participating In Historic Flag Raising," *Johnstown Democrat*, April 9, 1945.

160. "Community Ready To Give War Hero Stirring Welcome," *Johnstown Tribune*, July 28, 1945; "Special Veterans Receive Special Honors," *Tribune-Democrat*, November 11, 1994.

161. "Boy, 14, Confesses 3 Car Slashings," *Johnstown Tribune*, July 30, 1943; "Upholstery In 15 Cars Slashed in Westmont," ibid., November 10, 1943; "Lock Parked Cars...Cuttings Jump To 45," ibid., January 25,1944; "Car Slashings Jump to 70," ibid., March 2, 1944.

162. "Students Elated By School Board Action On Coach" and "An Oversight Corrected," editorial, ibid., March 26, 1943.

163. "U.S. Army Reports 1350 From Area Died," ibid., June 28, 1946; The Home Front, *Johnstown Tribune*, October 6, 1945. From the beginning of the military draft in 1940 until shortly after the war, 40,300 men from the four-county district (comprised of Bedford, Indiana, Cambria and Somerset Counties) were either drafted or voluntarily enlisted in one of the armed services. This number excludes career military already on duty and women service personnel. Since Cambria County's population was just over half that of the four counties combined, one concludes that about 20,300 of its men were drafted or enlisted during the war. If one allows another 3,100 for career military already on duty in 1940 plus women volunteers, Cambria County's manpower contribution to the armed services would have been about 23,400 (on active duty sometime during the war). This would have been in proportion to Pennsylvania's contribution of roughly 1,225,000 out of an estimated wartime population of 10,250,000 (11.8 percent) or 15,272,600 from the nation with an estimated 1943 population of 136,739,000 (11.17 percent).

164. "Stores Closed, War Work Continues As Johnstown Stages Quiet Observance," ibid., May 8, 1945.

165. "Johnstown Quiet Again After Staging Biggest 'Blowoff' To Mark War's End," "Business Joins Industry In Two-Day Suspension For Peace Celebration" and "District Will Go Back To Normal Industrial and Business Basis Tomorrow," ibid., August 16, 1945.

15. A WEAK PIPING TIME OF PEACE: POSTWAR JOHNSTOWN

166. Conversation with Dr. David Borecky, Johnstown physician and World War II navy veteran.

167. "Work At Sylvania Plant Comes To Abrupt End," *Johnstown Tribune*, August 15, 1945; "Army Withdraws Goldstein and Levin Dress Contract," ibid., August 16, 1945; "Official Closing of Shell Plant Revealed Today," ibid., August 20, 1945.

168. "Bright Post-War Outlook for Johnstown Seen in National Industrial Report," ibid., August 28, 1945; "Johnstown's Future Looks Bright," ibid., August 29, 1945.

169. "Thousands of Men Idle," ibid., January 12, 1946; "Five Local Plants Are Strikebound and Picketed by Steel Workers," ibid., January 21, 1946; "Bethlehem and Lorain...Start Production As Strike Ends," ibid., February 28, 1946.

170. "Davis Brake Beam Caught In Squeeze: Will Invite Strikers Back To Work," ibid., December 16, 1946; "Radiator Firm Wants To Reopen Plants; Seeks Abolishment of OPA" and "Steel Continues Improvement, But Fabrication Idle," ibid., February 19, 1946; "Strike Ends At National Radiator's Plants Here," ibid., November 23, 1946.

171. "Coal Strike Idles 11 Open Hearths," ibid., March 23, 1946; "Bethlehem Production Cut 40 percent; Strike To Hit Many Local Industries," ibid., November 25, 1945; "Idle Workers Increasing As Coal Stoppage Hits Refractories, Fabricators," ibid., November 29, 1945.

172. Strohmeyer, *Crisis In Bethlehem*, 28.

173. "A.B. Homer...Inspect Johnstown Plant," *Johnstown Tribune*, April 11, 1946; "Improvements In Johnstown Plant...In $134,000,000 Program," ibid., April 30, 1946; "Bethlehem Boosts Expenditures Here...To More Than $8,000,000," ibid., July 9, 1946.

174. "Real Estate Boom," ibid., December 31, 1946.

175. "Johnstown Needs More Housing," editorial, ibid., June 21, 1945.

176. "Holding the Price Line," editorial, ibid., July 2, 1946.

177. "Johnstown To Be Given Dwellings For 150 Vets," ibid., February 15, 1946.

178. "Realty Survey Confirms Acute Housing Shortage," ibid., March 27, 1946.

179. "Real Estate Boom and Industrial Reconversion Mark 1946 Here," ibid., December 31, 1946.

180. "Many Homes Built in Post War Period" and "Boroughs and Townships In Local District Issue 2500 Building Permits," *Tribune-Democrat*, March 23, 1953.

181. "440 Acre Tract of Land In Westmont, Lower Yoder," *Johnstown Tribune*, December 14, 1945.

182. *Com ex.rel. v. Schwing*, 1943, D&C 251, 35 Mun. 154, 91 P.L.J. 505.

183. "Chamber Issues Protest" and "Council Orders Warrants For Collection of Taxes," *Johnstown Tribune*, January 5, 1943; "Motion To Quash Order on Schwing Filed," ibid., February 1, 1943; "Make Them Pay Up," editorial, ibid., April 1, 1943; "Schwing Ordered To Collect Tax," ibid., May 4, 1943; "Dual Role...May Solve Tax Issue," ibid., June 12, 1943; The Home Front, ibid., September 18, 1943; "Schwing Next Mayor," ibid., November 3, 1943. Prior to his election as city treasurer in 1935 (and later in 1939), Schwing had been an assistant treasurer at two different banks. After the bank crisis, he had served briefly as a school-tax collector.

184. "Departmental Assignments Changed As New Council Organizes," *Johnstown Tribune*, January 3, 1944.

185. "City Closes Up 1944 Fiscal Year Well In Black," ibid., January 3, 1945.

186. "City And County Speeding Airport Authority Plan," ibid., March 30, 1950; "Incorporators Are Named," ibid., April 15, 1950.

187. "Five Members Of Proposed Parking Authority Appointed By Mayor Rose," ibid., October 13, 1950; see also Act 276, 1949 Pennsylvania Legislative Session.

188. An indication of the way the city council functioned in 1942 is revealed by the fact that each of the five councilmen named one member to the authority. Once this had been done, a single resolution was passed officially naming all five members.

189. Act 292 of the 1943 Pennsylvania Legislative Session.

190. "Rep. Rose's Home Rule Bill May Die," *Johnstown Tribune*, May 17, 1947; "City Stalemate," editorial, ibid., May 21, 1947.

191. "Political Courage," editorial, ibid., December 5, 1947; "Earned Income Tax," editorial, ibid., July 9, 1948; "Time For A Decision," editorial, ibid., July 31, 1948; "The City Budget," editorial, ibid., December 24, 1948.

192. "Former Mayor Dies In Apartment Blaze," *Tribune-Democrat*, February 3, 1969.

193. The data were derived from "first-day enrollment figures" published in the *Johnstown Tribune* in early September of most years. Beginning in 1951–52, the data came from another source and reflected November 1 enrollment and the elimination of all tuition pupils. In all cases the kindergarten program attendees were subtracted out for consistency. Kindergarten had been eliminated beginning in the 1939–40 school year. It was resumed in 1951–52.

194. In the postwar period, the important decisions of the school board were made in committee meetings that were closed both to the public and to news reporters. The official school board meetings were in public and were covered by the press, but the sessions were short and often devoid of policy discussion. The school board then typically ratified the committee recommendations in the public sessions.

195. "Dr. Roy Wiley...Becomes School Head," *Johnstown Tribune*, April 10, 1946; "The New School Board," editorial, ibid., December 2, 1947; "School Board Trouble," editorial, ibid., December 9, 1947; "School Board," editorial, ibid., November 15, 1949; "School Politics," editorial, ibid., November 27, 1951; "Dr. Wiley's Example," editorial, ibid., December 18, 1953.

196. The Home Front, ibid., March 20, 1943; "Johnstown's War Memorial," editorial, ibid., July 25, 1945; "Elections Fill War Memorial's Directors Board," ibid., January 15, 1946.

197. "Memorial Group Plans Practical, Useful Building," ibid., March 5, 1946; "Architect's Drawing," ibid., March 13, 1946; "Directors Plan War Memorial Drive For Funds," ibid., August 20, 1946; "Nokes Resigns Memorial Drive," ibid., October 8, 1946; "Cambria County War Memorial," editorial, ibid., December 21, 1946; "Leaders Named For County War Memorial," ibid., February 3, 1947; "Advanced Gifts...Total $281,200," ibid., March 28, 1947; "Establish New Super Goal Of $1,000,000," ibid., April 3, 1947; "War Memorial Over The Top," ibid., April 25, 1947; "War Memorial Asks for...Union Park," ibid., November 23, 1948; "War Memorial," editorial, ibid., November 25, 1948.

198. "Charles Kunkle, Jr. Named War Memorial President," ibid., February 3, 1949; "Cambria County Court Approves City's Request," ibid., February 11, 1949; "War Memorial Agreements," ibid., August 8, 1949; "Ground Officially Broken," ibid., October 31, 1949; "Success Of War Memorial...Hinges On Results Of New Fund Campaign," ibid., January 10, 1950; "Campaign for $200,000...Opened Officially," ibid., February 6, 1950; "The Last $50,000," editorial, ibid., March 17, 1950; "The War Memorial," editorial, ibid., March 22, 1950; "War Memorial Plans Suits To Collect Pledges," ibid., July 27, 1950; "War Memorial...Borrows $700,000," ibid., August 16, 1950; "War Memorial Membership Reelects Nine Directors," ibid., January 9, 1951; "Loss of $1000...In First Year's Operation," ibid., June 26, 1951; "Charles Kramer Named War Memorial Manager," ibid., June 24, 1952; "War Memorial's Situation Is Desperate," editorial, ibid., December 18, 1953.

199. "Torquato Death Marks End of Era," *Tribune-Democrat*, April 22, 1985; "John Torquato Reelected Head of Democrats," *Johnstown Tribune*, June 24, 1946; "Serious Grounds for Protest," editorial, ibid., July 3, 1946; "One Sided Registration Deal," editorial, ibid., September 13, 1946.

200. "Gleason Stresses Party Unity," ibid., October 13, 1947.

201. "The Election Results," editorial, ibid., November 5, 1947.

202. "Gleason Threat Is Told By GOP Committeeman," ibid., June 8, 1948; Interview with Andrew J. Gleason in June 2002.

203. "Complete Unofficial Returns," *Johnstown Tribune*, November 3, 1948; "Rep. Robert L. Coffey Killed," ibid., April 29, 1949; "The Candidates," editorial, ibid., May 5, 1949; "The Special Election," editorial, and "Unofficial Cambria Returns," ibid., September 14, 1949; "John Saylor To Be Sworn In Wednesday," ibid., September 22, 1949.

204. "City Highway Employee Charges He Was Fired For Objecting To Macing," ibid., April 5, 1951; "The Macing Issue," editorial, ibid., April 4, 1951.

205. "2000 Take Part In Testimonial For A.J. Gleason," ibid., March 24, 1952.

206. "Top 2 Million In Bottling," *Tribune-Democrat*, January 14, 1953.

207. Prior to the opening of the Easy Grade Highway (Menoher Boulevard), there were four basic roadways one could take between the city and Westmont Borough: Mill Creek Road from the Somerset Street–Hamilton Court area of Kernville (steep and winding); Southmont Boulevard to Westmont through either Orchard Street or Diamond Boulevard (called perhaps pejoratively "the big road"); from Cambria City through Brownstown by way of the Brownstown railroad bridge; and Gilbert Street and the Edwards Hill Road (modern D Street–Goucher Street link). There was also the incline plane. Being steep, winding or both, they were all unsatisfactory.

208. "Southmont Council Moves to Open New Road Leading Into City On Easy Grade," *Johnstown Tribune*, July 2, 1938; "Easy Grade Road Proposal," ibid., September 20, 1938; "Construction of Highway From City...Assured from Washington," ibid., November 18, 1938; "New Highway...On Federal-Aid Plan," ibid., July 20, 1939; "New 'Easy

Grade' Highway Gets City's Aid," ibid., October 13, 1939; "Cemetery Board Asserts Location of New Highway Will Damage Its Property," ibid., October 28, 1939; "New Road's A' Coming 'Round the Mountain!" ibid., May 2, 1940; "Landslip Slows As Workers Wait For Federal Engineers To Make Official Inspection," ibid., June 25, 1940; "Nasty Bombing On Barnett Street," ibid., September 30, 1940; "New Local Highway Will Open This Week," ibid., July 7, 1941; "Now To Remove the Bottleneck," editorial, ibid., July 16, 1941.

209. "Big State Road Projects In County Stalled In 1946," *Johnstown Tribune*, December 20, 1946.

210. "Berkley Hills Road Job Will Be Started," ibid., November 19, 1946; "State To Spend $3,714,314 On Highways in County," ibid., October 15, 1948.

211. "New Johnstown-Windber Road Will Be Million-Dollar Project," ibid., March 8, 1950; "Million-Dollar Modernization Job On Route 56 To Be Started Monday," ibid., June 10, 1950.

212. "More Highway Improvements Needed in Local Area," ibid., July 21, 1947; "Current County Projects Small Part of Over-all State Highway Program" and "Officials Outline Plan To Improve Airport Road," ibid., July 25, 1947; "Highway Network," editorial, ibid., August 9, 1947; "No Road Program," editorial, ibid., August 11, 1948; "Time To Wake Up," editorial, ibid., February 18, 1949.

213. "Chamber Makes Known 14-Point Plan of Progress," ibid., December 6, 1945. The fourteen points were city-borough consolidation, regional planning, adequate recreation facilities, a health and sanitation program with high school students cooperating, air transportation, continued fire prevention work, adequate highways, adequate railroad passenger service, service to retailers, service to wholesalers, service to existing industry, jobs for all through industrial development, adequate housing and adequate education.

214. "C. of C. Outlines Heavy Schedule For 1947 With Consolidation No. 1 Aim," ibid., December 13, 1946; "An Inspiring Program," editorial, ibid. December 14, 1946; "'Yours Is The Opportunity,' Dunn Tells Westmonters At Consolidation Meeting," ibid., March 6, 1947.

215. "Statement Is Issued On Strong Attempts Made Locally To Obtain...Radiator Plant For City," ibid., August 5, 1950; "Waters Admits Chamber Worked To Keep Plant Here," ibid., August 9, 1950.

216. "New Agency Set Up Here To Seek More Industries," ibid., January 21, 1951. JIDC Officers were C.R. Brickles, local manager of the J.C. Penney Company; Roland Dunn of the chamber of commerce; Frank Piazza, Penelec's industrial development engineer; Walter Krebs, *Tribune* publisher; James Foster, merchant; Orville Sellers, automobile dealer; George Fiig, proprietor of a men's clothing store (Woolfe and Reynolds); Warren Reitz, Johnstown Traction Company; and George Rutledge, banker.

217. "Bailey Building Here Is Bought By Station WJAC," *Johnstown Tribune*, March 2, 1945; "FM and Television Service Nearing For Station WJAC," ibid., December 4, 1947; "Radio Station WJAC To Hold Open House," ibid., February 26, 1948; "Reception Good On WJAC's First FM Broadcast," ibid., May 24, 1948; "Success Marks Opening of Station WJAC-TV," editorial, ibid., September 16, 1949; "Johnstown's TV Station Has Huge Audience," ibid., September 10, 1951; "WJAC-TV Has Made Rapid Progress In April Year Period," *Johnstown Tribune-Democrat*, September 23, 1953; interview with Richard Mayer, retired publisher of *Johnstown Tribune* and principal trustee, Anderson Walters Trust, August 5, 2002.

16. The Johnstown Economy from the End of World War II to the Vietnam War

218. "Employment in Local Area," *Johnstown Tribune*, June 28, 1947. During the war and in the immediate postwar years until mid-1949, the Johnstown Labor Market Area consisted of Northern Somerset County and all of Cambria County except its northeast sections around Gallitzin and Patton. In September 1949, the boundaries of the Johnstown Labor Market Area were changed to cover all of Cambria and Somerset Counties. The reconfigured district had a late 1949 workforce of just over 105,000 people. There have been no ongoing econometric studies or modeling efforts to allow one to follow the Johnstown economy over an extended period. The only Johnstown-area parameters (other than bank clearings) consistently followed monthly are those of the Pennsylvania Employment Service, which puts out employment data by job category including estimates of total workforce and the unemployed.

219. "All-Time High Reached In Area," ibid., July 7, 1948.

220. "Employment at All-Time Peak," ibid., October 6, 1951.

221. "See Employment Boom Underway," ibid., July 25, 1950; "Johnstown Off Critical List in Unemployment," ibid., September 1, 1950; Pennsylvania Department of Labor and Industry reports, "Total Civilian Work Force, Unemployment and Employment By Industry," Various Years 1949–1988; Pennsylvania Department of Internal Affairs, *Industrial Directory* 1950 and 1953—Cambria County Section. I note occasional discrepancies between employment/unemployment and workforce data (a half century ago) issued through press accounts and official employment records of the Pennsylvania Employment Service of the Department of Labor and Industry. Current staff are unable to explain these differences. When not identical, I have used the official reports rather than the press accounts, which were derived from press releases issued by the PES of the Pennsylvania Department of Labor and Industry.

222. See chapter 15, 51.

223. "Johnstown Plant Near Top—Fisher," *Tribune-Democrat*, May 5, 1953; "Modernization, Men Get Credit" and "Bethlehem Assures Jobs, Prosperity Here," editorial, ibid., July 1, 1953.

224. "Johnstown Works, U.S. Steel Enjoys Big Year," ibid., January 9, 1954.

225. "Aid to Industry on Way—Saylor," ibid., July 1, 1953.

226. "Bethlehem's Johnstown Plant To Share in $165 Million Improvement Projects," ibid., February 27, 1953.

227. "1953 Goals Considered By Chamber," ibid., March 24, 1953.

228. "We Need New Industries," editorial, ibid., February 20, 1953; "Drive for New Industries," editorial, ibid., Spril 15, 1953.

229. See Chapter 14; "New Agency Here to Seek More Industries; Plans Fund-Raising Drive," *Johnstown Tribune*, January 12, 1951; "Meeting Blueprints Plan for Industrial Expansion," ibid., January 26, 1951; "Development Corporation Begins Drive for $1 Million To Bring New Industries To Johnstown; Will Offer Stock For Sale," ibid., April 24, 1951. Stimulated by the recent National Radiator humiliation (unveiled August 1950), a group of Johnstown leaders created the Johnstown Industrial Development Corporation (JIDC) in September 1950, but the new group did not begin to function until late January 1951 when the Korean War was raging. The JIDC replaced the disbanded Johnstown Industrial Development Commission that had actually purchased or leased a few buildings in Johnstown during World War II. These had been subleased to new wartime industries that had been attracted to the city. JIDC was initially a for-profit stock corporation (ten dollars per share). It also assumed the residual cash resources of the old Johnstown Industrial Commission. JIDC intended to assemble land and acquire buildings for sale or lease to industrial firms. Like the Johnstown Industrial Commission, the JIDC was an affiliate of the chamber of commerce. Its board members were C.R. Brickles (president), David Glosser (M. Glosser's son), Roland Dunn, James M. Foster, Frank Piazza, W.W. Krebs, Orville Sellers, George Flig, Warren Reitz and George Rutledge.

230. "City Acts To Get More Industries," *Tribune-Democrat*, October 6, 1953; "New Industry Efforts Merged," ibid., October 22, 1953.

231. "Steel Leaders Pledge Cooperation In New Move to Create More Jobs," ibid., March 26, 1954.

232. "Many Cities Competing For Industrial Plants" and "Activities Outlined by C. of C.," ibid., March 23, 1954; "Businessmen Launch Drive For More Industry," ibid., March 26, 1954.

233. "Chamber of Commerce Plans Big Drive for New Industry," ibid., July 3, 1956; "Industrial Fund Drive Successful," ibid., August 27, 1956.

234. The community's role in attracting the Hiram G. Andrews Center to Johnstown is covered in chapter 18, 115.

235. "Chamber Cites Industrial Need," *Tribune-Democrat*, March 27, 1957; "Industrial Developer Takes Over Task Here," ibid., May 22, 1957; "Area Units Plan Joint Move On Industrial Development," ibid., July 26, 1957; "Area's Industrial Gains Cited in Chamber Report," ibid., October 31, 1957; "Council Okays C of C Development Agency," ibid., November 12, 1957; "Chamber's Activity Producing Results," ibid., October 21, 1958; "$176,000 Plant Proposed Here," ibid., October 23, 1958; "Chamber's Drive for New Industries Shifts Into High Gear," ibid., January 13, 1959.

236. John Stockton (chamber president in 1960) in conversation with author.

237. Pennsylvania Department of Labor and Industry, Pennsylvania Employment Service, "Total Civilian Work Force, Unemployment and Employment by Industry," various years, Cambria-Somerset County Reports.

238. Hanten, "An Analysis of the Industrial Potential of Johnstown," 117.

239. Ibid., 64–66.

240. George Walter's administration is covered in chapter 18, section IV, "Winds of Change—Dr. George Walter," 104.

241. "Industry Park Tract Bought By Chamber," *Tribune-Democrat*, November 1, 1963; "Firm Plans Industrial Park Plant," ibid., April 10, 1965. The Johnstown's economic development program narrative continues with chapter 25.

242. Pennsylvania Department of Mines—Bituminous Division, Annual Reports for 1950 and 1960; Pennsylvania Department of Internal Affairs, Annual Reports for 1950 and 1959—Cambria County Section.

243. For a description of the earlier 1927 mergers creating the National Radiator Corporation, see part one, chapter two, section I, "National Radiator," 60.

244. "National Radiator Makes Personnel Changes," *Johnstown Tribune*, June 25, 1952; "Radiator Firms Propose Merger," *Tribune-Democrat*, December 20, 1954; "Good Year Heralded for Radiator Firm," ibid., December 20, 1954; "Radiator Firm Chairman Hits Merger Plan," ibid., February 9, 1955; "City Favored for Offices of Proposed Merged Firm," ibid., February 21, 1955; "National-U.S. Radiator to Maintain Headquarters," ibid., March 16, 1955; "Directors O.K. Sale of National-U.S. Firm," ibid., January 12, 1959; "National-U.S. Sale May Help, Not Hurt Community," ibid., January 12, 1960; "City Selected for Key Role By Crane Company," ibid., February 3, 1960; "Closing of Deal By Natus Corporation 'Not Imminent,'" ibid., March 11, 1960; "Focke Quits Crane Posts," ibid., August 2, 1960; "Crane Co. To Close Operations In City," ibid., January 5, 1965; "C. of C. Seeking Replacements for Crane Co," ibid., January 19, 1965.

245. "Oxygen Plant Job," ibid., April 25, 1961; "Bethlehem To Launch Major Improvement," ibid., September 19, 1961; "Bethlehem Firing Up 'E' Furnace Here," ibid., November 7, 1961; "Bethlehem Plans 2 New Rotary Furnaces Here," ibid., December 28, 1961; "$6 Million Job at Open Hearth," ibid., July 31, 1962; "2 New Mills," ibid., August

10, 1962; "Growth Expenditures Will Continue Here, Homer Says," ibid., November 2, 1962; "New $18 Million 11-Inch Mill...in Production Here," ibid., August 22, 1963; "Bethlehem Plans To Spend $10 Million," ibid., December 9, 1964; "Bethlehem Plans $1 Million Job at Rosedale Coke Plant," ibid., January 9, 1965; "Airco To Build New Oxygen Plant Here for Bethlehem," ibid., March 9, 1966; "Bethlehem Putting $4 Million Into Wheel-Axle Plants," ibid., August 11, 1966.

246. "Moxham Plant Makes Big Car," ibid., December 14, 1961; "Moxham Plant Lands Big U.S. Steel Order," ibid., October 16, 1962.

247. "Penn Traffic On Threshold of Merger With Food Chain," ibid., October 1, 1961; "Penn Traffic Outlines Plans," ibid., December 4, 1961; "Penn Traffic Merger Gets Final Approval," ibid., December 21, 1961; "New PT Store Draws Crowd," ibid., October 3, 1962. The author is also indebted to John Kriak, former secretary and treasurer of the Penn Traffic Corporation, for insight into the PT corporate philosophy in the early to mid-1960s, and to Chris Menna of the Crown America Corporation for information about Crown America Corporation.

248. Interview with Johnstown attorney and political leader Andrew Gleason and Johnstown accountant James Saly on April 11, 2003; "First of 30 Homes Moved From Housing Site Here," *Johnstown Tribune*, February 26, 1951; "Profit in Moving Homes From Housing Site Was Small, Probe Report Shows," ibid., April 1, 1952; "Local Firm Awarded 3 Contracts," ibid., January 2, 1957; "2nd Shopping Center Planned In Westwood," ibid., December 1, 1961; "Big Year Is Seen By Crown Firm," ibid., January 22, 1965; "8 Area Firms Being Merged," ibid., April 20, 1965; "City Sells Old Post Office To Crown Construction Co.," ibid., March 7, 1967; "Crown Construction Company," full-page advertisement in connection with opening of new corporate headquarters in former post office building on Market Street, ibid., July 11, 1968.

249. "Glosser Bros. Plans Branch," ibid. February 27, 1963.

250. "Metals Firm Enjoys Boom," ibid., January 13, 1959; "Brooklyn Hospital Firm Building Sold," ibid., June 2, 1959.

251. "Nonsinkable Boat Developed Here," ibid., August 20, 1960; "Firm Retains Officers, Staff, 5 Directors," ibid., May 5, 1964; "Miller-Picking Breaks Ground For New Plant," ibid., January 25, 1966.

17. Educational Developments in the 1950s, 1960s and 1970s

252. Laws of Pennsylvania; 1949 Session: Act 14, Art. XVII, Section 1707. Also Act 67 (Amending Act 14).

253. In *Brown v. the Board of Education of Topeka*, the high court ruled that segregated schools violated the "equal-protection of the laws" (Fourteenth Amendment) principles of the U.S. Constitution because separate segregated facilities were judged to be inherently unequal.

254. There were no school mergers or union districts in Cambria County until the mandates of the mid-1960s took effect.

255. University of Pittsburgh School of Education, "Schools for a Greater Johnstown," 34 (an evaluation and recommendations to improve the Johnstown School District). The author of this chapter was Clifford Hooker, the team survey director. Hooker stated about the alignments of Stull's plan, "The criteria used to establish some of these units are a mystery to this writer."

256. "Johnstown-Stonycreek Township Boards Sign Agreement," *Johnstown Tribune*, August 7, 1951; "School Jointures," editorial, *Tribune-Democrat*, July 27, 1954; "School Jointures," editorial, ibid., August 6, 1954; "Conemaugh Township-City School Jointure Vetoed," ibid., August 19, 1954; "A Jointure Vetoed," editorial, ibid., August 21, 1954; "A Veto Vetoed," editorial, ibid., August 24, 1954; "County Office To Block All Jointures With City Schools," ibid., August 30, 1954; "A Recipe For Confusion," ibid., September 3, 1954; "Tempers Near Breaking Point," ibid., September 4, 1954; "Jointure Plans," editorial, ibid., September 18, 1954; "School Jointures," editorial, ibid., October 22, 1954; "Jointure Finds Southmont Split," ibid., September 20, 1955; "Jointure of Franklin, East Taylor Absolute," ibid., August 13, 1957; "West Taylor-City Jointure," ibid., August 21, 1957; "West Taylor Jointure Makes Sense," editorial, ibid., August 22, 1957; "It Is Time For Some Answers," ibid., November 21, 1957; "Richland Area Plans Study Of School Merger," ibid., February May 58; "New Hilltop Jointure," ibid., May 13, 1958; "Three School Boards Set Up New Jointure," ibid., October 28, 1958; "City District Will Accept Students From East Taylor," ibid., March 10, 1959; "City Schools Rule Out Tuition Pupils," ibid., March 15, 1960; "2 Districts Will Decide," ibid., February 21, 1961; "Lower Yoder Board Okays," ibid., March 7, 1961.

257. "School Districts Must Be Enlarged," *Tribune-Democrat*, January 19, 1962; "Greater Johnstown Willing To Admit 3 School Districts," ibid., March 13, 1962; "Single School District For Cambria County," ibid., October 17, 1962; "School District Views Outlined," ibid., October 31, 1962; "How Cambria County School Districts Compare," ibid., November 9, 1962; "Better Education Primary Aim," editorial, and "4 Systems In City District Buck Plan A," ibid., November 10, 1962; "County Board Adds 7th Plan," ibid., November 13, 1962; "Most Boards Against" and "How Directors Stand," ibid., November 17, 1962; "Toward A Realistic County School Plan," editorial, ibid., December 5, 1962; "15 City Area Systems Ask To Be 1 School Unit," ibid., December 22, 1962; "Hearing Fortifies Appeal," editorial, ibid., December 27, 1962; "Stull Quits," ibid., June 28, 1963; "Single Greater Johnstown School District Proposed," ibid., January 16, 1964; "County Adopts December District School Organization Set Up," ibid., February 13, 1964; "Streamlining School Systems," editorial, ibid., April 8, 1966; "New School Districts Begin Operating Today," ibid., July 1, 1966.

258. The school board's committees were Athletic, Finance and Purchasing, Education, Veterans and Operation and Maintenance.

259. University of Pittsburgh School of Education, "Schools for a Greater Johnstown," 114.

260. The opening day school enrollment data was published in the *Tribune-Democrat* in most years in early September. "Dr. Miller Named Administrator," *Tribune-Democrat*, March 15, 1955; "19-Mill School Levy Retained," ibid., May 10, 1955; "Will School Population Go Up Or Down?" editorial, ibid., July 19, 1956; "School Survey Planned In City, Stonycreek Twp," ibid., September 18, 1956; "Project Held Up At Joseph Johns Pending Survey," ibid., October 9, 1956; "School Policies, Problems Outlined for Board Members," ibid., April 14, 1965; "It's School Policy, So Follow It," editorial, ibid., April 14, 1966; "City's 2 Top Administrators Resign," ibid., January 11, 1967.

261. "Dr. Vonarx To Head City School District," *Tribune-Democrat*, March 28, 1967; "New Survey To Be Made," ibid., August 18, 1967; "Update School Plan," editorial, ibid., August 23, 1967; "New Educational Program," ibid., September 27, 1967; "Meeting Is Sought On School Proposal," ibid., October 6, 1967; "End of Era," ibid., November 23, 1967; "Proposed New Meadowvale School," ibid., June 25, 1968; "Price Tag Put On School," ibid., August 13, 1968; "Board Retains Piurkowsky...Will Restudy Building Program," ibid., December 3, 1968; "Directors Approve Vonarx Proposals," ibid., February 11, 1969; "Meadowvale's Progress Told," ibid., February 7, 1970; "Schools Face $1.7 Million Deficit," ibid., February 24, 1970; "ABCs and IPI," editorial, ibid., March 2, 1970; "School Board Approves February Mill Boost," ibid., July 1, 1970; "School Plan Bucked," ibid., October 22, 1970.

262. "Condition of City Schools Deplorable, Buchan Charges," ibid., October 14, 1971.

263. "Vonarx Retiring," ibid., September 7, 1973; "Dr. Vonarx—His Reflections: Politics, Education Don't Mix," ibid., June 7, 1974.

264. Interview with Donato Zucco, December 16, 2003; "Board Elects Zucco To Top School Post," *Tribune-Democrat*, April 16, 1974; "Let's Evaluate IPI, Zucco Says," ibid., July 9, 1974.

265. Telephone interview with James Hargreaves, retired principal of Meadowvale School, December 18, 2003.

266. "Costly Grade-School Repairs Might Face Johnstown Board," *Tribune-Democrat*, February 17, 1976; "City Board Faces Decision on Aged Elementary Schools," ibid., February 25, 1976; "District Told to Close Top Floor of 5 Schools," ibid., March 3, 1976; "Enrollment Dip May Affect School Plans," ibid., October 5, 1976.

267. "Committee Will Propose Cochran as Senior High," ibid., April 14, 1977; "Architect to Study Proposal to Eliminate City High School," ibid., April 19, 1977.

268. "Alternative Programs Needed—Zucco," ibid., May 21, 1975.

269. Hollis and Hollis, *The Saga of Johnstown City Schools*, especially chapter XI, "Levi Hollis—National Educator," 203–28.

270. "Technical High School May Be Set Up In City," *Tribune-Democrat*, April 10, 1962; "2-Year Technical School Is Needed," editorial, ibid., May 26, 1962; "Vocation Training Movement Launched," ibid., June 9, 1962; "Area Technical School Support Sought Locally," ibid., October 1, 1963; "Survey Starts On Technical Training Setup," ibid., October 10, 1963; "Technical School Planning in 1964," editorial, ibid., January 3, 1964.

271. A solid commitment to establish and support a new vocational-technical school could not be gotten from school districts that did not yet exist.

272. "2-School Plan Feared, White's Report Says," *Tribune-Democrat*, February 11, 1964; "Tech School Here Given Council Okay," ibid., August 18, 1964; "County Board Asks City Unit To Alter Stand," ibid., August 28, 1964; "Area Youth Denied Opportunities While Officials Squabble," ibid., September 2, 1964; "County Board Stands Pat On One Technical School Area," ibid., September 17, 1964; "County Convention Called To Decide on Tech School," ibid., October 22, 1964; "8 Districts in Opposition to Single Technical School," ibid., November 24, 1964; "Technical School Debate Nears End," editorial, ibid., November 25, 1964; "State's Tech School Plan Given Support," ibid., December 12, 1964; "Cambria Board Stays With One-Area Tech School Plan," ibid., December 17, 1964; "2-Area Tech School Program Approved," ibid., February 11, 1965; "2-Tech School Areas Get State's Approval," ibid., March 12, 1965; "School Boards To Get Plan For District Vo-Tech Setup," ibid., September 28, 1965; "Area Vo-Tech School Plan Gets City Board's Approval," ibid., October 12, 1965; "Vo-Tech School Up To Boards," editorial, ibid., January 10, 1966; "School Boards Have Come Through," ibid., January 21, 1966.

273. This was prior to the redistricting to take effect July 1, 1966. There would then be eight districts participating, including the Conemaugh Valley School District prior to its withdrawal later.

274. "Robert Kifer Named Head of Vo-Tech," *Tribune-Democrat*, September 30, 1966; "Vo-Tech Site Purchase" ibid., November 23, 1966; "King-Size Vo-Tech Complex Is Indicated," ibid., May 26, 1967; "Vo-Tech School To Be Built With Conemaugh In Or Out," ibid., February 10, 1968; "Vo-Tech Group Okays Pullout," ibid., March 23, 1968.

275. "State Gives Okay to Vo-Tech Project," ibid., April 8, 1968; "Vo-Tech Group Approves Bids," ibid., September 20, 1968; "New...School Opens Monday," ibid., August 27, 1970; "Vo-Tech Census Is 1184," ibid., September 4, 1970.

276. "Vo-tech Fouled," editorial, ibid., April 20, 1972; "School Board Sets 889 Vo-Tech Limit," ibid., May 23, 1972; "Vo-tech Limit," editorial, ibid., May 25, 1972; "City Board Seeks Policy on Vo-Tech," ibid., August 22, 1972; "Board Decries Vo-Tech," ibid., August 25, 1972; "Vo-Tech To Be Closed To Some," ibid., October 17, 1972.

277. "Vo-Tech Changes Proposed In Student Selection Policy," ibid., October 26, 1972.

278. "City Board Acts to Decrease Its Student Enrollment at Vo-Tech," ibid., January 20, 1976.

279. "City Should Have State Normal School, Stockton Declares," *Johnstown Tribune*, August 16, 1921.

280. Act 163 of the 1921 Pennsylvania Legislative Session; signed into law by Governor William Sproul on April 28, 1921. "Normal School" in the early 1920s meant a two-year college-level program.

281. "Build The Schools," editorial, *Johnstown Tribune*, March 19, 1919.

282. "Meyerholtz Makes Final Plans For Pitt Branch Here," ibid., June 21, 1923; "Registration of Students For New Pitt Branch Here," ibid., June 27, 1923.

283. Hunter, *The Evolution of a College*, 9–12.

284. Hunter, *The Evolution of a College*, 14.

285. "Board Advances Plans for Moving Junior College," *Johnstown Tribune*, February 5, 1946; "White 'Blackboards' and Unique Color Schemes Mark New College Quarters Here," ibid., July 17, 1946; "Pitt Center to Transfer More than 100 Pupils," ibid., August 5, 1947; Hunter, *The Evolution of a College*, 38–42.

286. "$1 Million Grant Is Asked To Establish College Here," *Tribune-Democrat*, October 2, 1959; "New Site Donated for Johnstown College," ibid., October 14, 1960; "Artist Author, Helen Price Expires at 68," ibid., November 23, 1960; "Building Fund Plan Set by Local College," ibid., August 17, 1961; "Plans for $6 Million College Campus Set Up," ibid., November 15, 1962; "Campus Campaign Success Is a Good Omen," editorial, ibid., April 4, 1963.

287. "Pitt Acquires Fort Stanwix For Johnstown College Use," ibid., August 8, 1964.

288. "Clearing of Campus Site Slated to Start," ibid., October 13, 1964; "Johnstown College Awards Contracts for 10 Buildings," ibid., December 10, 1965; "Fesler Edwards Will Head Campus-Completion Drive," ibid., October 29, 1966; "Nearly 8000…Tour New College Campus," ibid., August 28, 1967; "Pitt Officially Opens Campus in Richland," (several related articles in same issue) ibid., September 9, 1967; "City Is On Its Way To A April Year College," ibid., September 27, 1967.

18. CIVIC REFORM INITIATIVES

289. See chapter 16, section II, "An Economic Development Program," 71.

290. "Shortway Given Federal Okay," *Tribune-Democrat*, May 23, 1957; "Shortway Does Nothing for Western Pennsylvania," ibid., June 13, 1957; "Road Plan Splits Pennsylvanians," *New York Times*, August 17, 1958.

291. "Johnstown and Suburbs Should Face Facts About Consolidation," editorial, *Tribune-Democrat*, November 15, 1956; "Johnstown Could Be Fifth Largest City In Pennsylvania," editorial, ibid., November 19, 1956; "Realtors Urge Fast Action on Consolidation," ibid., December 6, 1956; "Action by Citizenry Is Key to Annexation," ibid., December 10, 1956; "Builders Back Consolidation," ibid., December 11, 1956; "Union Council for Merging," ibid., December 18, 1956; "Upper Yoder Displays Merger Enthusiasm," ibid., December 28, 1956.

292. "Need for Consolidation Grows Clearer," editorial, ibid., February 7, 1957; "Why Do Anti-Annexationists Insist on Being So Secretive?" editorial, ibid., February 19, 1957; "Readers' Forum," Smith Letter, ibid., February 20, 1957; "Annexation Rumors Marked by Threats," ibid., February 26, 1957.

293. "City Council Acts To Annex Township" and "Westmont Moves To Annex 3336 Acres," ibid., March 5, 1957; "Legal Battle Over Annexation Certain," editorial, ibid., March 6, 1957; "Appeal Looms on Annexation," ibid., April 2, 1957; "Westmont Annexing Ordinance Filed," ibid., April 3, 1957; "Annexation Protest Filed," ibid., April 8, 1957.

294. "The Odd Case of Upper Yoder Township," editorial, ibid., July 30, 1957; "Court Upsets Merger of Township and City," ibid., December 9, 1957; "Annexation Ruling Late," ibid., December 17, 1957; "Upper Yoder Asks Appeal Be Quashed," ibid., April 1, 1958. "Annexation Battle Ended," ibid., June 6, 1958.

295. "Cambria County Unofficial Returns," *Tribune-Democrat*, November 6, 1957; "City Charter Study," ibid., November 28, 1957; "Manager Plan Favored in Solid Charter Vote," ibid., May 2, 1958; "Second Snag Tossed in Commission's Path," ibid., May 20, 1958; "Democrats to Back Charter Commission, Torquato Says," ibid., May 23, 1958; "Progress of City Manager Plan Is Strewn With Broken Promises," editorial, ibid., May 26, 1958; "Shields Raps Manager Plan," ibid., October 21, 1958; "Smear Charged By Torquato" and "Questions For City Voters," ibid., November 4, 1958; "City Manager Plan Loses" and "Unofficial Returns," ibid., November 5, 1958.

296. "Penelec Plans New Johnstown Building," *Tribune-Democrat*, April 22, 1959; "Bigger Cambria City Project To Be Sought," ibid., May 21, 1959; "Penelec Planning $2 Million Office," ibid., June 20, 1959.

297. "Council Takes Rap at Renewal Board," ibid., June 30, 1959.

298. "Council, Urban Renewal Authority Meet Tonight," ibid., July 7, 1959; "Conflict of Interest Seen in Renewal Job," ibid., July 8, 1959; "Krumenacker Fired By April 1 Council Vote," ibid., July 10, 1959; "Council Flays Krumenacker and Gleason," ibid., July 14, 1959; "Cambria City Renewal Gets Council Pledge of Support," ibid., July 21, 1959.

299. The strike had begun on July 15, 1959, and continued until January 4, 1960, with a brief Taft-Hartley respite in November. In May the local unemployment rate was 13.8 percent, the most favorable month in all of 1959. In both July and September, it was above 17.5 percent. See chapter 16, section III for a discussion of the 1959 steel strike, 73.

300. "Metropolitan Plan," editorial, *Tribune-Democrat*, February 4, 1954.

301. "Group Set Up to Aid Development of Area," ibid., October 6, 1959; "Action Group Names Powell," ibid., January 21, 1960.

302. "Restore City's Place In State," ibid., September 19, 1959; "Walter, GOP Rival Slug It Out Again," ibid., October 8, 1959.

303. "City, County Democrats Gain Landslide Victory," ibid., November 4, 1959; "Why Republicans Lost City, County, State Elections," editorial, ibid., November 5, 1959.

304. The industrial-development revitalization is discussed in chapter 16, section III, "A New Response to an Old Challenge," 73.

305. "Steps Taken Toward Reviving Authority," *Tribune-Democrat*, February 4, 1960; "Time For Decision On Sewer Project," editorial, ibid., March 3, 1960.

306. "Sewer-Tapping Problem Looms Large In City," ibid., April 25, 1961; "Sewer-Tapping Notices Mailed," ibid., September 7, 1961; "Banks to Take Sewage Fees," ibid., November 23, 1961; "Speed Sewer Setup, Authority Asks City," ibid., March 23, 1962; "Authority Informed of Water Problem," ibid., February 14, 1962; "City Sewer Fund Not What It Used To Be," ibid., February 28, 1964; Johnstown Municipal Authority, *Cleaner Streams* (an undated brochure issued for general public tours of the then new sewage treatment plant).

307. "5 Named to Sewage Disposal Authority," *Tribune-Democrat*, February 28, 1964; "Council, Authority Will Air Price of City Sewage System," ibid., May 11, 1960; "Hilltop Gives Sewage Plant Tentative OK," ibid., June 14, 1960; "City Offered $1.5 Million in Sewer Sale" and "Disposal Plant Cost Set Near $2 Million," ibid., June 17, 1960; "Approval Given On Sewer Sale," ibid., July 7, 1960; "10 Districts Agree to Join in Central Sewage Plant," ibid., August 11, 1960; "Joint Action Has Many Advantages," editorial, ibid., August 12, 1960; "Sewer Authority Lets Contracts for Plant," ibid., August 15, 1960; "Sheesley Gets Trunkline Job," ibid., October 14, 1960.

308. "3 City Redevelopers Dismissed By Walter," ibid., February 13, 1960; "3 Selected By Walter" and "Redevelopers Warn Of Delay," ibid., February 15, 1960.

309. "Court Upholds the Mayor," ibid., March 15, 1960; "Title Certification Snags Renewal Job," ibid., March 24, 1960.

310. *Com. ex rel. Hanson v. Reitz*, 170 A. 2nd 111; 403 Pa. 434, Sup. 1961; "High Court Withdraws Opinions," *Tribune-Democrat*, January 27, 1961; "Mayor Won't Block Beegle, Hanson Return," ibid., April 20, 1961.

311. "To Ask Glaspey To Take Leave," ibid., June 27, 1960; "Renewal Board Fires Glaspey," ibid., July 11, 1960; "Flynn Placed In Top Job By Redevelopers," ibid., February 22, 1961.

312. "Penelec Will Buy Tract In Cambria City," ibid., June 18, 1961; "Bestform To Be B-1 Pioneer," ibid., August 3, 1963; Monroe, *The Cambria City National Historic District*, 1994; "The Redevelopment of Cambria City," Southwestern Pennsylvania Heritage Preservation Commission.

313. "Broad 17-Point Program Set For Rejuvenation of City," *Tribune-Democrat*, June 30, 1960; "Good Start Toward Urban Rejuvenation," editorial, ibid., July 1, 1960.

314. "Regional Planning Program For Greater Johnstown Set," ibid., March 26, 1960; "Council Okays Regional Plan," ibid., April 23, 1960; "City Master Plan Unveiled," ibid., August 9, 1960; "Regional Study Unit Organized for Area," ibid., November 23, 1960; "Council Okays Regional Plan," ibid., April 19, 1961; "Planning Unit For Johnstown District Set Up," ibid., June 16, 1961; "Survey of Downtown Area Ready To Start," ibid., April 5, 1961; "Here's Scoreboard on City Planning," ibid., June 26, 1962; Pawlowski, "The History of City Planning in Johnstown," in *Johnstown: The Story of a Unique Valley*, Berger, ed., 468–72. Beginning December 4, 1961, through December 8, 1961, the *Tribune-Democrat* published a series of five articles on the Community Planning Service's master plan for Johnstown, including extensive coverage of its downtown plan.

315. "What Has Started Sudden Activity on Water Authority?" editorial, *Tribune-Democrat*, June 25, 1958; "Council To Meet In Bethlehem On Water Deal," ibid., July 21, 1958; "$13 Million 'Tag' Put on Water Firm," ibid., July 24, 1958; "Council Chooses Fiscal Agent Despite Bethlehem's Warnings," ibid., August 12, 1958; "Council Disregards Bethlehem's Advice On Water Finances," editorial, ibid., August 13, 1958; "Council's Secrecy On Water Project," ibid., August 14, 1958; "Bethlehem Withdraws Offer To Sell Water Firm To City," ibid., August 19, 1958.

316. "Offer Made To Sell Water System to City," ibid., December 20, 1962.

317. "To Make Study on Water Offer," ibid., February 27, 1963; "Council Is Moving on Water Project," editorial, ibid., February 27, 1963.

318. Laws of Pennsylvania, 1943 Session: Act 292, Section 9 (b) later amended. Purdons: 53 PA CSA 5613 (B) (2).

319. "Water Purchase Terms Written," *Tribune-Democrat*, July 3, 1963; "Water Pledge Figures Given," ibid., July 9, 1963; "City Council Votes 3 to 2 To Study Joint Water Deal," ibid., July 22, 1963; "City's Offer Turned Down," ibid., August 1, 1963; "Will Someone Think of the Water Users?" editorial, ibid., August 3, 1963; "City to Join 2 Boroughs in Water System Purchase," ibid., August 6, 1963; "Agreement Reached," editorial, ibid., August 8, 1963; "11-Man Authority Is Named to Purchase Water Works," ibid., August 13, 1963; "Water Unit Given Vote of Confidence," ibid., September 17, 1963.

320. "3 Water Deal Pacts Okayed by Authority," ibid., January 22, 1963; "Lower Water Rates to Begin," ibid., February 7, 1964; "Water System Sold To Joint Authority," ibid., February 12, 1964.

321. "Exploratory Talks On Consolidation," *Johnstown Tribune*, February 16, 1961; "Interest Rising In Consolidation

of Greater City," editorial, ibid., October 11, 1962; "Coordinators To Aid In Drive For Annexation," ibid., November 24, 1962; "Come In, City Council Invites Area Neighbors," ibid., December 18, 1962; "Roddis Urges Consolidation," ibid., February 13, 1963; "Feeble Argument Of the Opponents Of Consolidation," ibid., March 23, 1963; "Final Consolidation Target of New Group," ibid., October 31, 1963; "Consolidation Best Choice," editorial, ibid., May 15, 1965.

322. Coversation with Ron Stephenson on May 14, 2003.

323. "Drive for Signatures Begins in Westmont," *Tribune-Democrat*, November 30, 1966; "IJA Says It Has Enough Consolidation Signers," ibid., January 5, 1967; "Southmont Group Will Seek Signers for Consolidation" and "Westmont Presented Consolidation Papers," ibid., February 14, 1967; "Southmont Asks Vote On Merger," ibid., March 16, 1967; "Southmont Group To Start Campaign," ibid., April 10, 1967; "Hilltop Council Still Checking on Petitions," ibid., April 11, 1967; "Consolidation Victory," ibid., May 18, 1967; "Truth Committee Says Consolidation Failed," ibid., May 23, 1967; "IJA Opens New Drive With Feelings of Victory," ibid., June 1, 1967; "Southmont Consolidation Drive Said Over the Top," ibid., June 17, 1967; "Consolidation Petitions Invalid, Westmont Rules," ibid., December 12, 1967; "Consolidation Petitions Fall Short, Southmont Reports," ibid., July 9, 1968; "Southmont Rules No On Consolidation," ibid., September 10, 1968; "City Seeks Law for Voter Approval of Consolidation," ibid., September 22, 1967.

324. "GOP Elects 5 of 9 Area Constitutional Delegates," ibid., November 8, 1967; "Pasquerilla Given Convention Post," ibid., December 12, 1967; "Majority Vote Would Okay Consolidation," ibid., January 19, 1968; "A Job Well Done," editorial, ibid., February 29, 1968.

325. Ferg, "The Politics of Improvement in a Declining Community," chapter VII, "Consolidation." Bruce Ferg's senior thesis is a brilliant study prepared in 1970 and early 1971. This author is indebted to this work for much of the section on the 1970 consolidation referendum.

326. "Consolidation Referendum Seen In Spring," *Tribune-Democrat*, November 21, 1969; "Petitions Signed for Consolidation," ibid., December 16, 1969.

327. "Consolidation Committee Aims For New City," ibid., April 17, 1970; "New Effort Begun For Better Living," ibid., April 23, 1970.

328. "Both Sides Have Their Say On Consolidation," ibid., April 25, 1970.

329. See chapter 16, section V, "National Radiator Corporation's Farewell," 75.

330. "Consolidation Charge Raised," *Tribune-Democrat*, May 13, 1970; Ferg, "The Politics of Improvement," viii–10.

331. Telephone interview with Patrick Casey on June 2, 2003.

332. Interview conversation with former executive secretary to the Greater Johnstown Committee Carol Harrison on June 5, 2003.

333. See chapter 21 for a discussion of both the cable TV scandal and the Pennsylvania Crime Commission's report about Johnstown.

334. As a beautification project, Malinowsky (in charge of parks and public property) had developed a plan to install a small linear park along Washington Street from Clinton to the Public Safety Building. Its greenery was arranged to shield the unsightly railroad yard and Gautier Works from the view of people downtown. At the groundbreaking for this project, a police officer (working on orders of the mayor whose responsibilities had included overseeing city law enforcement) showed up to arrest Malinowsky. A former professional boxer with a loud boisterous voice, Malinowsky dared the policeman to arrest him. The officer left. No arrest was made. Cited in Ferg, "The Politics of Improvement," v–11.

335. Purdon's Pennsylvania Code: Article 53, Section 41400.

336. "Voters OK City Charter Unit," *Tribune-Democrat*, November 3, 1971; "City Government Change Advocated," ibid., December 15, 1971; "2 Praise 'Strong Mayor,'" ibid., January 2, 1972; "Mayor-Council Form Backed," ibid., February 8, 1972; "3 Councilmen Oppose Change," ibid., March 29, 1972; "City Voters Give Okay to Strong-Mayor Plan," ibid., April 26, 1972; "Council Picks 10 For Unit," ibid., August 2, 1972; "Casey To Head Transition Unit," ibid., September 7, 1972; "Powers Urged for '74 Mayor," ibid., October 12, 1972; "Transition Unit Gets Support," ibid., February 6, 1973. For a discussion of the initiation of the strong-mayor plan, see chapter 22, 141.

337. Interview with Andrew Gleason, July 23, 2003.

338. Pennsylvania Board of Vocational Rehabilitation Minutes: October 3, 1952, April 10, 1953, October 1, 1953, November 4, 1954, and January 6, 1955; "Johnstown Chosen for New State…Center," *Tribune-Democrat*, August 24, 1954; "Rehabilitation Center," editorial, ibid., August 25, 1954; "Rehabilitation Center," editorial, ibid., January 19, 1955; "$4 Million Added For Construction," ibid., February 25, 1955; "'Rehab' Center Best Anywhere, Leader Asserts," ibid., October 27, 1958; "Boost in Rehabilitation Funds Sought As Bids Top $7 Million," ibid., December 15, 1955; "Rehab Center Admitted 300 In First Year," ibid., May 6, 1969.

339. "Rehab To Get 'Hi's Name," ibid., July 12, 1979.

19. All Politics Is Local: Political Developments from 1950 to 1980

340. "Ike Captures Cambria," *Tribune-Democrat*, November 7, 1956; "Fund Inquiry Said Routine," ibid., January 15, 1957; "John Torquato Asked to Quit," ibid., January 22, 1957; "More Light Needed on Torquato Affair," editorial, and "Torquato Says He'll Continue as Party Boss," ibid., January 23, 1957; "Andrews Blames Big Interests," ibid., January 25, 1957; "Top County Democrats Break with Torquato," ibid., March 21, 1957.

341. "Conway, Evans Win; Council Race Tight," ibid., May 22, 1957; "Shields and Johnson New City Councilmen" and "Cambria Unofficial Returns," ibid., November 6, 1957; "Court Told Torquato, Molino Ash 'Cut' Calculated in Bid," ibid., May 28, 1957; "5 Given Jail Sentences in Cinders Deal Fraud," ibid., May 31, 1957; "Hasson Wins Backing in Opposing Torquato," ibid., May 6, 1958; "Democrats Battle For Committee Jobs," ibid., May 21, 1958.

342. Louis Saylor (1890–1966), a Republican councilman from 1956 through the end of 1959 and previously a longtime West End magistrate, was no apparent kin to Congressman John Saylor.

343. "Shields and Johnson New City Councilmen," *Tribune-Democrat*, November 6, 1957; "Grandinetti Chosen For Council," ibid., July 8, 1958; "Johnstowners Subjected to One-Man Rule," ibid., July 9, 1958; "Krumenacker Fired by 4 to 1 Council Vote," ibid., July 10, 1959. The anti-Gleason coup is discussed in chapter 18, section III, "The Redevelopment Authority–City Government Feud," 101.

344. "City, County Democrats Gain Landslide Victory," *Tribune-Democrat*, November 4, 1959; "Move to Revive Cambria GOP To Be Started," ibid., November 6, 1959; "Crossroads Politics—'Good Show,'" ibid., April 13, 1960; "Saylor Wins Again; Bucks Democratic Tide," ibid., November 9, 1960; "Shields Bolting GOP," ibid., February 18, 1961; Daniel Shields's obituaries, ibid., May 4, 1961, and May 5, 1961.

345. "Malloy Is Appointed to Council Position," ibid., May 23, 1961; "McCloskey, Malloy Run Far Ahead for Council," ibid., May 17, 1961; "McCloskey and Conway Build Up Big Margins," ibid., November 8, 1961; "McCloskey to Hold His Own Inauguration," ibid., December 27, 1961.

346. "Perry Leads Walter By 16-Vote Margin," ibid., May 16, 1962; "Some Surprises in the Primary," editorial, ibid., May 17, 1962; "Perry Defeats Walter Despite Absentee Vote," ibid., May 26, 1962; "Cambria GOP Credited With Major Upset," ibid., November 8, 1962; "Andrews Ends Official Duties," ibid., January 26, 1963; "Walter Says He'll Not be a Candidate," ibid., March 5, 1963; "Blame Put on Mayor, Burns Case," ibid., November 14, 1961.

347. Statement made by Curt Davis, a former colleague of Lynch's at Johnstown High School. Lynch was killed in an automobile accident in early October 1971.

348. Private conversation with Gus Margolis on October 13, 2003. Margolis was the late Louis Coppersmith's law partner. Bill Joseph, County Democratic chairman following Torquato's tenure and earlier Torquato's secretary, disputes this view. He stated that after Coppersmith had gotten elected, Coppersmith and Torquato "mended their fences."

349. A procedural change would have required an overhaul of the party's rules, upsetting the process all over Pennsylvania.

350. Ferdinand Bionaz, district attorney; Joseph Gorman, county commissioner; Joseph Dolan, prothonotary; Michael Hartnett, register of wills; Robert Casey, recorder of deeds; and Stephen Oblackovich, clerk of courts.

351. Joseph Roberts, county commissioner; Robert McCormick Jr., county controller; Spear Sheridan, county treasurer; and Joseph Govekar, coroner.

352. "Dolan Says CID Has Answers," *Tribune-Democrat*, May 11, 1963; "Primary Returns," ibid., May 23, 1963; "It's Up to CID, Democrats Say," ibid., July 13, 1923; "CID Yes; Torquato No," ibid., June 28, 1963; "Regulars Lauded By Torquato," ibid., August 22, 1963; "CID Blasts Torquato and Gleason," ibid., September 26, 1963; "New Peace Appeal," Crossroads Politics, ibid., October 9, 1963; "As for CID, Forgive Them," ibid., October 24, 1963; "What's Next for the Democrats?" Crossroads Politics, ibid., November 6, 1963; "Unofficial Election Returns," ibid., November 7, 1963; "No Decision," Crossroads Politics, ibid., November 20, 1963; "CID Candidate Said Available," ibid., January 21, 1964; "No Change in Chairman," Crossroads Politics, ibid., February 6, 1964; "CID Fires at Gorman," ibid., February 8, 1964; "Bionaz Denies CID Dictated to Gorman," ibid., February 18, 1964; "Changing Times," Crossroads Politics, ibid., May 6, 1964; "Where Was the CID?" Crossroads Politics, ibid., June 9, 1965.

353. J.J. Haluska was elected state senator from Cambria County first in 1936. He had served every term since then except from 1961 through 1964, a result of his loss to Ernest Walker in 1960.

354. "Cambria County, Complete Unofficial Returns," *Tribune-Democrat*, April 24, 1968; "Coppersmith Scores Upset; Saylor Wins," ibid., November 6, 1968; "Coppersmith's Lead Hits 65 As Count Ends," ibid., November 29, 1968.

355. "Metzger vs. Murtha vs. Mesko," Crossroads Politics, ibid., May 7, 1969; "Murtha Makes Swearing-In Arrangements," ibid., February 7, 1974.

356. "Most Courthouse Employees Donate," ibid., March 2, 1960; "No Change in Chairman," Crossroads Politics, ibid., February 26, 1964; "Where Was the CID?" Crossroads Politics, ibid., June 9, 1965.

357. Interview with Herb Phul Jr. on August 21, 2003.

358. Ferg, "The Politics of Improvement," vi–11.

359. Wid Shonek, obituary, *Tribune-Democrat*, September 28, 2001. Schonek (1913–2001) earlier had worked for Penelec and the Automotive Supply Company. In 1946, he was a co-founder and co-owner of Dick's Automotive, Inc., which eventually expanded into West Virginia, Maryland and along the western coast of Florida. He owned and operated the Schonek Insurance Agency and became a long-serving member of the Johnstown-Cambria County Airport Authority. He also had major interests in radio and television in Sarasota County, Florida.

360. Interview with Johnstown attorney Richard J. Green on October 15, 2003.

361. "W.E. Schonek Recommended," *Tribune-Democrat*, December 1, 1970; "Schonek Fired As Racing Commissioner," ibid., July 3, 1972.

362. Interview with Andrew Gleason on October 20, 2003.

363. "NAACP Chapter Reelects Collins," *Tribune-Democrat*, December 16, 1970.

364. Interview with Mark Singel, November 3, 2003. Mark Singel is married to the late Wid Schonek's daughter, Jacqueline. He was a state senator (1981–87) and served two terms as Pennsylvania's lieutenant governor (1987–95), becoming "acting governor" for several months during Governor Robert Casey's surgery and recouperation. An estrangement developed between Schonek and Singel. While the facts of this falling out are not publicly known, they were rooted in Schonek's boisterous, domineering personality clashing with Singel's independent nature. Schonek had wanted Mark Singel to run against Congressman Jack Murtha. Singel refused. Singel was also embarrassed and troubled by Schonek's racist and anti-Semitic leanings and loud uttering about them in public places.

365. See chapter 21, 135. Tompkins's subsequent conviction for extortion in connection with a city cable television franchise doubtless colors Tompkins's reputation. Had he never gotten implicated in the cable scandal, he would have fared better in people's later memory of him.

366. Paul Malinowsky had served in the merchant marine during World War II when he had made the hazardous "Murmansk Run," for which he was cited by the Russian government following Glasnost. He had also been a professional boxer, a light heavyweight. In the commission form of government, Malinowsky had been in charge of parks and playgrounds, an assignment he pursued diligently. He had a spotless reputation for both hard work and integrity.

367. At this point, the City of Johnstown had established a charter commission and had adopted its recommendation for a strong-mayor plan of Municipal Government. There would be nine councilmembers. See chapter 18, section VI, "A Strong-Mayor Charter Initiative," 114. For the launching of the Strong-Mayor Plan, see Chapter 22, 141.

368. The effort was also referred to as the "Gleason Probe."

369. "Shapp Brands Gleason Probe an 'Inquisition,'" *Tribune-Democrat*, October 12, 1974; "Gleason Panel Surrenders Records," ibid., December 5, 1974; "No Decision on How Report Will Be Handled," ibid., January 2, 1975; "Didn't Walk Out on Probe—Gleason," ibid., January 8, 1975; "No Macing Found by Abood," ibid., December 8, 1975; Readers' Forum, letter from District Attorney Caram Abood and "Either There Was Macing Or There Wasn't," editorial, ibid., December 15, 1975; "Torquato…in PennDOT Charged With Extortion," ibid., November 2, 1977; "Torquato: Grand Jury Indictment a Surprise" and "Torquato Blames GOP for Ills," ibid., November 3, 1977; "Grand Jury Returns 23-Count Indictment Against Torquato," ibid., February 11, 1978; "Torquato Convicted on All Counts; 2 Others Also Guilty," ibid., June 10, 1978; "The Torquato Conviction," editorial, and "Gleason Hails Convictions, Says Bigger Issues Remain," ibid., July 1, 1978; "Gleason Memo Names Names, Including GOP Chief Gleason's," ibid., July 23, 1978; letter from Richard Thornburgh, Readers' Forum, ibid., August 9, 1978; "Torquato Verdict: Not Guilty," ibid., September 8, 1978; "The Torquato Case," editorial, ibid., September 11, 1978; "Torquato Loses Post-Trial Bid," ibid., October 14, 1978; "Torquato Sentenced," ibid., November 19, 1978; "Appeal Lost by Torquato," ibid., July 6, 1979; "Patrick A. Gleason Dead at 47," ibid., February 18, 1982; "John Torquato Dead—End of Era," ibid., April 22, 1985.

370. Throughout this section about politics in 1955–1980, I have relied extensively on the analytical articles by the late Robert John, a political writer for the *Tribune-Democrat*. Especially valuable was his ongoing column Crossroads Politics. People active in politics with both parties have consistently spoken highly about John's coverage and explanations. Although John may have been critical of what they had been doing, every political leader I consulted judged his work "fair and accurate." Interview with Bill Joseph, chairman of the Cambria County Democratic Party, October 30, 2003.

20. Highway Developments in the Post–World War II Era

371. "Time To Wake Up," editorial, *Johnstown Tribune*, February 18, 1949; interview with David Belz, Cambria County Transportation Planner, June 17, 2003.

372. Capper, *Pennsylvania Turnpike: A History*; "Engineering Dream of All Weather Highway May Be Built On Site Of South Penn," *Johnstown Tribune*, January 22, 1937; "Now Hope To Extend South Penn Highway Clear Across State," ibid., February 1, 1938; "Joint Committee Favorably Reports on 'Super-Highway,'" ibid., March 4, 1937; "Presidential Approval Of WPA Project Assures Start On Superhighway," ibid., April 9, 1938.

373. U.S. Bureau of Public Roads, *Toll Roads and Free Roads*.

374. "Ambitious 1939 Program Adopted by Highway Unit of Chamber of Commerce," *Johnstown Tribune*, December 21, 1938.

375. "Toll Road From City to Harrisburg Urged," *Tribune-Democrat*, April 21, 1953.

376. "Cut Us In on the Interstate Highway," editorial, ibid., June 28, 1956; "Who Would Benefit From the 'Shortway'?" editorial, ibid., November 21, 1956; "Need Better Roads? Blame the Shortway," editorial, ibid., January 16, 1957; "Shortway Does Nothing for Western Pennsylvania," ibid., June 13, 1957; "Road Plan Splits Pennsylvanians," *New York Times*, August 17, 1958.

377. "Long-Range Plan To Develop Highway Network Unfolded By State Commission," *Johnstown Tribune*, January 11, 1951; "Big Road Jobs Planned Here," *Tribune-Democrat*, January 9, 1957.

378. McNally's presence at this meeting was significant. In 1960 he was elected to the first of several terms (January 1961 until his death in November 1968) in the Pennsylvania House of Representatives. He also would serve on the Pennsylvania Highway (later Transportation) Commission.

379. "Big Road Jobs Planned Here," *Tribune-Democrat*, January 9, 1957.

380. "Report on Highway Prospects for City," editorial, ibid., March 19, 1958; "Fast Action Needed To Get New Roads," editorial, ibid., February 17, 1959; "Lawrence Supports Access Road Improvements in Area," ibid., April 21, 1959; "June 26 May Be Important Date," editorial, ibid., June 6, 1959; "219 May Lose Stepchild Status," editorial, ibid., July 11, 1959; "New Highway Here Approved," ibid., September 9, 1959; "New Route 219's Importance Is Emphasized," ibid., June 14, 1960; "Windber Bypass Opens," ibid., October 6, 1960; "Major Highway To Start Next Summer" (with map), ibid., November 30, 1960; "Secretary Martin Cites Road, Bridge Plans," editorial, ibid., February March 61; "New 219 Bypass Moves Step Closer," editorial, ibid., May 11, 1961.

381. "Enthusiastic Backing Given Route 219 Plan," ibid., June 3, 1961.

382. "Scranton, Dilworth Pledge Aid For Highways Here," editorial, ibid., October 3, 1962.

383. "Completion by '67 Predicted for Richland-Route 22 Job," ibid., March 16, 1964.

384. "Route 219 Will Bypass City," ibid., November 17, 1967; "Route 219 Job Moving Faster Than Planned," ibid., July 3, 1969; "Construction of Route 219 Started 28 Months Ago," ibid., December 11, 1969; "Opening Near For Route 219," ibid., June 20, 1970.

385. "School Board Calls for Road Hearing," ibid., July 30, 1965; "Benefits of Road Stressed," ibid., August 26, 1965; "Cross-Kernville Road To Get Thorough Study," ibid., May 11, 1966; "'69 Start Seen On Expressway," ibid., January 11, 1968; "Expressway Demolition Nears End," ibid., May 6, 1970; "Road-Opening Program Listed," ibid., November 2, 1972.

386. "Association To Promote Route 219 Is Planned," ibid., March 2, 1964; "Drive Set On 219 Extension," ibid., September 30, 1965; "Route 219 North Said Remedy for Area's Economic Ills," ibid., April 28, 1966.

387. "State, Route 219 Not On Interstate List," ibid., December 16, 1968; "219 Interstate Status Given Federal Setback," ibid., February 4, 1970.

21. The Stench of Crime

388. Pennsylvania Crime Commission, *Report on the Conditions of Organized Gambling and the Administration of Criminal Justice in Johnstown, Pennsylvania*, 43. The *Tribune-Democrat* was incessantly editorializing against gambling in Johnstown throughout the postwar period into the 1970s. Its writings suggested gambling was widespread.

389. "Mayor Declares War On Gambling," *Tribune-Democrat*, June 4, 1960.

390. "Patrons of Rackets Might Think of This," editorial, ibid., September 9, 1961; "Federal Aid Pledged In Fight on Rackets," ibid., October 11, 1961; "Cambria Ought to be—Mayor," ibid., February 8, 1963; "City Rackets Worse Than Most Thought," editorial, and "Mayor Wants 'Big Fish' Caught," ibid., May 11, 1963; "Mobs, Not Local Bookies, Run Gambling Here—Mayor," ibid., May 15, 1963; "43 Nabbed by Federal, State Agents in Mass Gaming Raid," ibid., November 8, 1963. Federal law did not outlaw gambling. Its agents enforced a requirement that gamblers had to procure and display federal gambling stamps, a revenue measure.

391. "Says Mayor Should Quit," *Tribune-Democrat*, November 3, 1961; "Mayor Walter Blasts McCloskey, Tompkins," ibid., November 6, 1961; "Payoff Hotly Denied At Council Hearing," ibid., November 14, 1961.

392. Pennsylvania Crime Commission, *Report on the Conditions of Organized Gambling*, 50–52.

393. "Joint City-County Drive on Rackets," editorial, *Tribune-Democrat*, January 17, 1964; "Mayor Blasts Bionaz After State-County Raid in City," ibid., March 27, 1964; "Rackets Not at Work Here, Tompkins Says," ibid., January 23, 1965; "Want to Bet You Can't Gamble?" and "It's Petty Says Mayor on Gambling," ibid., May 20, 1965.

394. "Ex-Mayor of Johnstown Tells of Teleprompter Bribe Offer," *New York Times*, October 14, 1971; p. 90.

395. "Facts About Cable TV's Johnstown Contract," *Tribune-Democrat*, January 28, 1971; "Who Will Evict Cable TV Firm If Another Comes In?" ibid., January 22, 1966; "Teleprompter To Come Out Fighting, Council Warned," ibid., January 25, 1966; "Teleprompter Gets Franchise," ibid., February 2, 1966; "Pfuhl Raps TV Pact Procedure," ibid., February 3, 1966.

396. "Tompkins Talks at Kahn Trial," ibid., October 14, 1971.

397. For some reason, this issue was not preserved on microfilm, one of the very few skips in about one hundred years of the *Johnstown Tribune* or *Tribune-Democrat*.

398. "Crime Probers Find Organized Gaming, Payoffs," *Tribune-Democrat*, October 29, 1971; "The Crime Report," ibid., November 3, 1971.

399. Sifakis, *The Mafia Encyclopedia*, 181–82.

22. A NEW DAY AT CITY HALL: JOHNSTOWN LAUNCHES THE STRONG-MAYOR PLAN

400. "Publisher's Wife, Son, Niece Victims" and "Speakers Call for City Unity," *Tribune-Democrat*, January 7, 1974; obituary of W.W. Krebs,. ibid., March 26, 1974, and March 27, 1974.

401. "Pfuhl Picks W.H. Heslop For Key Job," ibid., November 23, 1973; "Pfuhl Chooses Harold Jenkins," ibid., December 3, 1973; "Mayor Spells Out Details of New City Government," ibid., January 2, 1974; Crossroads Politics, ibid., January 16, 1974.

402. Interview with Harold Jenkins on August 8, 2003.

403. "Gleason Agency Is Named Insurance Broker," *Tribune-Democrat*, November 6, 1974; "City's Insurance Deal," editorial, ibid., November 7, 1974; "It's A Change, Officials Agree…" ibid., January 15, 1975; "Initiative—Does the Mayor Act Too Independently?" ibid., January 16, 1975; "Criticism Not All Bad," ibid., January 17, 1975; Interview with Victor Bako on August 19, 2003.

404. "Recreation Plan Approved," *Tribune-Democrat*, August 2, 1972; "Face Lifting for Roxbury," ibid., March 7, 1973; "Roxbury Bids Total $434,830," ibid., May 29, 1973; "Roxbury Job Nears Finishing Stage," ibid., June 13, 1974.

405. See chapter 18, section IV, "The Sewerage System," 105.

406. "Sewage Plant Control Urged," *Tribune-Democrat*, May 23, 1974; "City Council Okays Taking Over Dornick Point Treatment Plant," ibid., September 12, 1974; "Sewage Plant Switch," editorial, ibid., September 18, 1974; "Problems Seen for City Plan," ibid., October 31, 1974; "Suburbs to Fight JMA Take-Over In Court," ibid., March 8, 1975; "City Seeking Court Order Against JMA," ibid., March 19, 1975; "JMA Clears the Way," ibid., March 27, 1975; "City Takes Over System," ibid., May 1, 1975.

407. "Revenue passenger" means one trip made by a paying customer.

408. Cambria County Planning Commission, *Mass Transit*.

409. "Johnstown Chamber Adopts Operating Budget," *Tribune-Democrat*, June 25, 1974; "3 Local Groups Will Discuss Bus Situation," ibid., June 26, 1974.

410. "City Accepts Transit Role," ibid., July 12,1974.

411. "Service in Some Areas Will Be Slashed—Reitz," ibid., September 13, 1974.

412. "Pfuhl: City Won't Join," ibid., June 7, 1976; "City Still Recipient of Transit Funds, JTSA Told," ibid., July 10, 1976; "Transit Showdown Fails to Materialize," ibid., July 14, 1976; "County Recommended As Bus-Fund Recipient" and "City Drops Transit Effort," ibid., July 29, 1976; "Transit Authority Briefed on Goals, Duties," ibid., August 3, 1976; "Pfuhl, Metzger in Argument," ibid., August 7, 1976.

413. "No City Transit Agreement," ibid., October 20, 1976; "Sign, Mr. Mayor," editorial, ibid., October 27, 1976; "Does City Really Stand to Lose on Mass Transportation?" ibid., November 11, 1976; "Poor Performance," editorial, ibid., November 24, 1976.

414. "Jenkins Named Manager of Transit Authority" and "It's Time to Heal Wounds—Jenkins," ibid., September 2, 1976; "Authority Covers Transit Losses Through October 1," ibid., September 28, 1976; "Expanded Bus Service Begins Monday in Area," ibid., December 11, 1976; "Traction Company Purchase Cleared," ibid., April 26, 1977; "Federal Transit Grant Approved For Authority," ibid., July 14, 1977.

415. "Democrats Rap Mayor Pfuhl," *Tribune-Democrat*, May 8, 1975; "'All We Know About City Business Is What We Read'—Walter," ibid., May 14, 1976; "Walter Blasts Pfuhl; Denies Campaigning," ibid., November 11, 1976; "Councilmen Vent Frustration With Pfuhl," ibid., November 20, 1976.

416. "Pfuhl Vetoes City Budget Ordinance," ibid., December 31, 1975; "Council Overrides 2 Vetoes," ibid., January 2, 1976.

417. "Pfuhl's Veto Is Overridden," ibid., March 11, 1976; *Pfuhl v. Kleinmeyer.* 75 PA D. and C. 2nd 337 (1976).

23. A RESTRAINED MILITANCY: JOHNSTOWN'S POSTWAR BLACK COMMUNITY

418. "NAACP Leader Speaks Against Discrimination," *Johnstown Tribune*, November 12, 1947.

419. Interview with Hope Johnson on November 11, 2003. Marion Holton Patterson, said to be Johnstown's first black hospital nurse, was initially listed as a Mercy Hospital nurse in the Polk's Johnstown City Directory for 1962.

420. The Johnstown Urban Region as herein defined consists of Johnstown City plus all the boroughs and townships that physically adjoin the city together with Richland Township, Brownstown Borough and Geistown Borough—nineteen localities in all, including Johnstown City.

421. "Percy Johnson, Negro, Named Alderman Here," *Johnstown Tribune*, November 12, 1947; "7 Incumbents Among 10 City Aldermen Elected Tuesday," ibid., November 6, 1947; "Miss Gordon Named to Post of Alderman," *Tribune-Democrat*, January 2, 1957.

422. Hollis and Hollis, *Saga of Johnstown City Schools*, chapter IX, "Hollis—National Educator, " 2003. Hollis had joined the Greater Johnstown School District staff in the summer of 1975 as director of secondary education. He later became assistant superintendent. His career is covered in the above citation.

423. Minutes of the Johnstown City Council Meetings, August 8, 1979; January 7, 1980; and July 22, 1991. Also election returns in *Tribune-Democrat*, November 4, 1987, November 5, 1987, and November 6, 1991. In November 1971, two black men, Saul Griffin and Reverend Andrew Tilly, were elected to the Johnstown Charter Commission, an ad hoc, single-purpose position that ceased to exist when the commission's work was completed.

424. The Johnstown Branch of the NAACP was founded in late 1917 or early 1918. In an article in the *Johnstown Tribune* of April 11, 1918, "Hon. J.W. Johnson Will Speak Here," its new officers were listed.

425. Ferg, "The Politics of Improvement," iv–12.

426. "NAACP Branch Rejects 'Black Power,' Violence," *Tribune-Democrat*, September 8, 1966.

427. "City Curfew Stays; Other Rules Lifted," *Tribune-Democrat*, April 8, 1968; "Dr. King Eulogized…" and "NAACP Unit Reaffirms Stand Against Violence," ibid., April 9, 1968; Hollis and Hollis, *Saga*, 172.

428. Laws of Pennsylvania: Act No. 222 of the 1955 Legislative Session. Acts No. 19 and 341 of the 1961 Legislative Session. Act 533 of the 1965 Legislative Session.

429. "City Council Enacts Human Relations Law," *Tribune-Democrat*, March 9, 1971; "City Commission Is Ready to Act," ibid., September 15, 1971.

430. Keyes, *Rehousing Johnstown*. *Rehousing Johnstown* is a preliminary feasibility study into the need for public housing in Johnstown. "Negro Housing Project Needed," editorial, *Johnstown Tribune*, July 9, 1941; "Johnsons Played Major Part in Removing Discrimination," *Tribune-Democrat*, February 12, 1980 (Special Black History Supplement), 8.

431. See chapter 15, section II,"Housing," 52.

432. "Negro Quota Rule Slows Filling of Prospect Homes," *Johnstown Tribune*, January 16, 1943.

433. "Board Rescinds Action Limiting Negro Occupancy," ibid., February 26, 1943.

434. "NAACP Hits Segregation," *Tribune-Democrat*, November 13, 1952; "No Color Line At Homes, Authority Tells NAACP," ibid., March 12, 1953.

435. "Housing Policy Is Questioned," ibid., March 12, 1953; "State Unit Issues Orders on Housing," ibid., December 16, 1970; ibid., December 16, 1970; "More Blacks Occupying Public Housing In City," ibid., December 16, 1970; Ferg, "The Politics of Improvement," iv–16.

436. See chapter 24, "The Central Business District Under Seige," section III,"Market Street West," for a discussion of the Workable Program requirement and the NAACP's using it to attain Black goals.

437. "Decision Soon On School Plan," *Tribune-Democrat*, June 15, 1971; "School Closing Taken to Court," ibid., August 21, 1971.

438. "Youth Shot Fatally; Policeman Charged," ibid., March 31, 1969; "Panel Indicts City Policeman In Boy's Death," ibid., June 4, 1969.

439. Interview with Hope Johnson on November 11, 2003.

440. "Cunningham Renews Charges," *Tribune-Democrat*, June 10, 1969; interviews with Allen P. Andrews, student in 1969, and Claudia Jones, an instructor in 1969 at Joseph Johns Junior High School, November 11, 2003; "City Board Draws NAACP Criticism," *Tribune-Democrat*, May 13, 1969; Hollis and Hollis, *Saga*, 171–74.

24. THE CENTRAL BUSINESS DISTRICT UNDER SIEGE

441. "Penn Traffic Reports 'Biggest-Day' Record," *Tribune-Democrat*, October 7, 1955.

442. Johnstown City Directories for 1869, 1876, 1884, 1889 and 1900. Miss Mary Jane Foster, Andrew Foster's granddaughter. Foster's had its origins in 1854 as a partnership between John Geis and J.J. Murphy on the northern corner of Clinton and Adams Streets and operated until 1862. John Geis then opened a large, general merchandise store at 113–15 Clinton Street. After he sold out in 1868 to his son, William Geis, and his son-in-law, Andrew Foster, it operated as Geis and Foster. By 1884 a cousin, James Quinn, joined the two and the store operated as Geis, Foster, and Quinn. After Geis withdrew and started the Geis Furniture Company on Clinton Street in 1894, the remaining two cousins operated as Foster and Quinn. By 1900 James Quinn had separated from Foster to start a dry goods and notions firm of his own. Eventually located at Bedford and Main Streets, Andrew Foster and later his sons and heirs operated as Foster's. In 1960 the century-old firm went out of business.

443. Founded in 1933 by Fred S. Suppes, Walter R. Suppes and his father-in-law, Samuel B. Waters, Suppes Motor Sales was first located on Bedford Street across from the Haynes Street Bridge. The Johnstown Automobile Company site at Main and Johns Streets had been used for automobile sales since 1910 when the Johnstown Automobile Company became a distributorship for Cadillac in a building constructed in 1909 by Charles S. Price, then soon-to-be president of the Cambria Steel Corporation. Over the years, the Johnstown Automobile Company had also become an area distributorship for other brands of vehicles including LaSalle, Oldsmobile and finally Chevrolet. Cadillacs were actually assembled in the building from parts shipped by rail. In 1933 the Johnstown Automobile Company spun off

its parts and accessories division through the creation of a new concern, the Cambria Equipment Corporation, first located in old Millville near the PRR Passenger Station at the base of the Prospect Viaduct. "Johnstown Automobile Company Relinquishes Accessories Division," *Johnstown Tribune*, July 26, 1933; "Johnstown Auto Building To Be Occupied by Suppes Co.; Lease Signed Today," ibid., October 5, 1935; personal conversations with Fred Suppes and Charles S. Price, October 2003.

444. Polk's Johnstown City Directories, especially the 1954, 1955 and 1956 editions; Sanborn Map Company, *Johnstown, PA Structural Survey Maps*; "Glosser Store…Formal Opening," *Johnstown Tribune*, November 16, 1931; "Capitol Building Leased by Thomas Department Store," ibid., November 9, 1936; "New J.C. Penney Department Store Opens Tomorrow," ibid., April 19, 1939; "Capital Hotel Here Changes Hands At Public Sale Today," ibid., August 31, 1940; "Grant's Store Here One Of Largest Built Since 1908," ibid., March 7, 1952.

445. "City's New Postoffice Building Dedicated," ibid., September 24, 1938; "Tribune to Launch Building Program," ibid., February 24, 1940; "Bethlehem's New Office," editorial, *Tribune-Democrat*, June 9, 1954; "Analysis Says Downtown Old, Obsolete," ibid., February 8, 1961.

446. Buchart-Horn Engineers, *Johnstown Central District Plan*, 30–32. The 1962 CBD Plan documents convincingly that there was little new investment taking place in the Johnstown downtown in the late 1950s and early 1960s but offers little analysis of the reasons.

447. "Penn Traffic Closes $235,000 Deal for Capital Hotel," *Tribune-Democrat*, June 6, 1955.

448. "C of C, Dale Bank Will Be Neighbors," ibid., March June 59.

449. "Downtown Motel—$200,000 Job Started Here," ibid., March 11, 1959.

450. "Local Group Buys Main Street Site," ibid., June 3, 1961.

451. "Curtain Going Down On Cambria Theater," ibid., December 2, 1959.

452. "2 Properties Change Hands," ibid., January 4, 1961; "Downtown Landmarks To Be Razed," ibid., July 27, 1961; "Glosser Annex To Be Enlarged," ibid., July 31, 1962.

453. "Geis Store Building Is Sold," ibid., July 16, 1966.

454. "Main Street Building Is Sold," ibid., August 6, 1963.

455. "City Sells Old Post Office To Crown Construction Co," ibid., March 7, 1967.

456. "U.S. Bank Looks Ahead," ibid., March 18, 1972.

457. "2 Buildings To Be Razed for Center," ibid., May 21, 1973.

458. "Capitol Building Coming Down," ibid., April 27, 1978.

459. "Downtown Johnstown Putting On New Face," ibid., September 11, 1970; "Cambria Savings Expansion," ibid., January 4, 1974; "Downtown Building Will Be Torn Down," ibid., March 31, 1977.

460. "U.S. Bank Confirms Plans For New Headquarters," ibid., August 19, 1976; "U.S. Bank Launches Expansion," ibid., April 20, 1978; "Modern Day Jericho," ibid., October 25, 1977.

461. See chapter 18, section IV, "Planning Initiatives," 107, and chapter 20, "The Route 56 Bypass and the Cross-Kernville Expressway," 133.

462. Pawlowski, "History of City Planning in Johnstown," (chapter 14, in Berger, Karl, editor. *Johnstown—The Story of A Unique Valley*), 468–70; "Downtown Old, Obsolete," *Tribune-Democrat*, February 8, 1961.

463. "Planners Ask Study of Business District," ibid., September 27, 1960; "Planning Study Fund Approved," ibid., October 26, 1960; "Survey of Downtown Area Ready To Start," ibid., April 5, 1961.

464. Buchart-Horn Engineers, *Johnstown Central District Plan*; "Multi-Million Improvement Plan For Downtown Unveiled," *Tribune-Democrat*, May 25, 1962; "Here's Planners' Concept of Rejuvenated Downtown Johnstown," ibid., June 25, 1962.

465. "Action Urged On City Plans," ibid., June 7, 1962.

466. "Urban Renewal Policy Outlined," ibid., February 27, 1963; "Major CBD Renewal Eyed," ibid., March 12, 1963; "Council Takes Step in New Redevelopment," ibid., April 2, 1963.

467. "Only 1 Proposal Presented," ibid., June 8, 1965; "Firm Selected As Redeveloper For Market St.," ibid., June 9, 1965; "Delay Can Hurt Urban Renewal," editorial, ibid., June 15, 1965; interview with John Sroka on September 17, 2003.

468. "Renewal Hearing Air Is Stormy at Times," *Tribune-Democrat*, February 8, 1966; "A Unanimous Vote For Progress," editorial, ibid., March 3, 1966; "Market Street West Wallowing," editorial, ibid., September 3, 1966; "Market Street West—at Last!" editorial, ibid., September 30, 1966.

469. See also chapter 23, "A Restrained Militancy," "The NAACP and Other Johnstown Community Issues," 152.

470. "Enclosed Shopping Mall Okayed for Renewal Area," *Tribune-Democrat*, September 7, 1967.

471. "Redevelopment Area Land Transfer Okayed," ibid., April 4, 1968; Torquato letter in the Readers' Forum, ibid., April 18, 1968.

472. "More Trouble in Renewal," ibid., July 9, 1969; "Market Street Job Said Success Story," ibid., August 1969; Johnstown Redevelopment Authority Minutes for meeting, June 22, 1970.

473. "4 of 5 On Authority Threaten To Resign" and "Redevelopers Get Council Blessing," *Tribune-Democrat*, May 27, 1969.

474. "City to Be Beehive With Market Street West…" ibid., February 21, 1971.

475. "Authority Okays Apartment, RC Building Plans," ibid., October 5, 1971; "Zamias Plans To Develop New Site," ibid., August 10, 1971; "Authority Okays Sale To Crown for Sheraton Inn," ibid., February 1, 1971; "Jonel Will Build July Story Complex," ibid., May 13, 1972; "13.5 Million Downtown Facelift Nearing End," ibid., January 31, 1973; "Market Street West," editorial, ibid., May 23, 1973.

476. "Library Looks Toward New Building…" and "Needs New Quarters," ibid., April 5, 1968; "Library Offered $348,000 Gift Toward New Building," ibid., August 1, 1968; "Library Building Plan Is Approved," ibid., April 30, 1968; "Board to Push For a New Library" and "Project Library Site No Longer Available," ibid., August 20, 1968; "Earth Turned for New Library," ibid., October 31, 1970; "Library System Dedicates Unit," ibid., October 9, 1971.

477. "Parking Group Reactivated," ibid., June 15, 1960; "4-Level, 306-Car Municipal Garage Is Planned for City," ibid., February 8, 1969; "$685,000 Assistance Grant Okayed for Parking Garage," ibid., September 20, 1969; "Council Okays Parking Unit," ibid., November 18, 1969; "Parking Garage," editorial, ibid., March 20, 1970; "Authority Takes Surprise Move," ibid., April 14, 1970; "Money Provided to Build Parking Garage," ibid., June 5, 1970; "Developers OK Condemnation," ibid., June 23, 1970; "Zamias Plans To Develop New Site," ibid., August 10, 1971; "Inroads Made Throughout Downtown," ibid., February 22, 1972; Johnstown Redevelopment Authority Meeting Minutes, especially for October 3, 1969, June 22, 1970, and March 8, 1971.

478. See Chapter 16 about the postwar Johnstown economy; Section 6, the subsection, "The Penn Traffic Metamorphosis—the Merger," also "440-Acre Tract of Land In Westmont, Lower Yoder Sold By Bethlehem to Local Men: Development Planned," *Johnstown Tribune*, December 14, 1945.

479. "Shopping Center To Be Expanded," *Tribune-Democrat*, October 9, 1956.

480. "Glosser Bros. Plans …" ibid., February 27, 1963. See also chapter 16, section VI, "Gee Bee Outlets," 79.

481. "Grant's Names 2 Managers," ibid., July 12, 1966; "Grant Center Fully Occupied," ibid., November 3, 1966; "Sears Store On the Way," ibid., May 20, 1964; "Sears…Will Open New Store…" ibid., January 7, 1965; "Sears-Roebuck Will Open New Store Jan. 20," ibid., January 7, 1965.

482. "Richland, Developer Reach Agreement on Shopping Mall," *Tribune-Democrat*, February 6, 1973; "Richland Unit OKs Plot Plan For Mall," ibid., February 14, 1973; "Mall Developers Boost JARI Effort," ibid., September 25, 1973; "3 Major Stores Among 90," ibid., January 24, 1974; "Richland Mall From the Air" and "Hard Work, Luck Behind New Mall, Developers Say," ibid., July 17, 1974; "City Retailers Expect Mall to Deal Them a Setback," ibid., September 12, 1974; Polk Johnstown City Directories, especially 1974, 1975 and 1976.

483. See chapter 22, "The Bus Crisis," 143.

484. "City's Experimental Mall Removed After 1st Day," *Tribune-Democrat*, August 13, 1974.

485. "W.T. Grant Closing Out" and "3 Grant's Stores Shut Down," ibid., February 13, 1976.

486. "Downtown Still Has Lot Of Life, Merchants Say," ibid., January 26, 1977; "Updating of Study Notes CBD Changes," ibid., March 30, 1977; "Nagging Uncertainty Future of Downtown," ibid., April 24, 1977.

487. "City Talks of Mall on Upper Main Street" and "$10 Million Project Unveiled," *Tribune-Democrat*, October 29, 1974; "Council Gives Unanimous Okay to Main Street East," ibid., August 28, 1975.

488. Johnstown Redevelopment Authority Meeting Minutes: 1975, 1976, 1977 and 1978.

489. Interview with Edwin Pawlowski, a Johnstown architect who was heavily involved in the Main Street East Urban Redevelopment Project.

490. The Burger King was to remain. In addition to two vacant buildings, there was the Stephen Conway Funeral Home, Brett's Store (women's fashions), Minit Print (Losh Building) and the Laurel Management Building. There were also five parking lots.

491. "Let's Do It Ourselves," editorial, *Tribune-Democrat*, July 11, 1978; "$4.4 Million Federal Grant Okayed for 2 City Projects," ibid., October 5, 1978; "UDAG Funds Not for Sheraton Project, Pasquerilla Says," ibid., October 10, 1978; "3 Businesses Oppose Lee Hospital Plan," ibid., November 10, 1978; "City Planners OK Lee Design," ibid., December 29, 1978; "Lee Job to Start In Summer 1980," ibid., February 22, 1979; Johnstown Redevelopment Authority minutes for 1979, 1980 and 1981; Lee Hospital, *The Lee Hospital Legacy*, chapter 9.

492. "Housing Job Given Boost," *Tribune-Democrat*, July 11, 1967; "14-Story Apartment Planned on Main Street," ibid., May 10, 1968; "'Towers' for Elderly Soon to Become Reality," ibid., October 1, 1969; "Demand Still Growing," ibid., July 18, 1970; "Group Plans 250 Low-Rent Units," ibid., July 21, 1970; "2nd Project for Elderly Approved," ibid., September 4, 1970; ibid., July 18, 1970; "Work to Start on 13-Story Apartment Unit," ibid., January 11, 1971; "Apartments…To Open Soon," ibid., January 14, 1972; "Housing Authority Okays Apartments for Elderly," ibid., October 30, 1974; "Housing Authority Gets Full Funding," ibid., June 18, 1975.

493. The failed Point Park Mall proposal remains an "if" of history. It is discussed briefly in chapter 26, section III, "The Pathway Back to Progress," 212.

25. THE BETHLEHEM CUTBACK ANNOUNCEMENT AND THE CREATION OF JOHNSTOWN AREA REGIONAL INDUSTRIES

494. U.S. Bureau of the Census, *Statistical Abstract of the United States*.

495. Strohmeyer, *Crisis In Bethlehem*, 62, 104, 124; "Bethlehem Plans 1st Caster," *Tribune-Democrat*, November 4, 1971.

496. "Obsolescence Has Been Stalking Local Plant for Years," ibid., June 16, 1973.

497. Interview with Tom Crowley, former general manager of Bethlehem Johnstown Works, September 1979.

498. "How Johnstown 'Wires' Your Car," *Tribune-Democrat*, January 25, 1967; "Maybe You're Using Johnstown Steel," ibid., October 12, 1967.

499. "Bethlehem Plans Pollution Curbs," ibid., August 15, 1972.

500. "Johnstown Plant's Future Looks Bright," ibid., August 24, 1967; "Startup Target Set For Caster," ibid., June 19, 1969; "Bethlehem Halts Work On Caster," ibid., November 29, 1969.

501. "Bethlehem Plans 1st Caster," ibid., November 4, 1971.

502. "Johnstown Mill Threatened By Ecology Suit," ibid., May 14, 1973.

503. "Bethlehem Force Increases by 1000," ibid., July 26, 1974; "Bethlehem Steel Reports Record Profits," ibid., October 31, 1974; "Bethlehem Allots Funds For Furnaces," ibid., December 21, 1974; "Bethlehem-DER Agreement Near," ibid., January 29, 1975; "$39 Million to Purify Water," ibid., January 24, 1975; "Air Cleanup Here—Bethlehem Will Spend $27 Million," ibid., April 28, 1975. For a description of the impact of the 1977 Flood on the Bethlehem Steel Corporation in Johnstown, see chapter 26, section III, "Industry: Bethlehem Steel Corporation," 208.

504. "JARI Asks DER To Withdraw Suit," *Tribune-Democrat*, March 2, 1976; "Bethlehem and DER," editorial, ibid., March 4, 1976; "Bethlehem To Start Open-Hearth Phaseout," ibid., April 28, 1976; "Coke-Oven Closing Order Is Stayed," ibid., May 5, 1976; "$70 Million BOF Project Under Way at Bethlehem," ibid., June 29, 1976; "Job of Erecting Steel Begins at BOF Shop," ibid., February 7, 1977.

505. "Bethlehem To Cut Operations In Johnstown in Half By '77," *Tribune-Democrat*, June 13, 1973.

506. "Foy To Be President of Bethlehem Steel," *Tribune-Democrat*, April 28, 1970; "Bethlehem to Keep Impact to Minimum, Foy Says," ibid., July 12, 1973.

507. "What Caused the Cutback?" editorial, ibid., June 15, 1973; "2 Denounce Clean-Air Standards," ibid., June 19, 1973; "Local Governments plan Job Strategy," ibid., July 11, 1973; "Shapp and Goddard to Meet With JARI," ibid., July 18, 1973; "Mill's Fate Might Lie In Hands Of Congress," ibid., August 17, 1973.

508. "City, Steel Leaders May Have Plan to Save Jobs," ibid., June 22, 1973. The delegation meeting with Lewis Foy was Charles Kunkle Jr., Howard Picking Jr., John Williams, Leonard Black, Frank Pasquerilla, Walter W. Krebs, H. Russell Knust, Louis Galliker and Dan Glosser.

509. "Committee Formed To Combat Cutback," *Tribune-Democrat*, June 28, 1973.

510. "Shapp and Goddard To Meet With JARI" and "Personnel of Jobs Group," ibid., July 18, 1973; "Help for JARI Pledged by Shapp," ibid., July 24, 1973; "Time and City Jobs," editorial, ibid., July 27, 1973.

511. Interview with John Burkhard, August 4, 2003; "Charles Kunkle To Head JARI," *Tribune-Democrat*, September 7, 1973; "Flynn Chosen JARI Executive," ibid., February 26, 1974.

512. "EDC Will Be $2 Million Organization," ibid., December 2, 1975; "Key JARI Group Picks…Burkhard," ibid., July 12, 1975.

513. "Urban Land Panel Begins Study of City," ibid., September 10, 1973; "JARI Officials Brief Panel On Objectives," ibid., September 11, 1973.

514. "Must Convince Residents of Threat, Kunkle Says," ibid., September 12, 1973.

515. "JARI Tops $2.25 Million Goal," ibid., June 26, 1974.

516. "Bethlehem Reverses Plans…Will Maintain Jobs, Output," *Tribune-Democrat*, May 6, 1974.

517. "JARI Begins Goals Study," ibid., July 11, 1974; "New Industry Coming Here, JARI Announces," ibid., December 20, 1974.

518. Interviews with Charles Kunkle Jr., July 2003; interview with Joseph Guiffre, former vice-president and head of the Metropolitan Mideastern Regional Office, September 11, 1979; interview with John Burkhard, former president of Johnstown Economic Development Corporation, July 4, 2004; "Metropolitan Coming to Johnstown," *Tribune-Democrat*, July 1, 1975; "Metropolitan Life to Build Quarters Here," ibid., July 2, 1975; "Richland Okays Rezoning of Site," ibid., July 8, 1975; "Met Life Event, Outlook Bright," ibid., May 27, 1978.

519. Ibid.

520. At this point in time, John Murtha had been both a founding and an active member of the Steel Caucus established by the U.S. House of Representatives in 1977. As such, he was becoming well-known and influential throughout the American Steel Industry including IC Industries.

521. "Bethlehem To End Wheel Output Here" and "Bethlehem Not Deciding Local Mill's Fate for a Year," *Tribune-Democrat*, June 24, 1978; "Abex Decision Expected Soon," ibid., June 25, 1978; "EDC to Raise $17 Million To Aid Abex," ibid., August 5, 1978; "Site Preparation Okayed for Abex Plant," ibid., November 7, 1978; "Abex to Build $57 Million Factory Near Hollsopple" and "Teamwork Was Key Factor, Leaders Say," ibid., November 21, 1978; "Salute to Project Unites 2 Counties" and "Officials: Plant Symbolic Of a New Economic Day," ibid., April 5, 1979; "Abex Till Grows By $4.7 Million," ibid., April 11, 1979; "$11.5 Million Swells Abex Plant Outlay" and "Abex Move Viewed as 'Just the Tip,'" ibid., July 31, 1979; "Welcome Abex!" ibid., September 9, 1980; "Abex Plant to Shut Down," ibid., November 8, 1981; "Abex to Halt Work Here Indefinitely," ibid., January 17,

1985; "Abex Expected to Make Comeback," ibid., March 23, 1985; "Job Picture Brightens at Abex Plant," ibid., February 19, 1988.

522. "Abex Plant Bought; Hundreds of Jobs Possible," ibid., December 23, 1988; "First Miss Steel Production Ceases," ibid., July 1, 1999.

26. All The King's Horses and All the King's Men: The 1977 Flood

523. "Anti-Flood Plans Just in Case," "Calls Swamp Insurance Agencies" and "River Job Halted," *Tribune-Democrat*, February 9, 1977; "River Walls Saluted," ibid., March 31, 1977; "Flood Prevention," editorial about Agnes aftermath, ibid., July 19, 1972; U.S. Army Corps of Engineers, Pittsburgh District, *Review of Reports on the Feasibility of Extending the Existing Channel Improvement; Johnstown, Pennsylvania*, May 1972.

524. "Everything's Cool, Penelec Reports" and "Weather," *Tribune-Democrat*, July 19, 1977.

525. "Flooding Was Unavoidable, Weather Experts Say," ibid., July 21, 1977. The exact time the rain started in Johnstown varied from place to place. Accounts of the beginning times are inconsistent. Two investigators for the National Weather Service indicated that it began raining in Johnstown as early as 6:30 p.m. A Little League baseball game at the Cochran School was called off sometime after 7:00 p.m. Around 8:00 p.m., people swimming at the Meadowvale School indoor pool were advised to leave. Richard Uzelac, who had been watching the All-Star Game on television in Franklin Borough, recalled that the rainfall began about the time the game began—around 8:30 p.m.

526. "Solomon Run Survivor Recalls Flood Horror," ibid., July 22, 1977.

527. "Dormer Perch Saved Family As Solomon Run Rampaged," ibid., July 22, 1977; "Survivor Recalls Flood Horror" and "Baumgardner Rescues Woman From Flood," ibid., July 24, 1977; "Heroes of the Johnstown Flood," ibid., September 11, 1977; "Dark Stormy Night: A Play-By-Play," ibid., July 20, 1987; "A Night Survivors Will Never Forget," ibid., July 20, 2002.

528. Interview with Daniel Glosser, president of M. Glosser and Sons, September 21, 1979. I also interviewed former Mayor Herbert Pfuhl Jr. several times about the 1977 Flood and other matters.

529. Like many things associated with the 1977 Flood, accounts vary. Some people stated that the dam had broken as eary as 2:00 a.m. on July 20. Ed Cernic Sr. figured the break had taken place at about 3:30 a.m.

530. "Flood-Flattened Tanneryville Now Valley of Desolation" and "Breast of Laurel Run Dam Breached by Rainfall," *Tribune-Democrat*, July 22, 1977; "He Held On 15 Miles and Lived," ibid., August 15, 1977; "Ed Cernic Recalls the 1977 Flood Tragedy," ibid., October 15, 1978; interview with Ed Cernic Jr., January 6, 2004; interview with Ed Cernic Sr., April 1, 2004.

531. Interview with Richard Uzelac, January 17, 2004.

532. Interview with Fred Beiser, former general superintendent of the U.S. Steel Plant at Johnstown, September 21, 1979.

533. "'Plane' Took 1500 to Hilltop," *Tribune-Democrat*, July 23, 1977.

534. "A Panicky Night in Johnstown: 'We Were All Scared to Death,'" *Pittsburgh Post-Gazette*, July 21, 1977; WJAC-TV, *Flood-77*, footage of the 1977 Flood, courtesy of WJAC-TV; "City Women Fight Way to Safety in Glosser Store" and "Patrolman Says There Was Time for Warning," *Tribune-Democrat*, July 20, 1977; "Lee Hospital Transferring All Patients," ibid., July 23, 1977; interview with Dr. Thomas Shaffer, January 8, 2004.

535. I could find no published accounts about Woodvale during the flooding. It had become impossible for reporters to reach until after the waters had receded. Emil Vavrek loaned a collection of photographs taken throughout lower Woodvale just after sunrise on July 20. In addition, Don Hysong, then Conrail trainmaster at Johnstown, who had been called out and was on duty in and near Woodvale during the flooding, drove throughout Woodvale with the author describing the conditions he vividly remembered.

536. "Cambria City Not Discouraged Despite Heavy Loss," *Tribune-Democrat*, August 23, 1977.

537. Conemaugh Valley Memorial Hospital, *Annual Report for 1977*.

538. "Flood-Weary Riverside Residents Have Some Complaints," *Tribune-Democrat*, July 24, 1977.

539. "Flood-Watch Network 'Leaks' Need Plugging," *Pittsburgh Post-Gazette*, July 31, 1977.

540. "Disaster 'Harrowing',"*Harrisburg Sunday Patriot-News*, July 24, 1977.

541. "River Backed Up, How Much?" *Tribune-Democrat*, April 1, 1979; "Engineer Disputes Theory," ibid., December 23, 1978.

542. U.S. Department of Interior, Geological Survey Professional Paper 1191, *Storm-Induced Debris Avalanching and Related Phenomena in the Johnstown Area*, a study of storm-induced mass movement forms.

543. Pennsylvania Electric Company. *Flood*, September 1977.

544. "'Til We're Normal Again, Here's How News Gets Out," *Tribune-Democrat*, July 22, 1977.

545. "Police List Flood Events Chronologically" and "Flood Experience to Aid Police," ibid., August 21, 1977; "Dark, Stormy Night: A Play By Play" and "City Firemen Were Stymied at Every Turn," ibid., July 20, 1987.

546. Johnstown City Fire Department, "Ash Street Fire Station Log for 1977"; Richland Township Police Department, "Log for July 1977."

547. "Memories of 1977 Flood Deluge Johnstowners," *Altoona Mirror*, July 19, 1992.

548. "Flood Relief Growing," *Tribune-Democrat*, July 23, 1977.

549. "Looters Hit Businesses," *Tribune-Democrat*, July 20, 1977; "What Others Are Saying," *Latrobe Bulletin*, July 30, 1977; "FBI Director Kelley Backs Pfuhl Order To Shoot Looters," *Somerset Daily American*, July 27, 1977.

550. "Lee Transferring All Patients," *Tribune-Democrat*, July 23, 1977; interview with John Unger, assistant hospital administrator in 1977, January 8, 2004.

551. "The Warnings Johnstown Never Got," *Philadelphia Inquirer*, July 25, 1977; "Man Saw Mother Swept From Home," *Tribune-Democrat*, July 21, 1977; interview with Herb Pfuhl, April 6, 2004.

552. "Stewart Found Ironies in Golfers," *Tribune-Democrat*, July 20, 1987; "For a Ravaged Flood Region, Shapp Was Johnny-on-the-Spot," ibid., July 20, 2002. Both articles by Bill Jones in anniversary issues.

553. Telephone interview with Richard Sanderson, February 25, 2004.

554. "Johnstown Flood Toll Reaches 46 As the Task of Digging Out Begins," *New York Times*, July 22, 1977.

555. "Johnstown Recovery Gains Speed," *Altoona Mirror*, July 27, 1977.

556. "Johnstown Flood Briefs—Assistance Report," ibid., July 29, 1977; U.S. Disaster Assistance Administration (Johnstown Office), *News Release of August 1, 1977*.

557. "Hud Chief Sees Devastation," *Altoona Mirror*, July 30, 1977.

558. "Organizational Efforts Building Slowly to Cope With Massive Cleanup," *Tribune-Democrat*, July 22, 1977.

559. "Facts on Flood: Paper Nightmare," *Pittsburgh Sunday Press*, July 31, 1977.

560. Mason's store in 1977 was on the same site as the Value City store in 2006.

561. "Guards Remain," *Altoona Mirror*, July 28, 1977.

562. "200 Troopers Among Unsung Heroes," *Tribune-Democrat*, July 31, 1977.

563. U.S. Army Corps of Engineers, *The 1977 Southwestern Pennsylvania Flood*, 36, 41–49, 66–69.

564. I am indebted to Susan Mitchem, director of the Salvation Army Archives and Research Center in Alexandria, Virginia, for information about the Salvation Army's role in 1977 Flood Relief and Recovery. "Salvation Army Mobilizes Units," *Indiana Evening Gazette*, July 28, 1977.

565. "Blood Donations Urgent in Aid for Johnstown Victims," *Philadelphia Evening Bulletin*, July 25, 1977. "Recovery Effort In Full Swing," *Somerset Daily American*, July 27, 1977.

566. American Red Cross, Cambria-Somerset Chapter, *An Operational History of the American Red Cross, 1946–1978*, 75–77; "Facts On Flood: Paper Nightmare," *Pittsburgh Sunday Press*, July 31, 1977.

567. "Hams Hampered by Hubbub," *Harrisburg Patriot*, July 29, 1977; "Ham Operators Give Voice to Distressed," *Altoona Mirror*, July 29, 1977.

568. "Dale Flood Aid a 'Mistake'," *Tribune-Democrat*, August 18, 1977.

569. Hutcheson, "The Role of Ecumenical Organizations in Flood Recovery."

570. "Area Units Act to Aid Flood Zone," *Harrisburg Patriot*, July 28, 1977; "Countians Help Johnstown Dig Out," *Lancaster New Era*, July 30, 1977; "Volunteers Help Flood Clean-Up" *Somerset Daily American*, August 1, 1977; "Supply Convoy to Roll Friday," *Pittsburgh Press*, July 27, 1977.

571. "High School Pupils to Aid Flood Cleanup," *Philadelphia Evening Bulletin*, July 28, 1977.

572. "Johnstown Flood Briefs—Disagree on Figures," *Altoona Mirror*, July 28, 1977.

573. "Richland School Overflowing as Homeless Pour In" and "UPJ Awakens Late to Flood, Then Shelters Evacuees," *Tribune-Democrat*, July 23, 1977; "No Place Like Home for Flood Refugees," *Greensburg Sunday Tribune Review*, August 14, 1977.

574. "Area to Get 900 Mobile Homes To Shelter Flood Victims," *Tribune-Democrat*, July 31, 1977; U.S. Housing and Urban Development Disaster Field Office News Release, August 1, 1977; "2 Sites Obtained for Mobile Homes," *Tribune-Democrat*, August 7, 1977; "Residents Oppose Trailers," ibid., August 10, 1977; "The REAL Objection to the Trailers," editorial, ibid., August 14, 1977; U.S. Army Corps of Engineers, *The 1977 Southwestern Pennsylvania Flood*, 51–54, 70–73.

575. "Rescue Squads at Work," *Tribune-Democrat*, July 24, 1977; "Dogs Used to Hunt for Flood Victims," *Altoona Mirror*, July 28, 1977.

576. "SBA Survey Reports Damage," *Tribune-Democrat*, July 23, 1977; "SBA Loans at $6 Million," ibid., September 8, 1977; "Flood Statistics," ibid., July 16, 1978.

577. Interview with Ed Kane, February 21, 2004.

578. A one-time Florida state senator, George Firestone, originated the aphorism, one of his many.

579. "Residents Say Police Knew, But Didn't Warn Them," *Tribune-Democrat*, July 24, 1977.

580. "The Warnings Johnstown Never Got," *Philadelphia Inquirer*, July 25, 1977.

581. U.S. Army Corps of Engineers, *The 1977 Southwestern Pennsylvania Flood*, 42–43.

582. "State Official Seconds Complaints Against Mayor," *Tribune-Democrat*, August 7, 1977.

583. Interview with Richard Sanderson, February 25, 2004.

584. "Shapp Thanks Pfuhl" and "Coordinator Doesn't Want Stones Thrown at Others," *Tribune-Democrat*, August 9, 1977; telephone interview with Joseph Latch, March 16, 1904. Latch's remarks were supportive of Pfuhl. He confirmed the helicopter assignment but stated there had been no improper use of it.

585. U.S. Army Corps of Engineers, *The 1977 Southwestern Pennsylvania Flood*, 49.

586. "The Mud Is Unforgettable," *Pittsburgh Post Gazette*, August 5, 1977.

587. "Royal Plate Glass Explodes; 11 Persons Taken to Hospital," *Tribune-Democrat*, July 25, 1977; "Grove Counts Water Blessings," ibid., August 16, 1977.
588. "Repairing the Flood Damage," ibid., October 9, 1977; "Johnstown Expressway's 4 Lanes Open Again," ibid., November 23, 1977. Includes an overview of the PennDOT flood recovery (highway restoration) program.
589. This section about the Bethlehem Steel Corporation after the flood is a continuation of the Bethlehem Steel discussion in chapter 25, "The Bethlehem Steel Cutback Announcement and the Creation of JARI," 173.
590. Prior to the flood, the Johnstown Works of Bethlehem Steel had a capacity of about 2.3 million tons.
591. "Will Bethlehem Pull Out?" and "It Looks Bad…But Here's an Opportunity," editorial, *Tribune-Democrat*, July 31, 1977; "Officials to Meet on Local Steel Plant's Future" and "What Can Be Done to Stop A Bethlehem Steel Pull-Out?" editorial, ibid., August 1, 1977; "Bethlehem Cutting Up to 7500 Jobs," ibid., August 2, 1977; "Bethlehem Oks 7500 Jobs," ibid., August 6, 1977; "Mill Gets Lift," ibid., August 16, 1977; "BOF Stalled Indefinitely," ibid., September 2, 1977; "Crowley: 8000 Bethlehem Men on Jobs by September 30," ibid., September 8, 1977. I am also indebted to John Gundermann, John Schnabel, William McCann and Henry Moyer, all retired senior officials at Bethlehem's Johnstown Works, for observations and insights about the flood's impact on the steel mill.
592. Interview with Wilfred Frombach, retired foreman from U.S. Steel at Johnstown, March 10, 2004.
593. "Penn Traffic's Store Not Reopening," *Tribune-Democrat*, August 5, 1977.
594. "More and More Merchants Say: 'We'll Be Back Bigger Than Ever'," *Tribune-Democrat*, August 4, 1977. "Glosser Bros. Coming Back," ibid., August 6, 1977; "Glosser Opening Planned," ibid., August 17, 1977; "Most of Johnstown Small-Business Proprietors Plan to Remain at Sites," ibid., September 11, 1977.
595. "Funds for the Library," editorial, *Tribune-Democrat*, September 29, 1977; "Library's Recovery Promising," ibid., November 27, 1977; "Library and Flood," editorial, ibid., November 30, 1977; "Library to Get $740,000," ibid., October 21, 1978; "Dornick Point to Be Back in Operation Today," ibid., October 1, 1977; "Arena Aims at Jan 1," ibid., November 17, 1977.
596. "Council Sets Stage for Sending Funds to Flood-Relief Center," ibid., March 23, 1978.
597. Glosser, Weakland and Olek, "The Johnstown Flood of 1977 and How the Community Coped With Disaster."
598. "GJC, County Planners, Look to Recovery Setup," *Tribune-Democrat*, August 20, 1977; "City Begins 3 Flood Programs," ibid., November 9, 1977; "JARI Flood Group's Goal: $217 Million For 3 Counties," ibid., November 18, 1977; "Flood Recovery Will Take Years But the Job's Already Under Way," ibid., January 15, 1978.
599. "City Needs $100 Million To Recover, Pfuhl Says," *Tribune-Democrat*, October 20, 1977; "Cambria Will Apply for $25 Million on Behalf of 20 Municipalities," ibid., November 16, 1977; "JARI Flood Group's Goal: $217 Million For 3 Counties," ibid., November 18, 1977; "Coppersmith: Recovery Effort Chaotic," ibid., January 6, 1978; "Treading Water in Flood Recovery," editorial, ibid., January 10, 1978; "Munko: More Jobs Top Priority," ibid., January 11, 1978.
600. Interview with Richard Mayer, April 6, 2004.
601. Interview with Larry Olek, former executive director, '77 Flood Relief Center, March 22, 1904; "Tri-County Group Sets Sights on Long-Term Ills," "Flood Unit Gives Murtha Its Plans" and "Long-Lasting Problems Get Committee's Attention," *Tribune-Democrat*, March 5, 1978.
602. Act 1978, 1951, Laws of Pennsylvania (1978); *Tribune-Democrat*, May 24, 1978; "Coppersmith Raps Flood-Grant Block," ibid., March 5, 1978. "Flood Committee to Urge Shapp to Re-Think Aid," ibid., May 27, 1978; "The Coppersmith-Shapp Flap," editorial, ibid., July 7, 1978.
603. "Thornburgh to Release Act 51 Flood Payments," ibid., February 2, 1979; "2000 Fail to Seek Grants Under Act 51," ibid., August 15, 1979; "Act 51 Checks To Be Mailed To 1700," ibid., December 15, 1979.
604. Act 191 of 1978, signed by Governor Shapp on October 4.
605. "Flood Group Now Is Seeking $50 Million," ibid., August 8, 1978; "Official Expects Spring Start For Flood Recovery Funding," ibid., October 27, 1978.
606. Act 1978–191, Laws of Pennsylvania, 1978.
607. "Flood Plans Revised for Final Okay," *Tribune-Democrat*, February 11, 1979.
608. See discussion in "The Johnstown Redevelopment Authority-City Government Rift," section that follows in this same chapter.
609. "Flood Money for Flood Victims," editorial, *Tribune-Democrat*, February 18, 1979; "Tri-County Still Seeking Formula," ibid., May 31, 1979; "People First Is DCA's Plan," ibid., January 23, 1980.
610. "Tri-County Unit Adamant on Use of State Bond Issue," *Tribune-Democrat*, February 8, 1979; "Panel Will Try to Block Flood-Fund Distribution," ibid., December 15, 1979.
611. "Neighborhood Recovery—Provisions of City Plan," ibid., August 18, 1977.
612. "Pittsburgh Man Hired by City Redevelopers," ibid., August 11, 1977.
613. "Redevelopment Authority Staff Grows as Business Picks Up," ibid., December 11, 1977. See also chapter 24, section V, "Main Street East" and "The Lee-Sheraton (Main Street West) Project," 169 and 170.
614. "$21 Million Is City's Share of Bond Issue," *Tribune-Democrat*, February 14, 1979; "Redevelopment Authority Contracts Top $35 Million," ibid., December 19, 1979.

615. "'Kutch' Seeks Funds for New Department," *Tribune-Democrat*, December 2, 1977; "Mayor Cuts Off Funds to Redevelopment Unit," ibid., June 8, 1978; "Planning Must Leave City Hall—Mayor Told," ibid., October 3, 1978.
616. "Complaints Aimed At RIFLE," ibid., January 10, 1979; "RIFLE Work Moving Ahead," ibid., January 21, 1979.
617. "Bad Records or Snow Job?" editorial, *Tribune-Democrat*, July 25, 1983; "Continue Pressure for Flood Monies," editorial, ibid., July 21, 1983; "5 Plead in Rehab Schemes," "Court to Decide Restitution" and "We Got What We Wanted, D.A. Says of Pleas," ibid., January 10, 1984; "Probe of City RIFLE Program Appears to Have Come to Dead End," ibid., January 15, 1984; "Audey Was 'Mr. Big,' Haidar Says" and "Haidar Bitter Over Role," ibid., March 1, 1984; "Audey, 2 Sons Get Jail Terms" and "Audey: 'I wasn't Kingpin'," ibid., June 20, 1984.
618. "History of Tanneryville Suits" and "20 Flood Suits Settled Out Of Court," *Johnstown-Tribune*, April 18, 1989; "Flood Victims Still Waiting," ibid., July 20, 1989; "'77 Flood Lawsuits Settled," ibid., April 26, 1990.

EPILOGUE
619. "Flood Statistics," *Tribune-Democrat*, July 20, 2002.

SELECTED BIBLIOGRAPHY

Al-Khayat, Hassan A. "Johnstown, Pennsylvania: A Geographic Analysis of the Basic-Non Basic Economic Functions."
 PhD diss., University of Pittsburgh, 1962.

Altoona Mirror.

American Red Cross, Cambria-Somerset Chapter. *An Operational History of the American Red Cross, 1946–1978.* N.d.

Barck, Oscar T., and Nelson M. Blake. *Since 1900.* 5th ed. New York: Macmillan, 1974.

Berger, Karl, ed. *Johnstown: The Story of a Unique Valley.* Johnstown, PA: Johnstown Area Heritage Association, 1985.

Bernstein, Irving. *Turbulent Years: A History of American Workers.* Boston: Houghton Mifflin, 1969.

Blumenthal, Frank. "Anti-Union Publicity in the Johnstown Little Steel Strike of 1937." *Public Opinion Quarterly*,
 October 1939.

Buchart-Horn Engineers. *Johnstown Central District Plan.* 1962.

Cambria County Planning Commission. *Mass Transit.* 1975.

Capper, Dan. *Pennsylvania Turnpike: A History.* Harrisburg: Applied Arts Publishers, 1995.

Conemaugh Valley Memorial Hospital. *Annual Report for 1977.*

Crichton, Jean. "Music and Lights of Main Street." In Berger, *Johnstown: The Story of a Unique Valley*, Chapter 15.

Dasch, George. *Eight Spies Against America.* New York: McBride, 1959.

Dubofsky, Melvyn, and Warren Van Tine. *John L. Lewis: A Biography.* New York: Quadrangle, 1977.

Ferg, Bruce. "The Politics of Improvement in a Declining Community: Johnstown, PA." Senior paper, Brandeis
 University, May 1971.

Glosser, Ruth, Gilbert Weakland and Lawrence H. Olek. "The Johnstown Flood of 1977 and How the Community Coped
 With Disaster." Presentation to the National Conference on Social Welfare (NCSW) Forum, May 13–17, 1979.

Greensburg Sunday Tribune Review.

Hanten, Edward W. "An Analysis of the Industrial Potential of Johnstown." Masters thesis, University of Pittsburgh,
 1958.

Harrisburg Patriot.

Hirschhorn, Clive. *Gene Kelly.* New York: St. Martins Press, 1974.

Hollis, Clea, and Leah Hollis. *The Saga of Johnstown City Schools.* Johnstown, PA: Patllis Press, 2003.

Hunter, Robert J. *The Evolution of a College: A Chronicle of the University of Pittsburgh at Johnstown, 1927–1993.*

Hutcheson, Edwin L. "The Role of Ecumenical Organizations in Flood Recovery." St. Francis College, April 1978.

Indiana [PA] Evening Gazette.

"It Happened in Steel." *Fortune*, May 1937.

Jenkins, Phillip. *Hoods and Shirts: The Extreme Right in Pennsylvania.* Chapel Hill: University of North Carolina Press, 1997.

Johnstown Democrat.

Johnstown Municipal Authority. *Cleaner Streams.* Brochure, 1967.

Johnstown Tribune.

Johnstown Tribune-Democrat.

Keyes, Scott. *Rehousing Johnstown.* Memo to the U.S. Housing Authority, ca. 1941.

"Labor: Mr. Roosevelt Helps a Friend." *Newsweek*, June 26, 1937.

Lancaster New Era.

Selected Bibliography

Latrobe Bulletin.

Lee Hospital. *The Lee Hospital Legacy.* Johnstown, PA: Lee Hospital, 1990.

McPherson, Donald S. "The Little Steel Strike of 1937 in Johnstown, Pennsylvania." *Pennsylvania History*, April 1972, 219–38.

Monroe, Nicole. *The Cambria City National Historic District.* Southwestern Pennsylvania Heritage Preservation Commission, 1994.

New York Times.

Papinchak, Andrew E. "A History of the Johnstown Symphony Orchestra." Masters thesis, Indiana University of Pennsylvania, 1969.

Pawlowski, Edwin. "The History of City Planning in Johnstown." In Berger, *Johnstown: The Story of a Unique Valley*, 1985.

Penelec Forum. *From Then to Now…Penelec.* Johnstown: Pennsylvania Electric Company, 1947.

Pennsylvania Crime Commission. *Report on the Conditions of Organized Gambling and the Administration of Criminal Justice in Johnstown, Pennsylvania*, 1971–72.

Pennsylvania Department of Labor and Industry. *Total Civilian Work Force, Unemployment and Employment.* Cambria and Somerset Counties, 1949–1988.

Pennsylvania Department of Mines. *Annual Reports*, various years.

Pennsylvania Electric Company. *Flood.* Johnstown, PA: Pennsylvania Electric Company, 1977.

Philadelphia Evening Bulletin.

Philadelphia Inquirer.

Phillips, Cabell. *From the Crash to the Blitz.* New York: New York Times, 1969.

Pittsburgh Post Gazette.

Pittsburgh Press.

Pittsburgh Sunday Press.

Schlesinger, Arthur M. *The Age of Roosevelt: The Coming of the New Deal.* Boston: Houghton Mifflin, 1958.

Sifakis, Carl. *The Mafia Encyclopedia.* New York: Facts on File, 1987.

Sofchalk, Donald. "The Little Steel Strike of 1937." PhD diss., Ohio State University, 1961.

Somerset Daily American.

Strohmeyer, John. *Crisis in Bethlehem: Big Steel's Battle to Survive.* Bethesda, MD: Adler and Adler, 1986.

University of Pittsburgh, School of Education. "Schools for a Greater Johnstown." 1957.

U.S. Army Corps of Engineers. *The 1977 Southwestern Pennsylvania Flood: A 500 Year Flood.* 1978.

U.S. Army Corps of Engineers. *Review of Reports on the Feasibility of Extending the Existing Channel Improvement; Johnstown, Pennsylvania*, May 1972.

U.S. Bureau of the Census. *Statistical Abstract of the United States.* Various annual editions.

U.S. Bureau of Public Roads. *Toll Roads and Free Roads*, 1938.

U.S. Department of the Interior: Geological Survey Professional Paper 1191. *Storm-Induced Debris Avalanching and Related Phenomena in the Johnstown Area with References to Other Studies in the Appalachians.* GPO, 1980.

Wall Street Journal.

Wechsler, James A. *Labor Baron: A Portrait of John L. Lewis.* New York: William Morrow, 1944.

Williams, Bruce T., and Michael D. Yates. *Upward Struggle: A Bicentennial Tribute to Labor in Cambria and Somerset Counties.* Johnstown: Johnstown Regional Central Labor Council and the Pennsylvania Bicentennial Commission, 1976.

Wish, Harvey. *Contemporary America.* New York: Harper, 1955.

WJAC-TV. *Flood-77.* Footage of the 1977 Flood.

Yudkoff, Alvin. *Gene Kelly: A Life of Dance and Dreams.* New York: Back Stage Books, 1999.

INDEX